Beyond the Boundaries

Beyond the Boundaries

American Alternative Theatre

Theodore Shank

A New and Enlarged Edition of
American Alternative Theatre

Ann Arbor

The University of Michigan Press

Copyright © by Theodore Shank 1982, 2002
All rights reserved
Published in the United States of America by
The University of Michigan Press
Manufactured in the United States of America
⊗ Printed on acid-free paper

2005 2004 2003 2002 4 3 2 1

A CIP catalog record for this book is available from the British Library.

Library of Congress Cataloging-in-Publication Data
applied for
ISBN 0-472-11166-3 (cloth)
ISBN 0-472-08535-2 (paper)

ACKNOWLEDGMENTS

Especially I want to thank the theatre artists whose work is discussed here for their generosity in conversations, interviews, and correspondence. I am also indebted to the photographers who allowed me to use their photographs and in particular thank Gianfranco Mantegna and Paula Court. Also I am grateful to Tom Leabhart, editor of *Mime Journal,* for permission to use material from my book *California Performance,* volume 1. And finally, special thanks to my wife, Adele Edling Shank, for her careful and insightful work as the first editor of this book.

CONTENTS

Preface ix

Part I.
American Alternative Theatre
1960–80

1. **The Alternative Theatre** **1**

2. **Primary Explorations** **8**
 The Living Theatre 9
 The Open Theatre 38

3. **Theatre of Social Change** **50**
 The San Francisco Mime Troupe 59
 El Teatro Campesino 74

4. **Environmental Theatre** **91**
 Richard Schechner: The Performance Group 93
 The Bread and Puppet Theater 103
 Snake Theater 113

5. **New Formalism** **123**
 Robert Wilson 125
 Suzanne Hellmuth and Jock Reynolds 134
 Alan Finneran: Soon 3 140
 Michael Kirby: The Structuralist Workshop 149

6. **Self as Content** **155**
 Richard Foreman: The Ontological-Hysteric Theatre 159
 Spalding Gray and Elizabeth LeCompte:
 The Wooster Group 170
 Squat Theatre 179

Part II.
American Alternative Theatre
since 1980

7. An Introduction to Alternative Theatre Since 1980 193

8. Outrageous Performance 199
 "Indecency" and the National Endowment for the Arts 199
 The Shock of Nakedness 202
 Karen Finley, "The Chocolate-Smeared Woman" 202
 Holly Hughes, Everybody's Girlfriend 209
 Tim Miller, Everybody's Boyfriend 211
 Juliana Francis and *GO GO GO* 213
 Annie Sprinkle, Post-Post-Porn Modernist 215
 Sacred Naked Nature Girls 217
 Body Mutilation and Performance 219
 Ron Athey: Self-Mutilation as Religious Experience 221

9. Social Commitment 225
 The San Francisco Mime Troupe 230
 Anna Deavere Smith 236
 Guillermo Gómez-Peña 246

10. New Technologies and Techniques 252
 Ping Chong 253
 George Coates Performance Works 264
 Alan Finneran: Soon 3 279
 Antenna Theater: Putting the Spectator
 in the Performance 287

11. Self-Reflections 296
 Mabou Mines 297
 Richard Foreman 311
 The Wooster Group 327

 Notes 343

 Index 351

PREFACE

This is really two books bound together. The first, *American Alternative Theatre,* was originally published in 1982 and deals with the period from the 1960s until about 1980. It is republished here unchanged. The second, which is entirely new, covers the years since 1980.

The companies discussed have been selected from a large number of practicing theatre groups, so in a sense they are exemplary. I have discussed only those whose work is unique for its creative process, concepts, techniques, or social interaction. Because direct experience with the work is important, I have written only about artists whose productions I have seen; and whenever possible, I have talked with the artists. I regret not being able to include other deserving companies.

My aim has been to describe both the work of these companies and their creative processes. Because my own activity in the theatre has been primarily as a director and playwright, the works themselves and the processes used to create them—rather than theoretical matters—are my principal interest. The companies and individuals discussed here are those who create work autonomously, from inceptive idea to public performance. While there are many excellent playwrights practicing an alternative aesthetic who deserve serious attention, I have not discussed their plays because they usually work in isolation.

In the new part of this book I have followed the practice in part 1, grouping companies into categories; but of course some companies could have been placed in more than one category. Included in part 2 are many new groups and a few that were previously discussed in part 1. Among those that would have appeared in the earlier book had I seen enough of their work are Mabou Mines, which was mentioned only briefly, and Ping Chong. Among other new inclusions are several solo performers, a phenomenon that burgeoned during the 1980s and 1990s. Included are groups considered outrageous by some, others dedicated to social issues, a few who are known for their imaginative use of media, and some whose work is self-reflective. Discussed in part 1 and now updated are the San Francisco Mime Troupe, probably the oldest surviving political theatre in the United States; Richard Foreman's Ontological-Hysteric Theater; Alan Finneran's Soon 3; Antenna Theater, which evolved from Snake Theater and has found a unique way of subsidizing its work; and the Wooster Group, whose founding members came from Richard Schechner's

Performance Group and which has developed, under the direction of Eliza-beth LeCompte, into one of the country's most innovative theatres.

Certain companies from the earlier book, some still extant, are not included in the new part. Following the death of Julian Beck in 1985, the Living Theater continued under the direction of cofounder Judith Malina, but is best known for its earlier groundbreaking work. The Open Theater disbanded in 1974, although its founding director, Joseph Chaikin, continues to direct and perform. Michael Kirby died in 1997, bringing to an end the Structuralist Workshop, which for several years had been producing only intermittently. El Teatro Campesino faded when its founder and director Luis Valdez turned his energies to presenting Chicano and Latino issues in mainstream theatre and film (the sons and daughters of Luis and Danny Valdez have recently revived the company). Squat Theater disbanded and fragmented into smaller groups that have not been very active, though a few of its members have continued to work individually. Jock Reynolds, whose background was visual arts, turned from theatre to museum and has been one of the most vocal in protesting limitations that politicians would put on freedom of expression in the arts. The Bread and Puppet Theater and Robert Wilson continue as active as ever, but they are so well known that discussion here is not needed.

Because the first part of this book was originally published in England by Macmillan Press, its spelling and punctuation are British. In the second part, written for the University of Michigan Press, I have followed common American practice.

PART I

American
Alternative
Theatre
1960-80

CHAPTER 1

The Alternative Theatre

The social upheaval in the United States during the 1960s and early 1970s not only gave rise to a new cultural movement outside the dominant culture; it also spawned an alternative theatre. Initially, the new theatre was expressive of those who aligned themselves with the various social movements of the time – civil rights, free speech, hippie, anti-nuclear, anti-Vietnam War, ecology, feminist, and gay. It was an alternative to the theatre of the dominant complacent middle-class society which tended to perpetuate the *status quo* in its aesthetics, politics, working methods, and techniques. The alternative theatre companies directed themselves to the new audiences, often a specific constituency such as intellectuals, artists, political radicals, workers, blacks, Chicanos, women, or gays. They explored new working methods, new techniques, and new aesthetic principles that would be in harmony with their convictions and could be used to express their new theatrical conceptions.

By the mid-sixties there were five kinds of theatre organizations in the United States other than the new alternative theatres. (1) There were theatres which existed as part of the training programmes of colleges and universities. These were increasing rapidly and were distinctly American, as only later did a few such programmes develop in Europe. (2) There were amateur theatres which served primarily the recreational needs of the participants whose occupations were outside the theatre. (3) The commercial professional theatre of Broadway presented productions intended as business ventures and, if successful, they were packaged and toured to major cities around the country. (4) The participants in Off-Broadway theatres were seriously pursuing theatre professions even though they often

received only token salaries for their theatre work and subsidized themselves and their theatres by working at non-theatrical paying jobs. In the late forties and early fifties such theatres were formed not only in New York, but in Dallas, Houston, Washington D.C., and San Francisco. At the outset these theatres were the vanguard of the time, presenting productions from the new absurdists such as Genet, Ionesco, and Beckett, as well as new American plays and plays from the classical repertoire which, because of their limited appeal, were not of interest to the Broadway theatres. By the mid-sixties, however, because of increased production costs, some of these theatres began to choose productions which would rival Broadway. (5) Beginning in 1963 with the founding of the Guthrie Theatre in Minneapolis, large regional repertory theatres were formed in major cities throughout the United States to produce plays from the classical repertoire and Broadway. At first these theatres were subsidized by municipalities and private foundations, then in 1965 with the establishment of the National Endowment for the Arts they began to receive federal subsidy. It was the first U.S. government support for theatre since 1939 when funds for the Federal Theatre Project were discontinued.

When an alternative culture and life-style began to take shape in the mid-1960s, another kind of producing organization came into being. In part it was a grassroots movement in that some of the participants did not come from the theatrical profession but were drawn to theatre as a means of expression for their social and political commitment. On the other hand, in the early sixties New York theatre professionals had begun to form off-Off-Broadway theatres such as Cafe Cino and the La Mama Experimental Theatre Club. These became the new vanguard, taking up the slack left by the increasing conservatism of Off-Broadway. These two strands – the grassroots and professional theatrical experimentation – were intertwined and produced the unique qualities of alternative theatre.

At the outset, it was the new life-style which made these theatres an economic possibility. Within the alternative culture it was not only acceptable to drop out of the established culture's universities and employment, but it was also desirable to withdraw the support of one's labour and tuition fees. It became both a necessity and a badge to live frugally – used clothing, inexpensive shared housing, food from money provided by middle-class parents, food stamps, unemployment benefits, welfare. As time passed, many of the theatres began receiving subsidies from private foundations and from municipal, state, and federal governments.

For the individual participant, the theatre companies frequently served as a total community. Often out of necessity, the companies provided theatre training because the participants had none and because the objectives, techniques, and styles of the new work required skills which were not taught in the universities nor practised in the older theatres. The theatre group and the work in which they were engaged provided the individual with family, work, education, and recreation. It also provided a social experience not

2

usually available in the established culture as membership in these companies cut across traditional lines. Working side by side on an equal basis were students, teachers, theatre professionals, amateurs, people of different races and social backgrounds, those with artistic commitment, and political activists.

The two energizing forces of the new theatre – the moral energy of social causes and the spirit of artistic exploration – gave rise to two perspectives from which artists viewed human experience. There were those who looked outward, exploring human beings in society, analyzing social institutions, considering political issues, and sometimes advocating social change. The other perspective was inward-looking and involved a consideration of how we perceive, feel, think, the structure of thought, the nature of consciousness, the self in relation to art. In the late sixties and early seventies those groups with a social perspective were predominant; but after the successes of the civil rights movement and the withdrawal of American military forces from Vietnam, companies and individuals focusing on intuition, perception, and form were in the ascendancy. Some theatres disbanded, others remain active after fifteen or twenty years, and new ones continue to be formed.

Regardless of perspective, these groups have many things in common which set them apart from the established theatre. Unlike the commercial theatres, they are not primarily concerned with entertainment as a product to be sold. Instead, they are anxious to improve the quality of life for themselves and their audiences. The theatre of the absurd had reflected the philosophical alienation of the individual; the alternative theatre tends to reflect the commitment of the group. The traditional theatrical spaces are economically unfeasible and artistically unsuitable. They are too large and typically are divided into stage and auditorium which dictates a particular performer–spectator relationship unacceptable to many artists on aesthetic grounds and to others because the arrangement hinders the development of a community spirit. However, the most important changes are the development of an autonomous creative method, a shift from the dominance of words to a visual emphasis, and an aesthetic that keeps spectators conscious of the real world rather than focusing them exclusively on a fictional illusion.

An autonomous method of creation became the typical means of making new plays. Instead of the two-process method of the conventional theatre – a playwright writing a script in isolation and other artists staging it – the autonomous method involves a single process wherein the same artists develop the work from initial conception to finished performance. In part the development of this method was a reaction against the psychic fragmentation the artists experienced in the technocratic society which believed that human needs could be satisfied by technical means requiring a high degree of specialization. Instead of the individual specialists of the established theatre, the typical member of an alternative theatre has broad creative responsibilities.

3

Despite the automonous method of creation, the structures of alternative theatre companies vary greatly. Some early groups did not distinguish between the work of performer, director, designer, and playwright. Some collective theatres embraced the idea that everyone should do everything regardless of skill. But as idealism faded and artistic commitment came to overshadow social commitment, the collective method became less rigidly democratic. After its reformation as a collective the San Francisco Mime Troupe did not publicly identify the responsibilities of individual members, but specific directors and playwrights were selected from the company for their productions. Joseph Chaikin was the director of the Open Theatre in New York throughout its ten years, but the productions were created by the entire group under his guidance. In other instances playwright–directors such as Richard Foreman and Alan Finneran have the primary responsibility for the creation of a work from inception to performance.

A visual focus became an alternative to the established theatre's dependence on words as the chief medium of expression. There was a distrust of words because of the end to which they were used by politicians and advertising. It was also recognized that some experiential concepts cannot be expressed by words, and it was thought that society, having relied upon words, had tended to cut itself off from its experience. Furthermore, the alternative culture denigrated nationalism which in part is perpetuated by national languages. Painters and sculptors who were beginning to create theatre productions were naturally inclined toward visual means, and other theatre artists experimented with non-verbal sounds, with placing focus upon the performer's body, and with a variety of other non-verbal means.

With few exceptions, alternative theatre performances are intended to be perceived as existing in real time and place. If one were to devise a continuum of audience consciousness in relation to performance, it would extend, on the one hand, from the spectator's complete awareness of perceiving to, on the other hand, complete psychic absorption into the fictional world created by the performance. Since the nineteenth century when the auditorium lights were turned off during performance so as to focus attention exclusively on the fictional stage events, theatre artists have attempted to make spectators forget where and who they are. This objective continued with even greater success in talking motion pictures. It is the intention of these productions to cause the audience to focus on the fictional illusion being presented and to become psychically absorbed in it to the extent that they lose their self awareness – to make them perceive characters, not the actual performers; to focus on the evolving fictional action, not the tasks of actors as they create the illusion; to concentrate on the fictional time and place of the play and lose their consciousness of the real time and place in which the performance is being presented. By contrast, most artists of the alternative theatre adopted a spectator–performance relationship similar to that in the visual arts. Spectators in a gallery do not lose consciousness of themselves or of the time and place of the exhibition. While viewing a paint-

4

ing they remain aware that the illusion presented is in fact an illusion and they are also conscious of the means used to create it. Similarly, in the work of most alternative theatres the audience is aware of both the illusion and the performers.

Some theatre artists were drawn to the new aesthetic in their attempts to discover the unique possibilities of live theatre as distinct from motion pictures and television. The most important condition of theatre that distinguishes it from these newer media is that performers and spectators are physically present in the same time and place. This is abrogated, however, when the spectators are permitted only to see the illusion of character and not the performer, when they are focused exclusively on a fictional time and place. If a compelling all-absorbing realistic illusion were to continue as the aesthetic means of live theatre, then live theatre would be doomed to compete unsuccessfully with motion pictures.

Among alternative theatre workers there was general suspicion of the illusionistic theatre because of its apparent use of pretence and the mystique surrounding it. There was much talk about demystifying the theatre. Those who advocated the use of theatre to help bring about social change saw a similarity between the function in society of religion and of the all-absorbing illusionistic theatre. Both distracted their constituents from the real world and helped them mentally escape from social problems. For these social activists it was essential that the audience be made to focus on the real world where the changes were needed. Furthermore, it was important to create a sense of community among the spectators who then would have the potential for collective action. Such a community was possible only if the spectators were psychically present.

Models for a focus on the actual could be found in performance situations outside the theatre. The success of a cabaret performance does not depend on audience belief in a fictional illusion. The spectator's focus during circus performances is on the events happening in real time and place. A story teller is viewed as himself in the present even if telling of past events or demonstrating how a fictional person moved or talked. And athletic events consist of tasks performed by individuals without resorting to illusion.

An influx of visual artists into the theatre was a major impetus toward theatre of real time and place. Painters and sculptors, who in the late 1950s were discontent with their traditional static media, began creating happenings in which they hoped to eliminate the separation of art and life. As in theatre these works used environments, performers were engaged in tasks, and there was a controlled time dimension; however, as in painting and sculpture, the spectator perceived them in real, rather than fictional, time and place. Even though the spectators were physically within the environments and sometimes even participated in the events, they were not psychically involved with a fictional world.

In practice this focus on the actual takes many forms and theatre artists have invented or rediscovered numerous techniques. Jerzy Grotowski of the

5

Polish Laboratory Theatre influenced American theatre artists by his actor training method which put into focus actual responses of the body by eliminating all impediments between impulse and reaction. Through his psycho-physical exercises he hoped to eliminate the disparity between the actor's physical and psychic functions. Joseph Chaikin, director of the Open Theatre, also sought to focus attention on the actor's body and voice. His non-illusionistic actor training exercises were designed to intensify what he called the 'presence' of the *actor* as distinct from the *character*. Such exercises became part of the performance in some Living Theatre productions, and in *Paradise Now* (1968) spectators participated in some of the exercises. Members of the company, including Julian Beck and Judith Malina, performed various tasks as themselves. Even when performers represented characters, there was a dual focus on the characters and the performers.

Most guerrilla theatre events of the late sixties and early seventies consisted of tasks performed without a time and place illusion whether or not characters were represented. Abby Hoffman threw real money on the floor of the New York Stock Exchange and the real stock brokers scrambled for it. At a demonstration in Washington in 1970 a black man exhibited himself tied to a cross. Others symbolized the carnage in the Vietnam war by smearing themselves with blood from a slaughterhouse and carrying animal entrails.

The style of acting developed by the San Francisco Mime Troupe permits actors to create an illusion while keeping the audience aware of the real world. We acknowledge the presence of the performers who seem to be demonstrating the characters rather than pretending to be them. Furthermore, the group uses non-illusionistic popular entertainment techniques – juggling, dancing, a band playing familiar music – as the means of attracting spectators in a public park and these techniques are sometimes incorporated into the productions.

In some environmental theatre performances the audience moves from place to place which helps them perceive the events in the present. The same perception occurs in some of Richard Schechner's productions when several focuses are offered simultaneously. The spectators, free to shift attention from one event to another as they wish, structure their own time; the events are viewed as happening in real time much as when watching a three-ring circus. When Snake Theater incorporates into a performance the actual environment of the beach and ocean, the spectator is simultaneously aware of both the actual and the fictional.

The new formalists, coming to the theatre from the visual arts, brought with them an interest in composition and other formal elements, and their productions put these into focus rather than emphasizing a compelling illusion. Some of the resulting works, such as those by Alan Finneran, are animated compositions of objects, projections, and the tasks of performers. Other productions, as in the case of Robert Wilson, have a hypnotic effect somewhat like music, and some make one conscious of structure as in the work of Michael Kirby's Structuralist Workshop.

Those artists who used themselves as the content of their work focused on actuality in another way. Richard Foreman's plays reflect directly his natural thinking processes. The work of Spalding Gray and Elizabeth LeCompte of the Wooster Group presents events from Gray's life using both documentation and imagination. The space in which Squat Theatre performs is separated from the sidewalk by a storefront window so that the actual passersby become part of the performance for the audience inside and vice versa.

Because in the alternative theatre there is no need to keep the audience focused on a fictional illusion, a linear cause-and-effect plot creating suspense is not of pre-eminent importance. This has been the traditional technique for keeping the spectators focused on the evolving future of the fictional characters, on what is about to happen, rather than upon the actual present. It is a psychic state in which one does not perceive keenly and is somewhat like the way one experiences the non-perceptual art of literature. When reading suspenseful fiction one is unaware of the words on the page and focuses only on the fictional events happening mentally. In the new theatre aesthetic it is not desirable to empty the spectator's mind of perceptual values, which are often of primary importance.

The artists who comprise the alternative theatre explore the relationship of the artist to the work and the performance to the spectator. They attempt to discover the unique possibilities of live theatre, and seek ways of extending the use of theatre beyond its entertainment and financial functions. They set out to find or invent more expressive ways to articulate what they know about being alive in the changing times, about society, about perceiving, feeling, and knowing. Of necessity they find new materials, develop new techniques, and create new forms to hold and express this knowledge because the theatrical conventions cannot express the concepts they consider important.

The conventional theatre is usually expressive of a time past. Artists convey through their works a knowledge of how it feels to be alive in their particular time and place. Those concepts, materials, and techniques which are particularly expressive are imitated by others and become conventions. As time passes and these conventions persist, they may cease to convey insights about life in the new circumstances. The realistic box set, for example, may have been particularly expressive in the late nineteenth century when the new social sciences were suggesting that humans, like other biological organisms, should be studied in their environment. But its continued use in the mid-twentieth century became a mere convention. Similarly, the concepts and techniques of the theatre of the absurd expressed the absurdity of life in the 1950s at a time of social and political complacency while governments were adding to their stockpiles of nuclear weapons. While some artists perpetuate such conventions, those who are identified with the new alternative theatre look afresh at the artist's primary source: human experience – emotive, perceptual, intellectual, and social.

CHAPTER 2

Primary Explorations

In the early 1960s there were two alternative theatre groups which, because of their commitment, their experimentation with creative processes, and their development of new techniques, had a profound impact upon many who followed. Both companies developed methods of collective creation, but they had distinctly different basic objectives – the Living Theatre, while engaging in aesthetic exploration, came to use theatre as a means of bringing about social change; while some members of the Open Theatre were politically committed, they devoted their work solely to aesthetic experimentation.

When Julian Beck and Judith Malina formed the Living Theatre in 1951 their radicalism was only aesthetic. Since then they have explored a variety of theatrical techniques, some adapted from happenings and aleatory music, they have experimented with group living, and since about 1964 they have committed their lives and their work to an anarchist–pacifist political view with unwavering tenacity. The life-style of the company and their production techniques became models for other new groups in America and Europe, but none has had the commitment, the skill, the persistence, or the longevity, of the Living Theatre which continues to work under its original directors.

The Open Theatre was founded by Joseph Chaikin and directed by him throughout its existence-(1963–73). Although Chaikin had been a member of the Living Theatre, his new company avoided overt political content in its productions. The actor training exercises developed by the group, as well as their improvisational techniques for collective creation and their performance style, have been used by many other alternative theatre companies.

The Living Theatre

'Life, revolution, and theatre are three words for the same thing: an unconditional NO to the present society.' This view was expressed in 1968 by Julian Beck who, with his wife Judith Malina, founded and continues to direct the Living Theatre. For three decades they have committed themselves to theatrical and social experimentation which has more than once led to imprisonment.

Beck and Malina met in New York as teenagers and were married in 1948. In 1951 they formed the Living Theatre. For the first few months their productions were presented in their apartment. When Beck inherited six thousand dollars they rented the Cherry Lane Theatre but eight months later it was closed by the Fire Department. From 1954 until 1956 they performed in a loft at Broadway and 100th Street but that was closed by the Building Department because 65 seats were considered too many for safety. More than three years passed before they again had a place to perform. In January 1959 they opened a 162-seat theatre in a former department store at Sixth Avenue and 14th Street. In October 1963 they were evicted by the Internal Revenue Service for non-payment of nearly 29,000 dollars in federal excise and payroll taxes and their last New York theatre closed.

During these first twelve years Beck and Malina were formulating their view of theatre. Beck says that they wanted a revolution in the theatre similar to those which had already taken place in painting and sculpture. They were reacting against naturalism and were primarily interested in experimenting with poetic language. They began by producing the non-realistic plays of people they knew such as Paul Goodman and plays by Gertrude Stein, Brecht, Lorca, Rexroth, T.S. Eliot, Jarry, Auden, Cocteau, and Pirandello. While they worked together in close collaboration – he as designer and director, she as director and performer – their plays were not developed collectively. Their theatre work and their political convictions were at first separate.

Beck had become a dedicated anarchist–pacifist before the first production of the Living Theatre. He had dropped out of university and taken as his mentors Thoreau and Gandhi. Both Beck and Malina were arrested at sit-ins and demonstrations. This defiant, individualistic behaviour was reflected in their theatre works which were intended to jolt the audience into a new awareness, to present entirely unique works, and to explore production techniques which would alter the usual audience–performance relationship.

The search for uniqueness involved experiments with putting actuality on stage which led eventually to eliminating the separation between art and life, between dramatic action and social action, between living and acting, between spectator and performer, and between revolution and theatre. The first blurring of the line between fiction and reality was in Paul Goodman's *Faustina* (1952), named after the wife of Emperor Marcus Aurelius. At the end of the play the scenery disappears as Roman civilization crumbles and

9

the performer of Faustina comes forward. She chastises the audience for not leaping on stage to stop the murder which has taken place. The power of the moment came from a shift of audience perception from the illusion of Faustina to apparent direct communication by a performer. Of course the implied criticism of the audience had no real basis. The stage events were clearly illusory. The spectators were no more guilty in watching them than the performers in enacting them. However, it was the beginning of direct audience confrontation by the Living Theatre, a technique used extensively in later productions.

Similar perceptual shifts were achieved in works making use of the play-within-the-play technique which created an ambivalence in the spectator's mind between fiction and reality. The first of these was Pirandello's *Tonight We Improvise* (1955). After a three year hiatus Beck and Malina opened the 14th Street theatre with *Many Loves* by William Carlos Williams. As the audience enters the theatre, electricians and actors on stage are attempting to replace a blown fuse. When the lights are restored the play begins.

The most important of the productions using the play-within-the-play technique was Jack Gelber's *The Connection,* which Beck and Malina read in the summer of 1958. They were also reading *The Theatre and Its Double* by Antonin Artaud, whose concept of the 'theatre of cruelty' articulated their own feelings about the theatre. Like Artaud, Beck and Malina wanted not merely to entertain but to affect the audience so deeply that it had a cleansing effect. Beck wrote that the problem was 'how to create that spectacle . . . that would so shake people up, so move them, so cause feeling to be felt . . . that the steel world of law and order which civilization had forged to protect itself from barbarism would melt'. This was necessary because that 'world of law and order . . . cut us off from real feeling'.[1]

The Living Theatre felt that *The Connection* was successful in arousing such feelings. They claimed that during its run fifty men fainted. When the spectators enter several heroin addicts are waiting on stage. Another man steps off the stage and explains that he is the producer. He introduces Jaybird as the author and explains that he has induced several real addicts to come to the theatre and improvise on Jaybird's themes for a documentary film which is being shot by the two camera men who are in attendance. The addicts have co-operated in return for a promised fix. They are waiting for Cowboy to arrive with the heroin. During intermission the addicts pan-handle the audience, and in the second act Cowboy arrives and rewards each with a fix.

The dramatic device was that of a play within the play, but the unsuspecting spectators took it for authentic real-life events. The play is not structured conventionally in terms of story, suspense, dramatic pace. The characters simply wait for Cowboy to arrive, put on a Charlie Parker record, play improvized jazz, and get their fixes. Except for the violent reaction of one junkie who overdoses, it seems to be the tempo of real life.

At first Beck and Malina were pleased with this production, believing they

had achieved their objective of putting reality on stage and eliciting from the audience a true emotional reaction rather than the modulated feelings orchestrated by traditional drama. In fact it was one of the three productions they took on their first European tour in 1961. However, they were eventually disturbed by what they came to think of as their dishonesty in deluding the audience. They wanted to put reality on the stage, not pretence.

Their next attempt took a new tack. Under the influence of John Cage, who was exploring the use of chance in musical composition, they produced in June 1960 *The Marrying Maiden,* by the pacifist and libertarian poet Jackson MacLow. The text consisted of words or groups of words chosen by a chance system from the *I Ching* and various acting instructions – five different vocal volumes, five tempos, and a hundred or more adverbs and adverbial phrases such as 'gayly' or 'sorrowfully'. Their placement had also been by chance and they determined the feeling with which the actor was to read the text. In performance other chance elements were introduced and the 'acting' of the performers was transformed into actual tasks. The Dice Thrower rolled dice. Every time a seven came up a card was drawn from a pack of cards on which actions had been written. The card was presented to the actor whose turn it was to speak and the action was incorporated. When a five was thrown a sound tape of the actors reading the play, prepared by John Cage, was turned on. Another five and the tape was turned off. Every performance was different.

The frequency of new productions was decreasing – a sign of growing financial difficulties. Longer runs meant decreased production expenses and the directors were spending increasing amounts of time on financial matters. In the last three years before the 14th Street theatre was closed Beck and Malina produced only four plays. Two of these were by Brecht, including *Man Is Man* in which Joseph Chaikin, the future founder and director of the Open Theatre, played Gayly Gay. Thematically the play expressed the directors' growing anarchistic concerns about the loss of individual identity. Of greater importance to the development of the Living Theatre aesthetic and its non-violent convictions was *The Brig* by Kenneth Brown, which opened in May 1963 and was their last production in New York.

Kenneth Brown had been a prisoner in a U.S. Marine Corps brig in Japan. His play is a detailed documentary of routine life in such a prison. The prisoners' activity is totally controlled by the prison system codified in the regulations of the brig. A white line is painted on the floor across each doorway. Even when carrying out an order a prisoner is required to ask permission to cross the line – to enter the toilet, the compound, the storeroom. Speaking to other prisoners is strictly forbidden. No movement or speaking without orders from the guards is allowed. The oppressiveness is intensified by the frequent repetition of the sentence 'Sir, prisoner Number – requests permission to cross the white line, sir'. Any mistaken movement or phraseology is punished with a punch in the stomach, pushups, or other strenuous exercise which pushes the prisoner to the edge of

Maybe used as
part of the performance.

11

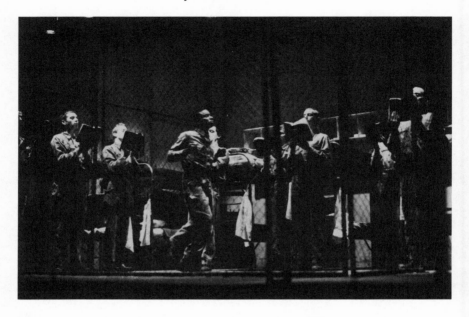

1. *The Brig*, **photo: Gianfranco Mantegna**

endurance. There is no conventional plot, only the structure of routine – jump out of bed, stand at attention, go to the toilet when ordered, do regimented exercise, carry out precise cleaning assignments, and when no other orders are given stand at attention reading the Marine Corps manual. It is the epitome of an anarchist's hell. It is an environment made suffocating by restrictions which, they hoped, would make the audience gasp for freedom. Director Malina and Beck felt that the production should make the audience want to break down all prison walls. Prison had become for them a metaphor for what Malina called 'the Immovable Structure', whether that structure is 'a prison or a school or a factory or a family or a government or The World As It Is'.[2] Of course, it was not only a metaphor for a repressive society, but the actual means of punishing those who failed to observe its restrictions.

The production brought together several strands of Malina's and Beck's aesthetic and social ideas. First, the production advanced their attempts to present reality. The play was a documentary account of Kenneth Brown's experience rather than a fictional story. The set reproduced the brig in which Brown had been imprisoned. And the performers actually underwent the punishments prescribed, which sometimes resulted in minor injuries, so there was no separation between what the actors experienced and what the spectators observed. Many of the infractions and penalties were improvised in rehearsals, where the usual informality and personal interaction were replaced by a set of rehearsal regulations which paralleled those of the brig,

and there were prescribed penalties for infractions. In performance, however, these actions were absorbed into the stage illusion of a prison, and the actors represented prisoners and guards. Beck saw that their work differed from Artaud's theatre of cruelty in that Artaud imagined horror could be created from the fantastic. To Beck horror is not in what we imagine but in what is real. He hoped that the production would cause the audience pain, that it would 'produce real horror and release real feeling'.[3] Second, the production helped formulate his and Malina's ideas of the prisoner as victim. In Beck's view *The Brig* exposed the authoritarian nature of American society and the barricades which divide people into victims and executioners; it put into focus the concept of imprisonment and violence as physical and psychological repression. Third, when the Internal Revenue Service closed the theatre in October 1963, it further strengthened his and Malina's view of the 'money system' as a destructive force. Beck came to 'realize that the entire economy is strangling most of the creative efforts', and this led to his conviction that 'the work you do in the theatre' must attempt 'to do away with the whole system'.[4] The Living Theatre from the beginning had experimented with radical aesthetic concepts and had held radical political views. Now they were convinced that their theatre should serve a political purpose. Their lives, politics, and art were coming together.

When the I.R.S. told the company to leave the theatre on 14th Street, the actors and directors refused. Borrowing from the methods of passive resistance used to accomplish racial integration, they sat in. A further act of civil disobedience took place two days later when they gave a final performance of *The Brig* in the padlocked theatre. They were joined in this act by forty spectators who climbed over an adjoining roof and into a window. After the performance they were again told to leave, and when they again refused twenty-five people were arrested. The following summer the Living Theatre began its voluntary exile in Europe. Beck and Malina returned only briefly in December 1964 to serve their prison sentences of sixty and thirty days respectively.

From September 1964 until August 1968 the Living Theatre performed exclusively in Europe. Leading a nomadic existence they moved through twelve countries, usually giving only one or two performances in a place. Twenty-eight people set out from New York. Some left, others joined and at one time there were over forty in the company. They lived communally and frugally and they made their most innovative works.

The first piece made in Europe, *Mysteries and Smaller Pieces,* embodied most of the innovations typifying their European productions. *Mysteries* consisted of nine segments made up of exercises and improvisations described as 'a public enactment of ritual games'. There was no text, no set, the performers wore their own clothes and did not play defined characters. For the first time there was an opportunity for spectators to participate physically and in one segment some of the performers sometimes performed in the nude. Although in one segment there was the suggestion of a fictional

plague, the production as a whole did not present a fictional world as the context for the action. The production did not attempt to project a place other than the actual theatre or performance space nor a time other than the actual time of the performance.

At the beginning a man stands at attention on stage facing the audience for about six minutes. At first the audience expects something to happen. When it doesn't they are provoked and become hostile, yelling jokes and insults. Another part of the audience puts down the first. Actors run up and down the aisle while others chant the words from a U.S. dollar bill. A woman sits on stage improvising a Hindu raga in Sanskrit which seems to go on and on. Part of the audience continues to be hostile, thinking the performers are making fun of them by making them listen to noise rather than entertaining them. After a time the rest of the company moves through the audience carrying sticks of incense which they give to the spectators. Julian Beck sits on stage intoning slogans of peace and freedom. The actors return to the stage, sometimes a few spectators follow, and a swaying circle is formed. A performer begins to hum a tone and one by one the others join in harmonizing for perhaps fifteen minutes. This exercise, called 'The Chord', had been introduced by Joseph Chaikin in his work with the Open Theatre. The final segment of Part One involves performers, seated at the front of the stage, doing a yoga breathing exercise.

Part Two is in three sections. Four vertical compartments stand side by side facing the audience like closets without doors. In the darkness four performers enter these boxes and freeze in improvised tableaux. The lights flash up for a few seconds, then go out as other performers take their places in the compartments or in front of them. Each team of four performers creates ten to twenty tableaux. In some performances a few performers are nude. Another exercise from the Open Theatre follows. Actors form two lines facing each other. One performer improvises a sound and movement which is adopted by another performer who changes it and passes it on to another. The final segment is inspired by Artaud's 'The Theatre and the Plague', in which he describes the effects of a devastating plague on the body and mind and draws an analogy to theatre. This is the only segment in which the actors create a fictional illusion. The performers enact the physical and mental deterioration caused by the plague as they crawl and writhe toward the audience. In approximately thirty minutes the wailing ends; they are all dead, scattered in the aisles. Several actors collect the rigid corpses one by one and pile them like logs. In some performances spectators participated. Some died with the actors and were placed in the pile, some tried to comfort the dying, others touched the bodies, hit them, or tickled them to get a response.

On several occasions fights broke out among the spectators who were anti- or pro-*Mysteries*. Other performances were stopped or banned by the authorities because of the nudity of some performers or the participation of the spectators who refused to be controlled by officials. The power of

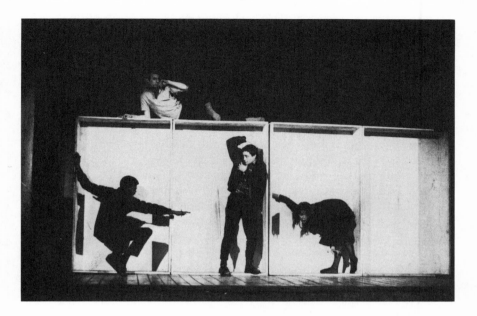

2. *Mysteries and Smaller Pieces*, **photo: Gianfranco Mantegna**

Mysteries was discovered almost by accident. The first performance was put together on short notice to provide an evening's entertainment in exchange for rehearsal space provided by the American Center for Students and Artists in Paris. The company used whatever came to mind – exercises they had recently learned from a visiting member of the Open Theatre, yoga exercises which some of the performers had been doing on their own, an idea that occurred to Beck when he saw some boxes backstage, etc. The company had not previously considered using these in performance. However, the audience reaction was strong and *Mysteries*, with variations, was performed a total of 265 times – more than any other Living Theatre production.[5] It contained most of the innovations for which the Living Theatre became known during their years in Europe – audience confrontation, spectator participation, breaking down the separation between stage and auditorium, collective creation, performance improvisation, performance without text, set, or costumes, nudity, focus on real time and place rather than a fictional illusion, and actors devoid of the usual stage mannerisms, voice, and bearing. These innovations were intended to unite the actors and spectators into one community in the here and now; their objective was to effect social change. The performers were surprised by the antagonism they frequently created, but they also created zealous devotees.

Frankenstein, the second European production, opened in October 1965, but underwent major changes. The original idea had come from Mary Shelley's novel *Frankenstein, or the Modern Prometheus* but was also

15

influenced by the Jewish concept of the Golem and by films including Chaplin's *Modern Times*. It had been developed collectively by the company as a whole through research, improvisation, and discussion, then was shaped and put into focus by Beck and Malina. The setting imagistically was an elaboration of the tableaux segment of *Mysteries*. It consisted of fifteen cell-like compartments of metal scaffolding in a three-storey arrangement six metres high. The performance took place in these compartments and on the stage floor in front of them.

The performance is non-linear and sometimes the action is indecipherable. It begins with the opening technique used in *Mysteries*. Fifteen performers wearing their own clothes sit on stage facing the audience. They do not speak or move, but approximately every five minutes an amplified voice explains that the performers are meditating in order to levitate the woman seated in the centre. After twenty minutes or so it becomes clear that the levitation has failed. (The Living Theatre is reported to believe that if the concentration is sufficiently intense the woman will levitate and the performance will end.) However, disbelieving spectators become annoyed at being forced to await the impossible. Rather than blame themselves for the levitation failure, the group on stage blames the woman and puts her in a coffin. An actor objects and is hanged. Someone says 'No' to the hanging and is executed. One by one individuals object and are executed in the compartments. They are beheaded, crucified, shot, electrocuted, or guillotined until only Frankenstein and two others are left. As Frankenstein works with a corpse centre stage, the compartments in the structure come alive as a representation of the world. Frankenstein asks, 'How can we end human suffering?' An old woman takes body parts from a bag and fits them to the corpse, then recites an incantation written by Beck.

> Human suffering need not be
> When you master three times three
> . . .
> These body organs from the grave
> Are all you need to make a slave.

Eventually the Creature is represented in three different scales. There is a human-sized version played by an actor, there is one as high as the three-tiered structure with a performer representing each arm and leg, and finally a profile head the full height of the structure is formed by plastic tubing with lights inside.

Much of the language is collaged passages from Mao, Walt Whitman, Marx, Bertrand Russell and Shakespeare, and current newspaper items. When the Creature first speaks near the end of Act Two, it is one of the few straightforward speeches in the entire production. In a passage from Mary Shelley's novel the Creature tells of his discovery of the physical world – darkness, light, fire, etcetera – and his discovery of society – division of

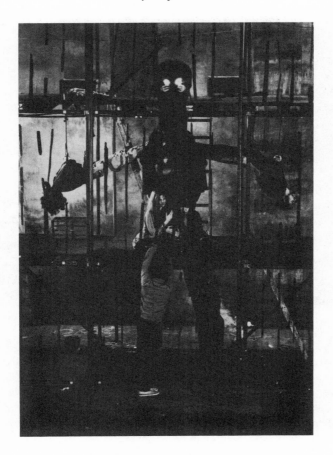

3. *Frankenstein,* **photo: Gianfranco Mantegna**

property, wealth, poverty – and his rejection by it. The rejection generates hatred and revenge which cause new acts of violence. The Creature disappears and Frankenstein and his assistants look for him in the auditorium. In Act Three the actors in the auditorium are captured, interrogated, fingerprinted, and imprisoned in the cell-like compartments of the structure. The prisoners revolt and kill the guards, Frankenstein starts a fire in his cell and the screams of dying prisoners are heard. The structure of society is the cause of perpetual violence. The only positive note is at the very end when the Creature, again created in giant proportions by the bodies of actors, raises his arms in a gesture of peace.

The two-and-a-half-hour performance is intended as a metaphor for the evil in each human being, the monster in each, which comes together to form our societies which perpetuate violence. The compartmentalized physical structure animated by performers is a visual articulation of the structure of

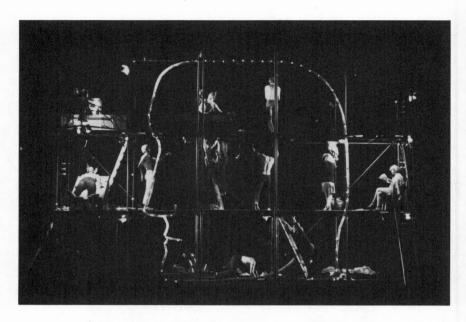

4. *Frankenstein*, **photo: Gianfranco Mantegna**

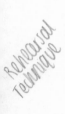

society. This concept led to a rehearsal technique in which individual performers contributed an autobiographical element by confessing crimes they had committed. According to Malina and Beck it was 'an ugly and painful rehearsal technique' which infected their daily lives. But the search for the 'evil madness' in themselves was essential for 'this evil that is corrupting all the great efforts of man is in each heart'.[6]

Except for Beck as Frankenstein each actor devised, chose, and played several roles. In some instances these roles were abstract. In one section they played qualities of mind such as Love, Imagination, Intuition, Ego. At times the performers created non-verbal vocal sounds for an environment such as the sound of wind and waves aboard ship, and they also mimed these elements through descriptive movement. As in *Mysteries* performers improvised during parts of the performance.

The production was more coherent than *Mysteries,* was more compelling visually, and presented more explicitly than ever before the Living Theatre's view of the relationship of the individual and society; but it was a theatrical metaphor. Except for the opening meditation scene, the entire performance was in the form of a theatrical illusion. Even those task-derived elements were absorbed into the fiction. So, while the production developed new theatrical techniques, it was a retreat from the development of a new means of presenting reality, from theatre as life itself.

Their next production (February 1967) was Judith Malina's translation of Brecht's version of Sophocles' *Antigone.* It again embodied the company's

18

anarchistic views, but its text was more akin to the earlier New York work. It was natural that they would be drawn to a play contrasting the pacifism of Antigone with the tyrannical government of Kreon and demonstrating the civil disobedience of Antigone as a necessity of conscience.

As in *Mysteries* and *Frankenstein* the opening of the performance creates hostility in the audience. However, this time it is used to a different end. The auditorium represents Argos, the stage is Thebes. The Thebans are at war with the Argives for their iron mines. When the performance begins, actors enter and begin staring at the Argive audience; they look it over, they talk among themselves about what they see. When the apparent coldness of the performers toward the spectators is repaid in growing hostility, the war begins. The sounds of gun shots, air-raid sirens, aeroplanes, bombs, troops marching are all created by the performers as they enter the auditorium to attack the enemy. Polyneices, who in the Brecht version is a deserter from the Theban army, having refused to participate in an unjust war, is surrounded and killed among the spectators. For many the play seems to be a metaphor for the war which the United States was waging against Vietnam. The spectators are the victims. Julian Beck hoped that 'if people feel how atrocious it is to kill each other, if they feel it physically then perhaps they'll be able to put an end to it'.[7]

The script of *Antigone* was Malina's precise translation of Brecht's text with only a few minor deletions, but the company's acting techniques were continuing to develop. The performers again wore their everyday clothes, there were no sets or light changes, props were mimed, and all sounds were created by the voices and bodies of the actors. The elders of Thebes are Kreon's throne. Four performers become the prison walls enclosing Antigone, and when Ismene belatedly asks to share with Antigone the responsibility for burying Polyneices, the walls cover their ears. Beck says they wanted to eliminate the 'handicrafts of civilization' and put the focus on 'the physical presence of the human being'. This was aided by keeping the twenty or more actors in view throughout the performance. From the beginning the Living Theatre had wanted to 'destroy the conventions of theatre', but Beck had come to see that all of their early experiments 'had been bound inside the theatre of the intellect' and were products of 'rational civilization'. Beginning with *Mysteries* they had been attempting to find a basis for acting other than everyday behaviour. This led in *Antigone* to expressionistic movement and vocalization requiring each actor to unite what is said with 'an actual physical locality in the body'.[8] The monstrosity of the system which Antigone must face is represented by a writhing compact mass of actors in which the individual seems to have given up his freedom to the control of the whole.

While in *Antigone* the Living Theatre had retreated from collective creation of the text, they had further developed the concept of the presence of the actor – that is, causing the spectator to focus more on the live actor in their presence than upon the fictional character enacted. It was a tendency

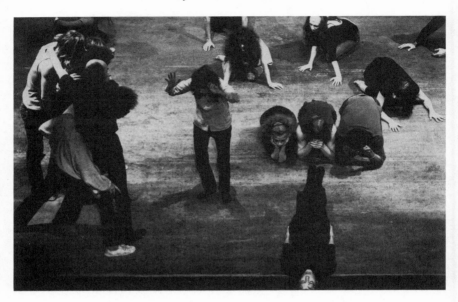

5. *Antigone*, **photo: Gianfranco Mantegna**

already being explored by Jerzy Grotowski of the Polish Laboratory Theatre and it was becoming the main focus of Chaikin's work with the Open Theatre. All three companies were attempting to eliminate the rational control of body and voice which restricted the actor to what could be conceived in advance. They wanted to discover a mode of acting which would be more authentic, more present, because there would be no conscious barrier or impediment between the impulse and the physical or vocal response.

By putting the physical presence of the actor in focus, even in a work using a fictional illusion of time and place, the Living Theatre had taken another step toward the presentation of reality. In their next production, *Paradise Now* which opened in July 1968, they used this concept in a production which in its entirety was created collectively by the company and then, as with *Frankenstein,* structured and edited to its final form by Beck and Malina. Although the production received only 84 performances – fewer than *Mysteries* (265), *Frankenstein* (89), and *Antigone* (172 excluding its revival in 1980) – it is the production for which they became notorious because it involved audience participation to a greater extent than any other Living Theatre work and caused the greatest difficulties with the police and other authorities.

Frankenstein and *Antigone* had been preoccupied with the repressive nature of contemporary culture; the company wanted the next production to be optimistic. In the published introduction *Paradise Now* is described as a spiritual and political voyage for the actors and the spectators. Its purpose 'is to lead to a state of being in which non-violent revolutionary action is

presentation aspect

possible'.[9] In the anarchist society envisaged the individual would no longer be a slave of money, of sexual taboos, of repressions by the state respecting freedom of movement and other restrictions. The result would be a non-violent society 'in which we simply produce freely what is needed . . . and then use the rest of the energy and the rest of the time of our lives for other things'. Beck and Malina believed this economic social revolution could happen only if simultaneously there was 'an interior revolution, a spiritual change'.[10] With *Paradise Now* they hoped to aid this interior revolution by changing the perception of the audience, by making them realize that a transformation is possible and urgent.

The play is in eight sections, eight rungs of a ladder depicting 'a vertical ascent toward permanent revolution'. This is graphically shown in a chart distributed to each spectator. Each rung consists of three parts: a ritual ceremony performed primarily by the actors, a vision consisting of an intellectual image also primarily by the actors, and an action introduced by the actors and performed by the spectators with the help of the actors.

In the first rung, 'The Revolution of Cultures', the performers present 'The Rite of Guerilla Theatre'. They move in the aisles from spectator to spectator speaking and then shouting repeatedly various statements: 'I am not allowed to travel without a passport.' 'I don't know how to stop the wars.' 'You can't live if you don't have money.' 'I'm not allowed to smoke marijuana.' 'I'm not allowed to take my clothes off.' To demonstrate this last prohibition they take off as much of their clothing as the law permits. The Living Theatre believes that society makes one ashamed of one's body, which causes a disunity between the physical and spiritual self, but if a harmony between these two selves could be achieved, all destructive urges would be eradicated.

The 'rite' of the first section is followed by 'The Vision of the Death and Resurrection of the American Indian' in which the performers sit cross-legged on the stage passing a peace pipe, then form five totem poles, and finally mime being shot by the white man. The 'Action' which follows is initiated by the performers encouraging the spectators to 'Act. Speak. Do whatever you want. Free theatre. Feel free. You, the public, can choose your role and act it out.'

The first section was intended to open people to new values and to discard the old values represented by specific prohibitions of the culture. Section Two, 'The Revolution of Revelation', was intended to describe the aims of the anarchist revolution. It begins with actors gently touching spectators and speaking softly to them. During the Vision part of this section the actors form with their bodies the words ANARCHISM and PARADISE.

Rung Three is 'The Revolution of Gathered Forces'. According to the play the people are now ready to work together for the revolution. During the Action part of this rung discussions are begun on the formation of revolutionary cells for radical action to continue work during and/or after the performance.

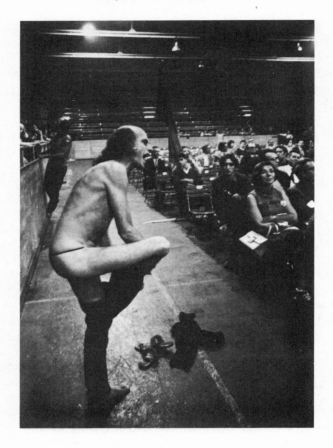

6. *Paradise Now*, **photo: Gianfranco Mantegna**

Rung Four, 'The Exorcism of Violence and the Sexual Revolution', is concerned with sexual repression, 'the fundamental taboo that is channeled into violence'. It begins with 'The Rite of Universal Intercourse' in which the performers lie on the stage floor in their semi-nude state entwined in a mass embrace – caressing and undulating. Spectators who join in are welcomed. Those who wish to temporarily pair off and sit face to face with sexual organs in contact, but because of legal restrictions they do not make love. In the Vision which follows actors in pairs are executioner and victim. The executioner mimes shooting the victim who falls and rises to be shot again. The action is performed twenty times. After a time the victim begins to speak gentle words to the executioner who answers with the prohibitions stated at the beginning of the play. Finally they embrace and the scene ends. In the Action portion of Rung Four the spectators are led back into 'The Rite of Universal Intercourse' in which 'the actors/guides seek to consummate the action by a sexual unification'. As a consequence 'the division between actor

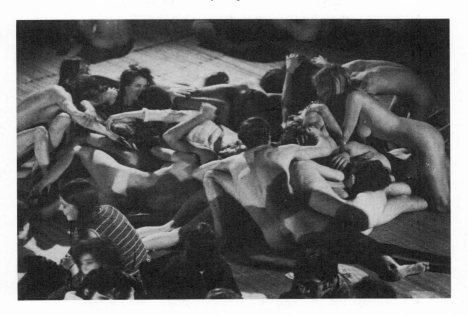

7. *Paradise Now*, **photo: Gianfranco Mantegna**

and public diminishes'. Hostilities can be eradicated in the act of physical love. The actors proclaim, 'Fuck means peace'. USE

Rung Five, 'The Revolution of Action', concerns the individual in relation to the anarchist community, the disappearance of conflicts between Jew and Christian, Black and White, Young and Old, I and Thou, once the money system and its coercive bribery are abandoned. It is a view of the future as are the following sections. Rung Six, 'The Revolution of Transformation', is the period of struggle between the non-violent revolutionary forces of love and wisdom and the reactionary forces of violence. 'The Revolution of Being', Rung Seven, gives glimpses of the post-revolutionary world. In the Action portion the performers and voluntary spectators participate in a trust exercise which became popular with other theatre groups. One person, standing on an elevated place, flies with arms outstretched into the arms of others waiting below.

The eighth and last rung, 'The Permanent Revolution', ends with the company leading the audience into the street as they say, 'The theatre is in the street. The street belongs to the people. Free the theatre. Free the street. Begin.' The ending is not to be mistaken for the revolution, it is an enactment or a demonstration. Nevertheless, it was their intention to bring the spectators to a state where non-violent revolutionary action was possible. An interior change was a necessary prerequisite to the external social and economic revolution.

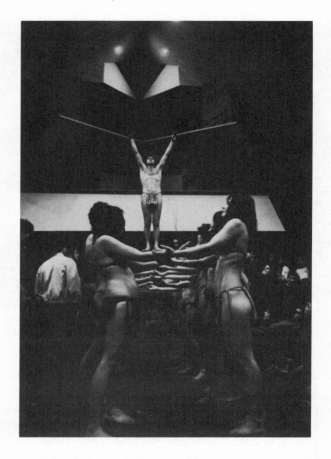

8. *Paradise Now*, **photo: Gianfranco Mantegna**

For the Living Theatre life, revolution and theatre had become one. The Action portion of each section of *Paradise Now* consisted in part of unrehearsed actual behaviour of performers and spectators without a fictional illusion. The company generally avoided going beyond legal restrictions during a performance as they had no wish to spend time in prison. It was not unusual, however, for spectators to smoke marijuana, burn money, or take off all of their clothes.

Malina and Beck were much influenced by the May 1968 uprising of students and workers in Paris which occurred while *Paradise Now* was being prepared for its short run at the Avignon Festival that July. At the end of the second performance about two hundred people surrounded the Living Theatre in the street celebrating their sense of new-found freedom. It was too threatening for the mayor of Avignon and the company was asked to

substitute another work for *Paradise Now*. Instead, the company withdrew from the Festival.

Some French students had criticized the Living Theatre for working within the bourgeois system, accepting contractual arrangements from established organizations and performing in theatres subsidized by the state. When they took *Mysteries, Antigone, Frankenstein,* and *Paradise Now* to the United States for a seven-month tour in 1968 there were other criticisms from the political left. While their rejection of authority, their non-violence, their sexual freedom, and marijuana smoking gave them a rapport with the hippies, their anarchist revolution was not the revolution envisaged by young Marxists and other political radicals who felt the Living Theatre was out of touch with the American situation and naive in believing radical change could be brought about by non-violent means. Indeed, major changes had taken place during their four-year absence. Students had been radicalized through demonstrations against university authoritarianism. They were subjected to arrest and police violence. Only a month before the arrival of the Living Theatre hippies were being transformed into radical Yippies at the Democratic Party convention in Chicago where demonstrations were met with police brutality. The non-violent stance of blacks had been eroded by the Watts riots in Los Angeles, the F.B.I. persecution of the Black Panthers, and the assassinations of black-power advocate Malcolm X and civil rights leader Martin Luther King. A split within the Students for a Democratic Society led to the creation of the Weathermen, an underground organization dedicated to the destruction of property as a means of disrupting the establishment.

The Living Theatre was caught between the reactionary forces of the establishment and the criticism of political radicals. Following the first U.S. performance of *Paradise Now* when they led the audience into the street, they were arrested and charged with indecent exposure, breach of the peace, and interfering with an arresting officer. Performances were cancelled more than once and the Internal Revenue Service impounded their receipts and bank accounts. On the other hand radical spokesmen criticized them for being a part of the institutional framework of the established society and the revolutionary movement considered them irrelevant. Surely the performance of *Paradise Now* in Berkely must have seemed artificial. The confrontation of spectators with such lines as 'I am not allowed to smoke marijuana' seemed frivolous compared to the student-police confrontations in the streets. During this U.S. tour Malina and Beck became aware for the first time of the American revolutionary movement, and it was instrumental in their dicision to stop performing plays *for* middle-class audiences in theatres and begin performing in the streets *with* people whom they considered the slaves of the privileged.

Their American tour had attracted large audiences, much larger than had come to their own theatres in New York. They had become accepted at least as a novelty, but they came to doubt their effectiveness. Some spectators

might participate in *Mysteries* and *Paradise Now,* even follow the company into the street at the end of a performance, but the performance was perhaps no more than a memorable evening's recreation. The lives of their middle-class audience and society remained unchanged by the experience. Malina and Beck came to believe that they were being assimilated as other trappings of social change were assimilated, thus forestalling a fundamental change in the structure. Even the words 'revolutionary' and 'radical' came to be used in the programmes of President Nixon and in advertising new products.

Back in Europe in early 1970 the Living Theatre announced to the news media that it was dividing into four cells which would have different orientations. However, only the one directed by Malina and Beck endured. The announcement stated the new objectives. They did not 'want to perform for the privileged elite anymore because all privilege is violence to the under-privileged'. Therefore, they did not 'want to perform in theatre buildings anymore'. And they did not 'want to be an institution anymore' because 'all institutions are rigid and support the Establishment'. It was necessary, furthermore, to liberate themselves 'as much as possible from dependence on the established economic system' and to 'survive through cunning and daring'. Finally, it was essential to find new art forms which would serve the needs of the people.[11] The idea of giving free performances outdoors and thereby minimizing dependence upon the economic system was not new in the alternative theatre movement; the San Francisco Mime Troupe had been giving free performances in the parks since 1962. But when Beck and Malina led their group to Brazil where they performed with and for the poor worker families, they became the first missionaries. However, unlike missionaries of a colonial power serving to contain the indigenous population, the Living Theatre functioned more as a guerrilla band hoping to spread the revolution. And in the end they were treated like other enemies of the state.

From spring 1970 until their arrest in July 1971 the company lived in several communities of Brazil, developing and performing plays which were to be part of a projected cycle of 150 called *The Legacy of Cain,* a reference to the origin of violence. These plays, mostly using movement, sound, and gesture, without dialogue so as to escape problems of censorship, were presented for poor workers and their families in public squares, factories, and the slums where they lived. It was important to make these plays in consultation, sometimes with the collective participation of the residents so as to avoid an attitude of superiority. Furthermore, it was the intention of the group to deal with the life and aspirations of the community in which the work was presented.[12]

Judith Malina had come to the conclusion after the American tour that her theatrical life had been spent working for the oppressors. Even *Paradise Now,* she said, was an attempt to shake up this audience. It became clear to her, however, that it was not these people who would make the revolution; it would be made by the economically and culturally deprived. She was determined to put herself 'at the service of the revolution'. In Brazil they

discovered that the circumstances of life tend to make the depr
accept their situation rather than attempt to change it. In the words o⸢ ⸢
Beck they accept 'a sado-masochistic view of the world' as the natural order.
'The Brazilian woman is a servant to her servant husband' who 'goes to work
and gives his body over to the boss.' On an international scale the worker is a
slave of the middle-class in the so-called developed countries for whom he
produces coffee and sugar at near starvation wages. The Living Theatre
hoped to raise the 'revolutionary consciousness' of these people so that
when the right time came they would be organized and prepared to 'seize the
power' and 'take over the means of production'. As a 'revolutionary artist'
Beck wanted to help 'transform the world from a master–slave economy and
psychology into a structure or system which is no longer parasitic and exploi-
tive but rather creative'.

Little progress was made toward these goals during the thirteen months
the Living Theatre worked in Brazil. They experimented, however, with
techniques for involving the people in collective creation. At first to make
money, they worked in São Paulo with a group of university students whom
they charged for lessons. Together they made a play which was performed
only twice in the public squares of a nearby truck-farming village and a
proletarian mill town.

In December 1970 they performed a new play in a slum community of
about 800 on the edge of São Paulo. They made four visits to the community
in advance, tape recording answers to such questions as 'What are your
dreams, what do you want to do, how is your life here, what is the communi-
ty like?' These were edited and collaged and used in a section of the play.

The play begins with a procession of twelve actors singing 'What is life?
What is love? What is Death? What is money? What is property?' etcetera.[13]
They place a box containing the props in an open area and take
positions around it in six pairs representing the bases of enslavement –
Money, Love, Property, The State, War, and Death. A Storyteller tells a
simple story about each as the corresponding pair of actors mimes the action
which ends in a master–slave position. For the next section a loudspeaker is
placed on the box and taped voices of the inhabitants are heard. A repetitive
song follows.

> My life is 1 hour for 50 *centavos* [about 4p]
> My life is 2 hours for 1 *cruzeiros* [about 8p]
> My life is 4 hours for 2 *cruzeiros*
> My life is 8 hours for 4 *cruzeiros*
> . . .
> My life is 40 years for 87,600 *cruzeiros*

Each master and slave sign a contract with their red thumb prints. Each
master binds his slave with a rope, chain, or strap, and then the masters bind
each other until only Death remains. The Storyteller tells about the future

which ends with a question: 'How did the people free everyone so that the Treasure Box could be opened so that everyone could eat the Celebration Cake and be merry?' The spectators untie the actors, the Treasure Box is opened revealing a large cake which is eaten by the actors and spectators as they talk.

The company came to realize that to avoid working superficially with the people it would be necessary to stay in one place for an extended period. So they went to Ouro Preto, an aluminium mining town of 40,000, with the intention of staying about eight months. At first they taught physical exercises and yoga in the schools. One of the schools asked them to help make a Mothers' Day play and they seized the opportunity. They asked the eighty children ranging in age from seven to fourteen to write down a story or dream about their mothers. The stories were sifted and codified according to content and then dramatized in terms of the same six aspects of the world which had been used earlier except that they substituted 'Time' for 'Death'. The children, attached to their mothers with crepe-paper umbilical cords, were led on a journey through The House of Money, The House of Love, and houses representing the other worldly causes of bondage. Then Big Mama (one actor on the shoulders of another) played a game with the children, whipping them with a crepe-paper whip as they danced and spun until dizzy while those parts of the children's stories dealing with punishment were being read: 'My mother punishes me because she is always right.' 'When she hits me it is because I am bad.' At the end of the performance the children broke their umbilical cords by jumping from a platform into the arms of other children below just as adults had done in the performances of *Paradise Now*.

When someone complained to the authorities, eighteen members of the company were arrested and charged with possession of marijuana which was said to have been found in their garden. They had been in Ouro Preto only five months, but the Living Theatre had forgotten a lesson learned in Europe – if they stayed in one locale more than two months they would be harrassed in one way or another. They knew from the nature of their work, their life-style, and their political convictions that they must keep moving. In Brazil they made a tactical error and they paid for it by spending two months in prison before they were deported.

Back in the United States the company continued to develop the *Legacy of Cain* cycle and to devote their energies to industrial workers. They lent support to various industrial organizing activities and in so far as possible they followed their principle of staying outside the money system, but it was necessary to raise money through lectures and workshops. They created, for performances to academic communities, *Seven Meditations on Political Sado-Masochism* (1973) which they considered a 'study piece' on the 'manifestation of the sado-masochist syndrome in various aspects of our lives'.[14]

They received a grant from the Mellon Foundation to produce theatre in Pittsburgh, where they moved at the end of 1974 and began working with

coal miners, steel mill workers, and their families. They set out to use their theatre skills to focus the attention of these workers on their condition and to stimulate discussion to help bring about social, political, and economic change that would result in the workers taking control of production and replacing the profit motive with a creative impulse in their work.[15]

While in Pittsburgh they produced two major plays for *The Legacy of Cain* cycle, also on the theme of the master/slave relationship which they believe to be the basis of all relationships in our society. The first of these plays, *Six Public Acts to Transmute Violence into Concord: Tampering with the Master/Slave System: Ceremonies and Processions: Changing Pittsburgh: Prologue to 'The Legacy of Cain'* (May 1975), again uses the six houses of enslavement. After gathering in one place the spectators move in a procession to six locations in the city and six ceremonial events are presented. The first stop is The House of Death represented by a utility company building. Performers enact the agony of death, other performers remove the shoes of the victims and line them up in front of the spectators. Then, as in *Mysteries,* the rigid corpses are put into a pile. At a public flag pole which represents The House of State, each of the performers pricks a finger and smears blood on the flag pole while commemorating an act of the state which has resulted in deaths. In front of a bank, The House of Money, money is burned and fake bills are distributed to the spectators. Each bill carries the statement: Whoever accepts money is the slave of the government who prints it.' Outside a highrise apartment house, The House of Property, the performers erect a two-tiered jail-like structure reminiscent of that used in *Frankenstein.* Simultaneously they sing 'Who built this building? Who built the pyramids?' etcetera. The ceremony for The House of War is enacted in front of the local police station. 'This is the house of our brothers. Flesh and blood like ours.' Bread and roses are given to the police or left for them if they do not appear. In a park, The House of Love, the actors recite a poem on the theme of love as a struggle for possession in the master/slave relationship.

Throughout the performance of *Six Public Acts* real time and place, and therefore the integration of the performance with life, were emphasized in several ways. In walking from place to place spectators could not help but be aware of real space. Furthermore, they were made to focus on actual buildings rather than theatrical scenery and to think about the building in relation to the real world. Finally, every fifteen seconds throughout the entire performance, an actor playing the Shaman of Time (Death) announced the actual clock time.

The Money Tower (1975), the second Pittsburgh play, focuses on one of the houses of enslavement analysing the enslaving power of money. It was presented in several locations including outside the gates of a steel mill as workers were changing shifts. A tower is erected eleven metres tall with five acting levels, graphically demonstrating the position of the worker in the capitalist society. At the very top is a dollar, then the elite, next the church/state/law/military establishment, then the bourgeoisie, the workers, and at the very

bottom the poor and the unemployed. The design was borrowed in part from Mayakovsky's 1930 production of *Moscow Is Burning,* and the construction of the tower was similar to that in *Frankenstein.* The tower depicts the conversion of ore into money as sacks of material are conveyed from the bottom of the structure to the top. The ore is pulled up by the workers and processed into ingots by the working class, on the next level the middle class regulates production, further up the police and law establishment guards the precious metal, and finally it reaches the elite who accumulate the money in a bank. A portion of the money is sent down the tower in the form of wages which are then reaccumulated by the elite in the form of payments for rent, products, food, and taxes. This is followed by a section in which the visions of the poor and working class are the nightmares of the rich. In the final section the ruling class want more money so they demand lower wages, longer hours, and layoffs. A strike and rebellion develop and a violent confrontation with the Army/Police seems inevitable, but a happy ending is provided as the people discuss bringing into being an anarchistic society which functions without money.

The Living Theatre had been undergoing another major transition. Not only did they give up performing in theatres, they gave up the confrontational method influenced by Artaud. Instead of the aggressive tone of *Paradise Now,* they wanted audience participation on a co-operative basis. And instead of the isolated super-individualistic approach, they attempted to learn about the problems and perspectives of their potential audiences. They participated in local progressive organizations and helped form food co-operatives. They invited spectators to visit them for informal discussions. In short the Living Theatre attempted to become a model of the anarchistic society. 'Our presence is our message,' said Beck, 'we are what we stand for.'[16] Their rehearsal methods became more collective. Malina and Beck still had the greatest impact on the productions, but rehearsals were now conducted without a director which, although less efficient, demonstrated that work could be accomplished without bosses. They were encouraged by the interest in their performances, especially since they had been warned that they would be greeted by apathy and rejection. They discovered, however, that they could not survive in the United States outside the economic system. Having given up theatres they had also given up their income. And as they had said in *Paradise Now,* 'You can't live if you don't have money.'

In the autumn of 1975 they accepted invitations and fees to perform at several European festivals including the Biennale in Venice. In Italy they found a volatile changing culture where municipal Communist governments were interested in using the arts to increase social and economic awareness. There was a keen interest in libertarian alternatives and they thought 'perhaps in this country something could actually happen'.[17] Furthermore provinces and cities were willing to subsidize performances. They made Rome their headquarters but toured throughout the country sponsored by schools, factories, unions, psychiatric hospitals and performing in the streets,

gymnasiums, schools and other non-theatrical spaces. *Six Public Acts* proved popular for such venues.

They also began performing again in theatres and on the theatre circuits in Italy and other European countries. While working exclusively with the culturally and educationally disadvantaged, there was little opportunity for interaction with the intellectual community. By re-entering the ambiance of theatre they could again participate in the 'moral, philosophical, social, psychological dialogue . . . taking place among those who have the social advantage of education'. They had become less hostile in their 'view of those who sustain the system because of social pressures'. According to Malina, during their years of street theatre they had learned to respect their audience.

Prometheus (1978) was collectively created for performance in theatres. It is a symbolic intellectual work using ideas from previous productions and introducing in the second act a new technique for involving spectators in the performance. As the title suggests, the play is concerned with the ways in which humans have been bound – physically, spiritually, and culturally. The setting is dominated by a large arch constructed of pipe. When the audience enters, performers are discovered bound with ropes in theatre seats. The performance begins when spectators untie them. Act One presents a dream-like history of culture using historical and mythological figures. It is a history of increasing confinement. The creative inventiveness of the anarchistic Prometheus (Hanon Reznikov), symbolized by his bringing fire to mankind, is punished by Zeus (Julian Beck) representing the forces of order. A chorus of doctors including Aristotle and Pythagoras discover various geometric shapes which bring order, but when each shape is placed on the head of an actor, he is overwhelmed. Zeus suppresses women's wisdom and incorporates it by swallowing Metis (Imke Buchholz). The belly of Zeus is represented by a prison where Metis is confined. Through the telescope of Metis Zeus sees the devout Io (Judith Malina) who is transformed into a cow pursued by the furies. The style of the first act is similar to their work of the late sixties – shouting, demonstrable speech rather than representational acting, nude and semi-nude bodies.

The style of Act Two is epic realism. The events surrounding the Russian Revolution are enacted by members of the company with the help of spectator volunteers. The script is primarily from the writings of the historical participants, but dramatic license is taken with chronology. For example, the act begins with the simultaneous arrival in Russia of Lenin (Beck) in 1917 and the anarchists Emma Goldman (Malina) and Alexander Berkman (Reznikov) in 1920. When the anarchists ask why fellow anarchists are being kept in prison, Lenin replies: 'Free speech is a bourgeois luxury . . . a tool of reaction.'

The rest of Act Two (about sixty-five minutes) is the re-enactment of the storming of the Winter Palace. Lenin/Beck gives a short illustrated lecture on the event using a map. He asks for volunteers to play four bolsheviks, ten-to-twelve anarchists, three-to-four Tolstoyan pacifists, four terrorists,

9. *Prometheus*

five women in jail, two actors in Mayakovsky's troupe, Red Guards, infantrymen, etc. Each group rehearses with a company member. Some are given scripts of their slogans and actions. Four red tapes are stretched across the stage indicating the entrance to the palace. Lenin/Beck, at a lecturn, narrates the action and gives historical speeches from time to time. Some of the actions of volunteers involve charging the palace with guns (rolled-up paper) firing (drums). At the end of each charge Lenin/Beck orders one of the red tapes to be cut. The Tolstoyan pacifists cross the stage cutting imaginary wheat while making swishing sounds. At one point everyone in the audience is involved as they are asked to perform emblematic gestures. Lenin is asked, 'If a worker has to work for sixteen hours a day, is he free?' Lenin replies, 'No!' but disdainfully refuses to answer when asked, 'If a worker has to work eight hours a day, is he free?' A woman describes how free women are after the revolution as she is bound up with a red cloth. Eventually, Lenin dies and is lifted to the top of a pyramid, the Living Theatre's symbol of hierarchical oppression. A scene from Mayakovsky's *Moscow is Burning* is performed with biomechanics, a gymnastic style of acting which the bolshevik

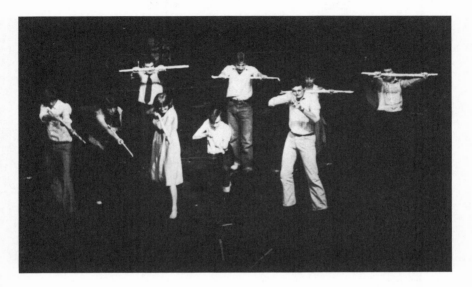

10. *Prometheus*

playwright–director had invented. However, Mayakovsky becomes disillusioned and shoots himself.

When the lights come up for Act Three the entire company is hanging by arms and legs, motionless, from the metal pipe scaffolding. After a time Julian Beck says, 'The scene is Prometheus unbound, a silent action. We will go to Holloway Prison [in the London performance] and there to perform an act of meditation – a five-minute vigil in the name of the end of punishment.' Those who wish go to the prison with the company to perform a vigil. A programme note for this act says, 'The question is: for what crime, if any, are we being punished when we are being punished?'

In the view of Julian Beck Acts One and Two tell the same story. They demonstrate how human consciousness has been contained within a pyramidal structure of conceptualization which is intrinsically hierarchical and patriarchal. In Act One the structure is represented by Zeus and the pantheon of gods as well as the historical progenitors of knowledge and culture. Against this structure Prometheus represents the creative self which wants to be free. This pattern is repeated in Act Two through the presentation of the Russian Revolution, which Malina considers the modern myth to which everyone is bound. The ideal of the communist revolution, according to Beck, had been the breaking away from a pyramidal social structure and replacing it with a more decentralized and less authoritarian structure. Unfortunately, it resulted in a re-establishment of 'an authoritarian pyramidal form which ultimately leads to the prison or Prometheus bound on the rock'. In the second act Lenin is the patriarchal figure and the anarchists Goldman and Berkman are the persecuted freedom seekers. Beck thinks of

33

the first two acts as two dreams which tell the same story with different incidents. They are also conceived as a parallel to the first two parts of the Aeschylean trilogy – *Prometheus the Fire Bringer* and *Prometheus Bound*. The third act relates to *Prometheus Unbound*, the third play in the Greek trilogy. However, the unbinding must take place in the spectator's head. Going to a prison carries the action into the street and permits the spectator to project the classical and modern mythology upon the architecture of our time. For Beck, 'Standing in front of a prison is to say that all of history has led to this brick wall. There is nothing to do but look and think about it. The objective of the play is to bring about this meditation in the spectator'.

The process of collectively developing *Prometheus* began with discussions concerning the subject and theme of the play and progressed to research on Greek mythology and psychological images. As always, the guiding principle was that the individual should not be sacrificed to the collective nor the collective to the individual. In attempts to find a structure for the play they decided that each actor would choose a character from classical mythology or a historical figure that would relate to the myth. For example, Beck chose Zeus because of his interest in overcoming the pyramidal power structure which crushes those on the bottom. Bucholz chose to play Metis because of her concern with the suppression of female knowledge and the imprisonment of women. Once the characters were chosen, the plot of the first act was developed around the roles. Then Beck had the idea (Act Two) of translating the Promethean myth into the historical myth, and they searched for analogous characters associated with the Russian Revolution. Each of them asked the question in relation to their Act One character – If so-and-so had been in the Revolution who would she/he have been? Zeus became Lenin, Prometheus became the imprisoned Alexander Berkman, Metis became an anarchist prisoner and a feminist. Judith Malina, who had played Io pursued by the furies in Act One, became the anarchist Emma Goldman in Act Two. The actress saw a parallel not only to 'the wandering, driven spirit of Io' but to her own biography – 'an exile, wandering, deported and pursued, nowhere at home'.

From the beginning the Living Theatre have adhered to an anarchist objective and have practised their message as much as they have preached it. But while their objective has remained constant, Judith Malina points out that their perspective has changed. 'We try to remain cognizant of the stream of history so as to stay valid within it. This means a constant change of vocabulary, form, and vision.'

In the course of their search for means to articulate their relation to a dynamic present, they invented or adapted nearly every experimental concept associated with the alternative theatre of the sixties and seventies. They were one of the first groups to explore the unique possibilities of live performers in relation to the spectators in their presence. Developing that relationship became important for the Living Theatre because it was a prerequisite to helping the spectator to a spiritual change which ultimately

could lead to the desired change in society. They developed a variety of means to keep the audience focused on real time and place so as to make possible an actor/spectator relationship. They attempted to shock the spectators into reality to help them break through the culturally-imposed restrictions on their feelings and actions. In *The Brig* they developed an acting style which they did not consider representation but 'a state of being' because the performer actually experienced what was being enacted. Beginning with *Mysteries* actors wore their own everyday clothes, sometimes played themselves rather than fictional characters, confronted the audience aggressively, used actual exercises in their performances, and permitted spectators to participate. Actors were not restricted to the stage nor spectators to the auditorium. In order to focus on the presence of the performer, actors played several roles, they remained in view throughout the performance, and there was an attempt to eliminate the rational impediment between impulse and reaction. The body and voice were used expressionistically. Through suggestive actions and sounds the physical setting used in *Frankenstein* became a ship, the world, prison cells, or the head of the Creature. With their voices and bodies the actors created the necessary sound effects. Through abstract miming and acrobatics they suggested fire in *Frankenstein* and spelled out words in *Paradise Now*. They encouraged the audience to participate in a group embrace which became so popular in *Paradise Now*, and later in *Dionysus in 69* by the Performance Group, that it was given the sarcastic epithet of 'group grope'. One-third of *Paradise Now* – the 'Action' sections – was not planned but left to the spectators and performers to develop through their own spontaneous actions. In parts of some performances the company functioned more as group therapists or recreation leaders than as traditional actors. All of these techniques and others served to focus on the live performer in the here and now rather than absorbing the spectator's psyche into a fictional illusion of character, time, and place. In short, the audience was made to focus on the real world.

For the Living Theatre life is theatre and theatre is their life. Beginning with *Mysteries,* they became primarily interested in presenting reality rather than fiction. It was expected that actors joining the company would fit into the committed, nomadic, anarchistic community which existed entirely to present themselves as theatre. 'Acting is not make believe', said one of the performers, 'but living exquisitely in the moment.'[18] In principle, the performance was built of the actors' experiences in probing within themselves. Although some members practised yoga or various psycho-physical exercises, there was no need for special training. Anyone can perform. All that is necessary, according to Beck, is 'an atmosphere in which the individual is free to create . . . to draw upon his own resources'. The Living Theatre community intended to promote this sense of freedom. They tended to avoid institutionalized relationships within the company and to practise sexual freedom. Although Beck and Malina were married, they came to believe that the institution of marriage was an extension of the concept of

ownership, loved one as property, which produced jealousy when domination was threatened. They eschewed institutionalized politics as this led to bureaucracy and repression. Because the mind and the body had been conditioned to restrictions by our culture, drugs could be used to release the mind and nudity could help free the body. It was hoped that by throwing off artificial restrictions their lives would become unified, they would break out of the compartmentalized structure of society which tended to fragment people's lives into work, recreation, family, religion, politics, etc.

In principle they avoided a company structure as this would tend to institutionalize a hierarchy, but members of the company received programme credit for specific responsibilities including Malina and/or Beck as directors of the productions. However, Beck said in 1969 that 'the real work of the director in the modern theatre is to eliminate himself' or 'at least to establish inside the acting company a situation in which the actor is . . . able to take more and more control of the total work'.[19] Although some members of the company contributed more to a production than others, beginning with *Mysteries* nearly all the productions were created collectively. In general the collective process involved discussion, improvisation, and research. Beck and Malina continued to provide the over-all view, the structuring of the works, and whatever writing was required.

The techniques they used over the years comprise a catalogue of nearly all the techniques associated with the alternative theatre in Europe and America. In many of the later productions the action was non-linear. They used language collage in *Frankenstein* and other plays. The concept of chance was explored in *The Marrying Maiden*. Improvisation in performance became common. In *The Connection* and other plays they experimented with the ambivalence of fiction and reality. They created productions inspired by other literary sources such as *Frankenstein*. In nearly all of the plays beginning with *Mysteries* there were opportunities for the physical participation of spectators. In Brazil, Pittsburgh, and Italy they set out to find a new audience of industrial workers, and some works were informed by discussions with this audience. *Six Public Acts* used the technique of a peripatetic audience and actual places were used instead of scenery.

The Living Theatre had begun in 1951 with an attempt to resuscitate poetic language in the theatre, but by the mid-sixties they had de-emphasized words in keeping with the dominant tendency of alternative theatre. This was practical as they were playing in countries where different languages were spoken, but after creating *Paradise Now* Beck discussed another reason. The object was not to destroy language, said Beck, but to reach toward a 'kind of communication of feeling and idea . . . that is beneath words or beyond words, or *in addition to words*' 'Words are too rational. They lead people to accept knowledge but avoid experience.'[20]

Various of the techniques introduced or adapted by the Living Theatre became formulated into theatrical modes of the sixties and seventies. It can be said that Malina and Beck explored more of these modes than any other

company, although they were not the pioneers in each of these. In many of their productions there were elements from *Happenings*. Some of their work can be considered *Political Theatre* in that it was concerned with social and economic problems. Many of their later productions were *Street Theatre*, being performed out-of-doors, going to the audience rather than the audience coming to them. Some of the work in Brazil was *Guerrilla Theatre* (a term popularized by R.G. Davis of the San Francisco Mime Troupe) in that they arrived at a site unexpectedly, performed illegally, and could get away quickly. In some of their productions the performers and spectators occupied the same space and there were several simultaneous focuses, important characteristics of *Environmental Theatre* which have been explored in greatest depth by Richard Schechner, the founder of the Performance Group.

The Living Theatre have been influenced by Meyerhold, Piscator, Artaud, and Brecht, but there has also been a reciprocal influence with some of their contemporaries – especially Grotowski and his Polish Laboratory Theatre, Peter Schumann and the Bread and Puppet Theater, Joseph Chaikin and the Open Theatre. And the Living Theatre have had an important impact upon younger theatre companies, some formed with the Living Theatre as their model and others making use of their techniques. These included in France Orbe–Récherche théâtrale, Théâtre du chêne noir, Tréteau libre; in England C.A.S.T., Red Ladder Theatre, The Freehold, T.O.C.; in the United States the Firehouse Theatre, The Company Theatre, Alive and Trucking. Fewer than half of these were still functioning in 1980.

In 1980 the Living Theatre was thirty years old, which probably makes it the oldest American theatre company of any kind. Surely it is the only existing theatre to have adhered to its ideals so tenaciously in the face of such hardships. Suffering ridicule, poverty, a nomadic life, deportation, and imprisonment they have continued their dedication to a spiritual revolution which they hope will bring about a revolution in social, economic, and political structures. Against the repression they saw in our culture they juxtaposed their experimental art as a non-violent challenge and their anarchistic community as a model of the better world which could exist. Judith Malina and Julian Beck held fast to their convictions as times changed – as the commitments of the counter-culture in the sixties dissolved in youthful opportunism in the seventies, as the pacifism of the sixties transformed into disillusionment or in some instances violence in the early seventies and indifference at the end of the decade. At all times there were those who ridiculed the Living Theatre – even other revolutionaries who were prepared to exchange one violent oppressive system for another. For some others, Beck and Malina were martyrs and attending a performance was akin to a religious experience. The Living Theatre lifted a responsibility from their shoulders by doing on their behalf what they lacked the commitment to do themselves.

The Open Theatre

More than any other theatre in the late 1960s the Open Theatre furthered the concept of collective creation. The company, under the direction of Joseph Chaikin, borrowed, adapted, and invented psycho-physical exercises which served as the chief means of creating material. By the time the Open Theatre disbanded in 1973 after ten years of work, the training exercises associated with them had come to be used by many other theatre groups in the United States and Europe as a means of creating their own productions.

When Chaikin formed the Open Theatre in 1963 it was to provide a workshop for theatre exploration rather than performance. Beginning in 1959 Chaikin had been an actor in the Living Theatre, the only experimental theatre in New York at that time. He was interested in finding a theatrical expression other than realism and in exploring the unique possibilities of live theatre as distinct from television and cinema. Eventually this led Chaikin to develop the concept of 'presence'. In the work of the Open Theatre the performer was in focus – not the character.

Chaikin came to refer to the 'outside' and the 'inside' of a situation. Realistic behaviour was the outside, and it was this which the conventional theatre presented in its productions. Chaikin was interested in discovering the inside through abstract non-verbal improvisations. The first performances by the new theatre consisted of these improvisations and exercises, some of which were structured into short pieces by playwrights Jean-Claude van Itallie and Megan Terry.

The first long play developed improvisationally was *Viet Rock,* presented at Cafe La Mama in 1966. Megan Terry had been conducting a weekly Open Theatre workshop. the anger of Terry and the workshop participants toward the involvement of the United States in the Vietnam war resulted in improvisations on the theme of violence. Using a variety of sources dealing with the war – newspapers, eyewitness accounts, letters – as the basis for improvisations, they developed material which was then structured by Megan Terry. The group met every day for the two or three weeks prior to performance when Chaikin helped with some of the staging.

The finished work was a collage of transformations unified by the theme of war and a loose chronological structure dealing with young men who are inducted into the army, trained, sent to Vietnam to fight, and are killed. The sixteen actors in the production change character frequently and sometimes are inanimate objects or simply themselves. The continuity is that of the presence of the performers rather than of specific characters. No scenery is used, the actors wear their own clothes, and there are few props.

The actors enter while a recording of the song 'The Viet Rock' is playing. They lie on their backs with their heads together forming a circle. Gradually movement can be detected, then sounds of humming, babies gurgling, child-like sounds of laughter, sounds of children playing war games, cowboys and

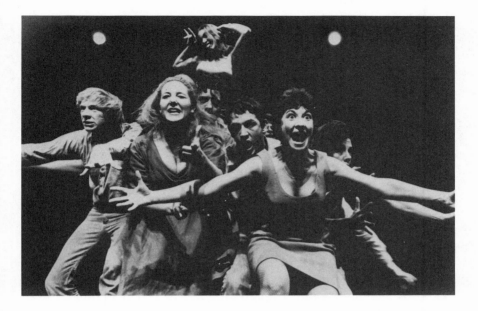

11. *Viet Rock*, **photo: Open Theatre**

Indians, cops and robbers. The sounds build to a climax and the performers rise holding hands. They circle around and are flung to different parts of the stage. The men are transformed into babies and the women become mothers who kneel beside the nearest baby. The only words they speak are 'mama' and 'baby'. One actor is transformed into the Sergeant. He jumps to his feet, yells orders and the male performers become men who form lines. The women become doctors who examine the men for induction into the army. Later the women form an aeroplane and make aeroplane sounds as they fly the men to Vietnam. The story of American soldiers in Vietnam unfolds – one of the men is wounded and dies, the men dance with Vietnamese women in a bar, and at the end everyone is killed in an explosion. After a period of silence, disjointed phrases referring to violence, war, and religion are heard from the pile of bodies in the centre of the stage. Then the performers go into the audience, each chooses a spectator and touches his or her hand, head, face, and hair. The group refers to this action as 'a celebration of presence'. It is an expression of what Chaikin considers the distinctive possibility of theatre as compared with cinema or television or the absorbing fictional world of the realistic theatre. It is the immediacy, the existential encounter which the live actor makes possible. He believes that the ultimate value of the theatre is the confrontation of the spectators with the mortality they share – 'the visceral confrontation with the reality that one is living now and at some other time no longer living'.[21]

Although direct confrontation was not used again, other means of accen-

tuating the presence of the performer were used in all subsequent work. Actors did not wear costumes to identify them as specific characters, even though special clothing was worn. By playing the 'inside' of a situation, actors did not play realistic characters which would mask them from the audience. And movement and speech were not representational in style but abstracted, so that they tended to indicate or demonstrate.

In autumn 1967 Chaikin and a group of actors began using the Book of Genesis as a focus for discussions and improvisations. The psycho-physical exercises continued with renewed commitment because of a visit by Jerzy Grotowski who was working with similar exercises in his Laboratory Theatre. The Open Theatre workshop met four days a week for four hours, and van Itallie took the responsibility of giving structure to the work being evolved. When completed *The Serpent* included places for the group to improvise in performance. In addition to biblical images, the finished non-linear transformational work includes images from the assassinations of President Kennedy and Martin Luther King. However, most of the scenes derive from the Book of Genesis.

As women in the chorus echo Eve's thoughts, the five-man serpent leads Eve to the choice of eating the apple. She takes a couple of frantic bites, savours her experience, then goes to Adam and persuades him to eat. When Adam has tasted the apple, all of the actors, in a kind of ecstasy, form the serpent. The serpent separates and the actors take apples from a bag, eat them, and carry them to the audience. Adam can neither swallow the bite he has taken nor spit it out. Adam is pulled up by his arms and speaks for God when God is speaking to Adam.

In the Cain and Abel scene Cain wants to kill his brother but he does not know this will cause his death. Cain does not know how to kill. He pulls at Abel, lifts him up, chops at him with his hands. When Abel stops breathing, Cain tries to breathe breath back into him with his own mouth, he tries to stand him up, he wants Abel to be alive again. At the end of the play they walk through the audience and leave the theatre.

While the plays which followed were developed by much the same method as *The Serpent,* the starting points were somewhat different. Each of the last three plays began with an exploration of a universal human concern.

Terminal (1969) evolved out of a collective investigation into human mortality and a consideration of both personal and societal responses to the fact of death. Directors Joe Chaikin and Roberta Sklar and the group of eighteen performers prepared for work on the new play by reading David Cooper's *Death in the Family* and the prison letters of black radical George Jackson. An embalmer explained how people are embalmed, and the description became a part of the production. Joseph Campbell talked about death in mythology, and the performers themselves collected ideas and improvised on their dreams and on specific characters. Susan Yankowitz, who was responsible for the text, joined the workshop at a later stage to observe, to help focus ideas, and to create original material which would elucidate the themes.

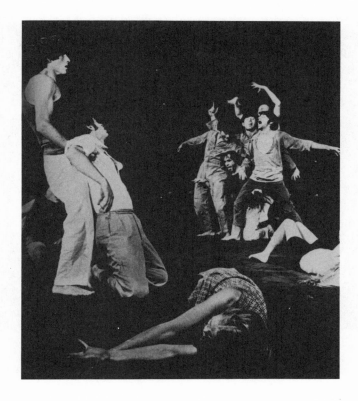

12. *The Serpent*, **photo: Open Theatre**

Terminal was first performed in Europe, touring to France, Switzerland and West Germany. When they returned to the United States there were serious frictions within the group. Some believed the Open Theatre should be primarily a social community while others believed the primary purpose of the group should be theatrical exploration. They disbanded, and after a few months Chaikin re-formed the group with only six performers. Raymond Barry, Shami Chaikin, Ellen Maddow, Jo Ann Schmidman, Tina Shepard, and Paul Zimet were chosen for their skill in carrying on the theatrical explorations of the Open Theatre. The performances of *Terminal* resumed.[22]

The only scenery used in the production is small rolling platforms of various heights, a clothing rack, a ladder, several stools, and large pieces of plywood. These props serve as beds, embalming tables, walls, and graves. The actors wear simple white garments and play a number of roles – hospital attendants, wardens, embalmers, and the dying. As in other Open Theatre productions there is much use of percussive sound, in this case most often produced by body percussion.

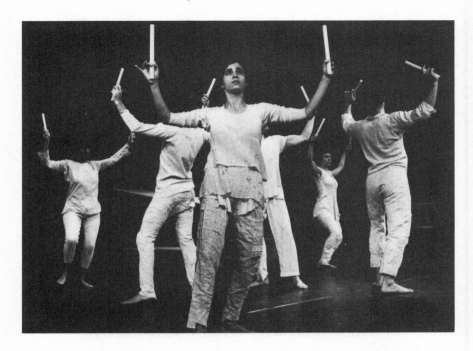

13. *Terminal*

Each segment of the play is announced by one or more actors.[23] The performance begins with 'The Calling up of the Dead'. The performers call upon the dead to speak through them, the dying. 'Let them take my body, let them use my tongue.' The actors change from street clothes to white costumes. They are alive, but they are dying. In 'The Last Biological Rites', an actor faces the audience, an anonymous attendant at his side who says without feeling, 'This is your last chance to use your eyes.' The actor tries to see to the utmost, but his vision fails. The attendant gives him pieces of black tape with which the blind man seals off his eyes. The actor makes sounds but his voice fades and he can no longer speak. He is given a piece of black tape and he puts it over his mouth. The attendant says, 'This is your last chance to use your legs.' The actor stumbles forward, his legs give way, and he falls to his knees. The attendant lifts him onto a small low platform. His only remaining visible sign of life is his breathing.

The actors perform 'The Dance on the Graves of the Dead'. At various points throughout the play one of the dead inhabits the body of an actor as when the Soldier speaks through the actor's mouth. The actor marches in place saluting to the rhythm of the march as she repeats 'Dead because I said "Yes", dead because you said "Yes".' In another segment, 'Cosmetics', three performers makeup, transforming themselves into artificial-looking people. In 'The Interview' the person being interviewed is forced to remove

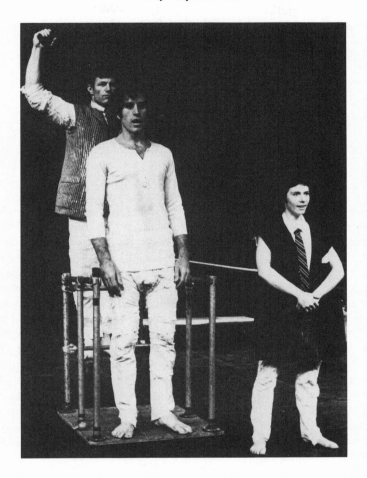

14. *Terminal*

all his clothes in exchange for the white hospital uniform. He is also measured for his coffin and his photograph is taken so his appearance can be restored when he dies. Another of the dead, the Executed Man, tells the audience they are condemned to death like him. Another performer holds a piece of plywood upright, rocking it from side to side making a rhythmic knocking sound. 'The Dying Imagine Their Judgment' is the concluding section. The judge, using a megaphone, reads the judgements as the other performers act out appropriate images.

The judgment of your life is your life.
You will finally possess the thing you wanted most in life – and eternity
will be that thing and that thing only.
· · ·

43

You neither faced your death nor participated in your life, but straddled
the line between one place and the other, longing for both.
The judgment of your life is your life.

. . .

You are standing in a space filled with bodies and you watch their
couplings and breathe their odors, but you cannot touch them and
they will not reach out to you.

At the end of the performance the actors stand silently; the focus is on the
relationship between the spectators and performers who are in each other's
presence, on the moment which is passing as all move inevitably toward
death. The performance has shown up our cultural tendency to make the
death of others relevant while obscuring the fact that we ourselves are dying.

Their next production, *The Mutation Show* (1971), grew out of workshops
on another universal human quality. The unifying theme was the adaptation
of people to various circumstances which tend to transform them into social
freaks. In preparing the work the group drew upon some of the same sources
they had used for *Terminal* and they also studied mythology and rites of
change – puberty rites, marriage ceremonies, funerals – practised in various
cultures. They became interested in Kaspar Hauser, the early nineteenth-
century German boy who spent the first sixteen years of his life in a cellar
removed from the influence of society. The members of the Open Theatre
asked themselves and each other questions such as 'Who do you see when
you look at me? What do you think I see when I look at you?' According to
Chaikin, who with Roberta Sklar directed the workshops, these questions
were intended to bring the group to a kind of crisis so as to release the work.

As in their other collective work, *The Mutation Show* made use of
performer-produced sound–non-verbal vocal sounds, percussion created by
body and feet. But they also played tom tom, tambourine, drum, cymbals,
sliding whistles, wooden flutes, accordion, washboard, and home-made
instruments. Most of the music was developed improvisationally.

The structure of the play is that of a circus controlled by a ringmaster
(Shami Chaikin) who announces the scenes and participates in them. She
introduces each of the performers as one of the characters they play during
the show. They project personalities which society has imposed upon them
or which have resulted from their adaptations to the expectations of society.
In part the traits assumed by the performers are based on an aspect of their
own personality which they came to recognize during the course of the work-
shops. Tom Lillard, dressed in a football jersey, smiles continuously. Jo Ann
Schmidman, announced as the Bird Lady, prances around the stage.
Raymond Barry is introduced as the Man Who Hits Himself on the Head,
which he does regularly. Tina Shepard is the Thinker; she wanders around
the stage trying to think. Paul Zimet is the Petrified Man. Each character has
his or her own vocal sounds suggesting a pre-language state where the
distinction between human and animal is unclear.

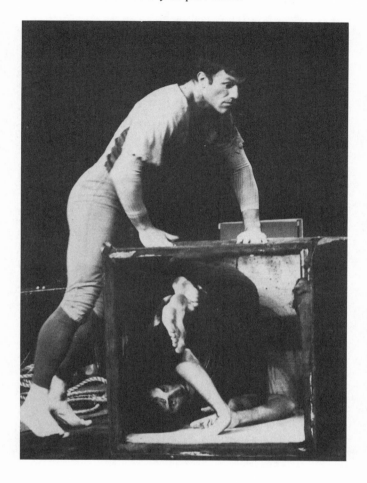

15. *The Mutation Show*

 The Ringmaster introduces the next character who is derived from Kaspar
Hauser. 'The Boy in the Box. He lived alone in his box all his life . . . One
Day he was torn from his box and carried to a hill where he was left.' The boy
is curled up in the box as in a womb. As Ray Barry pulls him from the box he
makes frightened animal sounds. The boy attaches himself to his abductor's
back, and the man walks in place, swaying from side to side, panting in time
with his steps. The boy holds tightly around the man's neck, sometimes
strangling him, and the man must push his arms away. From time to time the
boy makes animal cries as he sways from side to side countering the move-
ments of the man carrying him. At the end of the journey, the man struggles
to untangle the boy from his back and eventually succeeds, leaving him on
the ground.

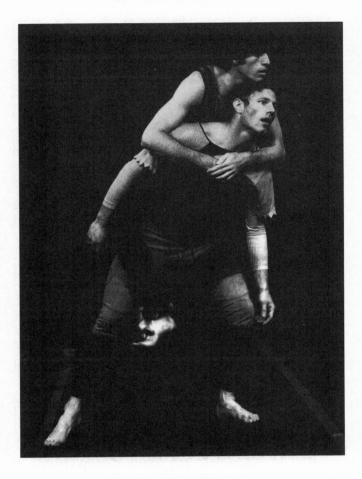

16. *The Mutation Show*

The Ringmaster introduces 'The Animal Girl. She ate and drank and slept with an animal pack. One day she was torn from her cage and taken away and made civilized.' The Animal Girl cries and screeches as she is roped by a hunter. The Ringmaster explains 'We will name her. We will give her words. We will straighten her bones. We will caress her.' As this is repeated over and over the girl's legs are straightened, her feet are put into a pair of high-heeled shoes, and her legs are made to walk as she is held in an upright position. Finally she walks on her own. She has adapted.

In the section called The Weddings the performers are pairs of lovers adapting to each other and to society. Music plays and a man and a woman come forward smiling to show the world how happy they are. A man-as-master and a woman-as-dog come forward. Two men are holding hands but looking innocently away from each other. A man and a woman come

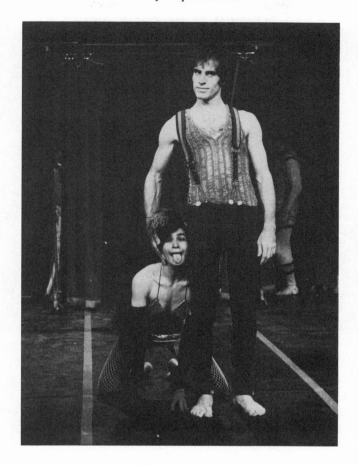

17. *The Mutation Show*

forward, she with a bicycle horn between her legs which her friend beeps by reaching behind her and squeezing the bulb. Each time he beeps, she is startled and then looks at him coyly.

In The Wedding Dance which follows, the performers dance as the Musician plays a small accordion and announces 'The groom is now dancing with the mother of the bride . . . The father of the groom is now dancing with the Captain of Police . . . The butcher is now dancing with the people . . . The earth is now dancing with the stars.'

The six performers line up across the stage holding large photographs of themselves from other periods in their lives and the Musician gives a brief biography of each. Through the observable changes in their appearance and their histories the audience gains insights into the adaptations they have made to people, places, periods, and events. The performers, like the characters they have been demonstrating, are social mutants.

47

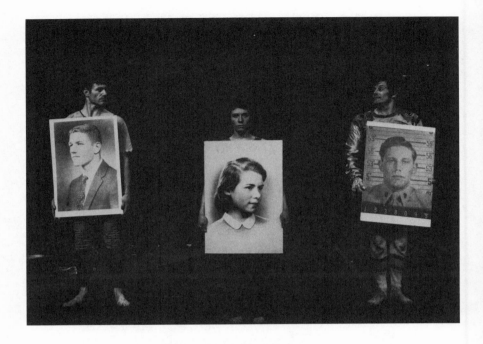

18. *The Mutation Show*

The theme of social mutation had been in Chaikin's mind for some time. He has commented several years earlier on how people modify themselves because of a desire to succeed in the theatre. The more you adapt, he said, the less you know yourself. You lose a connection to your real responses. Chaikin sought to avoid this kind of adaptation in forming the Open Theatre. The workshops, unlike training for the commercial theatre, would not try to make the actors 'better commodities'. The purpose of the Open Theatre was not so much the creation of a product, but investigation through theatre of certain forces in our culture and an attempt to invent the means necessary to express and share the actors' insights through performance. As their reputation grew the pressures to remain the same increased. They had a reputation to protect. Furthermore, by continuing to do similar work there was a probability of increased financial rewards. Chaikin and some others felt they were being seduced by these pressures and the group decided to disband. Ironically, it was not possible for the Open Theatre to remain the same and still be the Open Theatre. The purpose of the theatre was exploration and change.

They made one more play, but it was still considered a work-in-progress, not having been enriched by continuous improvements over an extended period of performances. *Nightwalk* (1973), like previous plays, dealt with universal human conditions, in this case sleep and consciousness, both

physical and social. However, *Terminal* and *The Mutation Show* were the most mature and complex works created by the Open Theatre.

The Open Theatre was open and deliberately eclectic. Chaikin had trained as a Method actor, but the Open Theatre was also influenced by Brecht, Artaud, the Living Theatre, Grotowski, Peter Brook, Viola Spolin, and, no doubt, by everyone who worked with it. Eclecticism is typical of the alternative theatres in general, and Chaikin made it a strength through his ability to select and assimilate those ideas and practices which served its needs.

Of all the groups in the United States, the Open Theatre most nearly paralleled Grotowski's Theatre Laboratory in its search for the distinctive elements of theatre and in its physical and vocal discipline. It adapted some of Grotowski's psycho-physical exercises as well as those from other sources such as Spolin. The exercises, according to Chaikin, provided a 'common ground for those who study together'. Furthermore, they provided structures for improvisation, which was the chief means used by the group to develop their plays. It was through improvisation that the performer shared with the playwright and the director the responsibility for the artistic conception. The collective creation of a work in this manner requires much more energy and time than the conventional method of writing a script and staging it. Discovering ways of working together intimately without destructive friction, and concentrating sufficiently to stave off enervating boredom, requires persistent energy.

Chaikin came to believe that a writer could provide an important ingredient in collective work that otherwise would be lacking, and he attempted to incorporate a writer into the group for each of the collectively created works. However, he thinks he never found a satisfactory way of working with a writer in the collective situation. Although writers participated to varying degrees in the creation of *The Serpent, Terminal,* and *The Mutation Show,* the importance of the writer seemed to decrease with each production.

All of the collective plays beginning with *The Serpent* toured extensively in the United States and Europe. These performances and the exercises disseminated by the Open Theatre influenced theatre groups on both continents in the late 1960s and the 1970s. Nearly every institution which trains actors uses exercises developed or adapted by the Open Theatre. But the principle which chiefly distinguished Chaikin's work was that the performer was always in focus – not a character as in realistic theatre. His concept of acting is based upon the idea that the uniqueness of live theatre is the encounter between live performers and spectators.

CHAPTER 3

Theatre of
Social Change

Many theatre groups formed in the sixties and seventies reflect social move-
ments. As with the movements themselves, these theatres aim to bring
about social change. Some are content to change attitudes and raise the
morale of their constituent audiences, others promote acceptance by the
dominant culture, and others would change society, equalizing economic
and social benefits. A few groups do not represent an identifiable ethnic or
social movement, but attempt to raise political consciousness by presenting
in their work a socialist analysis of American society. The Living Theatre has
provided one model for making theatre with a social efficacy. Other models
had existed in the workers' theatres during the depression years of the 1930s.
And Brecht's plays and theoretical writings were especially important for
demonstrating an aesthetic involving social analysis.

Among the new groups who see themselves as reviving the workers'
theatre concept, the most important is the San Francisco Mime Troupe.
There are other groups, however, with less doctrinaire political views who
feel an affinity with workers in a capitalist society – especially blue-collar
workers – and present in their plays a discussion of their economic problems.
During the Vietnam War, however, most of these groups focused their work
on raising audience consciousness of horrors being perpetrated upon South
East Asia by the United States.

The Provisional Theatre formed as a collective in Los Angeles in 1972.
Their first work, *Xa: A Vietnam Primer,* is a history of the people of Vietnam.
It is performed on a large map of Vietnam outlined on the floor with tape. In
alternating scenes the performers speak directly to the audience as them-
selves or read a narrative history of Vietnam while others, using dance-like

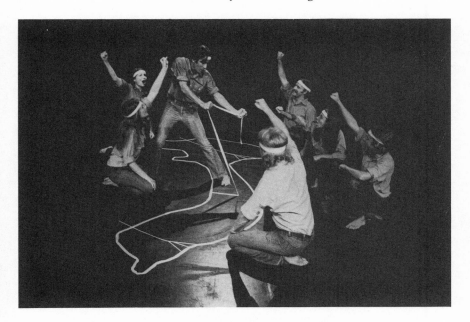

19. Xa: A Vietnam Primer, photo: Provisional Theatre

movement, act out the various armies and rearrange the tape as borders change. The acting style emphasizes body movement and vocal sounds based on Open Theatre exercises. A later production, *Inching Through the Everglades* (1978), is an idealistic play with songs about working people in America – their self-image, frustrations, and isolation. The characters tell their own stories directly to the audience, touching on themes of racism, sexism, loneliness, and growing old.

The first of the black theatres of the 1960s was the Free Southern Theatre formed in 1963 by Gilbert Moses and John O'Neal as part of the civil rights movement in Mississippi. Their aim was to develop a theatre which would reflect the cultural experience of blacks. They hoped to develop self-esteem among their black audiences; by presenting plays with historical and social analysis they intended to educate their audiences to the causes of their oppression and indicate means for alleviating it. The objectives of other black theatres were much the same, although the emphasis varied. In 1966 The Negro Ensemble Company was formed in New York by Douglas Turner Ward, Robert Hooks, and Gerald S. Krone for the additional purpose of providing continual training and performance opportunities for black theatre artists who were ignored by the Broadway and Off-Broadway theatres. The early plays, such as *Ceremonies in Dark Old Men* (1969) by Lonne Elder III, dealt with the problems of black people as victims in society. In the early 1970s productions such as *The Black Terror* focused on black–white conflicts and showed the black man as a revolutionary. By the

mid-1970s the plays were concerned with more universal problems, such as family loyalty in *In the Deepest Part of Sleep* (1974) by Charles Fuller. The New Lafayette Theatre, founded in 1967 by playwright Ed Bullins and director Robert Macbeth, was conceived as a theatre for Harlem, New York City's black ghetto. Until it closed in 1974 it provided training and work opportunities for black theatre artists. Unlike the N.E.C., it presented performances *in* the black community.

Following this lead, many black companies have emerged in major cities. Although their productions tend to be more traditional in form than those of some other minorities and the plays produced are not always by members of the company, they do provide an alternative to the more common theatre fare. They present productions from a black perspective that are by, for, and about black people.

Of equal importance are the Chicano theatres which began to form in the Southwestern United States in 1965. The first of these is the prototypical El Teatro Campesino (The Farmworkers Theatre). The Chicanos, of mixed American Indian and Spanish ancestry, have social handicaps not shared by blacks – for many Spanish is their first and sometimes their only language, which puts them at a scholastic and employment disadvantage. The productions usually make use of Mexican-style music and, so that they can be understood by everyone, are a bilingual mixture of Spanish and English. Only a few of the companies are sufficiently subsidized that their members can devote themselves full time to the theatre. Among these are El Teatro de la Gente (The Theatre of the People), formed in 1970 in San Jose, California, under the direction of Manuel Martinez and Adrian Vargas, who subsequently were instrumental in forming other Chicano theatres at the various colleges where they taught or offered workshops. El Teatro de la Esperanza (The Theatre of Hope) was founded in Santa Barbara, California, under the direction of Jorge Huerta in 1971. These groups perform primarily in Chicano communities – in cultural centres, churches, schools and parks. While they intend their productions primarily for other Chicanos, to raise their understanding of social and economic problems, their causes and solutions, the general population has shown increasing interest.

In the 1960s, as *laissez-faire* attitudes concerning life-style became more common, some homosexuals no longer hid their sexual orientation and a few overtly gay theatre groups were formed. As with other minority theatres, these groups helped to develop self-acceptance of their minority status and attempted to make themselves more acceptable to the community at large. Attempts by gay theatre groups to change social attitudes have taken two theatrical forms. Transvestite performances create sex-role confusion and ridicule strict social attitudes toward sex roles. This reduces the emphasis on sexual distinctions and orientation and focuses on individualism. Other groups present plays about the problems of homosexuals living in a predominantly heterosexual society.

The Play-House of the Ridiculous, formed in New York in 1965 by

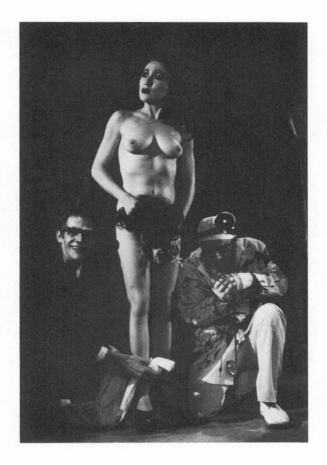

20. *Bluebeard*

director–performer John Vaccaro and playwright Ronald Tavel, was the
first of those groups employing transvestite performance. While the loose
plots resemble camp parodies of old movies, the frenetic action involves a
variety of sexual and scatological elements and reduces politics, society, reli-
gion, and sex to absurdity. In *Indira Gandhi's Daring Device* (1966) many
sex acts were performed, including the use of a large dildo on Indira, while
the characters talked of overpopulation and starvation.

In 1967 Charles Ludlam, an actor in Vaccaro's group, left and formed the
Ridiculous Theatrical Company. Ludlam's company also uses cross-gender
role creation. In *Bluebeard* (1970), based largely on a 1935 horror movie,
Ludlam plays a sex-crazed doctor who is trying to develop a third sex and
needs wives for experimentation. In his adaptation of *Camille* (1973) he
plays the title role in an elaborate costume with his hairy chest showing,

21. *Razzmatazz*

vascillating between convincingly playing a woman and reminding the audience that he is a man. Ludlam believes that the audience comes to 'believe in the character beyond the gender of the actor, and no one who has experienced that can go back . . . It allows audiences to experience the universality of emotion, rather than believe that women are one species and men another.'[1]

The most exuberant gay group were the Cockettes, who came into being in San Francisco to celebrate New Year's Eve 1969. Previously, as members of a gay hippie commune, they had presented free spontaneous performances in the parks. Under the leadership of a man named Hibiscus, the Cockettes became a group of about twenty gays, straights, and young women who created productions in the style of camp Hollywood musicals of the 1940s. Their performances, intended primarily for the gay community of San Francisco, were anarchic and aggressively amateurish as they celebrated fun, dress-up, drag, exhibitionism, and sexual freedom. Soon Hibiscus left the group and formed the Angels of Light who gave their first performance on Christmas Eve 1970 at Grace Cathedral – a mock nativity scene in which Mary was played by a man in drag. Although the Cockettes disbanded soon afterwards, the San Francisco Angels of Light continued even after Hibiscus and his lover Angel Jack moved to New York and formed another company

22. *Holy Cow*

of the same name. They continued the Cockettes tradition of living out show business fantasies in amateurish performances. In *Razzmatazz* (1974), a collection of production numbers and songs hang on a flimsy plot, singers miss notes, choreography is forgotten, headdresses fall off, and backstage whispers are heard. The company has child-like fun playing at being performers. The same unpretentiousness is present in the performances of the San Francisco group, but more attention is given to developing skill and polish. *Holy Cow* (1979) is a romantic story of long-ago and far-away India where a girl is forced to give up her lover and marry a tyrannical maharajah. However, the plot mainly serves as a structure for camp Indian palace drops, costumes, dances, acrobatics, and music. As always, men and women performers dress as either sex.

In the 1970s many gays and feminists came to consider transvestite performances offensive. They were seen as mocking women and misrepresenting gays. They did not deal with the problems of homosexuals. New companies were formed to deal seriously and realistically with the social issues. The Gay Theatre Collective, which began in San Francisco in 1976, was formed initially as a gay men's theatre and subsequently included lesbians. They create their productions collectively using improvisation, storytelling, discussion and writing, and present them to predominantly gay audiences.

In contrast with the gay theatre companies, those theatres which grew out of the women's movement are nearly always composed exclusively of women. The first objective of these theatres is expressed in the name of one of the earliest – the It's Alright to Be Woman Theatre formed in New York in 1970.

Roberta Sklar, who had co-directed some of the Open Theatre productions and worked with various women's groups, came to focus on presenting a feminist analysis of human behaviour and a model for change. In 1976 she began a collaboration with Clare Coss and Sondra Segal which became the Women's Experimental Theatre. Their play, *The Daughter's Cycle Trilogy,* is an exploration of women in the patriarchal family – the relationships of mother–daughter and sister–sister – and an historical investigation of violence toward women.

The theme of violence in relation to women has been the single most important subject of women's plays in the second half of the seventies. The multi-racial Spiderwoman Theatre Workshop collectively created *Women in Violence* (1975) to offer 'support for women involved in the struggle against violence and present alternatives to those who find themselves trapped by "feminine" behaviour'. In the production the women tell their own stories of violence interspersed with grotesque jokes of violence and pornography told in a slap-stick style. Los Angeles visual artist Suzanne Lacy has also dealt with this problem. *In Mourning and in Rage* (1977) presented a funeral procession of two-metre-tall figures dressed in black who circled city hall memorializing the women who had been killed by the 'Hillside Strangler'.

The productions of Lilith – A Women's Theatre, formed in San Francisco in 1975, have focused upon various concerns of women in society. Developing their work through improvisation, storytelling and writing, they attempt 'to expand the general public's understanding of women's lives'. Their first play dealt with the personal concerns of women – menstruation, birth control, lesbianism, mothers, masturbation, and celibacy. *Good Food* is the story of five waitresses who learn to work together. *Moonlighting* is a play about women and work based on the personal experiences of the company. And *Pizza,* the first play to be written entirely by a single member of the company, focuses upon the playwright's relationship to her mother and is set in the family pizzeria. Through these plays the members of the company have not only aimed at raising the consciousness of the general public to the plight of women, but they have done what they would like society to do – provide more theatre jobs for women.

Other people suffering discrimination by society have used theatre as a means of articulating their needs, raising the awareness of fellow sufferers and the public at large and, they hope, developing social and self-acceptance. The National Theatre of the Deaf was formed in 1967 to provide opportunities for deaf actors. Their performances combine sign-language, mime, dance, music, and narration to make their work accessible to all audiences. The Family was formed in New York in 1972 to facilitate the re-entry of ex-prisoners into society by providing opportunities for involvement in theatre. They offer workshops and performances in prisons and elsewhere. In San Francisco, Tale Spinners was formed in 1975 to provide performing opportunities for elderly people and to create productions from the perspec-

tive of the aged. The Asian-American Theatre Workshop in San Francisco serves a similar function for their constituency.

Some of these companies believe, as does Joan Holden of the San Francisco Mime Troupe, that people will be moved to change society only when they know what they want. She calls upon the arts to 'piece together a vision of a better life so strong that people will finally insist on realizing it'.[2] Of course the 'vision of a better life' can be incorporated into the action of the play as an alternative to the existing society. But there are two other ways of demonstrating the better life – in the circumstances or spirit of the performance and its relationship to the audience, and in the collective organization of the group itself as a model for the improved society.

Companies such as the San Francisco Mime Troupe believe the theatre collective presents a model for a better society through the example of its own working conditions. There is no institutionalized hierarchy. Important decisions are made by the group, work and money are evenly distributed, and unpleasant tasks are shared. Group members focus on the co-operative making of a useful work rather than on individual self-expression. Director Luis Valdez says that the 'major emphasis' in the work of El Teatro Campesino 'is the social vision, as opposed to the individual artist or playwright's vision'.

Usually these theatres intend their plays for a specific constituency of people like themselves – blacks, Chicanos, gays, etc. – but they also want to perform for others. Not only is a larger audience important to their financial survival, but they also hope to reach outsiders who will come to understand their problems. Often those for whom the company particularly wants to perform, whether they be minorities or working people, do not usually attend the theatre. This has influenced their work in several ways.

The admission charge is usually low or spectators are encouraged to contribute what they can. Many groups go to the audience because they cannot expect the audience to come to them. Lilith has performed in women's prisons and in community centres. They provide free childcare at the performance. In the early days El Teatro Campesino performed at union meetings and labour camps. The San Francisco Mime Troupe performs each summer in the parks.

In order to attract and keep this atypical audience, they present work which is not identified with the established theatre, which the spectators have avoided or from which they have been excluded for financial or geographical reasons. One solution is the adaptation of popular entertainment techniques. This is not a condescension, but a recognition of the entertainment values of such techniques and their appeal to the public at large. They have borrowed techniques from *commedia dell'arte,* as is evident in the stereotypes, masks, and broad comic action of El Teatro Campesino. The Pickle Family Circus in San Francisco incorporates circus techniques into their performances. The San Francisco Mime Troupe has a band and for a time they began their performances with juggling exhibitions. Popular

entertainment techniques are not only fun, but in them the performers do not hide themselves completely in their characters and, therefore, they can relate to the spectators as real persons. It is important for the *performer* to be present – not merely the fictional character.

Some of these companies are content to change the attitudes of those present. Others, however, would rally those present into a force which can have an effect upon society at large. In either case it is important that the performance create a community among the spectators and between the spectators and the performers. For this to happen the spectator must be psychically present in actual time so as to acknowledge other spectators with like interests and concerns. In the traditional theatre the spectator is a recipient – sitting in the dark relating privately to the work. If it is successful, it empties the spectator's mind of the actual present because he focuses upon the fictional illusions. The artists take care that the play does not direct the focus to events in the real world because it would distract the spectator from the fictional world. In the traditional theatre only fictional time is important. In the theatre of social purpose actual time and real events are important. If the spectator's focus becomes wholly absorbed in the illusion, it must periodically be brought back to the actual world. The spectator must be psychically present in order to form a community with others and to make the necessary connection between the events in the play, the conditions referred to, and the circumstances of her or her own life.

Aside from the use of popular entertainment techniques, the most universally practised means for distancing the illusion and creating a relationship between the performer and spectator is a kind of acting similar to that described by Brecht. The performer *demonstrates* the character rather than *becoming* the character. Instead of becoming submerged in the fiction to the extent of being indistinguishable from the character, the performer is seen through the character as is the person who tells a story and enacts some of the people in it. Charles Ludlam of the Ridiculous Theatrical Company says the performer should seem to be winking at the audience. In most transvestite performances the spectator sees simultaneously (or at least alternatingly) the performer of one sex and the character of the other. Another technique is for the performers to talk informally with the audience before the performance. The Provisional Theatre's production of *Xa: A Vietnam Primer* begins with each of the performers talking to a small group of spectators, encouraging them to ask questions about the large map of Vietnam outlined on the acting area. Members of the San Francisco Mime Troupe always mingle with the audience before the performance and during performance they break the illusion by commenting on unplanned events as when a dog wanders on stage. Many groups hold discussions with their audiences after performances. This demystifies the performers so they can be seen as people sharing the same concerns as their audience, and it reinforces the concept of characters as illusions created by the performers for the purpose of demonstration. Such discussions also assist the spectator in relating the stage events

to the realities of society.

Some groups invent ways for the spectators to be physically active in contrast with their traditionally passive role. By moving from place to place during a performance, the spectator not only breaks the illusion of the fictional world but changes the viewing perspective and thereby exercises a prerogative that does not exist for the audience of television, cinema, or traditional theatre.

The interaction of performers and spectators helps create a sense of community which on some occasions results in an exuberant communal expression at the end of a performance, as when spectators danced with performers at the conclusion of a performance by El Teatro Campesino at the Mexican pyramids of Teotihuacan. At least temporarily a small change takes place in the society that is present. A single performance may not have a great impact upon the society at large, but these companies believe that each performance potentially brings society closer to the better world the theatre groups envisage. Most such groups see themselves as part of a larger movement which can bring about significant social change.

Those contemporary theatre groups who intend a social efficacy have developed a mode of theatre that is distinct from the traditional twentieth-century theatre. In the creation of a community such theatre resembles that of certain periods before the advent of naturalism, and it is the closest twentieth-century theatre has come to the communal festivals in ancient Greece where Western theatre originated.

The San Francisco Mime Troupe

The San Francisco Mime Troupe gave its first performances in 1959, making it one of the oldest of the contemporary theatres dedicated to bringing about social change. Although at the outset the founder of the theatre, R.G. Davis, did not speak of political intentions or of a desire to perform for a non-traditional audience, these objectives were implicit in the direction he gave the theatre from the very beginning. Throughout its history the San Francisco Mime Troupe has focused on forms of entertainment which historically have appealed to people regardless of their social, economic, or educational status and has avoided those forms which tend to be more contemplative than energetic. In keeping with other political theatres of the last twenty years they have used techniques from *commedia dell'arte,* circus, puppet shows, music hall, vaudeville, parades, magicians, carnival side shows, buskers, brass bands, comic strips, melodrama, minstrel shows, and other means of exhilarating entertainment.

R.G. Davis set out to explore a theatrical form which was in clear contrast to the psychological realism of the established theatres. His company performed silent mime in the common man tradition of Charlie Chaplin and Buster Keaton – not that of the more aesthete Marcel Marceau. They focused on the use of body movement to convey action, character, and atti-

59

tude, thus already forming the basis for a unique style. Soon they added words to their performances and their historical model became *commedia dell'arte*.

In 1962 the Mime Troupe took a major step toward broadening their audience. They began performing in the parks of San Francisco and made an effort to attract neighbourhood people to their shows. While the early indoor audience had been predominantly young middle-class intellectuals, the audience in the parks varied, depending on the neighbourhood. In the North Beach area there were beatniks and hippies, but the Mime Troupe also got the interest of the working people in the area, who were mainly of Italian and Chinese extraction. In the Mission district the neighbourhood consisted of working people, but their core audience of young intellectuals followed them wherever they played. It was a difficult transition to the open air because there was no tradition for performances in the parks and because the plays being performed were far from innocuous in their language and politics. The resulting struggle with the authorities brought them the support of the young New Left. In 1965 Davis was arrested when the group performed after a permit had been denied on the basis that there was 'vulgar' material in the script. The action was appealed and the denial was ruled an unconstitutional attempt at censorship. Since then the Mime Troupe has spent the summer of each year giving free performances on a portable stage in the parks of San Francisco.

From 1962 until 1970 the staple of the group was adaptations of scripts by Molière, Goldoni, Machiavelli, Beolco, Bruno, and Lope de Rueda, performed in the manner of *commedia dell'arte* with the traditional stereotype masked characters, exaggerated movement and voice, and sufficient flexibility to incorporate news event of the day and to permit impromptu responses to unplanned events during the performance. The *commedia* style served well to hold attention and compete with the usual outdoor distractions. Each of these adaptations, while keeping the traditional characters and costuming, was infused with the general political radicalism of the San Francisco hip scene of the mid-1960s.

An adaptation of Goldoni's *L'Amant militaire* in 1967 became their first long anti-Vietnam play. The plot is mostly from Goldoni. The Spanish army is fighting in Italy, a clear parallel with the U.S. army in Vietnam. Pantalone, the mayor, connives with the Spanish general to profit from the war. The general is determined 'to pursue peace with every available weapon'. Pantalone would marry his daughter off to the old general, but she is secretly in love with a young lieutenant. Arlecchino disguises himself as a woman in order to avoid military service. In the end, the soubrette, dressed like the Pope, appears above the curtain and stops the war. She then tells the audience: 'If you want something done my friends – do it yourselves.'

The *commedia* stereotypes of authoritarian well-to-do old man, general, young lovers, soubrette and tricky servant, had undergone some changes, but in appearance were still very much traditional *commedia* with half masks

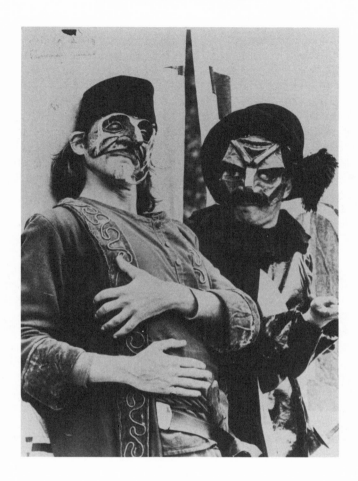

23. *L'Amant militaire,* **photo: San Francisco Mime Troupe**

and costumes. Further, the names were unchanged and the plots, while somewhat adapted, were still more from an Italian past than an American present.

In 1969 the group began experimenting with different styles. They spent many months working on a production of Brecht's last unfinished play, *The Congress of the White Washers,* a clearly Marxist play produced in the style of a Chinese opera. The conflicts brought into the open by their work on the play resulted in a series of meetings held to resolve differences respecting the focus and the organization of the company. The discussions are recalled by Joan Holden who has become the principal playwright of the group.[3]

The company was divided ideologically. The conscious Marxists believed that they should focus on playing for the working class. Davis, however, was convinced that they should aim their work at pre-revolutionary young

middle-class intellectuals. Furthermore, some were determined that the Mime Troupe become a collective in its structure with all decisions made by the group as a whole. Davis, however, was equally determined that he continue as the company's sole director and make all important decisions himself. The conflicts culminated in Davis and the most militant of the Marxists leaving the company. Those who remained felt leaderless. Partly for this reason and partly on principle they formed a theatre collective. The structure of the organization came to reflect the ideals presented in their plays as they made the shift from intellectuals commenting on political issues to political activists; from artists who had a proprietary attitude about their individual contributions to art workers with a common objective of bringing about social change.

Since 1970 each of the Mime Troupe's productions has focused upon a political problem selected by the group. Most often the plays have been written by Joan Holden, sometimes in collaboration with other company members, but the programmes have rarely carried the name of any individual as they have preferred to take collective credit for their productions. Despite scripting by individuals, the plays express the consensus of the group as developed through study and discussion of the political issue by the entire company.

The first production after reorganization as a collective was also the first of their productions to break with the *commedia* style. Joan Holden recalls that while they liked *commedia* because the characters were clear, it had a broad comic style, and it was funny, they were dissatisfied with it because it was foreign. They had been searching for an American equivalent, and they found it in a parody of nineteenth-century melodrama. *The Independent Female, or A Man Has His Pride!* (1970) was written by Holden in this style. American stereotypes of the capitalist, the young naive man and the strong woman were used in much the same way as the *commedia* stereotypes.

This women's liberation play, set in the nineteenth century, concerns Gloria Pennybank who is engaged to marry a junior executive, John Heartright. Gloria, however, is unhappy because, although she likes her job, John insists that when they are married she must quit. He wants 'a wife, not a business partner'. The villain is Sarah Bullitt, a feminist who persuades Gloria that 'femininity is a drug to make us slave'. Together they lead a women's strike for equal pay, free nurseries, and free transportation. To frustrate Gloria's leadership, John resorts to deception. He holds a gun to his head and threatens to kill himself if Gloria does not sign an agreement to renounce all of her political activities and live for him alone. She relents and is about to sign when Sarah pulls a gun on John and exposes his deceit. John takes advantage of the confusion and shoots Sarah who dies. After all, she is the villain. Gloria renounces her love forever and vows to work for the cause.

The original version of the play had followed the melodrama form more closely, but it was strongly criticized by a group of feminists who suggested

24. *The Independent Female or A Man Has His Pride!*

changes. In the earlier version Sarah's ironic villainy was maintained more strictly so that she was a manipulative woman who cast a spell on innocent Gloria in order to destroy all men. The first version of the play was also criticized for its mock happy ending in which Gloria gave up her fight and returned to John. During the course of the discussions with the feminists the Mime Troupe decided it was important to resolve the conflict between the form and the message on the side of their political intent.

Another potential danger in *The Independent Female* was that some spectators might not distinguish between the parody of the melodrama form and the seriousness of the political statement and take the play as a spoof of the women's liberation movement. In the next major play this problem was averted. Its form was not specifically from the past, but borrowed elements from the old melodrama, from *commedia,* from the spy movie, and even from comic strips. In part, this diffuse form may have come about because the scenario of *The Dragon Lady's Revenge* (1971) was developed collectively by five members through discussion, and then each wrote assigned scenes.

The Dragon Lady's Revenge was set in the present (1971) in the 'capital of Cochin, a small country in S.E. Asia'. A young American lieutenant, the son of the U.S. Ambassador, attempts to find the man who murdered his friend with an overdose of heroin. He becomes a pawn in the power struggle

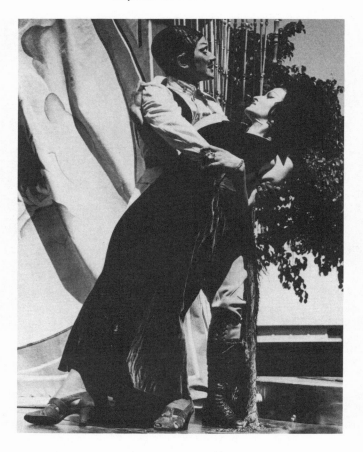

25. *The Dragon Lady's Revenge*

between those running the drug traffic – the Dragon Lady, General Rong Q who is head of the country, and the C.I.A. In the end they are exposed by Blossom, a member of the N.L.F. who works as a B-girl in the den of iniquity run by the Dragon Lady. When Mr Big, the man behind the drug traffic, is revealed to be the American Ambassador, his son changes sides and joins Blossom.

The stereotypes are mostly a blend from forms previously used by the Mime Troupe. The lieutenant and Blossom are the young lovers from *commedia* or melodrama. The U.S. Ambassador is a blend of Pantalone and the capitalist boss of *The Independent Female*. General Rong Q is a cross between the Capitano of *commedia* and the intriguing villain of foreign espionage movies. An agent of the Ambassador who makes each appearance in a different disguise is like one of the *commedia zanni*. The Dragon Lady is the evil woman of von Sternberg films and the comic strip *Terry and the Pirates*.

26. *The Dragon Lady's Revenge*

While masks were not used in *The Independent Female* or *The Dragon Lady's Revenge,* the acting style was broad enough to accommodate a man playing the mother and a woman General Rong Q. Both pieces used devices such as overhead conversations, disguises, mock heroic speeches, slapstick comedy, surprise revelations, and endings that provided models for action by the spectators.

Although the Mime Troupe had come to think of themselves as art *workers,* the subjects of their plays continued to come more from the intellectual Left than from the working class. No doubt this resulted in part from the fact that their core audience continued to be made up of this group and in part because most members came from middle-class backgrounds or had recently been students. Furthermore, it was not altogether clear who constituted the working class. In practical terms, according to Joan Holden, the Mime Troupe came to think of working people as those who are difficult to reach. They are the people who work for wages, who are not college educated, and who think the theatre is not for them – people who watch television and attend sports events but think that theatre is for an educated elite. Since 1971 most of the productions of the Mime Troupe have been concerned with the issues of working people in an attempt to serve this audience.

For several years in the early 1970s the group began performances with an exhibition of juggling, a skill developed by most members of the company.

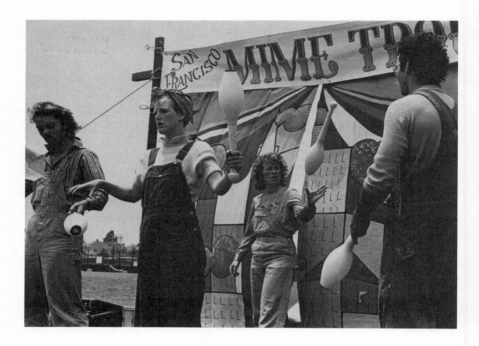

27. *Frozen Wages*

In *Frozen Wages* (1972), a protest against Nixon's price and wage control policies, juggling was integrated into the action of the play to represent an assembly line. At first six workers juggle six clubs, leisurely tossing them to one another. Then, a figure resembling the State of Liberty suggests to the Boss that while price controls prohibit him from raising prices, he can increase profits by reducing expenses. How? By firing some of his workers. One-by-one he fires workers until only two are left to juggle all of the clubs. The Boss is still not satisfied with his profits, so, at the suggestion of the government representative, he steps up production – faster and faster until one of the worker–jugglers becomes catatonic. Eventually, a strike provides a solution for the workers who force the Boss to accept more humane working conditions.

About this time the Mime Troupe was attempting to resolve an issue concerning the composition of the company. In 1971, when they would go each Friday noon to the docks to play music and juggle for the longshoremen on strike, the question of race arose. The performers were all white. The longshoremen were mostly black. In fact, the working people in San Francisco were largely non-white. The Mime Troupe knew they must become multi-racial. Their affirmative action programme got underway in 1974 and by 1980 the membership of the company was seven white, five Latin, and three black. They were able to play for a black church in Illinois, a Mexican

farm workers' picnic in Texas, a Filipino organization in Oakland, the Californian prison system, and anybody in San Francisco.

The Great Air Robbery (1974) had a black hero even though it did not focus on a specifically working-class issue. In this parody of a television detective story, Ray Von is hired by Hugh G. Magnum, an oil capitalist, to protect one of his inventors, Violet Mince. When Ray Von goes to her house and discovers her dead, he vows to find her killer. Meanwhile, because of increasing air pollution, it has become difficult to breathe. The capitalist is making another fortune by selling air, but only to those who can pay and are not 'trouble makers'. Ray Von finally figures out that Violet Mince was killed because she had invented a way of converting sunshine to energy by using plants, and this solar energy would ruin Hugh G. Magnum's plans to control the world. Ray Von finds the hidden plays and gives them to the Red Bat, a people's revolutionary group which is the only hope of the world.

The relationship between those who grow the food and those who control its distribution is explored in *Frijoles or Beans* (1975). (*'Frijoles'* is the Spanish word for 'beans'.) Two couples, a poor man and wife who grow bananas in a South American country and a poor unemployed man and wife in the United States, discover that they have much in common – hunger and unsatisfying lives. The U.S. housewife finds a note put in her banana by the woman who grew it which says 'Somebody gets ripped off, you know, when somebody else gets rich. Ask who wants things this way?' When they ask, they see the answer – international capitalists, those who own the food, the land, the stores, and the government. The two couples find that they have a common enemy, and through a series of comic reversals force the U.S. Secretary of Agriculture and Henry Kissinger, who represent all the evil forces, to feed the world, to stay out of Third World countries, and to stop manipulating world affairs.

In 1976, to commemorate the American bicentennial year, the Mime Troupe presented the longest and most complex play written within the group. *False Promises/Nos Engañaron* (Spanish meaning 'We've been had') is a two-hour play with songs which places the events of American history into a materialist context. Again the central characters are working people – in this instance miners. It is their first play to borrow from the style of the American western movie, but it owes more to Brecht than to John Wayne. The company's intent is serious analysis, but the play is entertaining because of skilful acting, dancing, and songs, and because the play connects the historical events with the emotions of working-class characters involved in everyday activities.

The play concerns the year 1898–9 when the United States formulated overseas expansionist policies which took American military forces to Cuba, Puerto Rico, and the Philippines in what is known as the Spanish–American War. The effect of this policy is shown through three carefully interrelated stories which provide three perspectives. It is seen from the top in Washington, D.C., where plans are made to extend the country's economic influence

28. *False Promises/Nos Engañaron*

to create new markets for American capitalism. The effects of the policy are experienced from the bottom by the citizens of a Colorado town where copper, an essential war material, is being mined. The impact of the policy is also felt by a black soldier who is sent to suppress black people in Puerto Rico. The three stories collide at the end of the play.

The Prologue is set in a polling place in South Carolina on election day 1896, the day on which William McKinley was elected President of the United States. Washington Jefferson, a black man, attempts to vote. A lynch mob is formed, but he escapes. The scene shifts to the White House in the spring of 1898. The king of high finance, J.P. Morgan, persuades President McKinley to extend the country's economic influence and create new markets for American capitalism. Colonel Theodore Roosevelt has the solution. 'Our destiny's manifest: to liberate Spain's island colonies, and then to keep them.'

The next scene focuses on the central story. In a small town in Colorado, copper miners want to strike for the eight-hour workday, but whites and Mexicans are divided. The news arrives that the battleship Maine has been blown up at Havana, signalling the start of war with Spain. Casey, a socialist miner, opposes the conflict as a bosses' war; Charlie, the union chieftain, who sees a strike as threatening to his power, argues that the war boom will improve wages and conditions without a sturggle. The pivotal character,

29. *False Promises*

Harry (brave but ignorant, he is the Troupe's stock character of the white American worker), sees no contradiction between the war and the strike. 'Hell, we'll take the Spaniards on with one hand, and the mine owners with the other!' His confusion is amusing, but the miners' failure to see that imperialism is good for the owners, not the workers, contributes to the eventual failure of the strike.

The tragic death of a Mexican miner brings about an uneasy alliance between whites and Mexicans; but even as they shake hands, Casey admits to the Mexican leaders that racism will not disappear overnight: 'Us whites have been hating for a long time. We had to, to take over this country.'

The theme of racism permeates the play, and lends it much of its impact. Some members of this multi-racial company have described the rehearsals for *False Promises* as 'racial encounter therapy'. The play, however, does not treat racism as a psychological problem, but as an historical one. It is an instance of what is seen as people's deepest failing: the blindness to their true self-interest which leads them to fight others of their class instead of joining them. In different ways, all the working-class characters (except the socialist) defeat themselves by fighting for 'me and mine' against people who should be their allies. Washington Jefferson joins the army to win advancement for black Americans, and finds himself suppressing black Puerto Ricans; because the war is supposed to mean jobs at home, Harry's wife

69

30. *False Promises*

(Belle) sends her brother off to get killed; Harry betrays the Mexicans to save the white miners' jobs, and precipitates the disaster that engulfs everyone.

When Copper City is occupied by the same army that has fought the Filipinos, the townsfolk who have supported the war begin to understand that the promises of imperialism are false. There has been too much racism and betrayal to allow for a sentimental vision of unity, but the black soldier ends the play on a pragmatic note:

> When the time comes, you don't get to pick who's on your side – history decides that for you. You just got to understand history.

In form and style as well as in content *False Promises* represents a synthesis of several years work. Discussions which ultimately led to its making were begun in 1973 when the group considered the possibility of making a play on the history of the U.S. labour movement, but having insufficient time for such a large project they produced Brecht's *The Mother* instead. When discussions resumed in the summer of 1975 they set out to make a 'people's history' for the American bicentennial year. In January 1976, after an intervening tour, they began their research by reading materialist histories of the United States and inviting speakers from the labour movement – mainly from union 'radical caucuses' – to give political education sessions.

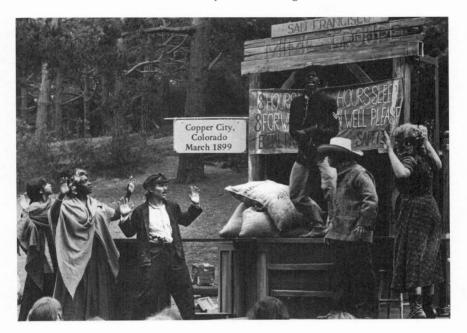

Copper City,
Colorado
March 1899

31. *False Promises*

The company divided up into smaller groups which met separately in order to develop possible scenario ideas. These scenarios were then presented to the entire company for discussion. Inevitably there were frictions as members became advocates for competing scenarios. After weeks of discussion, the scenario which had been put forward by Joan Holden prevailed and she was assigned to write the script. However, the play came from a collective concept developed and tested through months of reading, discussion, and rehearsals in which members of the company continued to participate in the development of the play as questions arose and were resolved.

False Promises is stylistically the most complex of the Mime Troupe's plays. Holden adapted Shakespeare's device of a main plot presenting heroic figures speaking in blank verse and a sub-plot of low characters speaking in prose. But the 'heroic' figures are the comic ones, and the 'low' characters are taken seriously. They had learned with Brecht's *The Mother* that a style of heightened realism could be made to work outdoors, so they could abandon older styles which they now found too limiting. So the working-class characters in the new play, although based on comic types, were made realistically complex. They are sympathetic, but are not drawn as simplistically good.

The style, however, is quite different from that of illusionistic realism. In part this is because of the need to heighten and energize the acting to make it carry outdoors, as well as the necessity of dealing with distractions such as a

71

drunk coming onto the stage. But in addition the style of acting, derived from mime, results in gestures which not only express the character but are also the actor's comment on the character. The audience, because it is not completely absorbed into the fictional illusion, is able to see the ideas in relation to the real world, and that is of course the major focus of the Mime Troupe's work.

The energetic heightened realism of *False Promises* became the style of two subsequent plays which focus on working-class issues. *Hotel Universe* (1977) by Joan Holden returns to the issue of urban renewal dealt with in *High Rises* and *San Fran Scandals of '73*. The events of the play loosely parallel the actual events at San Francisco's International Hotel. The eccentric elderly tenants of Hotel Universe are threatened with eviction by a real-estate speculator who wants to demolish the hotel so as to use the property in a more lucrative way. The down-and-nearly-out inhabitants include a longshoreman who has been replaced by a machine, a former hot dog vendor named Gladys, the lady who used to run the bumper cars at Playland, and a retired prima ballerina. This multi-racial group, instead of being intimidated by the march of capitalism, unites the working community in opposition. Although they eventually lose their battle, as did the tenants of the International Hotel, they see their fight as a model for those who follow. While the characters are realistic, the show includes band music, songs, comic pantomime, and energy that is exuberant beyond reality.

Electro-Bucks (1978), by Holden and Peter Solomon, is set in an electronics factory in 'Silicon Valley' (the Santa Clara Valley just south of San Francisco) which, typical of the industry, employs mostly minority women at low wages. The female workers in the play are supervised by Henderson, the production manager of the factory who was born Hernandez but thinks the anglo image will help him advance faster. He is attracted to Dela, a new Chicana worker, but comically tries to resist the temptation and maintain his new identity. When business exigencies result in the firing of Edith, Dela uses Henderson's love to save her colleague's job and put the workers in charge of the factory.

While the company has managed to work full time at theatre for many years, their economic conditions are difficult. The donations the company receives from passing the hat in the parks do not pay their salaries and other expenses even for the summer. During the autumn and spring they usually tour to other parts of the country and to Europe. In 1980 they became the first American theatre to tour Cuba since the revolution. Although their work is well received – they have been awarded Obies for at least two of their productions – financially they barely survive.

The Troupe has played two Decembers in a row at the Victoria Theatre, an ex-burlesque house in San Francisco's Mission District, and is encouraged by the broad audience it draws there. Says Joan Holden, 'I dream of the Victoria in a few years as a mini-version of the French T.N.P. [Théâtre national populaire] – packed out with subscriptions sold through union

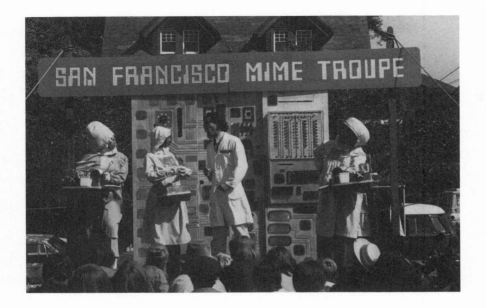

32. *Electro-Bucks*

caucuses and grass-roots organizations.'

Despite more than twenty years of financial poverty, the San Francisco Mime Troupe has continued its commitment to audiences who normally are culturally disenfranchised. While such audiences are probably the least lucrative, they are essential to the company's objective of bringing about social change. Joan Holden points out that change will not come from people who are comfortable in the system, it will come from those who are made uncomfortable by it. 'The basic theme of all our plays is the same: there is a class system in this country that is not run in your interest. It is run in the interest of rich people and they fool you about your interest.'

It is the objective of the Mime Troupe to help those who do not benefit from the system to understand what is in their self-interest and to see that change is possible. But this can only be accomplished, according to Joan Holden, by breaking down the atomization of working-class life.

> Television has tended to put an end to bars, theatres, and social clubs. It keeps people isolated in their homes, keeps their focus on personal problems and private issues to the exclusion of public or community issues. This is a massive weight holding people down and keeping them from bringing about change.

It is this weight that the Mime Troupe is trying to lift. It is Holden's conviction that theatre can function as a shared communal event much as it did in

primitive societies and in ancient Greece. The Mime Troupe wants to make that experience available to people who have been deprived of a community life, in order to restore that life in some small degree. There is a sense of community from gathering together to share a common experience, and that sense of community is important because people know they cannot change the world by themselves. The potential for change is felt when they are part of an energy, a movement, that is bigger than they are.

> When we do the right show at the right time for the right people on the right subject, the energy that surges up from the audience gives a taste of what people really moving could be like.

El Teatro Campesino
(The Farmworkers Theatre)

In 1965 Luis Valdez, then a theatre student in California, saw a *commedia* performance by the San Francisco Mime Troupe. He was so amazed by the vitality, the colour and the sound that he joined the troupe. At about the same time he began thinking of a theatre for farmworkers which would bring together his roots as the son of migrant labourers and his theatre training. He was convinced that if any theatre would appeal to farmworkers it would be the lively, bawdy, outdoor style of the Mime Troupe.

It was also in 1965 that the National Farm Workers Association of Cesar Chavez, after three years of development, first began to test its strength by joining the Agricultural Workers Organizing Committee in a strike against the grape growers in Delano, California, Valdez says that he knew he had to do something, so he talked to officers of the union about the value of the farmworkers' theatre. They were encouraging, so he decided to go to Delano, where he was born in 1940, and attempt to start a theatre.

Nearly all of the field workers were Chicanos – that is, of American Indian and Spanish ancestry – which made organizing very difficult. The only work available to most of them was in the fields, as they had poor or non-existent formal education and limited English. Typically they considered themselves fortunate to have a job, so they were reluctant to strike even though their low wages kept them at poverty level. Progress toward forming a viable union was slow. The situation was further aggravated by Mexican workers who illegally slipped across the border, often with the help of labour contractors, and were willing to work as scabs for whatever payment they were offered. They could make no demands without the threat of deportation.

The strike had been in effect for a month when Valdez arrived in Delano and met one evening in the house behind the union office with a group of union volunteers. These workers and students spent their days attempting to persuade those who were still picking grapes to join the strike. Valdez had brought some signs along made for the occasion. He hung signs saying

Huelgista (striker) on two of the men and *Esquirol* (scab) on a third who was instructed to act like a scab. The *Huelgistas* started shouting at the scab and everyone began laughing.[4] It was the beginning of El Teatro Campesino.

For about three weeks the small group spent their days on the picket line, and at night they worked on skits. Then they gave their first presentation in Filipino Hall. Soon a pattern was established. The company would spend most of their time in the cities performing to raise money for the strike and return to Delano to provide entertainment for weekly union meetings. During the 1966 historic 300-mile 25-day march to Sacramento which brought press attention to the union, the Teatro provided entertainment at each night's rally. In preparation for the election which would resolve the jurisdictional dispute between the Farm Workers Union and the Teamsters Union, the group was sent to the labour camps to perform and organize.

The theatrical form which had taken shape came to be called the *acto*. It was a short bilingual skit of perhaps fifteen minutes dealing in a comic way with situations in the lives of Chicano workers. They were short enough for use on a picket line, and three or four could be put together for a longer programme. The style of performance was similar to that of the San Francisco Mime Troupe as adapted from *commedia dell'arte*. Taking the Mexican mime Cantinflas as their model, they used broad energetic movement that could convey a situation even without words, and some performers wore masks which highlighted the stereotype characters. Because the audience consisted of monolingual Spanish and English speakers as well as those who were bilingual, the Teatro's plays were always a mixture of two languages – a practice which is common in the everyday language of the *barrios*.

Each *acto* made a specific point. In *Las Dos Caras del Patroncito (The Two Faces of the Boss)*, first performed in 1965 on the picket line, the scab is shown as the second face of the Boss. The Boss, wearing a pig-like mask, attempts to persuade one of his scab farmworkers that it is better to be a worker than to have the burdensome responsibilities of a boss. He is so persuasive that he convinces himself, and the Farmworker and Boss exchange roles. The Boss discovers his mistake, but the Farmworker refuses to trade back. The performance ends with the Boss calling for the help of Cesar Chavez and shouting '*Huelga!*'

Valdez was finding it difficult to direct a theatre company that was a part of the union. The performers' primary obligation was to the union and the strike needed everyone to help with such activities as organizing a grape boycott. The quality of the theatre suffered and it was difficult to make plans. However, they managed their first national tour in the summer of 1967 to raise funds and publicize the strike. But when they returned, El Teatro Campesino became independent of the union and moved to Del Rey, a small suburb of Fresno about sixty miles north of Delano.

In their new location the group established El Centro Campesino Cultural (The Farmworkers Cultural Center) and their objectives expanded. As in other minority movements, the Chicano movement (La Raza) was

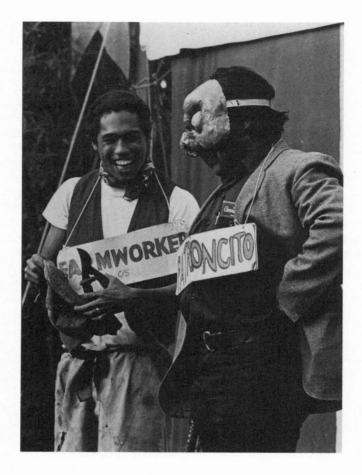

33. *Las Dos Caras del Patroncito*

attempting to identify and emphasize its own unique cultural attributes. At the Center Valdez and his associates taught classes in music, history, drama, English, Spanish, and practical politics. While they continued to support the union and to perform the *huelga actos*, the subjects of their new plays broadened to include various aspects of Chicano life and concerns.

Los Vendidos (The Sellouts, 1967) was concerned with Chicano stereotypes and tokenism in government hiring. A secretary from Governor Reagan's office comes to Honest Sancho's Used Mexican Lot and Curio Shop to find 'a Mexican type for the administration'. She is shown several models. There is the Farmworker whom Sancho describes as the Volkswagen of Mexico, very economical, a few pennies a day keeps him going on tortillas and beans. The secretary is impressed by the economical advantages, but when she discovers that he doesn't speak English she moves on to

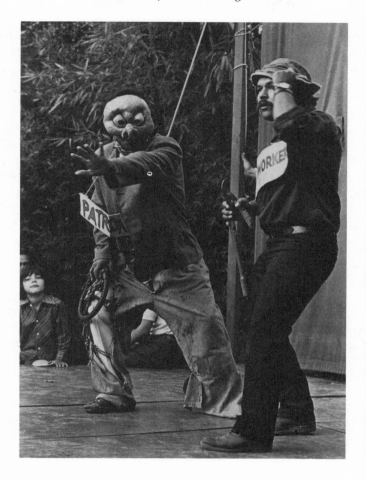

34. *Las Dos Caras del Patroncito*

Johnny Pachuco who runs on hamburgers, beer, and marijuana. Johnny has all of the necessities for city life – he dances, he fights with a knife, and he steals. Other models include the Revolucionario, a genuine antique, who has starred in all of the Pancho Villa movies and runs on raw horse meat and tequila. There is the Mexican-American who wears a business suit and tie. Sancho explains that he is just like the white model but he comes in several colours. He is a bit more expensive to run as he requires dry martinis. He eats Mexican food only on ceremonial occasions. The secretary thinks he is perfect and makes the purchase. However, as soon as money changes hands, the Mexican-American shouts, '*Viva la huelga*', and all of the models chase the secretary away and divide the money.

In 1969 the company moved to Fresno which had a metropolitan popula-tion of 300,000 including many Chicanos. In this urban environment they

continued their objectives of education and agitation by presenting plays concerned with various aspects of Chicano culture. In *The Militants* (1969), a five-minute play, comes the first indication of the company's worries about the movement – the internal conflicts, the tendency of some Chicanos to engage in stirring rhetoric and rallies while leaving the boring and arduous door-to-door work to others. The play makes the point that the outward show of militancy can be assimilated by the system with no real changes resulting. A white professor greets the audience and explains how pleased he is to welcome a militant speaker who will 'tell it like it is' and 'sock it to us'. It turns out that two militant speakers claim to be the one invited, so they take turns speaking in increasingly violent rhetoric. While each begins by agreeing with the other, they soon find fault with what the other has said. The professor assents to each of the disparaging comments about him and the establishment of which he is a part. In the end the two militants shoot each other. The professor announces the conclusion of the lecture, and through his laughter says, 'I feel so guilty'.

It was not long before the conflicts within his own company and the movement as a whole caused Valdez to shift the focus and style of the Teatro. But in the meantime they continued to use the *acto* style to present plays dealing with a variety of social, economic, and political concerns in the Chicano community.

Vietnam Campesino (1970) is a particularly complex *acto* touching upon several issues: the need to protect farmworkers from pesticides sprayed in the fields, the disadvantage Chicanos faced with respect to the draft, the problems of maintaining an effective boycott against non-union grapes when the Defence Department was buying such grapes for the military, the importance of recognizing that Vietnamese peasants and Chicano farmworkers have a common enemy in the American military–agricultural–business establishment. The play draws parallels between the conditions of the farmworkers in the United States on one side of the stage and the peasants of Vietnam on the other.

In 1971 Teatro Campesino and its cultural centre moved to a new permanent home in San Juan Bautista, a small town which is the site of a Franciscan mission built at the end of the eighteenth century by Indians under the direction of Catholic priests from Spain. Such a move had become important because of the urban distractions of Fresno and frictions within the group. Shortly before this Valdez had commented that although sloganeering was a necessary part of any political movement he was beginning to hunger for something else – a 'greater spirituality'.[5] He had come to believe that the frictions among those in the company came from a misdirected anger. The more they 'called for a fighting spirit, the more that same spirit manifested itself in terms of internal conflict'. Hostility against an unjust system was vented on each other. It destroyed the unity that was needed to continue and was in opposition to the reasons for doing their work – the brotherhood of Chicanos.

35. *Vietnam Campesino*

While the company continued to support the union and to work for social change, they were searching for a deeper spirituality. Since the group consisted of Chicanos, who were part American Indian – Valdez is part Yaqui – it was natural that the search would lead them to Mayan philosophy and practices. The Mayas, whose culture dates back to about 2000 B.C., were the intellectuals of ancient America; they developed a glyph-writing and complex calendix and built in the jungles of Yucatan, Chiapas, Guatemala and Honduras monumental ceremonial centres which were the earthly seats of their theocracy. In San Juan Bautista the members of the Teatro formed a community based on the Mayan model. They bought two houses where they lived communally, and on forty acres of land adjacent to the town they farmed according to Mayan practices. Their social lives were influenced by Indian philosophy, especially the Indian version of the Golden Rule – 'You are my other self'.

Their theatre work was also influenced by their study of Indian philosophy and mythology. Like the Mayas, they came to believe that people must be in harmony with other human beings and with nature or violence will result. No longer was the aim of their theatre work to rally the Chicano community against those who were seen as oppressors, but to harmonize the individual with mankind and with the cosmos. They still believed in social causes, but according to Luis Valdez 'the greatest cause that unifies all mankind is the

first cause, and that is god' – an expression of ultimate humanity whether symbolized by Jesus Christ, Quetzalcoatl, Mohammed, Buddha, or other god–men who have existed. Thus, according to Valdez, 'the cause of social justice becomes tied to the cause of everything else in our universe and in the cosmos'.

From the outset Valdez associated the realism of the dominant American theatre with the American 'hang-up on the material aspects of human existence'. In the published collection of Teatro Campesino *actos* (1971), he calls for a Chicano theatre that is 'revolutionary in technique as well as content' which would educate the people 'toward an appreciation of *social change*'.[6]

The *acto* had served the needs of the union and specific social issues, but the new interest of the company in their ancient American roots led to the development of a new form which they called the *mito* (myth). Almost from the beginning of El Teatro Campesino some characters in their plays were non-human. In 1965 actors played the title roles in *Three Grapes*. The following year, in *Quinta Temporada (Fifth Season)*, the cast of characters included Winter, Spring, Summer, and Fall. And in *Vietnam Campesino,* El Draft, wearing a death mask, takes away the young Chicano farmworker. The company had also dressed as *calaveras* (skeletons) for various events, borrowing the image from Mexican folklore. The *mito*, however, went even further in its use of non-human characters.

In *Bernabe* (*c.* 1969) mythological figures are used in a central way. The title character, a village idiot in a Californian *campesino* town, is confronted by Luna (Moon) dressed as a 1940s *pachuco* who arranges an assignation with his beautiful sister Tierra (Earth). She tempts Bernabe into trying to seduce her, but is told she must ask her father El Sol (the sun) for permission to marry. El Sol appears as the Aztec Sun God and the play is resolved through the Aztec ritual of offering a human heart to the sun god so that he can continue to feed life. Bernabe is sacrificed and resurrected as a cosmic man. La Tierra is again pure.

The work which most directly reflected their Mayan interests in the early 1970s is *El Baile de los Gigantes (The Dance of the Giants, 1974)*. It is their most mystical work, yet it is intended to have a social efficacy. The production is a re-creation of a ceremony that has been performed for at least a thousand years by the Chorti Indians of Yucatan. The Chorti ceremony, in turn, is based upon the mythology of the Mayan sacred book, the *Popul Vuh (People's Book),* an account of the cosmogony, mythology, traditions, and history of the Mayan people. It is presented at noon on the summer solstice and is intended to assure the well-being of the community.

The performance concerns the gods before the first dawn and tells how the sun and moon of our ancestors were created, thus preparing for the creation of man. It is narrated by Valdez and performed by eight dancers and musicians playing drum, cymbal, flute, rattles, guitar, and conch shell. Frequently the performers accompany their movement and singing. The movement, usually dance steps, is geometrical and precisely worked out

36. *El Baile de los Gigantes*

respecting the cardinal points and number of steps so as to correspond with Mayan science which underlies the myths. The performers wear masks or veils and tunics with coloured details corresponding with the colours associated with the various gods and cardinal points. The only props are sticks used in fighting and a ball that serves as a severed head, the belly of a pregnant woman, a new-born child, and the object of a battle. The ball has a special significance because from the earliest evidence of Meso-american culture the ball game was associated with the movement of celestial bodies and was a ritual act involving human sacrifice necessary for life.

The performance of this ceremony is intended to counteract the potentially violent effect of the summer solstice when the sun is directly overhead and the concentration of solar energy is the greatest. According to Valdez this tremendous energy can cause a person with spiritual impurities – for example, someone given to anger or envy – to commit violent acts.

So *El Baile de los Gigantes* is a purification for the performers and for the whole tribe as well. It shows the good forces against the bad forces, and by concentrating on the action, the people go through the struggle in a sense and it liberates them from their bad feelings. It is cathartic, but it is also in direct relationship with the Mayan mathematical knowledge of reality.

37. *El Baile de los Gigantes*

The ceremony was created specifically for the Chicano and Latin American Theatre Festival held in Mexico in the summer of 1974. *El Baile de los Gigantes* was presented at noon on 24 June at the pyramids of Teotihuacan. The audience sat on the Pyramid of the Moon and watched the performance down below with the other pyramids as a background. For those of us present it was an impressive occasion and it seemed to us that the performance succeeded in harmonizing the spectators with each other, with mankind, and with the cosmos. The audience joined in singing the final song in Spanish. As they sang, over and over, 'Please god, let the light flourish and come forth', the sacred ball was thrown back and forth from performers to spectators, and many climbed down from the Pyramid and joined performers in a jubilant dance of celebration.

The daily discussions during the Mexico festival made clear the extent of

the philosophical and political distance that had come to separate Teatro Campesino from the other Chicano and Latino *teatros,* many of which had originally been modeled after the theatre of Valdez. While the focus of Teatro Campesino was becoming increasingly spiritual, most of the other *teatros* were developing a Marxist consciousness and, through their plays, presenting a social-political analysis in terms of class struggle. They angrily accused Valdez of abandoning his proletarian roots and saw his spirituality as an opiate promoting the *status quo* by refusing to enter into combat against it. The conflicts which Valdez had recognized in his own company and in the Chicano movement, and had written about in plays such as *The Militants,* were present in the festival. The objective of unifying Chicano and Latino cultural workers by emphasizing their common indigenous roots and traditions had failed.

Never again did El Teatro Campesino perform a Mayan ceremony, although on their land in San Juan Bautista at least one Indian marriage ceremony has taken place, and they celebrate Christmas with re-enactments of events surrounding the birth of Christ. Their subsequent major works are less mystical. They combine the acting style developed for the *actos,* some mythological characters from the *mitos,* and elements from a new style called the *corrido.* The original *corridos* were narrative folk ballads often telling stories of love, heroism, and death. In the Teatro performances a small group of musicians sings ballads with new lyrics as narration for the action.

La Carpa de los Rasquachis (The Tent of the Underdogs, 1972) was the first production to use the *corrido* style. The *mito* elements in the play include El Diablo (the Devil), who symbolizes human vices, and La Muerte (a skeleton figure representing death) who, through the use of costume pieces such as a hat or a skirt, plays a variety of characters. The play has undergone many major changes reflecting changes in the focus of the group as well as political circumstances, and the length of the versions had varied from less than an hour to about two hours.

In one of the versions the play begins with a song and procession in which a large banner of the Virgin of Guadalupe is paraded. The Virgin of Guada-lupe is a brown-skinned version of the Virgin Mary who appeared as an apparition to a poor Mexican peasant. She has become a religious symbol for Mexican and Chicano Catholics. This is followed by flashes from history showing such events as the conquest of Mexico by the Spaniard Cortes. Most of the play, however, deals with more recent events. La Muerte introduces the story of Jesus Pelado Rasquachi, a Mexican who came to the United States to work in the fields. Throughout his life he wears the rope of a slave around his waist. He falls in love and is married (a priest ropes them together), buys a cheap used car (a tyre which he rolls around the stage), leaves his pregnant wife at home while he gets drunk with La Muerte dressed as a dance-hall girl, comes home and beats his wife who gives birth to seven babies who are baptized by 'Saint Boss Church'. Conditions are tolerable as

38. *La Carpa de los Rasquachis*

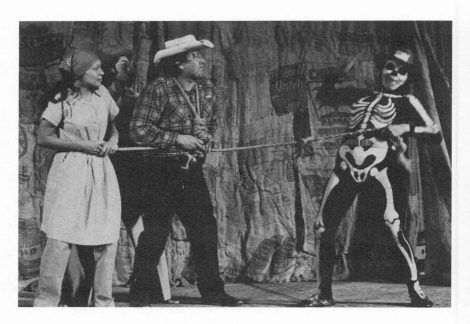

39. *La Carpa de los Rasquachis*

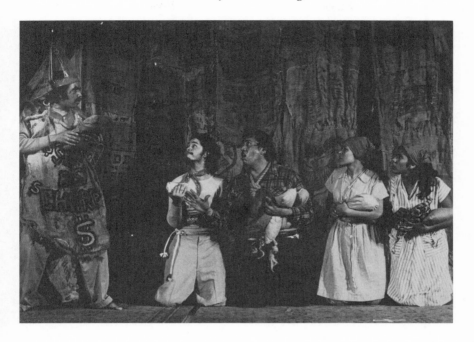

40. *La Carpa de los Rasquachis*

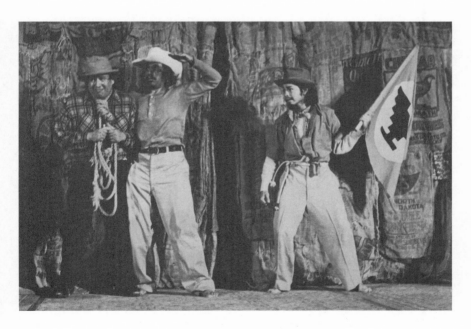

41. *La Carpa de los Rasquachis*

long as he is young and strong. When a United Farm Workers organizer comes around, he agrees with his boss that they don't need the union. But suddenly he is forty-seven, worn-out and broke, and he wants to go home to Mexico. His children refuse to go. The skeleton shakes his hand, and he dies, humiliated by the system. The rope he has worn all his life is still around his waist. In one version there is a happy ending. Rasquachi comes back to life, joins the union, and goes on strike

In an earlier version a second act concerns Rasquachi's widow and sons who go to the city where they are caught up in hatred and violence which brings about the deaths of the sons. The final section is a kind of mystical pageant in which the Virgin of Guadalupe appears. One of the sons is transformed into a figure suggesting both Christ and Quetzalcoatl, a Mayan man–god parallel to Christ. We hear, 'You are my other self.' 'If I do harm to you I do harm to myself.' 'Against hatred – love; against violence – peace.'

Despite the apparent pessimism of the story of Rasquachi and his family, the play, even when performed without the final section, is not bitter. The tremendous energy of the performance, the music, the dance, the acrobatic movement, project a positive reaffirmation of life. It is this spirit, without the obvious Mayan and Christian spirituality, that has continued to characterize the work of Teatro Campesino. However, the setting of subsequent plays shifted from the farm to the city, a transition first clearly seen in some versions of *La Carpa de los Rasquachis.*

In *Mundo (World)* the change in focus from *campesinos* to urban Chicanos is complete. Work on this play began in 1972 and was first performed in 1975 as *El Fin del Mundo (The End of the World).* This highly abstract version, greatly influenced by their Mayan studies, was envisaged as an event for the traditional Mexican celebration of El Dia de los Muertos (The Day of the Dead). The fourth version called *Mundo* (1980), which Valdez considers 'definitive', eliminated the Mayan abstractions and developed urban Chicano characters and an elaborate plot. Although it was no longer considered specifically as a celebration of El Dia de los Muertos, it is permeated by the Mexican concept of death which is a mixture of indigenous and European attitudes. The playwright–director describes the play as a twentieth-century 'Mystery/Miracle play . . . The Mystery is Death, the Miracle is Life.' As with *La Carpa de los Rasquachis, Mundo* combines elements of the *acto* and the *corrido* in its fast-moving *commedia*-like acting, its songs and dance. The *mito* element is still present, but in an altered form. There are no characters borrowed directly from Mayan or Christian mythology, nor is El Diablo or La Muerte present. Instead, all of the characters are human, but with two exceptions their faces are made-up to resemble skulls, and skeletal bones are superimposed on their costumes. The play is set in the world of the dead which parallels the world of the living except that its values are inverted.

In *Mundo* the concept of death is even more central than in previous work. The skeleton figures derive from the Mexican concept that death is not something that can be avoided, which is impossible; instead it is a

reminder of the commonality of all people who must eventually die. Material possessions and physical appearances are transitory. Underneath, all people are the same – merely skeletons. From the time of the Mayas, death was thought of as a phase in the cycle of life which is continually being renewed. Human sacrifices were offered to the sun god so that human life could continue. It is a communal rather than an individual view of life.

In *Mundo* we follow Mundo Mata, a kind of urban Chicano Everyman, on his adventures into the other side of reality. There he finds things much the same. His family and friends are living out their deaths as once they had lived out their lives. Mundo's adventures begin with an overdose of heroin. He is being released after serving his 'life' sentence. A jail door is rolled from place to place with Mundo behind it as if going through long corridors. He takes a bus (represented by five women) to the end of the line. Arrested, he is taken to a city jail for the night where he finds his father. His mother he discovers is a prostitute who takes him to her room and to bed in a coffin. Her pimp relieves Mundo of his wallet before he sets out to find his grandparents.

The staging is simple, but the bizarre costumes, the music, dance, and frenetic energy make it seem elaborate. Ten actors play thirty-six characters by changing costume pieces over their skeleton-painted body stockings. Props and two rolling-scaffold units the size of large closets comprise the setting. By rearranging these units they serve as a jail, the Department of Urban Housing Underdevelopment, a hospital, and other locales in the land of the dead. the easy movement from place to place is similar to the jump cuts, segues, and other transitions used in films. Because of these and other cinematic techniques, Valdez refers to the play as a *mono,* a *pachuco* word for movie.

In search of his grandparents Mundo crawls through a tyre and discovers the entire community lying in cemetery-like rows with tyre gravestones at their heads. He comes upon a vendor selling balloons (drugs). Since Mundo has no money he trades his knife for a balloon. The vendor uses it to burst the balloon, scattering glitter which the vendor identifies as 'bone dust' (a reference to the drug called angel dust).

With the help of a street-punk friend who has a bullet hole in his forehead, Mundo finds his pregnant wife Vera at the End of the World Dance. He kills a rival, Little Death, and together he and Vera go to the Department of Unemployment so he can find a job. He has no death certificate for identification, but when he shows them his arm they are so impressed with his 'track record' that they offer him a job as Executive Director of the Drug Abuse Center. Mundo and Vera are in an accident in their low-rider car. At the hospital Mundo is told there is good news and bad news. The bad news is that his wife is alive; the good news is that the baby was born dead. Mundo wants Vera to return to prison with him – that is, back to the world of the living. But Vera refuses to leave her skeleton baby behind.

In the land of the dead characters can be killed over and over. Little

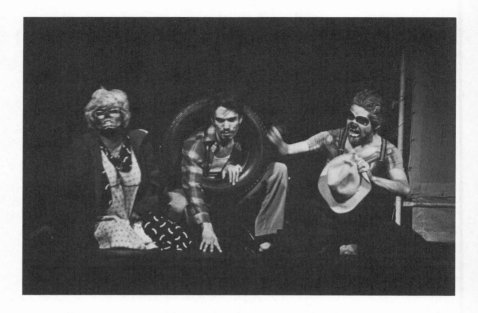

42. *Mundo*

Death, whom Mundo had killed at the dance, attempts to shoot Mundo, but kills Vera instead. The dead Vera wants Mundo to come home with her and the baby, but he is not yet ready to die. 'It's my world,' he says, 'and I'm going to make it survive.' Eventually, skeletons from the land of the dead force him out of their world, and Mundo again finds himself behind bars, sentenced to life. Vera is alive and pregnant. When offered some dust, he refuses. He is through with all of that. He has learned something.

The ironic view of life in the Chicano *barrios* is recognizable through the caricatures and stereotypes. Although *Mundo* concerns working-class people, no specific issue is in focus. The work of El Teatro Campesino has moved further from its identification with the farmworkers' union as it has become concerned with the urban Chicano. This new concern was also evident in *Zoot Suit* (1978), written and directed by Valdez for the Mark Taper Forum in Los Angeles and subsequently produced in new York where it was publicized as the first Chicano play to be presented on Broadway. However, *Zoot Suit* focuses on the historical trial of the 1940s in which seventeen members of a *pachuco* street gang were wrongfully convicted of murder.

Politically-doctrinaire Chicanos and some people identified with the New Left have accused Valdez of selling out because his work is no longer overtly political. It is ironic that in the view of Valdez the failure of *Zoot Suit* in New York was partly because critics perceived it as agitprop theatre. However, he believes that the apparent political advocacy of the play was simply

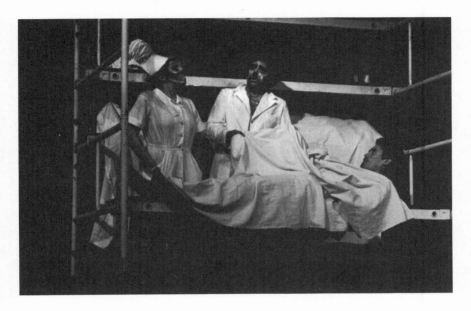

43. *Mundo*

implicit in the historical material. He does not consider the most recent work of the Teatro to be overtly political. The farmworkers are better organized now, there is no acute political cause. Now, according to Valdez, the purpose of their work is to sensitize the public to other aspects of the Mexican people, the history of California, and of the United States. The focus is the Anglo-Hispanic relationship.[7]

None the less, El Teatro Campesino has continued its commitment to the Chicano people as a whole, attempting to avoid divisiveness. And because he is a theatre artist, Valdez is especially concerned about the relationship of Chicanos to the theatre profession. He is convinced that Chicano theatre must establish itself on a professional level – not only for the sake of its artistry, but for the livelihood of its practitioners. The Broadway production of *Zoot Suit* and the projected Hollywood movie are, in his view, in keeping with this objective. Chicanos who have seen El Teatro Campesino, read about its successful European tours, learned that Peter Brook came to spend a summer working with the Teatro in 1973, or that the director of the company was appointed by the Governor to the California Arts Council, now know that it is possible for a Chicano to become a professional theatre artist.

No doubt the early work of El Teatro Campesino in support of the organizing activities of the farmworkers' union was useful especially in persuading scabs to leave the fields, in strengthening the strike, and in helping to make the boycott against non-union grapes and lettuce a success. It is likely,

however, the union would have succeeded without the Teatro. The most important contribution of El Teatro Campesino under the leadership of Luis Valdez was the creation of the first Chicano theatre. Since 1965 when his Teatro began, approximately eighty others have been formed. For many of these theatres Teatro Campesino was their model; others, while using the *acto, mito, corrido,* and *mono* styles pioneered by Valdez, focus on specific problems in their own communities and sometimes have a more doctrinaire political perspective.

CHAPTER 4

Environmental Theatre

Shortly before sunset spectators on an isolated Pacific beach near San Francisco saw on a distant cliff a giant figure in the form of a young woman standing motionless facing the ocean. After a time she stretched out her arms as if trying to reach something that was beyond the horizon. A squad of military men on a concrete bunker chanted English words in the style of Indonesian music. The words began to appear on white placards placed in long rows on the beach. The words were a letter to the young woman on the cliff written by her dead boyfriend, a sailor overseas during the Second World War.

It was a performance by Snake Theater, but it was taking place in an actual environment, rather than a created one. The young woman and the spectators shared this environment, and there was no clear separation between the real world and the created events. The actual environment was part of the play. The events of the play were happening in the real world and in real time. The beach, the sound of the ocean, the sunset, were all part of the performance and they were also the actual environment experienced by the audience. By contrast, a conventional realistic play happens in a fictional place and time. The theatre building is not a part of the performance and actual time is ignored.

In a perceptual sense, most theatre was environmental before the coming of realism in the nineteenth century. With the techniques of realism, theatre artists attempted to focus the spectator's conscious mind exclusively on fictional illusion so that everything except the world of the characters came to be disregarded. Prior to that time the experience of the audience included the theatrical environment – the theatre décor and architecture, the other

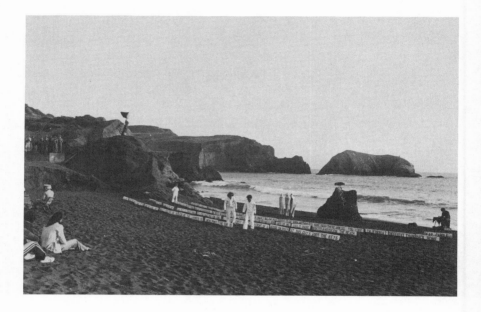

44. Snake Theater *Somewhere in the Pacific*

spectators, and interaction with other spectators and sometimes with the performers. Because the spectator was conscious of the details making up the theatre experience, he/she actively chose the specific focus at each moment, shifting from a performer on stage to a spectator in one of the boxes to the elaborate décor of the auditorium. Before realism the acting area in British and American theatres projected into the auditorium. So, although the scenery was separated from the auditorium by the proscenium arch, the actors shared the auditorium environment with the audience. With the interest in making the audience focus exclusively on the fictional action, the acting area withdrew behind the proscenium arch, the box set placed performers within the scenery rather than in front of it, the auditorium lights were darkened during the performance so as to exclude from consciousness everything that was not on stage, and the audience behaviour became passive. The environment which surrounded the spectator was no longer part of the performance experience. Neither were the other spectators as each was expected to relate solely to the fictional world on the other side of an invisible wall.

The American happenings beginning in the late 1950s, and many of the productions of the alternative theatres which followed, revived the earlier perceptual relationship of spectator to environment. They created performances which the audience perceived as sharing their environment. When the San Francisco Mime Troupe performs in a park, even though they use scenery to suggest the place of the fictional action, the audience is very much

aware of the park as the environment for the performers, the scenery, the other spectators, and themselves. The spectators interact with each other and the performers acknowledge the audience. The Living Theatre, in such works as *Paradise Now* and *Prometheus,* not only share the same environment, they intermingle during parts of the performances and some spectators participate in the action.

The physical surroundings for environmental performances can be divided roughly into (1) found environments such as that used for the Snake Theater production on the beach, and (2) constructed environments made for specific productions such as those directed by Richard Schechner for the Performance Group. In both instances, the first principle of environmental theatre is that the performers and audience share the same environment even if they stay in separate parts of it.

Richard Schechner
The Performance Group

The Performance Group was formed in New York by Richard Schechner in 1967 to experiment with environmental theatre, group process, training techniques, and the performer–audience relationship.[1] Schechner, a professor at New York University's School of the Arts, was interested in performance theory and had formulated '6 Axioms for Environmental Theatre'[2] published in *The Drama Review* which he edited.

These axioms are most helpful in understanding Schechner's production intentions: (1) It is necessary to accept a definition of theatre which is not based upon traditional distinctions between life and art. (2) 'All the space is used for performance' and 'all the space is used for audience'. (3) 'The theatrical event can take place either in a totally transformed space or in "found space".' (4) 'Focus is flexible and variable.' In environmental theatre the focus can be single as in the traditional theatre, or 'multi-focus' where the space is arranged so that the spectator cannot see everything without moving or refocusing and more than one event takes place at the same time, forcing the spectator to choose which to observe. Or there can be a 'local focus' where only a fraction of the audience can perceive the event. (5) 'One element is not submerged for the sake of others.' The performer is no more important than the other audible and visual elements. Sometimes performers may be 'treated as mass and volume, color, texture, and movement'. (6) 'The text need be neither the starting point nor the goal of a production. There may be no text at all.'

Schechner's environmental ideas deepened through practice, and a few years later culminated in his book on *Environmental Theatre* (1973). But his six axioms express his understanding at the time the Performance Group began work on the first of the three productions which did the most to explore the concept–*Dionysus in 69* (1968), *Makbeth* (1969), and *Commune* (1970).

There is another concept, relating specifically to acting, which had an impact on these productions. About the same time as Schechner's early workshops, Jerzy Grotowski was giving workshops at the University. When Schechner interviewed him Grotowski commented that he had observed in the United States a certain 'external friendliness' which was part of the 'daily mask'. 'There are qualities of behaviour in every country that one must break through in order to create. Creativity does not mean using our daily masks but rather to make exceptional situations where our daily masks do not function.'[3] Like Grotowski, in his work with the Performance Group Schechner wanted the actors to go beyond the mask, to become vulnerable.

The company found an empty garage on Wooster Street which became the Performing Garage. Michael Kirby, known for his work with happenings and later editor of *The Drama Review* and founder of the Structuralist Workshop, collaborated with Jerry Rojo in designing the environment for *Dionysus in 69*. In the empty space–approximately 15 metres by 11 metres with a height of 6 metres – they constructed several wooden towers with as many as five levels. These were arranged around the perimeter of the room. The audience sat on the floor or climbed to one of the levels. The centre floor was left open for the principal acting area, but the performers also used the towers, and the spectators could move into the central area when they wished. This arrangement of space had been suggested by an outdoor exercise which ended on the rooftop of a nearby building.

A book by the company, edited by Schechner, documents the development of *Dionysus in 69* in text and photos.[4] Soon after the workshops began, the exercises focused upon *The Bacchae* of Euripides. When the production opened they were using fewer than half of the lines of the play plus a few from *Hippolytus* and *Antigone*. The text for the remainder of the three-hour performance was made by the performers who wrote their own dialogue or developed it during workshops or rehearsals throughout the run.

Euripides' play deals with Dionysus, the god of wine, drunkenness, revelry, freedom from restrictions. He has arrived in Thebes to spread his worship, but is resisted by King Pentheus who opposes the irrational behaviour of the cult. Dionysus has roused the women of the city to emotional frenzy in the celebration of his rites. Even the blind seer Teiresias and Cadmus, the grandfather of Pentheus, are drunk. Pentheus arrests Dionysus as the leader of this debauchery, but the god gradually puts him under his spell, makes him drunk. Behaving like a female Bacchant Pentheus goes off to the mountains where the women are celebrating. A little later a Messenger arrives and describes how the frenzied women, led by Agave, the mother of Pentheus, tore the King to pieces believing him to be a wild beast. Agave enters with the head of her son. Gradually she regains her sense and comes to realize what she has done. Dionysus arrives and announces that the entire family of Pentheus will be punished.

In the Performance Group's production actors simultaneously played Euripides' characters and themselves, much as was being done by the Living

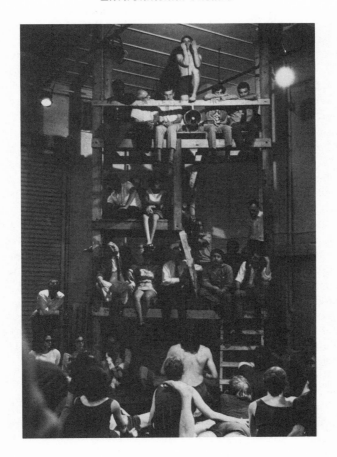

45. *Dionysus in 69*, **photo: Frederich Eberstadt**

Theatre. Dionysus was not only referred to as the god, but by the name of the actor playing the role. And that actor not only used some of Euripides' speeches, but also some that he improvised or had developed. This meant that some parts of the production were different each night, and it put focus on the presence of the actors more than on the fictional characters.

Several sections were devised which put focus on the bodies of the performers. The physicality of the birth of Dionysus was increased midway through the run when the entire cast began performing it in the nude. The actor playing Dionysus tells the audience some of the facts concerning his own birth and then excuses himself so that he can go to be born. The men lie side by side facing the floor. Above them stand the women, one behind another, legs spread forming a kind of birth canal. Dionysus lies across the backs of the men, between the legs of the women, surrounded by flesh, and is moved along by contraction-like movements of the men's backs and the

arms and legs of the women until finally he emerges and rolls into the lap of the closest spectator.

The birth ritual is followed by a dance of celebration which involves those members of the audience willing to participate. The tempo slowly increases and the dance continues to develop until it becomes ecstatic. Finally, it is interrupted when William Shephard as Pentheus climbs to the top of one of the highest towers and, speaking over a bullhorn, admonishes the Bacchants to return to their homes.

Pentheus has Dionysus put in the pit in the floor of the garage. In Euripides' text Dionysus revenges this imprisonment by humiliating Pentheus, but in the Performance Group production this mortification is not of Pentheus but of actor Shephard. The scene came from workshop encounter exercises. Each performer asks Shephard a question which is difficult to answer and personally revealing. The scene continues until Shephard is unable to answer. Once the questioning went on for more than an hour.

Dionysus says he can give Shephard any woman in the room. Shephard says he does not need Dionysus, and to prove it he goes into the audience, finds a woman whom he caresses and kisses. He tries to make love with her but is usually resisted. Once Shephard left with a woman at this point and did not return. If he fails, Dionysus says he can help, but first Shephard must make love to him. After a kiss, the two go into the pit where Pentheus is to be further humiliated by being forced to make love to Dionysus. The humiliation is not only of the character but also of the actor, and it becomes the equivalent of Euripides having Pentheus put on the clothes of a female Bacchant.

After the two go into the pit, the other performers move into the audience and select individuals to caress. It becomes a group caress nearly identical to that of 'The Rite of Universal Intercourse' in the Living Theatre's *Paradise Now* which opened in France the following month. As performers and spectators lie intertwined on the floor, stroking, hugging, and kissing each other, Dionysus and Pentheus come out of the pit and watch. Gradually the caresses become scratches and the kisses bites, eventually leading to the scene of Pentheus' death. Again the men lie on their faces with the women standing above them, legs spread. Pentheus goes back into the womb. It is his death; the women's hands, dipped in blood, are held over his head. By the end of the ritual blood is everywhere.

The production ran for 163 performances over more than a year and was continually being evaluated and changed. During most of this time there were six men and four women performers. After a couple of months the group decided to rotate some of the roles so that the production and performers could grow. Dionysus was played at different times by three men and a woman, Pentheus by two men, Teiresias by a man and a woman.

The Performance Group workshops had begun by using some of Grotowski's psycho-physical exercises involving imagination and body. A few of these and other workshop exercises subsequently served as public

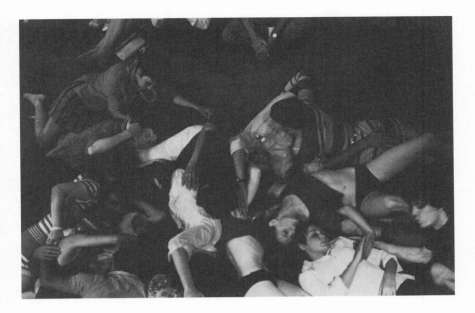

46. *Dionysus in 69*, **photo: Raeanne Rubenstein**

warm-up exercises, and others were incorporated into such sections as the mortification of Pentheus and the audience caress. But Grotowski had devised the exercises for the purpose of training actors and felt that they had no meaning as performance. Furthermore, he distrusted group improvisation and considered it a peculiarly American addiction which removed responsibility from individual performers by immersing them in what he called 'the warm waters of family relations'.[5]

Using exercises in performance was one means of focusing on the actors by exposing them without the mask of character. The potential vulnerability was increased by incorporating sections in which performers talked about themselves, responded as themselves, and interacted with spectators whose actions could not be precisely anticipated. Nakedness was another means of increasing psychic vulnerability. The elimination of clothing removed from the performer one of the chief social means of masking oneself. By exposing the body, some inner mental, muscular, and visceral processes became visible which helped to emphasize the actual performer rather than a fictional character. Although nudity was not again used as extensively as in *Dionysus in 69*, the Performance Group continued their interest in work which was performer-centred rather than character-centred.

The title of their next production, *Makbeth*, as in the Germanized spelling of *Amerika*, let the audience know they should not expect Shakespeare's play. By associating the play with Germany, audiences in 1969 might also assume that it had something to do with fascism. The company began working

on the production in autumn 1968, not long after the Democratic Party Convention in Chicago where the demonstrations of idealistic young people were confronted by the over-reactions of police in what many saw as a direct reflection of an autocratic government. The Performance Group had decided their new play would be concerned with fascism in the United States.

Schechner says that the group restructured Shakespeare's test, using it as a plasterer uses plaster. The nine characters in the production were divided into four categories. The *Doers* were Makbeth and Lady Makbeth, the *Victims/Founders* were Duncan and Banquo, the *Avengers* were Malcolm and Macduff, and the *Dark Powers,* of course, were the three witches. Duncan's children – including Malcolm, Macduff and Banquo – want to get rid of him and he hopes Makbeth will protect him. But at the first banquet Duncan is served as food to the children and the Makbeths. The plot generally follows Shakespeare except that at the end Malcolm has Macduff killed and goes off trying to eat the crown.

The space within the Performing Garage was redesigned for the production. The audiences (about seventy-five people) were free to move around in the space during the performance like unseen members of the court, hiding in corners and tiptoeing in stockinged feet from one shadow to another secretly to observe and overhear. There were stairways, ladders, a ramp, a trench, a vertical grandstand of five storeys, and cubes two and three storeys high comprising a labyrinthine environment.

Schechner has described the performance as occurring throughout the space, often with three or four scenes playing simultaneously.[6] There was no place from which a spectator could see everything. The murder of Banquo took place under a platform and was seen by only a few. When the Dark Powers made their prophecy in the trench fifty spectators stood or crouched around it. Sometimes spectators were included in the action. They gathered around a low central platform which served as the table for the banquet scene, and a few joined in the procession which was both Duncan's funeral cortège and Makbeth's coronation parade. Although, in general, the audience had the same experience, it varied somewhat depending upon the location of each spectator. The environment was not designed for a conformity of reactions.

A new environment was constructed for *Commune* which opened in December 1970. (After changes and a reduction in the number of performers it became *Commune 2* and then *Commune 3.*) This production was also developed through group improvisations. However, it did not make use of a script as a starting point. Instead, the mythic element came from events in American history, ancient and recent, from literary works such as *Moby Dick* and the Bible, from politics, and from folk songs and spirituals. The environment for this collage was a wooden construction consisting of platforms, ladders, catwalks, a vertical grandstand, a large tub, and a rolling floor which suggested an ocean, rolling plains, or a roller coaster.

The production centres on the killing of film actress Sharon Tate and her

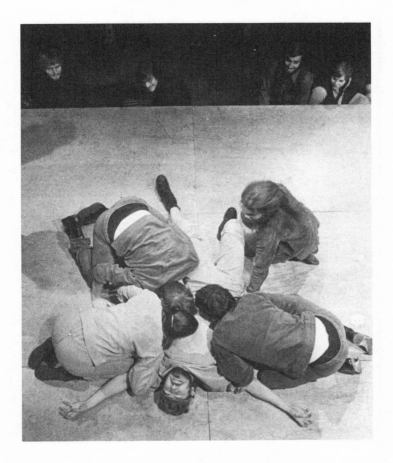

47. *Makbeth*, **photo: Frederich Eberstadt**

friends by members of the Charles Manson commune, and on the My Lai massacre by American soldiers in Vietnam. The two events, Schechner says, were understood by the company as 'rather identical incidents of national policy'.[7] The characters are young people who, like the Manson group, seek Utopia in California's Death Valley. In so doing they act out American history, including the sailing to the New World, the race across the continent, the killing of Indians, serving in the army, and vacationing in the Virgin Islands. Schechner says these scenes are performed as they might have been acted out by members of the commune the night after the Tate murders.

The Performance Group attempted in the production to develop non-manipulative ways of including the audience in the action. As the audience enters they are asked to remove their shoes and place them on a blanket where a large pile is accumulating. The performers are already in the room

dressed in costumes from a used clothing store. One of the two women performers walks among the spectators asking if they have anything they would like to burn and collecting bits of paper in a metal container. Later these are burned and become the camp fire in one of the scenes.

The audience is aware of the performance beginning when about a dozen people, including five of the performers, line up and one of the women points out those whom she is accusing. The sailing of the Mayflower with the colonists is suggested by performer-created sounds – the sea, wind, creaking ship, and seagulls. The ship arrives at the Statue of Liberty represented by one of the women who recites the inscription in a Brooklyn accent. Actors evoke the mood of Death Valley at night by howling like coyotes. Other scenes include a western movie gun fight that is predominantly comic until one of the participants is killed, and the arrival of one of the women at the commune. The newcomer, Clementine, is timid but gradually she comes to trust the others and with their help she flies. The other woman, blindfolded, searches for El Dorado as she wanders among the audience asking people for their help.

Near the end of the performance Lt Calley gives testimony on the slaughter of Vietnamese at My Lai. As he tells how men, women, and children were herded together and shot, other performers drag the pile of shoes to the centre of the environment. Wearing shoes chosen from the pile the performers approach the 'white house on the hill' to murder the inhabitants, including the pregnant Sharon Tate. The performance ends with a section called 'Possibilities' in which the actors wash themselves in the large tub and the spectators retrieve their shoes as they talk to one another and to the performers.

Commune is concerned not only with dropping out and violence, but also with American concepts of ownership. Hippies take from the established society because, as one performer says, 'Everything belongs to everybody.' During the performance various objects are taken from the reluctant audience, and when Clementine's self-image changes after adapting to the commune, she changes clothes with a spectator. The hesitancy of the audience in giving up these items stands for the larger preoccupation of Americans concerning property. The members of the commune do not escape this obsession any more than the middle-class audience. Their fantasy is to have dune buggies for everyone. They are all infected with the American dream.

However, the production also functions in a non-metaphorical way. It is a means of interaction between performers and spectators. Schechner believes that such interaction is essential in fulfilling what people need from the theatre – a narrative structure which provides an opportunity for exchange between people. Parties can provide this exchange without the narrative; cinema and traditional twentieth-century theatre provide the narrative without the exchange. Some have considered the interaction at the end of the play to be the most important because it creates a potential for

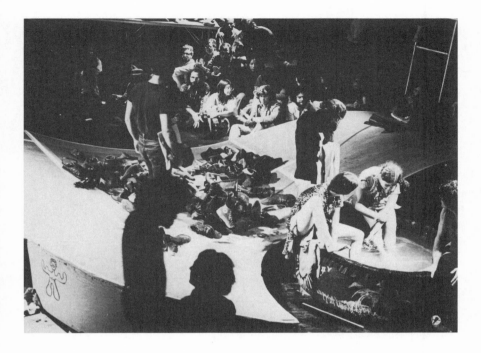

48. *Commune*

change.[8] The importance of interaction to the company is suggested by the fact that they pronounce *Commune* as a verb, with the accent on the second syllable, rather than as a noun.

The first three productions of the Performance Group had explored the principle techniques of the environmental theatre concept as it was being formulated by Schechner. Those works which followed had less to explore even though they were significant artistic achievements. In *The Tooth of Crime* (1972) Schechner worked with a new script by Sam Shepard. *Mother Courage and Her Children* (1974) was an environmental production of Brecht's play. *The Marilyn Project* (1975) used a script by David Gaard who worked daily with the group. In the next two productions the acting area and the audience were separate and distinct. *Oedipus* (1977), Ted Hughes's adaptation of Seneca, was presented in a miniature coliseum with dirt floor and steeply-raked seating built inside the Performing Garage. In *Cops* (1978), by Terry Curtis Fox, the audience looked down from two sides into the hyper-real environment of a functioning diner. The last Performance Group production directed by Schechner was Genet's *The Balcony* (1979) where, like the first three productions of the company, the acting areas were among the spectators.

Schechner had chosen as members of the Performance Group strong individuals who would have an impact on the work through their unique contri-

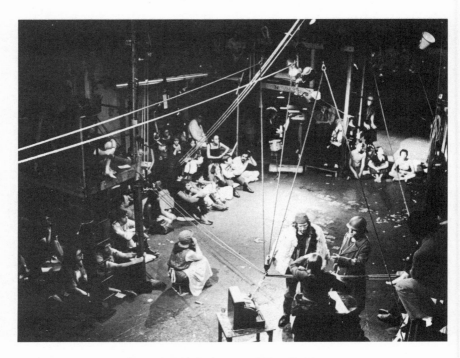

49. *Mother Courage and Her Children*

butions. As the unifying external forces dissipated with the ending of the Vietnam war, the energy that had been focused on social rebellion became focused on individual artistic expression. Schechner wanted to continue creating works which were expansive, which like Asian theatre and Western classics create an entire world. Spalding Gray, on the other hand, had a narcissistic focus and wanted to work with Elizabeth LeCompte in developing productions which explored his own life. Eventually, Schechner's work and the work of Gray and LeCompte could not be accommodated within the same company. The performer–collaborators in the company could not be committed to both, and economically two companies were impossible. Schechner withdrew from active participation in 1980 and began to direct individual projects elsewhere and to spend more time writing. Gray and LeCompte, together with several other members of the company – Jim Clayburgh, Willem Dafoe, Libby Howes, and Ron Vawter – took over the Performing Garage and became the Wooster Group, named for the street where the Garage is located.

Under Schechner's direction the Performance Group adapted techniques and concepts from several sources and made them their own. The concept of environmental theatre had already been revived by the producers of happenings; exercises were borrowed from Grotowski and used, with changes, in performance. Some of the techniques of group therapy, sensitivity train-

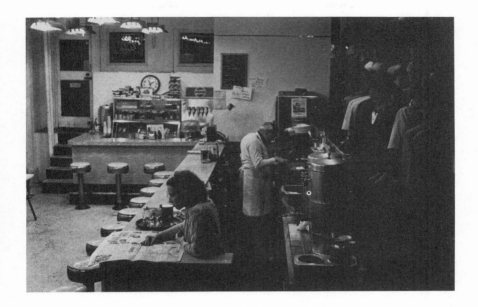

50. *Cops*

ing, and encounter groups were used in workshops. The Living Theatre and others had used classics as the starting point for collective works; simultaneity of scenes, audience participation, and improvisation had been used by the producers of happenings and by the Living Theatre. The Living Theatre had also used the technique of actors playing themselves. While the use of these techniques and the formulation of these concepts pre-dated the Performance Group, they were not simply borrowed by Schechner. They were thoroughly explored through practice and their understanding deepened through his writing.

Schechner's objective had been to develop through practice a theory of performance that was separate from the theory of texts. The key to this goal he found in environmental thinking. The fundamental principle of environmental theatre is to begin with an empty space, without a preconception of where the audience or the performers will be or how they will relate. These are developed as part of the rehearsal. Thus environmental theatre, according to Schechner, deals with whole worlds – not merely fragments placed in spaces predetermined by convention.

The Bread and Puppet Theater

When Peter Schumann founded the Bread and Puppet Theater in New York in 1961 he initiated the practice of sharing with the audience dark bread which he made from hand-ground flour. Schumann believes that theatre

should be as basic to life as bread. Some of his productions have been made for outdoor found environments where a carnival-like atmosphere is created involving as many as a hundred participants. Others have been designed for presentation by a few performers on sidewalks or indoors.

In Munich in 1959 Schumann had begun to introduce large sculptured bodies into dance performances. After moving to the United States, the productions always used puppets, some as tall as five metres, in combination with masked performers. The performances are predominantly visual, in the mode of popular entertainment accessible to everyone. The atmosphere is informal, the style projects an apparent child-like simplicity, and there is a spirit of gentleness which evokes a sense of community among the spectators. The performances, varying in length from a few minutes to three hours, sometimes use banners, painted backcloths, 'crankies' which tell a story through pictures drawn on a roll of paper which passes from one roller to another, folk music – both instrumental and vocal – and may involve a procession or parade. By 1981 Schumann had created well over a hundred productions.

While the intention of the Bread and Puppet Theater is not to advocate a political doctrine, Schumann's work is a protest against the dehumanizing effects of modern urban life and its materialism. He wants to evoke in his audiences a direct emotional response to those forces which promote destruction of the human spirit.

A fifteen-minute play such as *The King's Story* (first version 1963) could be presented outdoors without prearrangement, or with other short plays as an entire indoor programme. The staging requirements for this parable are especially simple. A red cloth about two metres high is attached to a pole on each side. One pole is held erect by the narrator, the other by a trumpeter. As the narrator tells the story, it is enacted by rod puppets visible above the cloth who use non-verbal vocal sounds. The story is punctuated by drum, trumpet and cymbals. One puppet, the Great Warrior, is a tall puppet with a man inside who walks in front of the red cloth carrying two swords. The Great Warrior comes into the King's country offering his services, but the King sends him away. When a Dragon appears, however, the people and the King are afraid. Ignoring the advice of his counsellors – a Priest, a Red Man, and a Blue Man and his Son – the King sends for the Great Warrior who kills the Dragon, then he kills the King and his counsellors, and then he kills the People. The Great Warrior is alone. And then Death comes and kills the Great Warrior.

Schumann is a pacifist and consequently many of the works he created during the Vietnam war were protests against such inhumanity. *A Man Says Goodbye to His Mother* (1968), 'a sidewalk show', is presented by three performers using simple gestures and only a few props. A narrator wearing a death mask prepares a young man for war as a woman wearing a white mask representing his mother looks on. The young man 'goes to a country far away . . . It is a very dangerous country.' The narrator gives the young man a gun,

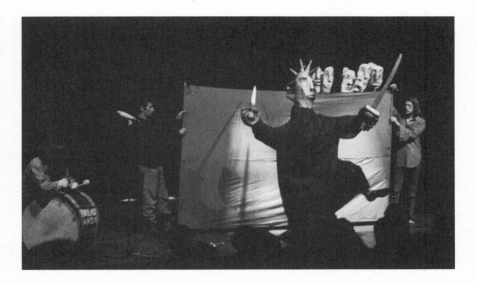

51. *The King's Story*

a gas mask, and a toy aeroplane. The narrator tells us that the man comes to a village in a foreign land. The woman exchanges her white mask for a black one. 'The man takes his aeroplane to look for his enemy.' (The man moves the toy plane as if it were flying.) 'The people are afraid.' (The woman cringes as drum and trumpet sound.) 'The man is afraid.' (The man covers his eyes.) The man poisons the crops, he burns a house, he bombs the children. The woman's arm guided by the narrator representing death, kills the young man with a pair of scissors. The woman changes back to the original mask, and the narrator presents a letter to her which says, 'We regret to inform you.'

Many of Schumann's productions have a mythological atmosphere, and many borrow stories, images, or characters from religious sources. *The Cry of the People for Meat* (1969) draws upon the Bible, presenting images from the creation of the world to the crucifixion. The material taken from the Old Testament depicts a corrupt society of imperialism and violence. Christ is shown resisting these powers and attempting to create a new order devoid of materialism and corruption. The parallels in our own times are underlined by the interjection of contemporary images.

Until 1970 the group centred its work in New York City, with extensive tours in Europe. In 1970 Peter Schumann, his family, and a few puppeteers became a theatre-in-residence at Goddard College in Plainfield, Vermont, where they lived and worked at Cate Farm. In 1974 this group disbanded and Schumann and his family moved to another farm near Glover, Vermont. They work this farm themselves without the help of motorized machinery. They raise animals and grain and make maple syrup from the trees on the

farm. From time to time Schumann invites those with whom he wants to work to come to Vermont to do a specific project which might subsequently tour to Europe. Schumann himself is invited to universities and other institutions where he works with students and others in the community for a specific period of time on a specific project. However, a kind of continuity is provided by a recurring project, *The Domestic Resurrection Circus,* first presented in 1970, and created anew each summer since 1974 in a meadow on the Vermont farm.

Past members of the company come to Vermont from throughout the United States and Europe, bringing their own shows and helping to build the figures and masks designed by Schumann for *The Domestic Resurrection Circus.* The director and performers then explore the appropriate movements of the figures they have built – giant puppets, flocks of birds, herds of deer or horses, clowns, and masked figures. A period of musical experimentation follows, and finally a narrative is developed by Schumann from the elements which have emerged. The performers are not actors, they use the puppets, masks, and 'crankies' to demonstrate a story. The performance of the multi-focused work lasts most of the day. Peter Schumann has explained why the *Circus* is presented at the farm.

> It's a piece that shouldn't be traveled, something we want to perform where we can integrate the landscape, that we can do with real time and real rivers and mountains and animals. It's something that is seen in the woods, up there in the hills, back here in the river. I guess it would be called an 'environment'.[9]

In the spring of 1975 Schumann was invited to the University of California at Davis where he made a production for a very different outdoor environment. The site he chose was an excavation for a building that had not been built. The excavation, partially covered with weeds, was approximately eighty-eight metres by sixty-three metres and was surrounded on all sides by mounds of earth about seven metres high. During a two-week period, with the help of more than sixty students, faculty, and townspeople, he made an entire parade and 'anti-bicentennial pageant' dedicated to Ishi, the last member of a northern Californian tribe of American Indians. The theme had been chosen by Schumann because of the approaching American bicentennial (1976) and his feeling that Americans of European heritage should understand their own celebration in the light of their forerunners' tragedy.[10] His idea was not to create a historical illustration of the tragedy, 'but a free-form work on the inherent theme: peace of the Indians, war of the whites'.

When Schumann arrived to begin work, he had only a vague idea of the form it should take. Upon seeing the outdoor environment, he abandoned even that idea as not suited to the terrain. By the following morning, he had formulated a new structure and principal images for the work and had made

some notes and sketches. It would begin with a parade through the town and campus, ending at the excavation site where the pageant would be presented. In a general meeting he described the project and explained that during the day participants would be building masks, costumes, and banners, and in the evening rehearsing movement and music.

In the following two weeks, with the help of the group, Schumann designed and made thirty-six Deer masks and costumes with tree branches for antlers, twenty-one Butchers' costumes with black top hats and beards, twenty hardboard printing blocks from which over fifty flags and banners were printed, sixteen masks and costumes for Hunchback Witches, and four establishment Gods ranging in height up to four metres mounted on two carts pulled by Dragons. Schumann designed each of these items and demonstrated how to make them. As he continued to work at designing or building, he also supervised the work of others.

In the evening rehearsals Schumann directed the music of a small band assembled from the participants, conducted the singing, or rehearsed the movement of the Deer and Butchers. Schumann worked from eight in the morning until past ten in the evening. Others worked when they could.

The anti-bicentennial pageant, *A Monument for Ishi*, was performed once at sundown on 23 May 1975. It was preceded by a parade through the town consisting of a small truck with a piano and a piano player, Peter Schumann on one-and-a-half metre stilts, several clowns with a baby carriage, a two-wheeled cart pulled by a Dragon which had two Gods mounted on top and eight Hunchback Witches surrounding it, twenty-one Butchers who walked in two orderly columns carrying flags, another two-wheeled cart with Gods surrounded by eight more Hunchback Witches, the San Francisco Mime Troupe Band, about thirty banners carried by participants, and finally one Deer and a little girl walking together. The girl carried a sign saying 'A Monument for Ishi'.

When the parade arrived at the performance site, the spectators stood or sat on an earth mound on one side of the excavation facing into the setting sun. The two carts from the parade were placed in the excavation so that the Gods appeared to be observing the performance.

The Clowns announce the beginning of the performance and the San Francisco Mime Troupe Band plays as the Clowns do tricks. One of the Clowns rings a large bell signalling the entrance of the Deer and Butchers. There are no more words spoken. A herd of thirty-six Deer, each with a performer inside, enters the excavation in slow motion. When they reach the centre, twenty-one Butchers with their flags flying appear on top of the mounds on the three sides where there is no audience. A bugle is heard and other bugles answer at various distances. The Butchers run down from the top of the mounds and surround the Deer, running in a circle around them with flags flying. A large bell is rung and the Butchers stop. Eight people with horns made of plastic pipe and the neck-half of plastic bottles form a circle around the Deer inside the circle of the Butchers. The horns make a

52. *A Monument for Ishi*

53. *A Monument for Ishi*

54. *A Monument for Ishi*

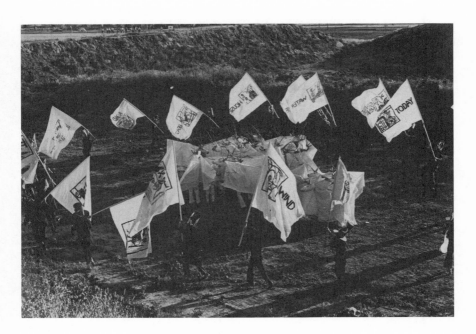

55. *A Monument for Ishi*

moaning sound as the Deer mill around their centre pivot in slow motion for perhaps three minutes before they lie down.

The large bell is rung again and the Butchers stop waving their flags and hold them as high as possible as a lone figure in black enters. He moves slowly and deliberately from one Deer to another, breaking the wooden antlers as the sound of the horns continues. When all the antlers are broken, the figure walks away and the horn blowers stop blowing and also leave. The Butchers lower their flags and rest the poles on the ground.

One of the Clowns walks to the pile of Deer bodies and realizes that they are dead. He runs sobbing loudly to the chief Clown who blows his whistle and organizes the Clowns into a military formation. He blows his whistle again, signalling the truck with its piano to move in toward the Deer. The Clowns dig a small hole in which they plant a tiny U.S. flag on a two-metre pole. The piano plays an *arpeggio* as the flag is raised. The Clowns salute as the 'national anthem', represented by a simple Bach piece, is played on the piano.

The large bell is rung and Peter Schumann on stilts, dressed as Lady Resurrection and wearing a mask, enters the excavation. He dances to the music of the four-piece band of recorders and flute. At the end of the dance Lady Resurrection bows and the Clowns bow in return, and she signals to the Clowns to distribute wings to the Deer. One of the Clowns puts on a costume painted blue with white clouds. The Butchers have disappeared. As Lady Resurrection dances, a Clown taps on the head of each Deer and the person inside comes out to receive a pair of diaphanous wings. The winged people form a group, and when all of the Deer have been resurrected and Lady Resurrection has exited, they sing three hymns. When the hymns have been sung, Schumann re-enters without his stilts and passes out bread and aïoli to the spectators who came down from the mound into the excavation. There is an exhilarating spirit of community as they eat and talk until twilight turns to dusk.

By 1978, in addition to the Schumanns, there was a full-time nucleus of four living on the farm and creating touring productions. Such a production was *Ave Maris Stella* (1978), using the medieval mass by Josquin des Pres which was sung by the Word of Mouth Chorus. However, the production is not a religious event, but a humanist one in keeping with all of Schumann's work. Images are drawn from the Old as well as the New Testament and other legends. Mary is the central figure who survives the calamities of the centuries including expulsion from Paradise and the Flood. Although there is a procession through the audience and performers serve bread to the spectators, most of the performance takes place on a platform stage and is viewed from one perspective. This arrangement was necessary to accommodate the elaborate visual production including painted drops and puppets of many sizes which are pulled on from the wings or lowered from above.

Myths from many cultures work on Schumann's imagination, producing

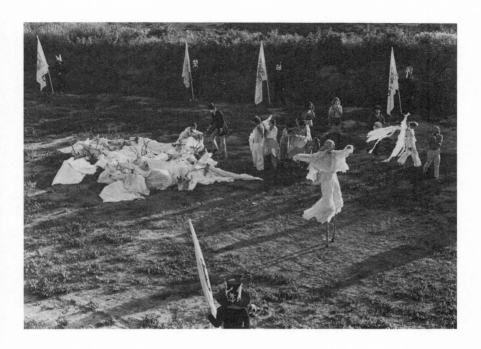

56. *A Monument for Ishi*

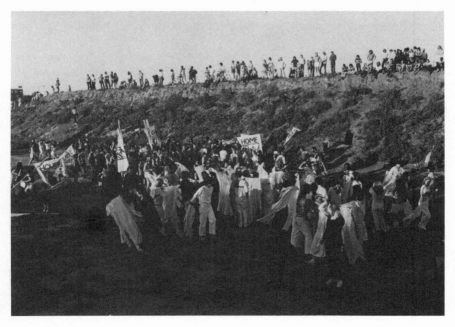

57. *A Monument for Ishi*

stories and puppets which have the simplicity and power of archetypes. It is his objective to make the puppets and masks directly expressive rather than using them as symbols. The movement of each puppet is carefully explored so as to make it expressive as in dance but outside of dance convention. It is the intent of direct emotive expression that makes words in these productions of secondary importance and dictates that they be used with poetic economy. The lighting serves a similar purpose whether provided by electric torches, candles, daylight, or theatrical lighting instruments. Although in general the plays may be concerned with social issues, they do not preach, they do not present social analyses, nor are they concerned with solving problems. Instead they deal with elemental human themes presented without ideological comment. They are not sentimental, but assertive in their humanism.

Peter Schumann has spoken of the *Domestic Resurrection Circus* as demonstrating the whole world. Each work creates a unique world that is complete, rather than presenting a fragment of everyday life following theatrical conventions and set in a space where the audience–performer relationship has been predetermined. Schumann attempts to avoid performing in traditional theatres because the audience's reaction is conditioned by what they expect to take place in such spaces. Instead, the Bread and Puppet Theater performs in a variety of non-theatrical spaces where the performance dominates the space rather than the other way around. In each environment they use all of the space. The performers are not confined to a specific area although there may be one or more principal performing areas. The physical relationship between spectator and performer varies with each venue.

This principle of inclusiveness applies not only to space, but also to the audience. The popular entertainment techniques of puppetry and circus are not exclusive; they can be enjoyed by all ages, classes, and sensibilities. Schumann strives to make the performances clear, concentrated, and precise. He says 'theatre is good when it makes sense to people'. If a five-year-old can understand it, so will the adults.[11] Furthermore, Bread and Puppet productions are intended to include the spectator in a community made up of performers and other spectators rather than aiming for individual psychic involvement in a fictional world to the extent that the audience is unaware of the actual world of performers and spectators. In part, the awareness of performers is accomplished by the use of story-telling techniques – narration and puppets – where performers are narrators or puppeteers. They are not to be taken as characters but as themselves. The communal relationship is aided by making the spectators active participants. They are always invited to share bread with the performers, and in some productions such as *The Domestic Resurrection Circus* or *A Monument for Ishi* many spectators are also performers. Even carrying a banner in a procession increases one's stake in the community of celebrants.

Schumann believes that 'art is by now what religion used to be. It is . . . the

112

form for the communal event, the shape of the celebrations that we might have with each other'.[12] Peter Schumann is not only the designer of these celebrations, he also officiates. He makes both the performance and the bread; he invites the audience to share both with the performers and each other. It is a celebration of the humanity they have in common.

The work of the Bread and Puppet Theater has influenced and stimulated theatre workers in America and Europe. They have been impressed by the techniques and unpretentiousness of the productions, by Schumann's commitment, and by his simple life style which lacks the usual separation of life and art. Art is his life. Groups emulating his work have been started by former members of the company as far afield as Germany and California.

Snake Theater

Snake Theater in California has used commonplace situations, sometimes created for found environments, and developed them into productions of epic dimensions. Their plays have concerned a waitress in an all-night cafe, a sailor and the girl he left behind, and a family whose car broke down in a gas station. The performers wear bold sculpted masks, and they use carefully designed props, paintings, puppets, and figures of all sizes which sometimes have live performers inside. Their theatre is a visual experience rather than a psychological one. Masks convey character directly and help put focus on the visual elements rather than on the inner needs of characters. Laura Farabough and Christopher Hardman, who formed the theatre in 1972 as the Beggars' Theater, trained in the visual arts and they set out to create a visual theatre. They think of puppets and live performers as moving sculptures, and of the performance as a painting animated by movement.

Hardman had worked with Peter Schumann of the Bread and Puppet Theater. Like Schumann's, the early work of Hardman and Farabough incorporated mythological themes and characters, and in a general way was concerned with social issues. Being interested in folk art and ethnic music, they set out to create a cycle of plays relating to the seasons, which would be in harmony with folk beliefs throughout the world. Subsequent productions, however, revealed a growing interest in using Californian environments while retaining a concern with the techniques of other cultures. They developed their own unique style based on everyday events and characters. In part the change was the result of two additions to the group in 1977 – Lary Graber, a composer and musician who combined Asian musical forms with electronics, and his wife Evelyn Lewis, who has a modern dance background and a strong interest in Indonesian dance. From 1977 until Graber's death in 1980 the four permanent members of the company studied Javanese mask dancing which greatly influenced the movement in their productions. After Graber died, the name Snake Theater was no longer used. Hardman and Farabough formed separate companies, Antenna and Nightfire, each with a distinct method and style.

113

The aesthetic of Snake Theater derived from the experience of its members in visual arts, music and dance, which helped the company avoid the pitfalls of episodic structure and the common-denominator principle which have plagued some other collectives. The four permanent members assumed specific responsibilities which arose from their particular skills. Farabough and Hardman shared the script writing, which tended to begin with visual ideas. The scripts, including Hardman's drawings, were then shown to Graber and Lewis for their reactions, and the four discussed the mood of the music, the masks, and props. Then Graber would compose the music, Hardman would design the masks and props, and Farabough and Lewis together would direct the movement of the performers. All four were involved in the productions, often as musicians or actors.

Snake Theater's productions were on two different scales. They created intimate performances which could tour to conventional performance spaces using a maximum of four or five performers, and they made elaborate productions with large casts for specific found spaces. Regardless of scale, the plays were set in California and presented stories of commonplace events which became extraordinary through a style that removed them from realism. The actors did not speak, instead their fragmented thoughts were on tape, or spoken by performers offstage, or projected as captions on a screen. The figures, wearing sculptural masks or mask-like make-up, moved in ways carefully developed to put specific characteristics into focus. Live music – vocal and instrumental – composed and conducted by Graber, helped imbue the events with a mood.

In the plays created for found environments, the company sometimes began with the mood that the place suggested. The site chosen for *Somewhere in the Pacific* (1978), a beach and cliffs at the Marin headlands near San Francisco, evoked in the company a feeling of yearning for something far away. They invented the story of Carole, a young woman represented by a puppet three metres tall, who stands on a distant cliff facing the ocean. Except for raising her arms, she is motionless throughout the performance as she awaits the return of her sailor boyfriend Ryan, who is with the navy somewhere in the Pacific during the Second World War. The narrative element is a letter written by Ryan to Carole which she receives after his death. The words used in the performance are from this letter.

The performance begins about an hour before sunset. As the giant Carole looks toward the horizon from her cliff, musicians dressed in army combat uniforms chant 'Chevrolet' which we learn later is from the letter. The vocal and instrumental music, based on Gregorian and Balinese chants, continues throughout the performance. General and Mrs MacArthur stroll down the beach and sit at a table listening to a radio playing sounds of the ocean, which competes with the real ocean sounds. The Sailor Ryan sits at the water's edge writing a letter. The words appear on placards which attendants place in the sand. Later, when only phrases from the letter are left on the beach, they take on other meanings. 'I shall return' is Ryan's promise to Carole and

58. *Somewhere in the Pacific*

it was General MacArthur's vow to return to the Pacific. MacArthur rises from the table and goes to the ocean. The placards spell out 'The sun is going down', and indeed it is setting. General MacArthur fires a flare pistol at the sun and it goes down.

The performance is much richer than the simple romantic story of Carole and Ryan because the repetition of carefully selected images gives multiple meanings to the narrative. At first the narrative fragments sung by the musicians have value only as musical sound, but as time passes the phrases in both aural and visual form relate to Carole and Ryan, to General Mac-Arthur, to abstract feelings of yearning, and to the actual environment in which the spectators are present. Indeed, the intermingling of actual elements in the environment with created elements contributes much to the complexity of the work. There is the actual sound of the ocean as well as the recorded ocean coming from MacArthur's radio. A real ship passes. A giant puppet looks at the ocean. The letter, revealed on placards, is as important for its visual presence as for its narrative information.

Laura Farabough says that their work had a surface of 'here and now'. They 'present the audience with a story line and then suddenly erase it, making the audience conscious of the fact that it's a real ocean out there, they are actually at the beach and there is nothing that can duplicate that experience'.[13] The use of a found environment as the setting for a perfor-

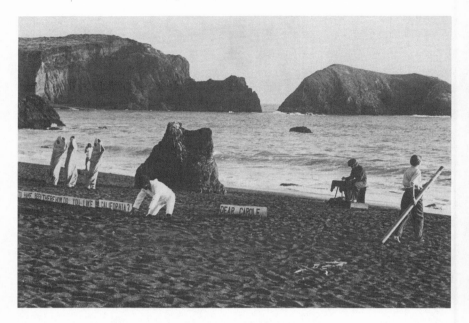

59. *Somewhere in the Pacific*

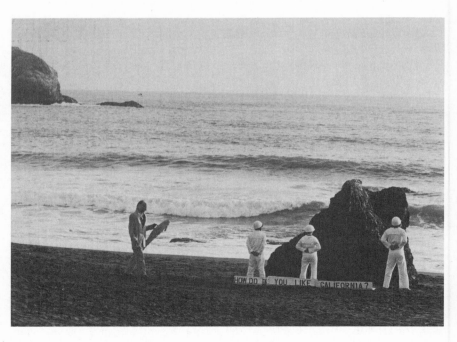

60. *Somewhere in the Pacific*

mance incorporates it into the theatrical work so that it is intended as much for perception as the created objects and events placed in it. In fact Chris Hardman says that people watched the beach perform aided by the Snake Theater.

Snake Theater continued to explore the environmental approach even when they created works which would tour to more traditional indoor venues. Hardman says that most theatre 'uses an actor/prop relationship; an actor moves through a frozen set, now and then manipulating props'. On the other hand, Snake Theater 'masked the actors so they would become props' and they 'animated the props so that they would have as much life as the actors . . . Everything became a kinetic sculpture'.

Large sculptured cacti indicated the setting of *24th Hour Cafe* (1978), which was made to be performed indoors. It was set in the Californian desert at an isolated truckstop cafe with its country-and-western music, truck drivers, and a lonely waitress. The company actually had in mind a specific cafe along a highway in California. The inceptive idea was the feeling of waiting. As in *Somewhere in the Pacific* none of the on-stage performers spoke. Their voices and thoughts as well as narration were provided by slide projections and the live voice of Laura Farabough in the pit, where she also played violin and assisted Lary Graber with the combination of live and recorded music.

The Truck Driver passes through without stopping, leaving miniature metal cut-outs of trucks behind him. The Waitress (Evelyn Lewis) has a cigarette before the arrival of customers, represented by bas-relief sculptures. She tolerates their holding her hand and their stares (indicated by strings from their eyes) as she pours coffee, represented by brown sand. She prepares plates which are cooked by the cactus men, and she serves the inanimate customers as well as the Lizard Man (Christopher Hardman), a stranger who moves on his belly. The Lizard Man flirts with the Waitress, who responds, but the Waitress's lover, the Truck Driver, enters and becomes jealous. He beats up the Waitress and knocks down the customers. The two men, wearing cactus masks, fight over the woman. Later the Truck Driver takes her among the cacti for sex as paintings of people kissing and embracing are shown. The voice of the Waitress says, 'Don't just take me, take me away.' But she is left waiting on customers at the cafe. At the end of the play she is still lonely, still hoping to be taken away, but she is only taken off for sex by the Lizard Man.

Again the narrative is not linear. It combines fragments of thoughts, fantasies, and third-person narration with verbal and visual puns all unified by the music. Images are repeated, each time with a variation providing new information or a different perspective. As in music the variations are understood associationally rather than linearly.

In *Auto* (1979) Snake Theater again combined an actual environment with fictional events. It was performed in a disused gas station. The audience sat with their backs to the main street in Sausalito, California, facing the gas

117

61. *24th Hour Cafe*

62. *24th Hour Cafe*

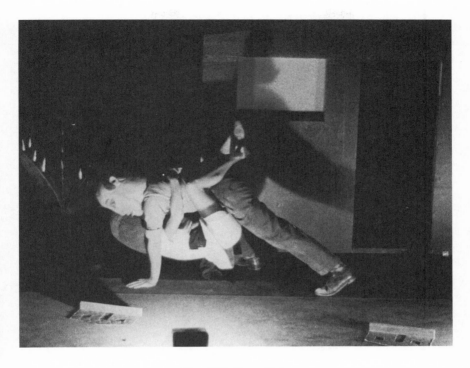

63. *24th Hour Cafe*

64. *Auto*, **photo: Ron Blanchette**

65. *Auto*, **photo: Ron Blanchette**

pumps and station building. The story concerns an engineer, his wife and daughter, who have car trouble just as they are setting out on a trip. They pull into a gas station and learn that the car has died from neglect. A funeral ceremony is held and the engineer, because of his anti-auto behaviour, becomes an enemy of the attendants who serve Auto, the power represented by the concept of automatic.

Auto uses the functions of an automatic transmission as a guide to its structure. The play is not divided into scenes but into 'gears' which advance the fragmented story of the engineer and his family. Between the 'gears' are 'shifts' which consist of passages from a manual about automatic transmissions being sung by the female voice of Auto.

The automatic transmission which conveys power from engine to wheels is a metaphor for other kinds of power transfers. There was a time when ordinary people could repair their own cars just as they could harness their horses. That was before the automatic transmission and other self-regulating automatic devices. Now even the engineer who designed it can't repair it. The power has been transferred to the attendants who serve Auto. The engineer is stuck and eventually killed. The play is not anti-automatic, but it does imply a widening gap between the abstract ideas of intellectuals and the concrete reality of the machines for which they are responsible.

The final production of Snake Theater before they became two separate companies was also their first production to tour Europe. *Ride Hard/Die Fast* (1980) is the motto of the Hell's Angels, an organization of motorcycle riders (bikers) whom the play compares with the brotherhood of medieval knights. Like the knights, the Hell's Angels are known for their violence and their independence from the rest of society; they have an identifiable dress and language. The central character is a biker who is run down by an automobile – the mortal enemy of bikers. As he lies between life and death he has

66. *Ride Hard/Die Fast*

a glimpse of 'the wings' which are an emblem of the Nazis as well as the Hell's Angels. The driver of the car is Henry Ford, the inventor of interchangeable parts which historically helped bring an end to certain kinds of individualism. Ford is contrasted with another character, Hitler, who historically saw himself as a romantic hero and thought of his Nazi movement as the last European brotherhood.

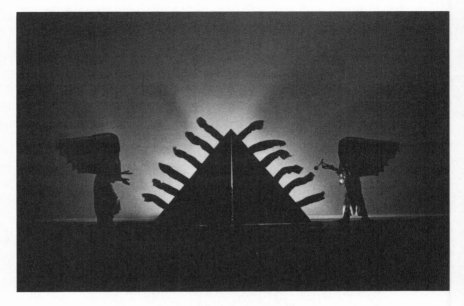

67. *Ride Hard/Die Fast*

As with other Snake Theater productions, the characters and events were abstract and associational rather than literal. Masks, movement, music, mobile props, and dynamic lighting were used to convey mood and character directly. By contrast, realistic drama tends to use language, gestures, and facial expressions to indicate the inner states of characters.

In the performances of Snake Theater the focus of the spectators tended to be on the objects, sounds, and movement themselves rather than on what they indicated or signified. It was somewhat like viewing moving sculpture and listening to music. Even the verbal content was sometimes used for its sound or visual values as much as for its value as discourse. The letter in *Somewhere in the Pacific* as it was revealed on the beach phrase-by-phrase became an important visual element. The words of the letter as sung and chanted by the musicians were of value principally for their sound.

Although there was a fragmentary plot, there was little conventional suspense. The plot did not unravel. Instead, one saw more and more details, connections between images, and formal relationships, giving the work complexity, texture, and richness. Sounds and images seen early in the play, which might have been interesting but apparently isolated and without further significance, became meaningful as the spectators were able to connect them to subsequent images, sounds, words, and movements. One of the pleasures for the spectator was making these connections.

CHAPTER 5

New Formalism

Several theatre makers of the 1970s and 1980s are formalists in that their primary concern is form or structure. It becomes the predominant content of their work. These directors are part of one tendency in contemporary art which includes the minimalist painters, makers of happenings, choreographers of post-modern dance, and certain composers of new music.

The association of these theatrical innovators with the formalist vanguard in other arts is not accidental. Each of the theatres discussed in this section is directed by a person who has a background in painting or sculpture, and in one of the companies the leadership is shared with a dancer. Robert Wilson, who began his professional life as a painter, has collaborated with post-modern dance choreographers Lucinda Childs and Andrew de Groat and with composer Philip Glass. The directors of Hellmuth–Reynolds – dancer Suzanne Hellmuth and sculptor Jock Reynolds – have used the music of Steve Reich in their performances. Alan Finneran of Soon 3 worked as both a painter and a sculptor before he began making theatrical productions. And Michael Kirby, the director of the Structuralist Workshop, made some of the early happenings and continues to work as a sculptor.

Typically, vanguard artists have rejected major traditional techniques and materials in order to free their explorations from the limitations of tradition. In 1913 painter Marcel Duchamp rejected the techniques and materials of painting when he attached a bicycle wheel to the top of a wooden stool. The minimalist painters of the 1960s eliminated most painting techniques and all content except the form created by shapes of colour and their compositional relationships. In music Arnold Schönberg dispensed with the traditional diatonic scale and created twelve-tone serial music. John Cage composed

music by chance operations thereby avoiding traditional music structures. He experimented with sounds produced by means other than musical instruments, such as the sound of opening and closing a piano keyboard cover. Allan Kaprow, first known as a painter, began making happenings at the end of the 1950s. As with assemblages and environments he considered happenings to be an extension of painting. Any material could be used in happenings except that derived from the arts, and he avoided traditional art techniques and trained artists so as to dissolve the barriers between art and life. Happenings lacked the permanence of traditional visual arts, so they could not be valued as objects or commodities. As a consequence their significance was in perception rather than in the object. Traditional artists embodied in their work specific conceptions which were intended to be conveyed to a spectator. Happenings, on the other hand, were open to a variety of perceptions by various spectators.

As with happenings, minimalist painting, and post-modern dance, the theatre directors included here are predominantly concerned with matters of form and perception. Kaprow's comments on 'formal art' in his book on *Assemblage, Environments & Happenings* apply equally to these theatres.[1] Such art, he says, is primarily intellectual manipulation whereby elements of the work are moved according to strict regulations. Care is taken in choosing the elements so that they do not have such powerful overtones that they take the focus from the form and its manipulation. The impact of the imagery must not be as important as the moves the imagery is put through.

As in happenings and post-modern dances, real-life movements, sounds, objects, and events may be used as material elements in new formalist theatre. When incorporated, however, they are transformed by the context. Following the principle for found art in general, these elements are separated from their real-world efficacy and have value only for perception. It is the same principle by which the environments of Snake Theater's outdoor productions become assimilated into their respective works.

An important difference between happenings and formalist theatre lies in the degree of control exercised by the director and in the circumstances of production. While 'happeners' such as Kaprow prepared scenarios which were discussed with the participants, there were no rehearsals and the performances were not repeated. Had they been presented more than once, each performance would have been quite different in its details. Kaprow also advocated that the happening should take place over several widely-spaced locales because a single performance space would resemble conventional theatre practice. By way of further disassociating with theatrical convention, he proposed that time be discontinuous and that the audience be eliminated entirely. By contrast, the theatre directors of formalist work plan the work in detail and rehearse it until it is precise. A performance continues without a break in time except, perhaps, for an interval. The work is most often presented in a theatre space and always with an audience. There is no limit on the number of performances of a single production.

At the outset all of these theatrical formalists tended to use performers who had not trained as actors. In so doing they paralleled the practice of post-modern dance choreographers who avoided using trained dancers. The choreographers and the theatre directors wanted performers who would move and speak as themselves rather than according to a predetermined style or technique. This applied whether they were required to perform everyday movements or special tasks. The emphasis is on the organization and structure of movement rather than a particular style, virtuosity, or expressiveness. Furthermore, using techniques developed for a traditional style would tend to impose that style on the new work. In genuinely experimental work, it may not be known in advance what skills and techniques will be required. It is better to use performers devoid of technique than to impose an established technique which might limit the exploration. Only after the artists begin to clarify for themselves the unique focus of their work are they inclined to introduce established techniques and use them toward the new purpose.

Robert Wilson

The work of Robert Wilson reflects his training as a painter and architect. His architectonic sketches tend to be the initial concepts for a production. Although he is primarily concerned with visual composition, he is also interested in movement and sound for their structural values. His performance ideas have been further enriched by his work with brain-damaged children, which has led to an interest in creating productions which are perceived in a state of reduced consciousness.

Some of his productions are on a grand operatic scale and resemble large surreal paintings with moving figures and objects. Other work, on a small scale, typically involves only two performers – Wilson and another, sometimes dancer Lucinda Childs. Regardless of scale, his collage-like works incorporate invented material as well as material from the real world. Verbal passages, movement, character ideas, and visual images are transformed into elements that are separate from the spectator's world and without reference to it. The aural and visual images are made to serve the complex formal composition of the production.

In 1969 Wilson formed the Byrd Hoffman School of Byrds to work with people of all backgrounds and capabilities and provide opportunities for them to interact and develop their individual potentials. Although he later used professional performers, in the early productions handicapped people worked on an equal basis with other untrained people he knew or found on the street. He uses physical activity to sensitize the body and thereby expand consciousness.

The performers in *The King of Spain* (1969) were from awareness classes he was conducting which were intended to make the participants more comfortable with their bodies. In the performance Wilson directed the partici-

pants to be themselves, to perform the various activities as they themselves would perform them. Wilson has commented that seemingly irrelevant activities, performed in this way, become perceptually important. The activities are intended to be perceived for their own sake rather than serving as clues to inner psychological states.

The productions became longer and longer. *The King of Spain* was incorporated as the second act of *The Life and Times of Sigmund Freud* (1970) which eventually became the first three acts of *Deafman Glance* (1970). In their combined form the performance lasted as long as eight hours. Then Wilson created a prologue for *Deafman Glance* which added another three hours. *The Life and Times of Joseph Stalin* (1973), incorporating all or part of five previous productions, was twelve hours long. The longest production by Wilson was *Overture to Ka Mountain* (1972), created for the Shiraz Festival in Iran. The performance lasted seven days and nights.

One of the reasons his performances are so long is that the events take place in extreme slow motion. At the beginning of *Deafman Glance* there is a tableau of a deaf adolescent black boy, his mother, and two little children (a boy and a girl) who lie on the floor. Nothing moves for half an hour, then very very slowly the mother pours a glass of milk for the little boy, he drinks it, she puts him to bed, slowly and tenderly stabs him, and tucks him under the sheet. Carefully she wipes the knife and repeats the action with the little girl. All the while the older boy watches, unable to move or speak. The action of this first scene takes about one hour.

Slow motion over such an extended period alters drastically the way we perceive the performance. It tends to carry one beyond boredom, beyond the point of being irritated by the slowness, and one tends to adapt by slipping into a mental state that is less acutely conscious than normal. (One of the ingredients of boredom – a feeling of being trapped – is absent because spectators are told they should feel free to go in and out of the auditorium as they wish.) This state of reduced consciousness makes possible the intended mode of perception.

Wilson believes that everyone sees and hears on two different levels. We experience sensations of the world around us on what he calls an 'exterior screen'. But we also become aware of things on an 'interior screen' – dreams and daydreams for instance. Blind people only 'see' things on an interior visual screen and deaf people can only 'hear' sounds on an interior audial screen. Wilson found that in his long performances the spectator's interior-exterior audial–visual screens become one. Interior and exterior images mingle so that they are indistinguishable. Wilson says that people sometimes 'see' things on stage that are not actually there.[2]

The development of this concept resulted from his work with two adolescent boys – Raymond Andrews, the deaf mute who played the title role in *Deafman Glance,* and Christopher Knowles, the autistic fourteen-year-old who became Wilson's collaborator on several productions. Both boys were partially cut off from the exterior world – Andrews as a result of being

126

unable to hear or speak, and Knowles because of brain damage which caused him to be absorbed in fantasy. They were 'less conscious' than other people, more closed off from the objective world, more absorbed with inner images than with external reality. They were in a kind of trance. Both of them, Wilson came to realize, had highly developed interior screens. He became interested in discovering how they structured their perceptions in order to understand what their worlds were like. Then, with their help, Wilson created productions that attempted to deal with reality in similar ways.

Wilson and the other members of the workshop imitated Andrews's sounds and movements in order to discover the way the eleven-year-old thought and communicated. They believed that his way of perceiving the world was as valid as theirs and they wanted to understand it. In the course of workshops for *Deafman Glance* they discovered that repetition of simple movements was a means of tuning to interior screens, a practice used by people in other cultures to enter a trance.

Christopher Knowles, when he began working with Wilson, used words but he did not use them for the usual aim of discourse. Instead, he seemed to be using words as sounds, as music, and sometimes for the visual patterns they would form then typed on paper. Knowles led workshops in which the group imitated his sounds, and his work formed the basis for the use of language in *A Letter for Queen Victoria* (1974). He also was responsible for some of the language used in the five-hour opera *Einstein on the Beach* (1976).

Einstein on the Beach was created by Wilson in collaboration with composer Philip Glass and choreographers Andrew de Groat and Lucinda Childs, who design geometric patterns in controlled space. The production incorporates techniques of repetition, extreme slow motion as well as fast repetitive dance movements, and non-discursive use of language. As in Wilson's other works there is no traditional dramatic narrative, but a visual and aural stream of images. The opera has a mathematical structure of nine scenes. There are three dominant visual images, each appearing in every third scene so that each is used three times. The images are (1) a train and a building, (2) a courtroom and a bed, (3) a field with a spaceship. Each act is preceded and followed by a musical 'Knee Play' (that is, a joint) which serves as prelude, interlude, or postlude.

Most of the performers are dressed like Einstein in shirt, baggy pants, and suspenders. The solo violinist, made-up like the elderly Einstein, looks on from his detached position in the orchestra pit. In the first scene a ten-year-old boy, suggesting Einstein as a child, looks down from a bridge as a nineteenth-century steam locomotive moves onto the stage so slowly that its movement is imperceptible. The slow-moving train is accompanied by the fast movement of several performers who repeat the same gestures and steps for the entire thirty-minute scene. Lucinda Childs skip-steps forward and backward on three diagonals while the gestures of another performer

68. *Einstein on the Beach*

suggest the writing of mathematical equations. When the train appears again (scene 4) it is the last car of a night train slowly moving on a diagonal away from the audience. In its third appearance (scene 7) it has been transformed into a brick building which echoes the lines and perspective of the train.

In the courtroom scenes (2, 5, and 8) a large clock without hands is eclipsed by a black disc moving imperceptibly slowly. In the first courtroom scene a platform in the foreground is the abstracted form of a bed. When the courtroom appears again half of the stage is transformed into a prison.

Inside the play's structure of recurring dominant images is a loose association of images about the life and times of Einstein and after. The train image of the first scene suggests the age of steam when Einstein was a boy dreaming of aeroplanes. In the last scene – the interior of a space ship with lights flashing in complex patterns – we have reached the nuclear age of space travel exemplifying the theories of Einstein. In between are trials and prison. Everything is unified and dominated by the architectural grandeur of the settings and the precise, repetitious, carefully constructed music of Philip Glass.

Philip Glass wrote the music for *Einstein on the Beach* responding directly to a series of Wilson's drawings. (These architectonic sketches were Wilson's inceptive idea for the opera and eventually they were the basis for the set designs.) The music, which is sung or played continuously throughout

69. *Einstein on the Beach*

70. *Einstein on the Beach*

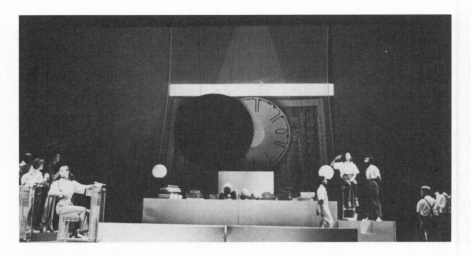

71. *Einstein on the Beach*

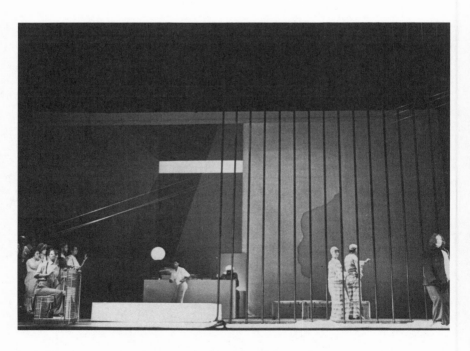

72. *Einstein on the Beach*

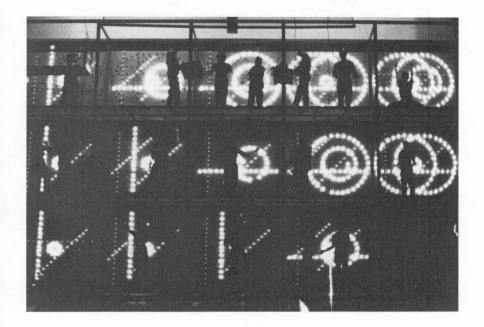

73. *Einstein on the Beach*

the performance, is as precisely constructed as the visual elements. For each of the recurring visual themes there is a musical theme. Sometimes the music is performed by an amplified ensemble of keyboards, winds, and violin; at other times amplified singers perform alone; and sometimes the ensemble and singers perform at once. The only words sung are the numbers one through eight and the sol-fa syllables – do, re, mi, and so forth. Not only are the numbers appropriate to the theme of Einstein, they represent the rhythmic structure (it is the way beats are counted). The sol-fa syllables represent the pitch structure (normally they are used to sing the scale). So, the text is descriptive of the music itself.

The usual predominance in Western music of melody and harmony over rhythm is reversed in the music of Glass. It is one of the means of making the structure audible. But there are other techniques which serve to keep structure and process in focus. He uses cyclic structures and an additive process. A musical phrase is repeated over and over, then it is changed slightly and repeated over and over again, and so forth. One is able to perceive the process. The form, created from structure and process, is the dominant content of the music as well as the opera as a whole.

The spoken passages, like the music, are used for their aural rather than their discursive value. Some of them by Christopher Knowles are disjointed and make use of recurring phrases. Others are non-dramatic, often banal conversational passages created by the performers through improvisation

131

74. *I Was Sitting on My Patio*

and writing. In the performance they are repeated over and over with identical inflection so that they lose their initial meanings and, like the musical phrases, become structured sound.

The play incorporates Wilson's free mental associations about the fourth dimension relating time and space as well as the technological world inspired by Einstein. But the play is also self-reflexive. It is this same technology which made the physical production of the play impossible with its complicated and expensive electronics and musical amplification systems designed and built specifically for this production. At the core of the work is a mathematical structure. Not only do the dominant images recur on a mathematical schedule, but the choreography of Andrew de Groat and especially the music of Philip Glass are precisely constructed on numerical systems. Glass says that the singers do everything by numbers, sometimes counting two or three things at once – the numbers they are singing, the measures, and the speed of a movement such as bringing a finger to the upper lip on a count of thirty-two.

Einstein on the Beach is the most elaborate production by Wilson to date. It cost approximately one million dollars to tour the opera houses of Europe

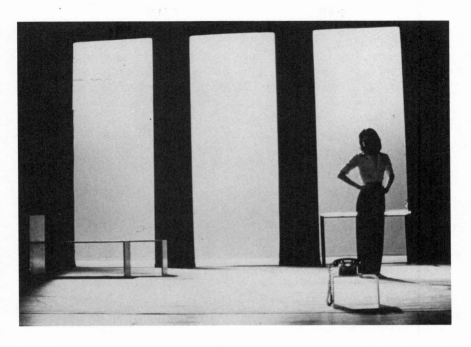

75. *I Was Sitting on My Patio*

before its two final performances at the Metropolitan Opera House in New York. By contrast his production the following year was comparatively simple and uncomplicated, although it used some of the same technology and had the same formalist approach. Robert Wilson and Lucinda Childs were the only performers in *I Was Sitting on My Patio/This Guy Appeared I Thought/I Was Hallucinating* (1977).[3]

The play consists of two identical forty-minute monologues made up of more than one hundred story fragments. The title is one of these fragments. Wilson, alone on stage, gives the first monologue and then Childs, also alone, speaks the second monologue which contains the same fragments. They speak in a quiet conversational tone and are amplified by wireless microphones worn by the performers. It is as if we were hearing their minds directly, their jumbled thinking, flitting from one banality to another in an a-logical stream-of-consciousness manner. Wilson says that the language was written more as 'a reflection of the way we think than of the way we normally speak'. He compares it to flipping from channel to channel on a television set. Sometimes when he writes he has a television playing at low volume and incorporates phrases that he hears.[4]

The setting is a simple architectural design – three large windows which become three large bookcases, a bench-like metal bed, a glass shelf with a wine glass, and a telephone on a small table. As a performer speaks he or she moves naturally around the stage. But the movement does not relate to what

is being said, it is abstract motion in space, sometimes deliberately contradicting what is implied by the words.

In her unpublished notes, Lucinda Childs says her work on the production involved the same kind of exploration as her earlier post-modern dance explorations as a member of the Judson Dance Theatre. The Judson work expanded the vocabulary of dance so as to include movement from everyday life. Also, instead of putting images, words, and action together so as to make sense, they isolated them and pulled them apart, playing one element against another. She says it is the spectator's job 'to make sense out of what he sees and to decide if it's chaos or order, formed or formless, or if that matters'.

Although the phrases and movement have the natural quality of everyday banalities, they are distanced by the microphone and by the fact that words and movement are disassociated. Each performer has decided on his or her own movements. So, there are interesting echoes and contrasts between the concrete image of Childs in front of us and the remembered image of what Wilson did on a particular phrase.

In *I Was Sitting on My Patio* Wilson has found another means of creating harmony and opposition between our interior and exterior screens, between memory and that being perceived at the moment. As in all of his other work, he is interested not only in form but in exploring the ways people perceive and how perception can be altered.

Suzanne Hellmuth and Jock Reynolds

The theatre work created by dancer Suzanne Hellmuth and sculptor Jock Reynolds uses images which derive from their observations in the real world. These images are used as formal elements in a moving composition. Like the other theatrical formalists, their work keeps the spectator's focus on the surface, on a form both visual and aural, not on what may be implied or on an underlying psychology. They carefully avoid overt sociological or political meaning. Because they do not create a fictional time–place context and there are no characters, even though there are performers, there is no plot suspense to focus the audience on an evolving future. Instead the spectator relates to the form.

As with the work of Wilson, one tends to respond to the productions of Hellmuth–Reynolds from a state of reduced consciousness. This results from some of the same techniques used by Wilson – repetitive movements, slow motion, and the extensive use of new music, especially the additive process music of Steve Reich. Also like Wilson's, their work is predominantly visual – in fact, in their large-scale productions they use no words at all. The way in which they develop a production, however, is very different.

Hellmuth and Reynolds base their productions on personal observations, experiences, and research undertaken in specific places in San Francisco where they live. This has been the approach of Reynolds since the early

1970s when he created sculptures using material and live animals from the Californian farm where he then lived. While on the farm he began raising and slaughtering animals for food, and he did a performance with the heads of two pigs he had raised and butchered.

This practice of extracting performances from his current experience continued when he began working with Suzanne Hellmuth, whose background had been in dance. Reynolds's mother was dying of cancer during this period and before her death in 1974 he had spent much time visiting her in the hospital. Suzanne Hellmuth had also had experiences with hospitals – her brother died after being hit by a drunken driver and she had been hospitalized for illnesses of her own. Having decided to make a production on the subject they began practical research. A hospital in San Francisco permitted them to observe most activities and they talked with patients and employees. *Hospital* (1977), their first major work together, combined the theatrical sculpture focus of Reynolds with the dance interests of Hellmuth.

The work is without narrative. Instead it is made up of sounds, images, props, and tasks abstracted from those Hellmuth and Reynolds had discovered during their hospital research. These elements were scored much as if they were different musical instruments and notes in a musical composition. While the audience recognizes many of the tasks as the usual hospital activities of doctors, nurses, patients, and janitors, they are not performed in a realistic fashion. Instead they are abstracted, becoming dance-like exaggerations, repetitions, or slowed action, accompanied by the sounds of squeaking shoes, whistling tea kettles, bells, plates on meal-trays, and the music of Steve Reich.

Hospital was presented in San Francisco at the Magic Theatre in an area of about 650 square metres. Seating was constructed along one wall. The remaining space, used for the performance, is divided into five planes, each extending thirty metres from the audience's extreme left to extreme right. Often there is simultaneous movement in several of these. In the plane closest to the audience a row of three hospital rooms is indicated by rectangles on the floor. Behind the rooms is a hallway, then a movable curtain, a large corridor, a metal cyclone fence, and another hallway and wall with five doors.

For the 'Solarium' scene the curtain is closed and the only movement consists of shadows of hospital images – a nurse (Suzanne Hellmuth) carrying pillows, a patient in a wheelchair. In the 'Slow Walk' scene several actions are performed simultaneously at different tempos. A nurse in the near hallway walks in slow motion. In the large corridor three janitors collect buckets, and two nurses walk very slowly, gently pitching and yawing like a sailboat. In the distant hallway two nurses walk in slow motion switching on the overhead lights. Two doctors with two-metre-long satchels slowly walk through the hallways. A man and two children walk in normal tempo to visit a woman patient; when they arrive they sit and talk quietly.

In another scene, a nurse in each of the hospital rooms spins like a whirling

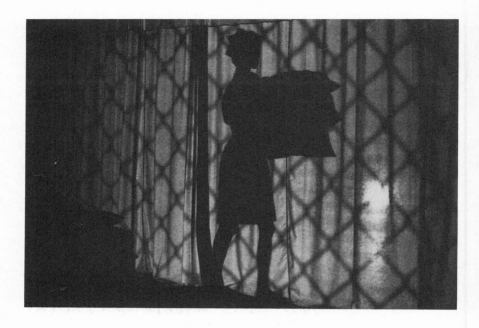

76. *Hospital*, photo: Bill Hellmuth

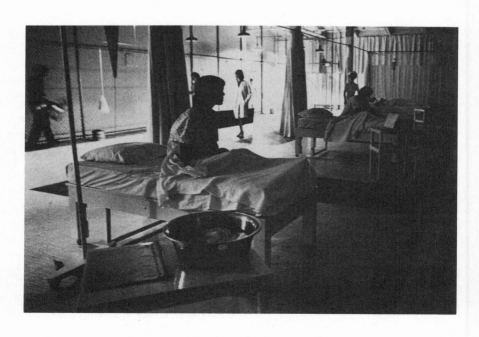

77. *Hospital*, photo: Jock Reynolds

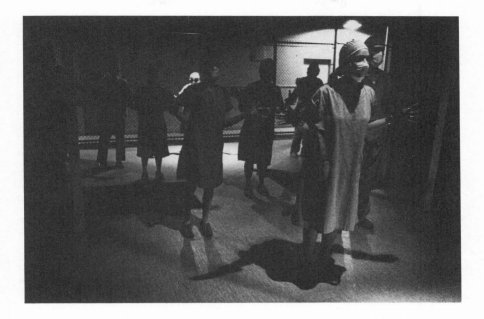

78. *Hospital,* **photo: Bill Hellmuth**

dervish as other nurses pass in the hallway. In the 'Surgeons' Dance' thirteen performers appear by ones, twos, and small groups until all are in place. Their dance consists of a choreographed series of gestures using only their eyes and hands.

'Accumulation/Treatment' uses the entire space. Two janitors in the distant hallway place large red keys on the far wall and set them swinging as nurses perform waiting movements – shifting weight, putting hands in and out of pockets. Patients lie on the floor on bed-sized rectangles and a nurse places a calibrated white stick across the body of each. At the nurses' station two nurses pivot in slow motion as they move soundless bells. A nurse walks through the corridor pushing giant white wheels. At the very end a hospital technician (Jock Reynolds) wheels a rack of laboratory animals through the corridor.

Unlike those theatres advocating social change that might study a hospital in order to present a socio-political analysis, for Hellmuth and Reynolds *Hospital* was a means of making their hospital experience more objective by focusing on the perceptual aspects of their experience – the visual and aural aspects – rather than on their subjective reaction of repugnance and loss.

In preparation for *Navigation* (1979) Hellmuth and Reynolds explored two different locales – San Francisco Bay with its ships and other nautical elements, and the large well-equipped theatre where the production was to be presented. Observing the Bay they were greatly affected by the gigantic scale of the bands of land, water, and sky, by the awesomeness of large ships

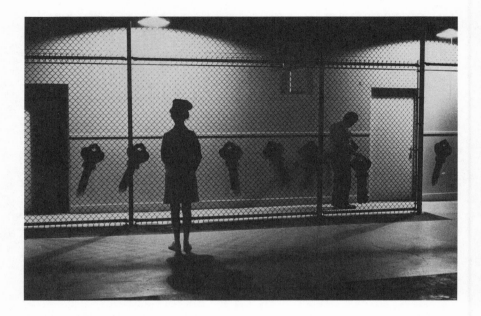

79. *Hospital,* **photo: Bill Hellmuth**

passing silently or rocking at anchor, by the changes in light as the day passes, by the sense of balancing on a rolling deck, and by the quietness, and the sounds. As they worked in the theatre building they were struck by its monumental scale, its austere functionality, the activities of technicians and maintenance workers. They became aware of the similarities between theatres and ships, especially the beauty of functional structure. The relationship was reinforced as they looked through photo archives of ships, seeing sailors dwarfed by the rigging and sails with which they worked.

The performance of *Navigation* uses the mechanisms of the theatre in the same undisguised manner as those of a ship. The rigging, the flats, workshop doors, paint racks, the unpainted concrete walls, are all used as visual elements. The mechanism of the theatre is activated by the crew and used by the performers in an analogous way to crews and passengers aboard ships.

The slow motion of the performance suggests the rhythm of ships at sea responding to the waves, wind, and currents. Bands of flats, stretching across the entire twenty-metre stage, raise and lower and swing slowly from side to side like the horizon line seen from the prow of a ship. All of the images are abstract rather than literal. Performers coil ropes which they pull from holes in the floor, and they sway as if to maintain balance. A large door opens at the rear of the stage and the image seen there suggests a sailboat passing in the distance. There are other nautical suggestions – large grids like nets, a wall which sways from side to side, and sailors with signalling devices.

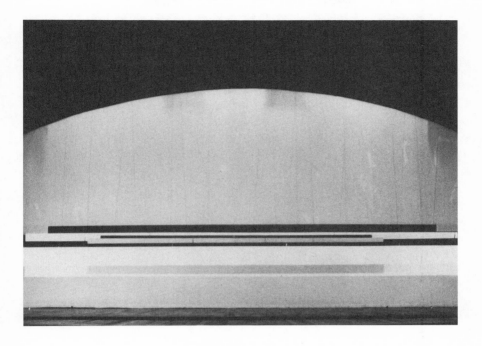

80. *Navigation*

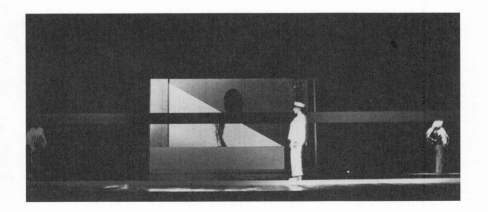

81. *Navigation*

Although the objects and movement on stage suggest ships, water, and sky, there is no realistic illusion. With the help of the music of David Behrman's 'On the Other Ocean' with its electronic synthesizer, flute, and oboe, the spectators are made to focus on the formal aspects of the work. As

139

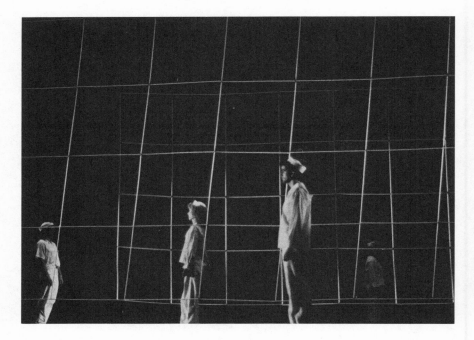

82. *Navigation*

in *Hospital* Suzanne Hellmuth and Jock Reynolds have transformed their experience of an environment into perceptible form.

Alan Finneran
Soon 3

The 'performance landscapes' of Alan Finneran began as extensions of the mobile painting and sculpture with which he was experimenting in the mid-1960s. The performances project a technological landscape of manufactured and precisely-constructed abstract objects which serves as an environment for the tasks of performers. Although they do not present a coherent illusion of a fictional world, in the most recent work the spectator's perception of the objects and performed tasks is 'coloured' by music, lighting, film and slide projections, repetition, language with the economy of poetry, and a fragmentary narrative.

Finneran first added performers to his kinetic sculptures in 1967. In 1972, when he moved from Boston to San Francisco and formed Soon 3, he began construction of a 'theatre machine' consisting of elaborate moving sculptures with rotating projection screens on which films and slides were projected. When *The Desire Circus* (1975) was presented at the San Francisco Museum of Modern Art it incorporated twelve performers who were little more than compositional elements.

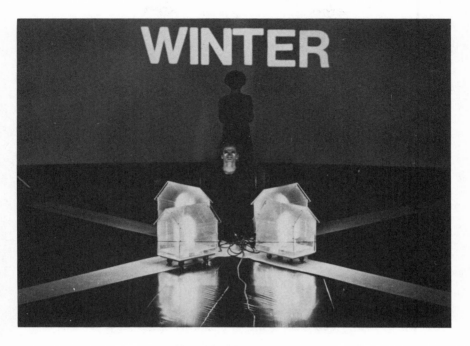

83. *Black Water Echo*

Beginning in 1977 with the first 'task activated landscape', the visual effects were achieved without the 'theatre machine' but continued the use of projections and the hard-edge manufactured look. The landscape of *Black Water Echo* is defined by a square of black plastic. Neatly arranged at the sides of the square are all of the objects to be used in the performance – doughnut-shaped fluorescent lights, small plexiglass houses with removable roofs, plastic tubes. These objects are manipulated by a Man and a Woman who carry out their tasks without enacting characters or emotions. The manipulations create a new element. The environment is given a past and a future. At the beginning of the performance the landscape is pristine, but by the end it is cluttered with debris comprising a history of the tasks performed there. The objects and projections are not merely an environment, they are as important as the non-speaking Man and Woman. There is a symbiotic relationship between the two elements. Changes made in the landscape by the performers cause changes in the actions of the performers.

In Finneran's works there is no pre-existing concept from which the performance grows, no idea to be investigated or illustrated. Instead, like an abstract painter, he makes intuitive decisions about the objects, colours, performers, tasks, and other elements which will comprise the production. This intuitive approach is more like that of Robert Wilson than that of Hellmuth–Reynolds, which begins with observation and research.

His next production, *A Wall in Venice/3 Women/Wet Shadows* (1978),

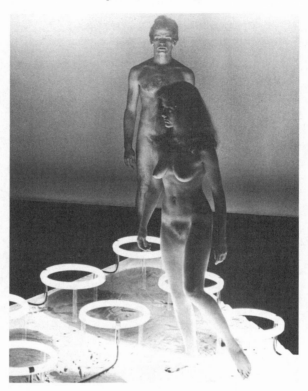

84. *Black Water Echo*, **photo: Alan Finneran**

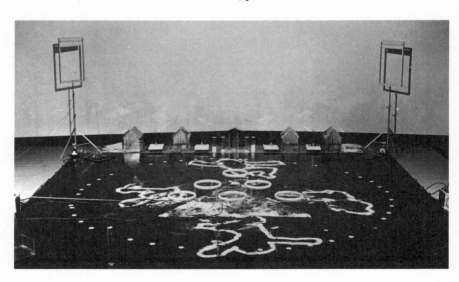

85. *Black Water Echo*

hints at a fictional illusion. For the first time the figures are named, the apparent place of the action is identified, and there is a fragmentary recorded narrative. These new elements, however, are no more important than the others. They are used more as a means of 'colouring' the events than of causing the spectators to acknowledge a fictional world.

At the beginning a recorded voice presents an open narrative intentionally incomplete. It begins,

> That evening I was rowing close to shore when I saw her.
> She was swimming alone in the cold water.
> She came close to my boat.
> She pretended not to notice me.
> . . .

We also learn that each of the three women is named Scarlet and that two of them live in a blue house on the canal. But there is no relationship between the narrative and the tasks of the performers unless the spectator contrives one. A red dress casts a shadow on the floor. One of the women in red (Candace Loheed) stands white dowels on end outlining the shadow, and another woman (Bean Finneran) also in red pulls a red pyramid on wheels through the dowels knocking them down.

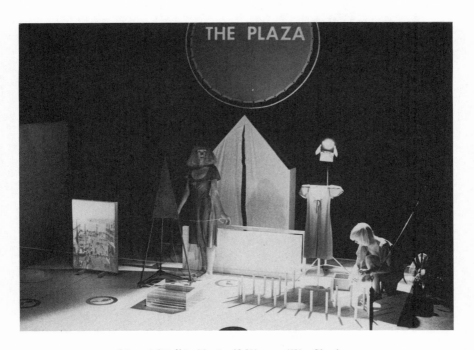

86. *A Wall in Venice/3 Women/Wet Shadows*

87. *A Wall in Venice*

The spectators are made to focus on the actual objects and tasks in the present moment rather than being seduced into a psychic involvement with fictional time, place, and characters. They relate to the work of Soon 3 much as they would to sculpture in a gallery – aware of the illusion created but seeing it as an object in the present. This way of relating to the work is enhanced by showing the means used to create the illusion. In one segment of *A Wall in Venice* a woman places a tiny white house on the floor. On a larger house-shaped screen behind the tiny house a photographic seascape is projected, and the sounds of seagulls and water are heard. She places small potted palm

88. *A Wall in Venice*

trees beside the tiny house and turns on an electric fan which makes them sway as if the wind were blowing. She sets up a movie projector which projects on the front of the tiny house a film of the second woman so that she appears to be standing in front of her house. A slide of the second woman is projected life-size on the front of the larger house, and the live second woman cuts a slit in it from behind and 'materializes'. She then goes to the tiny house and sets it on fire. Throughout the segment we are able to observe both the illusion and the means by which it is being created.

Tropical Proxy (1979) incorporates snatches of live dialogue, but these do not serve any of the usual purposes. Here the dialogue is not used to reveal character relationships, psychological states, or plot exposition. Instead, as with Finneran's use of music, it affects our perception of the visual events and, like his narrative fragments, serves to pique our curiosity.

B: Remember the last time this happened?
N: Yeah, I remember – nothing happened.

A projected sign says, 'mombasa kenya 1970'. Four white women sit on high stools facing the audience, each with a live black rabbit on her lap. Again there are several references to water. A clear plastic tank of water is prominent throughout, sometimes a sailboat floats on it, and there is a narrative fragment about a fire at sea. Again there are tasks which alter the stage environment. A concrete-block house is erected on one side of the stage, a room is painted blue on the other. Miniature buildings are set up near the tank of water and a tiny seaport takes shape.

The next Soon 3 work, *The Man in the Nile at Night* (1980), does not use dialogue, but the foreign woman's voice on tape is interrogating someone who apparently replies with gestures.

Was it at night?
Was it?
Were you in the water with him?
. . .
Which stocking did you take off first?
Please take that one off now.
Thank you. Now please drop the stocking onto the floor.

There is a mystery. The two live performers open suitcases, change clothes, and put on black wigs. A projection says, 'Cairo 1953'. One of the women removes a blue stocking from a room by tying a string to it and pulling it through a yellow door. A rod is pushed through a hole in a miniature yellow door and it 'bleeds' blue dye into a plexiglass tank of water. Several times projections of a man appear. Finally the two women burn the screen on which his image is projected. Actions on stage echo in an abstract way verbal descriptions, but the fragments of the story intentionally do not add up to a coherent whole. The work creates a strong focus not only because of the dynamic, animated, visible and audible compositions, but because it is so intriguing and mysterious that the spectator is seduced into projecting subjective interpretations upon the events. The results are rich, both perceptually and conceptually.

The Man in the Nile at Night and *A Wall in Venice* toured Italy in 1980. In the following year a new work was created during a three-months' residency at Theater am Turm, the experimental theatre centre in Frankfurt-am-Main. *Renaissance Radar* is described as a 'performance landscape' and uses some elements similar to those of other productions – mobile sculptural objects, three women who are sometimes in red, film and slide projections, pre-recorded narrative fragments, and music. However, the production is different from Finneran's previous performance landscapes in several ways. Because the scale of *Renaissance Radar* is much larger than other recent

89. *Tropical Proxy*, **photo: Ron Blanchette**

90. *The Man in the Nile at Night*

work, it suggests his productions of the mid-1970s which used the 'theatre machine'. The most elaborate mechanical device is a giant remote-controlled projection screen in the shape of a head on which is projected a sound film close-up of one of the performers speaking.

For the first time in Finneran's work, two places rather than one are indicated by projected captions alternating between 'Roma 1474' and 'California 1980'. However, as in previous Soon 3 productions, an indicated place serves only to colour the events that occur, it does not become an illusory setting for action. The action consists of tasks in the present on a manufactured landscape.

Renaissance Radar was the first Soon 3 production to use music composed especially for it. Working closely with Finneran, composer Bob Davis created a continuous score which functions somewhat like a motion picture sound-track. Using conventional instruments, synthesizer, and concrete sounds combined and electronically altered, this pre-recorded score suggests both the renaissance and San Francisco New Wave.

Another innovation is the conscious use of what Finneran refers to as a 'compositional theme' – the 'idea of murder and violence as product, especially the illusionary product of the California movie industry'. Three women – a Victim, a Killer, and an Accomplice – perform three murders accomplished with the use of modern technology. In the first murder the nude Victim is wired with twelve explosive devices such as those used in motion pictures to create the illusion of a person being shot. In the second, an imaginary device constructed of plexiglass, hoses and knives are used to stab projected images of the Victim. Finally, the Victim is enclosed in a plexiglass tank which is then filled with water while she breathes with the aid of an aqua-lung. These murders serve as the chief structural element of the production, but they do not comprise a conventional plot. They are experienced more as demonstrations by performers who do not seem to enact characters or emotions. Finneran suggests that the murders can also be seen as technical demonstrations of tricks used in Hollywood movies to create the illusion of violence. As in other Soon 3 productions the means used to create illusion are considered as important as the illusion itself, and the spectator is intended to be aware of both.

Alan Finneran is highly skilled in combining sound and visual elements in such a way that they lose their neutrality and are transformed into an environment charged with expectation. It is not the suspense of fiction, as the spectator focuses on the present time and place, but when a task is initiated there is a kind of suspense until it is completed. There is a matrix – a physical space and pattern of movement which, like any formal structure whether a sonnet or a building under construction, is in suspense until completed. There is also interest in the narrative and dialogue fragments which, like a puzzle, we may attempt to fit together with the other parts. But the narrative does not provide the cause-and-effect unity of fictional dramatic action. Instead, the work is unified by the cause-and-effect relationship of the tasks

which are mutated by the changes such tasks make in the actual stage space; and the shapes, colours, and recognizable objects are related through repetition, counterpoint, transformation, and visual echoes.

Michael Kirby
The Structuralist Workshop

In conventional realistic theatre the artists attempt to hide structure. If the audience becomes conscious of the structural mechanism, it will detract from the apparent life passing before them. Structure in such works is a means of creating suspense which keeps the audience absorbed in the fictional world. Technique hides technique. In the structuralist works of Michael Kirby, however, the end *is* structure and how it is perceived.

In his 'Manifesto of Structuralism' (1975) and in a subsequent article on structural analysis and theory (1976)[5] Kirby outlines the tenets of his theatre. He uses 'structure' to refer to 'the way the parts of a work relate to each other, how they "fit together" in the mind to form a particular configuration'. He is concerned with formal (rather than semantic) structures. While the structural principles of painting and sculpture can be applied to performance, in performance there is also the dimension of time which, according to Kirby, can be seen as 'a sequence of present moments, each of which moves away to become part of the past'. It is expectancy and memory that provide the structural relationship between these moments. While it is typical for structure to dominate in music and dance when words and mimetic action are not used, in theatre performances which use a semantic element, meaning tends to take over. Kirby's objective is to use words, real objects, and fragments of realistic scenes to create performances in which structure dominates.

'Structuralism is primarily mental or intellectual,' says Kirby. 'The mind works as it attempts to understand arrangements and interrelationships.'[6] The spectator may consciously recognize structure in Kirby's plays, may have a heightened awareness of its presence, or may merely be aware of reflections, echoes, premonitions, answers, frustrations, or fulfilments. Whether working as a sculptor, a maker of happenings, or a playwright and theatre director, Michael Kirby consistently creates works in which structure dominates. A typical sculpture consists of photographs taken from various perspectives according to a precise system and then mounted in a geometrical configuration reflecting the system.

In a 1966 happening, *Room 706*, he used acting for the first time as distinct from tasks assigned to participants. Principally the work consisted of an impromptu discussion of plans for the performance. The discussion was presented three times: (1) on audio tape, (2) on film, and (3) in a live performance using a script transcribed from the tape recording. The concept of three was echoed in the physical arrangements for the performance, an equilateral triangle with the audience seated on three sides. At each corner of the triangle was a table with a tape recorder, and in the centre three rectangular

tables were arranged to form a triangle. First the tape recording of the discussion is heard with one voice coming from each corner. Then the film is projected from the centre tables to a screen at each corner. Later the same scene is acted live by the three men in the original discussion.

In his plays, the principle means used to put structure into the foreground is a systematized repetition of related movements, speeches, sounds, objects, and images presented verbally or visually. There is always the hint of a narrative which creates a mystery, but the story is never complete. For *Revolutionary Dance* he wrote seven short scenes consisting of basic movements and speeches by people who seem to be involved in civil war activities in an unnamed country. The scenes were then put together in a certain order, but they could have gone in any order. It was the structural repetitions that were important. In *Eight People* there were twenty-five short scenes suggesting a story of love and espionage. There were echoes of dialogue phrases; recurring gestures such as ripping up a letter, tearing open a box of cookies, tearing up a manuscript; repetition of spacial and movement patterns – in three scenes a woman stands in the centre of a triangle formed by three other people and turns to each one as they speak. There were reappearing objects such as umbrellas, rakes, tape recorders and suitcases. Sounds were repeated such as raking leaves, and in every third scene there was the sound of a telephone being dialled and ringing.

In *Photoanalysis* (1976) three projection screens face the audience. In front of the centre screen is a lectern and a male lecturer. In front of each side screen is a woman with a chair or a stool. These three figures take regular turns speaking – first the man, then the woman on the left, then the woman on the right. As each speaks, a series of three photographic slides is projected on the screen behind that person. Each person speaks ten times, so thirty slides are shown on each screen.

The lecturer uses the slides on his screen to illustrate his talk on photoanalysis which he considers the newest science. By means of such analysis, he says, we can discover the subjective meanings of photographs. The lecture is repetitious, sometimes pointing out the obvious and at other times drawing unfounded conclusions. It is Kirby's parody of subjective criticism masking as objective science. The two women, when they speak, do not refer to the projections. Instead, each tells a story of a strange incident in her life.

The woman on the left is a widow whose husband Carl drowned in a stream under strange circumstances. However, there are suggestions that he might not be dead. She found one of his shirts wringing wet in the house. A friend found one of Carl's gloves. The projections seem to illustrate various places and objects mentioned in the story. The house where she lived with Carl, a nearby bridge, a large country house, playing cards seen on a table and later in a dry creek bed, a hand holding a glass with ice cubes, a graveyard, and so forth. The same man and woman appear in many of the slides. Similar but not identical photographs of the same subjects are shown in a dif-

91. *Photoanalysis*

ferent order on the screens behind the other two performers when they speak. The slides shown on the right screen are in the reverse order to those on the left.

When the woman on the right speaks, incidents in her story remind us of moments in the story of the woman on the left. She tells of visiting a friend called Amy in her San Francisco house. Strange things were seen there – for example, a man's shirt although no man seemed to live there. Amy mentioned a friend named Carlos. They were involved in some sort of covert political group, perhaps having to do with terrorism. Later Carlos was assassinated.

During the play one speculates on the possibility of Carl and Carlos being the same person. The lives of the two women might be intertwined without them knowing it. This is reinforced by the fact that the same places are shown in the projections which illustrate the two stories. Is there a connection between them? Yes, but it is only structural. Our suspicions are never answered. There is merely a web of anticipations and memories created by echoes of visual images and narrative fragments. The lecturer does not acknowledge the presence of the women and is unaware of the significance of his illustrative photographs to their lives. To him they are simply documents for analysis.

The acting area for *Double Gothic* (1978) is shaped like a large box about six metres square. The audience is divided in half and sits on opposite sides of the box looking into it. The two halves cannot see each other because six

92. Acting area, *Double Gothic,* **photo:** *Theatre Design & Technology*

black scrims are hung inside the box parallel to the rows of seats. These form five corridors each 1.2 metres wide. In two corridors are platforms which serve as beds. Usually only one corridor is lit at a time.

Two incomplete stories reminiscent of gothic novels are presented in alternating scenes. A scene from story A is played in the outside East corridor. Then the first scene from story B is performed in the outside West corridor. Each subsequent scene is presented one corridor further into the box. The third scene in each story occurs in the centre corridor. Then the two stories pass each other.

In story A a young woman in the near corridor puts down a suitcase. A passing car is heard, she waves but the car does not stop. She sits on the suitcase and examines one of her shoes which is broken. Someone unseen by the spectators has come near and the young woman smiles and says, 'Hello, I had an accident.' Lights go out and come up on story B in the far corridor. A young woman puts down a suitcase and opens an umbrella. In the distance a howling dog is heard. She seems to get something in her eye and examines it. Apparently someone has approached, and she speaks: 'It's not raining, is it?' The lights go out and come up again on the woman with the broken shoe for another short scene, then back to the woman with the umbrella, and so forth, alternating throughout the play. The woman with the broken shoe is met by another woman – a deaf mute with an arm in a sling who carries a lantern and leads her to a large house where they meet an older woman in a wheelchair. When the phone rings, the deaf mute mysteriously answers it. The young woman undresses for bed and discovers a snake in the bed. Putting on a glove, the young woman grabs the snake. The woman in the wheelchair accuses the deaf mute of playing a joke. In the night the deaf mute awakens the young woman and tells her she must leave, it isn't safe

152

93. *Double Gothic*, **photo: Michael Kirby**

here. Alone again the young woman picks up a lamp, begins exploring the corridors and then disappears.

In the second story, the young woman arrives by train and is met by a blind woman with a cane who leads her to a sanatorium run by a woman doctor. It seems the blind woman can see as she points to the house with her cane. When the young woman is getting ready for bed the doctor discovers a lily in the room, which is dangerous because it uses oxygen. The doctor accuses her blind associate of putting it there. In the night the blind woman awakens the young woman and tells her she must leave. The dialogue is the same as in the first story. She takes a candelabra, explores the corridors, and disappears.

In the beginning of the play, the performance of one story is close to each audience and the other is barely visible through five scrims. As it progresses, the close story recedes and the distant one comes nearer; eventually they pass through each other. This change takes place systematically, providing a spacial structure much as the alternating of scenes makes for a time structure. Once the audience realizes that the two stories are similar, there are many memory connections made across time, and these serve as structural mechanisms 'holding together' units of time. The spectator also begins to anticipate parallel events and images which relate time; and when they occur, there is a sense of structure being fulfilled. These anticipations and memories, sensitized by echoes, concordances, repetitions and parallels, make up a web of relationships that are purely formal. As Kirby points out, no new information is produced when the connections are made.

In all of Michael Kirby's plays there are motifs of mystery – apparent polit-

ical intrigues, assassinations, possible suicides, implied terrorist activities, gothic tales. No solution is presented to the mysteries – in fact the questions are never fully formulated. The real intrigue is the schematic structure which one attempts to grasp. The fulfilment is a fulfilment of form as we experience a structure being completed much as we would in a musical composition.

All of the new formalists, like Kirby, use narrative elements in their work, but like the other elements they are primarily compositional. The narrative is open, fragmentary, too many questions are left unanswered for there to be a specific narrative meaning. The audience may project their own interpretations upon the fragments, but such interpretations are subjective. The form is the content.

CHAPTER 6

Self as Content

The creators of some alternative performances are themselves the primary focus of their work. Some aspect of self becomes the principal content of their productions as well as the chief material from which the productions are made. In some instances the content is the artists' own cognitive and perceptual processes, in others it is autobiographical incidents from their lives, in still others they present themselves on stage as themselves but sometimes in such a way that it is not clear what is actual and what is illusion.

In a fundamental way all alternative theatre puts the performer more in focus than does conventional realistic theatre. Often the performer is seen through the character. However, in some productions of the Living Theatre, notably *Paradise Now*, the performers played themselves in so far as that is possible while being observed by spectators, attempting to engage them, and speaking some predetermined lines. In *Dionysus in 69* the Performance Group worked with the duality of performer and character. Sometimes actors were called by their names, at other times by the names of the characters. Performer and character were indistinguishable. In the performances of Soon 3 the performers simply carry out tasks, although they are done in a prescribed manner and more precisely than if they were not performing.

Similarly, all performances necessarily draw upon the experience and imaginings of the artists. However, some groups use their experience more literally in their performances. One of the plays of Lilith – A Women's Theatre is about the family of one of the performers and is set in the family pizzeria. The first productions of the Gay Theatre Collective in San Francisco and Spiderwoman Theatre Workshop in New York were developed around the personal stories of their members.

Many of the performances by visual artists use the self as content. The objective of Allan Kaprow and others to break down the barriers between life and art were partly achieved by those practising body art. Such work also attempted to shed the concept of the work of art as an object of commercial value. Admission was sometimes charged, however, and documentary photographs, films, and video tapes have become saleable items.

The body art of Californian artist Chris Burden makes performance and actuality coincide. His works from 1971 until about 1975 involved physical risk which tended to eradicate the performance sensibility of the artist who responded to the actual circumstances of the performance. In *Shoot* he arranged for a friend to shoot him in the arm. *Deadman* consisted of Burden lying under a tarpaulin on a Los Angeles street. He has had himself chained to the floor between bare electrical wires and buckets of water, which if kicked over would have electrocuted him. He has had pins stuck into his stomach, has crawled on broken glass, and has had himself imprisoned in a locker for five days.

More in the spirit of fun, but still focused on the bodies of the performers, are the presentations of the Kipper Kids in Los Angeles. Harry Kipper and Harry Kipper wear only jock straps during their scatological performances. They drink beer or whisky, mumble to each other and the audience, sing, belch, fart, and generally make a grotesque mess as they smear themselves and each other with food, mustard, and paint. The audience laughs nervously as they are intimidated with vulgarities and threatened by flying food. However, the performance shifts to the edge of brutality when, in a one-man boxing match, one of the Harrys punches himself in the nose until he bleeds.

The work of other performance artists is self-referential without having a body focus. New York artist Stuart Sherman objectifies his responses to acquaintances, cities, and so forth by creating short pieces of a minute or so. As himself he performs actions or gestures with props. The result is a language of ideas. In one of the approximately twenty short pieces comprising his *Seventh Spectacle* (1976), a cassette tape recorder says 'sh' several times as Sherman puts his finger to his lips in a silencing gesture and backs away from the sound. He puts on a necktie, and each time the recorder calls 'Stuart' Stuart Sherman, holding the end of the tie, pulls himself toward the machine. Reaching the machine the tape again calls 'Stuart' and he pushes the off button saying 'sh'. At one point in his *Tenth Spectacle: Portraits of Places* his impression of Toulouse/Lyon involves taking a telephone receiver from a flower pot and unscrewing the cap of the receiver, releasing rose petals.

Other performance artists draw more directly upon autobiographical material. Californian artist Linda Montano has designated portions of her actual everyday life as works of art. For example, in 1973 she sent announcements to her friends saying that she would stay home for a week and would be available. She photographed everyone who visited and documented food intake, telephone calls, and dreams. At the San Francisco Art Institute she

94. The Kipper Kids

walked a treadmill for three hours, telling the story of her life into a microphone. In *Mitchell's Death* (1978) she shows a video tape of herself inserting acupuncture needles into her face as she performs live, with the needles in her face, by reading from an account she wrote about her responses to the death of her estranged husband by a self-inflicted gunshot wound. The account begins with the phone call telling her of his death and ends with her encounter with the corpse in a mortuary.

Some artists have realized their self-referential works as part of a theatre company. Director/playwright Lee Breuer of the Mabou Mines group in New York has written and staged a great variety of works including three productions he calls 'animations'. In the first of these, *The Red Horse Animation* (1971), three performers create an abstract image of a horse with their bodies. While speaking as a chorus they join their bodies in various ways until the horse takes shape, gallops, and then disintegrates. The perfor-

95. Stuart Sherman *Sixth Spectacle*, **photo: copyright © Babette Mangolte.**

mance, however, is an objectification of Breuer's creative process. The
horse image and the apparent fragmented thoughts of the horse expressed
through language are an objectification of Breuer's mental process as he
attempts to create – his insecurities, his attempts to discover how he is relat-
ed to objects and events in the world, and his attempts to discover his
relationship to the work he is creating. This work and the animations which
followed – *The B-Beaver Animation* and *The Shaggy Dog Animation* – are
importantly self-reflexive.

Each of the three companies discussed in this section makes use of personal
content in a distinctive way. The work of Richard Foreman evolves from a
self-reflexive process similar to that of Lee Breuer's animations, but the
results are quite different. Performer Spalding Gray and director Elizabeth
LeCompte, working with other members of the Wooster Group (formerly
the Performance Group), created the trilogy *Three Places in Rhode Island* in
response to remembered events in Gray's life. And, as a solo performer,
Spalding Gray presents autobiographical monologues drawing directly from
his experiences. Squat Theatre in New York creates performances in the
building where they live. The performers may play themselves, but the atti-
tude of the audience is often ambivalent, not knowing if what seems to be
actually is.

96. **Mabou Mines** *The Red Horse Animation*

In conventional realistic productions only the illusion has value, so the artists take care not to call attention to actualities in the real world. In some of the work discussed here part of the interest in the work derives from a juxtaposition of actual and illusionary elements.

Richard Foreman
The Ontological-Hysteric Theatre

Richard Foreman began his theatre in 1968 in order to stage his plays, which reflect his concern with consciousness and the structure of consciousness. His scripts are notations of his thoughts as he deals with the problems of making art. Because the scripts include his thoughts on his thinking, they contain warnings to himself, observations about why he has written a certain line or thought a particular idea. The process is thinking turned back on itself. But it is more than a writing process, it is a style of living which produces a style of thinking which leaves a residue of a certain style of writing.

For Foreman writing is a continuous process. It does not begin and end for each play. When he is not actually rehearsing, he lies around the apartment with pen in hand reading, looking at pictures, making notes and diagrams in a notebook. The notes and diagrams become the text for a play. At a certain

time he picks up one of his notebooks, looks through it and decides 'go from here to here and I have a play'. He does not change the order. Because the text for a play is extracted from the notebooks, it is a series of 'change-of-subjects' which Foreman believes has become the subject of the work itself. The continual change-of-subject, interruption, and re-beginning, reflects the true shape and texture of conscious experience which is the structure of the work.

Roughly, Foreman's work falls into two periods. Until about 1975 his interests tended to be phenomenological. He was interested, he says, in taking an object, 'putting it on stage, and finding different ways of looking at it – the object was there in isolation bracketted from the rest of the world'. In these early plays it was often the introduction of a new prop that 'refocused the energies'. There was no conventional cause-and-effect relationship of events. Images were repeated, sometimes with variations. Furniture and other objects were isolated by space so they seemed not to have a functional relationship, props were lowered and raised by cords defying the logic of our expectations, and loud buzzers separated one speech or phrase from another. The tempo was greatly attenuated as if each moment were being stretched. The spectator responding to these early works luxuriated in the prolongation of the moment.

In these early works Foreman used untrained performers whom he did not permit to be expressive in the traditional theatrical way. As director, Foreman attempted to control every detail of their movements. They walk, stand, sit, pick up furniture, but they do not express emotion. Similarly, the language, which is all on tape, is spoken without inflection – a different voice for each character – and heard over speakers as the performers go through the movements slowly almost as if they were sleepwalking. Occasionally a live performer echoes one or two words from the tape.

Total Recall (1970), one of these early phenomenological productions, has four principal character – Ben (identified with Foreman) and Hannah who are married, Hannah's relative Leo, and Sophia about whom Ben has visions. At the beginning of the play Ben is sitting at a table. The closet at the rear opens revealing Sophia standing inside holding a lamp. Hannah comes halfway through the door. Buzzer! Hannah says, 'I came in at the wrong moment.' Later Ben looks in the closet where the goddess Sophia hides. She reaches out and touches his face. Ben says, 'Art doesn't interest me like it used to. How come.' Much later, in the middle of the night, Hannah crosses the stage several times with Sophia under her nightgown. Foreman considers this one of many 'intrusions of the ludicrous' which are treated formally with slowness and composure.

About 1975 Foreman became less interested in presenting objects and figures in a phenomenological manner and more interested in 'capturing something of the blueprint quality' of his notebooks as they evolve, as he tries to notate each day where his obsessions are taking him. Increasingly he became interested in a form of theatre which, as a direct reflection of his

notebooks, was a collection of fragments. The performances came to move faster because he was not interested in individual objects, but in 'the web of disruptions' as one thought displaces another. He became interested in whatever disrupted coherence. Beginning with *Pandering to the Masses: A Misrepresentation,* presented in his New York theatre in 1975, these disruptions were reflected in frequent and sudden changes to a new scene, a new locale. These scene changes are made by the performers in view of the spectators and are as much a part of the performance as other actions.

While the earlier slowed movement tended to put the spectator in a reduced state of consciousness somewhat like the work of Robert Wilson, Foreman's more recent focus on a rapid series of displacements or disruptions heightens spectator awareness. The stream of images passing at an accelerated rate makes one focus acutely so as not to miss anything. And because the images are so sensuous, one does not give up. In this conscious, active state one makes discoveries and connections, and sees formal relationships. These insights and intuitions occur in one's consciousness like sudden revelations producing a feeling of exhilaration.

The important thing, says Foreman, is not to succumb to the easy tendency to get carried away in some kind of emotional flow. In his daily life Foreman strives to be continuously self-aware, to be conscious of himself thinking and perceiving; and his performances are intended to stimulate the audience into a similar awareness. He sees this as a social and moral objective of his theatre – 'to force people to another level of consciousness' so that creative solutions are possible. This is accomplished by incorporating means which go against the audience's theatrically conditioned expectations, thus interrupting the flow. The voices on tape are detached from the figures on stage. The performers freeze in place and shift suddenly from fast to slow motion. They pull elastic cords to an object to give it focus and make the spectators conscious of where they are looking. A tape of Foreman's voice often comments on the performance. A buzzer or other sharp sound, so loud it is near the threshold of pain, is frequently sounded. Performers stare out of the stage picture at specific spectators, which makes them aware of themselves perceiving. Foreman believes that anything startling is an alienation device and serves to heighten consciousness.

Despite Foreman's interest in non-coherence, there is a vague situation in each play which none the less becomes a unifying element. In *Pandering to the Masses* the principal character Rhoda receives a letter with a red seal. It is an invitation to join a secret society which imparts a very special kind of knowledge. Although it is never clear what kind of knowledge is involved, the play focuses upon this invitation and her initiation into the society. Images of letters and envelopes appear in a variety of ways which also lend a compositional unity to the work.

Kate Manheim, who lives with Foreman and has been the principal performer in his productions since 1972, plays Rhoda, a character who appears in many of his plays. Rhoda lives with Max, another perennial character,

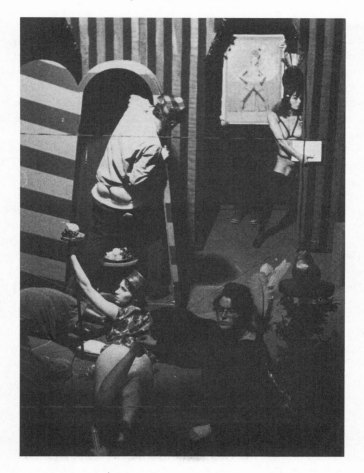

97. *Pandering to the Masses: A Misrepresentation*

who is a writer and seems to be analogous to Foreman; but, of course, all of the characters are fragments of the playwright since they speak only his thoughts and move according to his direction. The words are from his note-books where he has written thoughts triggered by his reading. The final speech in the play is spoken by Foreman's recorded voice: 'The meaning of the play', says the voice, 'will be found in the books scattered over the floor which include the text of *Pandering to the Masses: A Misrepresentation.*'

Although the productions consist of rapid-fire displacements reflecting Foreman's notations, they seem to have a coherence which probably is the structure of Foreman's thought processes. The entire procedure of making a production from notation to performance inevitably embodies the structure of the playwright–director's thinking. The sentences and gestures, Foreman says, 'write themselves' through him. Once he has chosen the notebook

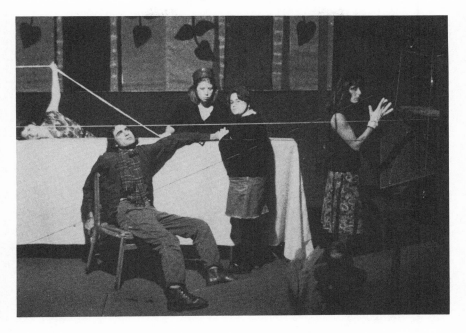

98. *Pandering to the Masses*

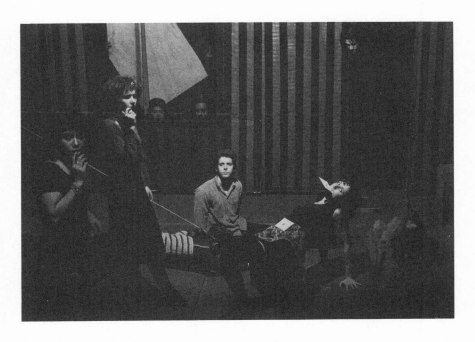

99. *Pandering to the Masses*

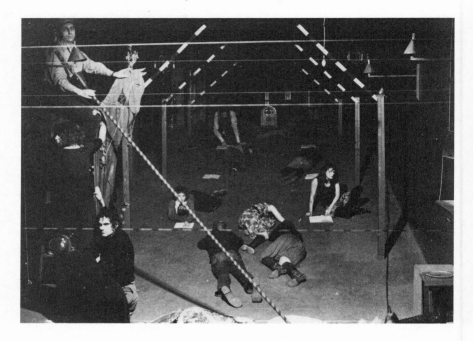

100. *Pandering to the Masses*

section which will be the text and has distributed the words among several characters, he makes a tape recording with the chosen performers reading the lines without colouration. In rehearsals this tape becomes a kind of found-object-score to which he 'choreographs' the performers, scenery, objects, sounds, and music. When the production is nearly ready for performance, he may make a tape recording of himself expressing his thoughts in reaction to the work. These comments are played at the appropriate times during the course of the performance.

Foreman believes that the rehearsal procedure 'discovers the unity'; 'The natural course of things insists that things fall into some coherence'. Rather than unity being hard to achieve, the important task is 'to try to punch a few little holes in this continual insistence of the universe that there shall be coherence'.

In *le Livre des splendeurs,* presented in Paris in 1976, he again attempted to avoid a theme and simply displace one image with another in rapid succession. However, even this objective resulted in a unifying structure – a structure of displacements – and led to the development of a theme during rehearsals. The theme is implied in a speech added in rehearsal. At three points in the play Foreman's recorded voice says:

> Ladies and Gentlemen, do you understand that an action is concluded and though one action does not lead to another, acts follow acts, discover-

ies follow discoveries, and one never stops inventing new ways to think about what one wants to think about.

The entire hour and forty-five minutes of *le Livre des splendeurs* consists of shifting images and associations punctuated by a buzzer, telephone bell, pings, and a loudly amplified sound resembling a cannon – all controlled by Foreman from his usual sound-control station in the first rows of the audience. Rhoda (Kate Manheim), who is naked most of the time, has various kinds of weights put on her body at different times in the play. A weight is put around her legs, a shoe with a large wooden block attached is put on her foot, a pole is strapped to her leg.

There is a home-made car resembling those of the 1920s. A naked woman lies at the front of the stage. As Max is about to leave in the car ('He resides in California with his mother.'), a pyramid of fruit is placed over the woman as a kind of *bon voyage* present. The Mother brings flowers in a large dish attached to her foot. Rhoda brings a large stack of books, staggering under the weight, but the car has gone.

A black weight one metre in diameter shaped like a potato is placed on top of Rhoda as she lies in bed. Max offers her a drink of water which he says will take away the pressure, but he drinks it instead and it gives him a pain which temporarily goes away when Rhoda asks for more weight. Eleanor is rolled on in a second bed, but when she tries to get out of it her foot is stuck. Water

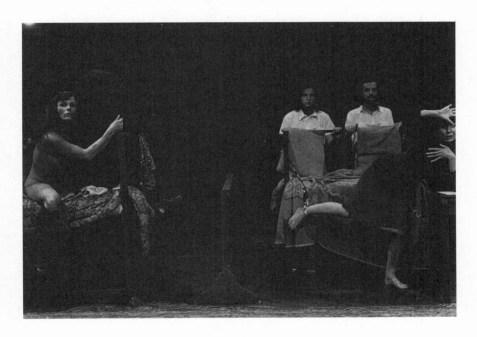

101. *Le Livre des Splendeurs*

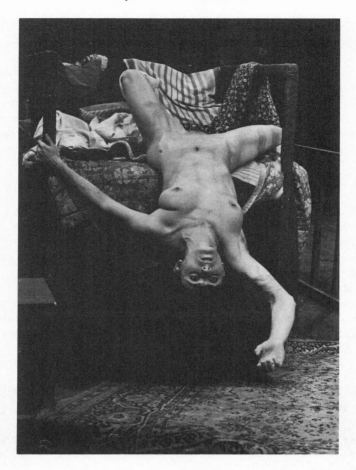

102. *Le Livre des Splendeurs*

is poured on the foot and Rhoda tumbles from her bed. Such surprising associations and connections continue throughout the play.

Rhoda is attacked by a 'wave of boredom'. She advises herself to 'accept it'.

> Don't let it know that you notice it even. Take it into your home and treat it comfortably. Subdue it with blankets and warm food.

At this point the voice of Foreman on tape announces that his name 'begins with a B. Boredom, is it not.'

Rhoda visits a Dentist who pulls strings from various parts of the stage to the painful tooth of his patient. But the Dentist himself sits in the chair, and Max becomes the dentist. He puts one end of a two-metre pole in Rhoda's

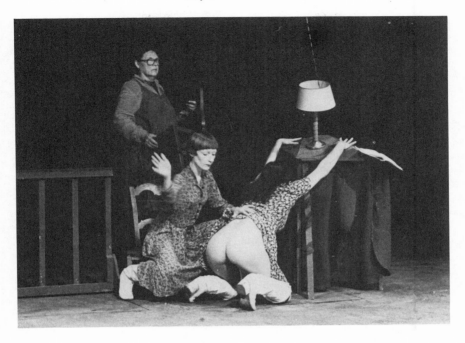

103. *Le Livre des Splendeurs*

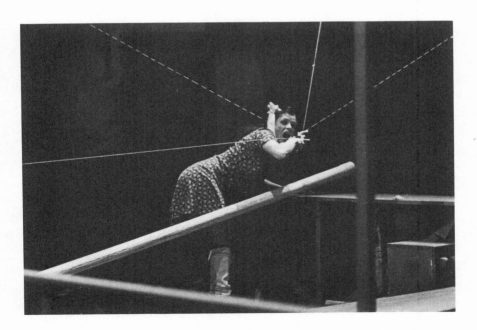

104. *Le Livre des Splendeurs*

mouth and the other end in his own. Limbo music plays as they do a slow dance while raising and then lowering the pole with their mouths.

There are references to the complicated relationship of Foreman to Rhoda and the other characters in the play. The taped voice of Foreman, referring to Rhoda and Hannah, says:

> They are a disguise for somebody else who is writing about them: or – to be more exact: they are still two people, one of them the writer and one Rhoda; but Rhoda –

Rhoda is a special case in that she is always played by Manheim, who has had increasing impact upon the work. According to Foreman the plays have come to be built around her, 'around a not-me'.

Rhoda picks up Hannah on a street and asks for fifty dollars. As Rhoda bends over with her head in a purse, Hannah inspects her ass through a plastic bowl – or perhaps she is looking through Rhoda into the purse. Then Max is seen in a cafe paying two women who get into the car with him.

Mother, as a vendor of ice cream, gives Rhoda a red ice cream cone and she is ecstatic, rolling her eyes as in a trance and stumbling in jerks around the stage as five women with similar ice cream cones do a shuffling dance.

A doctor's table like a padded butcher's block is brought on stage and a naked woman straps the naked Rhoda to it.

A radio is brought on stage on a dog's leash. Max and Rhoda stab themselves but recover immediately. All of the other figures do a dance which ends with them stabbing themselves. Max opens a suitcase and books tumble out revealing knives underneath. 'It's diabolical', he says, 'how these things keep turning up when you least expect them' (Foreman-the-writer's observation on the image he has just noted about knives in a suitcase).

Finally, an empty cone is given to Rhoda who inspects it, then throws it down in utter disgust. She washes her hands and discovers something is written on the soap. Foreman's voice starts to tell her what is written when she interrupts him with another question which stops him. The final speech is by the Voice: 'One is always stopped, just as one starts finding out where it is that the messages are written.' The play ends with three pings.

The final speech, of course, is Foreman's reflection on the process of writing, not knowing where the sentences come from. It relates to an earlier speech spoken by Rhoda but expressing Foreman's thoughts as he tries to write. 'Order my pen to move,' she says, 'there's always an order coming from someplace.'

Foreman remains true to his thought process by following intuition during both the writing and staging. He does not compromise this process by rewriting or making choices dictated by theoretical or superego concerns. Nevertheless, some of the means employed have changed over the years. In *Penguin Touquet* (1981), presented at the New York Public Theatre, the performers were people of considerable acting experience – but, for the

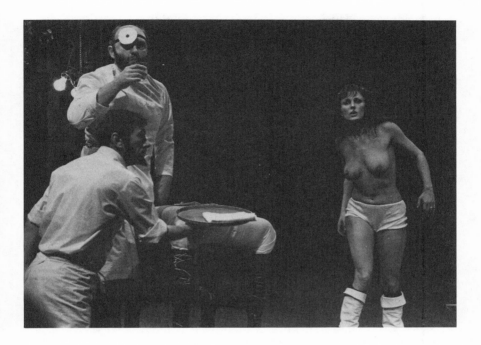

105. *Le Livre des Splendeurs*

most part, that experience had been with alternative companies such as the Open Theatre and Mabou Mines. During the years she has worked with Foreman, Kate Manheim herself has developed a high level of skill and a distinct performance personality which has had an inevitable impact on the style of Ontological–Hysteric productions. However, her acting is unrelated to that demanded by conventional theatre. The performers in *Penguin Touquet* speak their lines live rather than on tape, sometimes talking simultaneously so it is not clear whose ideas are being expressed. But, of course, as always, they are Foreman's ideas.

In contrast to his writing since forming the Ontological–Hysteric Theatre, Foreman's work while studying playwriting at Yale University was quite different. His plays at that time came out of what he describes as an effort to write what the superego determined was right and professional and impressive. And a great deal of effort went into rewriting to eliminate what did not seem right. In other words he denied his own natural thoughts and structures. The turning point came when he discovered 'a new aesthetic built upon a truthfulness in attempting to catch the natural rhythms of the individual artist'. He learned to accept and make central to his work the very elements which he had previously tried to suppress. The writing process, he believes, 'skims the crest off the wave' of his living, and he then tries to retune his living to the process so that another crest of writing will emerge.

In performance Foreman makes the spectators conscious that they are perceiving, and the performance itself makes them aware of the playwright's thought processes as he wrote the script, as he staged it, and even his thoughts about the work after it was staged. He is in direct communication with the spectators. In a fundamental way the performance is about the mental process of making it.

Spalding Gray and Elizabeth LeCompte
The Wooster Group

Unique autobiographical productions have been created using memories and documentary material from the life of Spalding Gray. These have been 'composed' by Gray and director Elizabeth LeCompte. Gray plays himself in their trilogy with the collective title *Three Places in Rhode Island*, which consists of surreal images derived from group improvisations and incorporates more literal material such as recordings and slides of Gray's relatives. Although the productions derive from a personal focus, invented elements are integrated with the documentary in such a way that there is no clear distinction between the two.

Spalding Gray and Elizabeth LeCompte were members of Schechner's Performance Group when they began developing their own work. The Performance Group disbanded in 1980 and they, together with several other members of the company – Jim Clayburgh, Willem Dafoe, Libby Howes, and Ron Vawter – became known as the Wooster Group.

Before Spalding Gray joined the Performance Group in 1970 he had worked for five years as a traditional actor playing roles in plays written by others.[2] His Stanislavski training had taught him to imagine himself to be someone else. One of the means toward this end was to observe others. It was under Schechner's direction that Gray came to approach his work in a different way. Schechner stressed performance rather than acting. To him the performer was at least as important as the text. When he performed in the Performance Group production of *Mother Courage*, Gray says he developed the role without any conscious thought of what Brecht might have wanted, but instead 'made the role' out of his own 'immediate needs and let the text supply the structure for these personal actions'. It was the discovery of this way of working that led him to his autobiographical performances and the separation from Schechner.

Gray says that by nature he is 'extremely narcissistic and reflective'. He has always been self-conscious and aware of his everyday actions. He wanted to use these qualities toward creating his own work. As long as he played characters, even if developed through observations of people, he could 'only guess at knowing this other'. He realized he did not want to study others as objects, he wanted to explore himself as other. He no longer wanted to pretend to be a character outside himself. He wanted to perform his own actions and be reflective at the same time on stage before an audience. He says it became a kind of 'public confession of this reflectiveness. It became, "Look at

me, I am one who sees himself seeing himself.'"

Elizabeth LeCompte, who had come to the Performance Group as assistant director to Schechner, began working with Gray and other performers in developing the autobiographical plays. She says that her interests in 'space and form and in the structure of a psychological performance' combine well with Gray's 'interest in performing, in confessing, showing himself'. For her the personal material has no special meaning, it is merely material to be used in making a structure. This detached view gave her the perspective necessary to direct the development of the trilogy and to structure it from performer improvisations and documentary material. She sees the work as being about Gray's 'love for the image of his mother [who committed suicide], and his attempt to re-possess her through his art'.

Each of the three plays comprising the trilogy is named after a place associated with Spalding Gray's past. *Sakonnet Point* (1975) is the name of the place where Gray spent his summers as a child. The piece was not planned in detail before rehearsals began, but he knew that he wanted to make a play about his growing up. He brought to each rehearsal objects with which to improvise. Most of the objects used in the performance are toys – an aeroplane, a few soldiers, a miniature garage, a toy house, a grove of tiny trees. The only objects used in all three of the plays making up the trilogy are a full-sized red camping tent, a record player, and the house.

The play was built entirely from free associations as the performers improvised with the objects. There is no attempt to tell a meaningful story. The movement is that of dreams or memory, and often is extended in time giving it a dream quality. Language is used rarely and is not in focus. There are the sounds of childhood. A woman's voice off-stage is heard calling 'Spalding' from time to time while Spalding Gray plays with toys. It is like the memory of being called by one's mother. An off-stage conversation of two women is heard, but we are unable to understand what is being said. There is the sound of a rocking chair rocking. A woman (Libby Howes) carries a small house. Later she hides it with her skirt and lies on top of it, protecting it with her body. *Sakonnet Point* ends with women hanging bed sheets on clotheslines. It is an image from Gray's childhood which makes connections with the childhood memories of the spectators.

The mother figure is even more important in *Rumstick Road* (1977), the second play of the trilogy, which takes its title from the address of the house where Gray grew up and his mother later committed suicide. The play concerns her suicide, and Gray believes it was his attempt to develop a meaningful structure into which he could place the meaningless act of suicide.

It was a confessional act. It was also an act of distancing. At last I was able to put my fears of, and identification with, my mother's madness into a theatrical structure. I was able to give it some therapeutic distance.

The materials with which the group began included letters written by

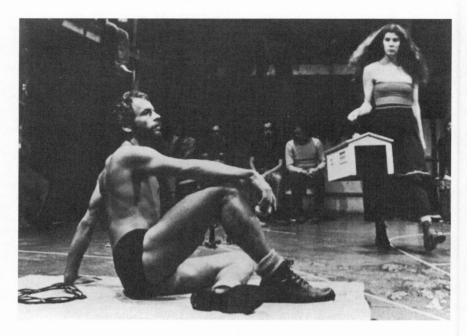

106. *Sakonnet Point,* **photo: Ken Kobland**

Gray's mother and father, old photographs of the family, and tape recordings he had made with his father, his two grandmothers, and the psychiatrist who had treated his mother during her nervous breakdown. He had asked them about his mother's suicide and how it had affected them. The performers did group improvisations in reaction to this material.

The first scene of the play, after Gray has introduced himself to the audience, consists of a farcical game of tag accompanied by lively music. Gray chases The Woman (Libby Howes) whom we begin to think of as his mother. They run in and out of a room slamming doors behind them. After a time The Man (Ron Vawter), whom we associate with Gray's father, appears with a gun and the two men struggle over it.

As the group worked with the tapes, using them as background for their improvisations and exploring through improvisation some of the situations described, surreal dream-like imagery emerged. In real life Gray's mother, a Christian Scientist, believed that she had been visited by Christ and had been healed by him. This led to an improvisation in which The Man attempts to heal The Woman. The improvisation culminated in a scene in which Gray, with a sheet over him, lies under a table. The Woman lies on the table. The Man raises her dress exposing her mid-section and gives a lecture to the audience about a process for relaxing the muscles of the torso. The lecture is followed by a demonstration in which he massages The Woman's belly with his hands and then with his lips, causing The Woman to laugh hysterically.

107. *Rumstick Road*

108. *Rumstick Road*

In performance the scene has no representational meaning so the audience can project on to it a number of associations. For example, it may suggest a child's interpretation of how his parents have sex, his imaginative assumptions about what goes on in his parents' bed when he hears his mother giggling. The scene also implies something about the relationship between Gray's parents. The Man presents his lecture as if The Woman were only an illustrative object.

The play also makes use of letters from members of Gray's family and photographs of them. At one point a slide of the house on Rumstick Road is projected on the wall and The Woman violently throws her head back and forth in a kind of mad dance. Finally, exhausted, she seems to hold onto the roof of the house for support. In another scene a slide of Gray's mother is projected onto the face of The Woman while she recites a letter written by Gray's mother.

A tape-recorded conversation about his mother's suicide between Gray and his father is played as The Man and Gray, seated in chairs, pantomime and lip-sync to the tape. Then Gray makes a telephone call and talks live to the previously recorded voice of the psychiatrist who treated his mother. The play ends with Gray reading a letter from his father.

The performance has a quality of personal revelation even though there are images which cannot be literally autobiographical. The line between documentary and imagination is intentionally blurred. The play is a collective work resulting, as Gray says, from 'group associations around facts in my life'.

The inceptive idea for *Nayatt School* (1978), the third play in the trilogy, grew out of Gray's interest in social themes relating to madness, anarchy, and the loss of innocence. He was also very interested in T.S. Eliot's play *The Cocktail Party* and particularly the character of Celia Coplestone whom Gray fantasized was what his mother might have been if she had been capable of intellectual distance about her nervous breakdown. The group began workshops with young boys. Eventually two boys and two girls were involved in the performances with the four adult members of the group.

The setting for *Nayatt School* appears to be a rear view of the room in *Rumstick Road*. The audience seating is raised about three metres so they look down into the space. At the beginning of the performance, Gray sits at a table on the audience level speaking directly to them about *The Cocktail Party,* and he plays portions from a recording of the play. Then the focus shifts to the room below which has a transparent roof and a window through which the action can be seen. It is used as a surreal doctor's office in which three scenes take place. First a dentist (Spalding Gray) drills holes in a patient who is the former lover of the dentist's wife. Then The Woman (Libby Howes) is given an examination for breast cancer after being wrapped in butcher paper. Finally, a chicken heart which has been used for experiments begins to grow uncontrollably and a scientist attempts to prevent it from destroying the world.

109. *Rumstick Road*

110. *Rumstick Road*

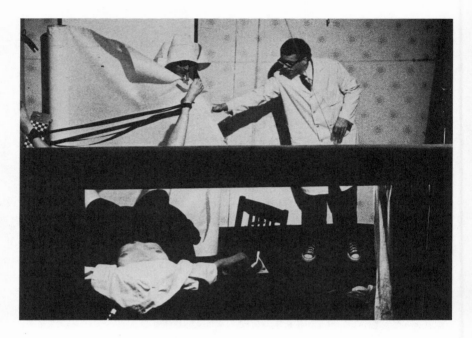

111. *Nayatt School*

Gray returns to the table on the audience level and plays a recording about breast self-examination while the lower level is set up for a cocktail party. At the party the four children are dressed and made-up as adults; they are manipulated like puppets by the real adults in the group. Periodically the party erupts into chaos.

At the end of the play, the adult performers, now on the audience level, partly undress and destroy the records in a fit of chaotic eroticism. According to Gray, the play does not talk about madness, it breaks into total madness, becoming the inside of a person's head.

While *Three Places in Rhode Island* was created collectively and therefore properly should be considered group work, its focus is Spalding Gray's life and his sensibilities. It expresses through abstract images and various forms of documentation how Gray feels about events in his life and how other members of the company feel about similar events in their lives. It is about the experience of growing up and living as a middle-class American. The three plays, says Gray, 'are not just about the loss of my mother but about the feeling of loss itself. I have had this feeling for as long as I can remember.'

The company made an 'epilogue' to the trilogy called *Point Judith* (1979) in which the main portion is a response to O'Neill's *Long Day's Journey into Night*. A house, which can be identified with the earlier plays, floats above the floor. Its inhabitants are engaged in repetitive actions of chaotic madness. There is no dialogue in this section, but many surreal visual images,

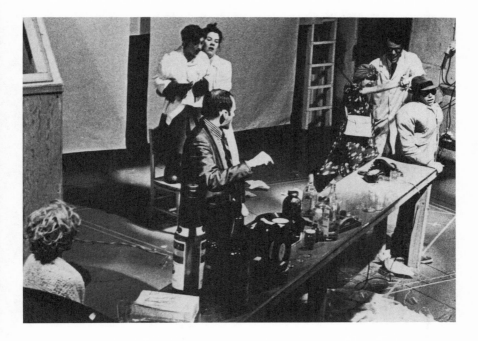

112. *Nayatt School*

including film projections, which create a metaphor for the destruction of the American family.

By the time of *Point Judith* the company productions were no longer explicitly personal. The more literal autobiographical material from Spalding Gray's life was being used in monologues composed by Gray and presented by him alone sitting behind a table and speaking directly to the audience in the first person. He considers these as extensions of his direct speech in *Rumstick Road* when he introduced himself to the audience and later described the house in which he and his family had lived. Each of the monologues runs about an hour and fifteen minutes and centres on a particular theme or period in his life. They are not written and not memorized, but for each monologue Gray has decided which events will comprise the performance.

The monologues were composed in an order approximating the chronology of the events in his life. *Sex & Death to the Age of 14* (1979) deals with his discoveries as he passed through puberty – the deaths of pets and their burial in an animal cemetery, discovery of sex in the form of his father's pornography and adolescent names for sexual organs. *Booze, Cars, & College Girls* (1979) concerns the period from post-puberty to young adulthood. He describes his experiences with alcohol, his temporary interest in becoming a race driver, his loss of virginity, and his loss of a lover. In *India & After*

(America), presented in the same year, Gray recalls his experiences while on tour with the Performance Group and his return to the United States. It was during this period that he thought he was going mad, but like the other monologues this one is mainly comic in tone. For a time he was an actor in a pornographic film in order to make money to travel west. In las Vegas he was arrested because he refused to give a policeman his name. *A Personal History of the American Theatre* (1980) is presented with the aid of forty-seven cards on which are printed the names of the plays in which Gray acted between 1960 and 1970. The cards are in a random order. Drawing one at a time he reminisces about events surrounding the plays, the actors in them, theatre anecdotes, and personal problems. After the monologue, the audience was invited to talk to him about the photos and other theatre memorabilia he had brought with him. *Points of Interest (America)*, first presented in San Francisco in 1980, draws upon his experiences driving across the United States from New York to perform at the San Francisco International Theatre Festival. He describes love-making episodes with his travelling companion, people along the way, visits to a sensory deprivation tank, a U.F.O. meeting when the speaker failed to show up, and his living circumstances while performing in San Francisco. Finally, he relates what happened to him today, and concludes with, 'That was today. And here I am.'

Ending with the present moment is just one of the means Gray uses to bring focus to the present so that the performance is not merely a relating of past events. It is important that the spectator does not have the sense that Gray is 'acting', but rather that he is speaking to them about real events. His style of delivery is flat, uncoloured, and candid. He really looks at spectators, especially when they react to something he has said. He actually reflects while in front of them rather than speaking memorized lines and pretending to reflect. He has incorporated various devices into his performances to make reflection necessary. The random order of the play titles in *A Personal History of the American Theatre* helps assure that he reflects on the events rather than falling into a repetition of previous performances. In *India & After (America)* he introduced a more complicated practice. An assistant, sitting at a table beside him, opens a dictionary to a random page, selects a word and its definition and calls out a time from fifteen seconds to four minutes. Gray then speaks for that length of time on an episode suggested by the word. For example, 'somnolent' reminded him of his inability to get an erection while making a pornographic film. This process continues throughout the entire performance.

All of his work, Gray says, has been made to satisfy his personal needs. *Sakonnet Point* came from a need to think about his childhood. An obsession about his mother's suicide led to *Rumstick Road*. His need to have children resulted in *Nayatt School* which provided the opportunity to work closely with boys and girls. His monologues, of course, were a direct means of thinking through various troubling events in his past. However, despite

the dwelling on personal problems, the tone of the monologues is predominantly comic because of a distanced, ironic perspective. The audience may sense how Gray felt while undergoing the experiences, but now he is alive in front of them having survived to tell about them from an objective perspective. Furthermore, the archetypical American experiences – love, sex, booze, cars, embarrassing situations – are recognized by the audience as similar to their own. A kind of catharsis takes place, and an important connection is made between the performer and the spectators.

Ideally, says Gray, a performance would deal with the present in the room where the performance is taking place. He would simply enter and start talking about the events taking place in the room. Although he has not actually presented such a performance, his monologues are the most literally autobiographical work that has been presented in the theatre. Although talking about past events, he is present as himself before the audience, living the most recent segment of his life.

Squat Theatre

The expatriate Hungarian company known as Squat Theatre have erased the distinction between life and art. They live and perform in the same space – a building with a storefront window looking onto a busy New York street. Those who pass outside become part of the performance for those inside and vice versa. Although members of the company sometimes wear bizarre costumes, they perform actions as themselves rather than as characters. And they take risks which have potential consequences for their lives.[3]

Originally the group formed in 1969 at the Kassák Culture House in Budapest. In 1972 the group's licence to perform was withdrawn on the grounds that it was 'obscene' and 'apt to be misinterpreted from a political point of view'. Being unable to give further performances in public, they began performing in the fifth floor apartment of members Péter Halász and Anna Koós and became the Kassák Apartment Theatre. During the next four years they also performed in a disused country chapel, a sand pit, and on an island.

In the autumn of 1973 the group performed at the Open Theatre Festival in Wroclaw, Poland, without an invitation. The play used some elements from earlier work including nudity, the cutting of a vein in the wrist, and the drinking of blood mixed with milk. When they returned to Budapest the passports of three members were withdrawn. In 1976 the group succeeded in leaving Hungary, and after performing for a year in Western Europe, the group of eleven adults and five children settled permanently in New York.

The first performances in the United States were of *Pig, Child, Fire!* (1977). It takes its name from three elements the group intended to use in the performance. They were unable to get a pig, however, so they substituted a small goat. The events take place in real-world time, rather than condensed dramatic time, and therefore seem to happen very slowly. While

the four parts of the play are presented in the same order, there is no attempt to duplicate exactly a previous performance.

In the first part, 'Stavrogin's Confessions – Dostoevsky's *The Devils'*, recorded music is playing as the curtain rises revealing a twice-life-size figure of a man hanging upside down with a normal-size head protruding from its anus. The small head, identical to the large one, is suspended by a rope around its neck. Tethered at one side of the stage is a live goat with a child's mask on its forehead. A little girl plays while the goat chews on various objects. A woman in red (Anna Koós) smokes a cigar. She chops up a head of cabbage with an axe, the little girl plays with a knife. The entire rear wall of the performance space is glass and other spectators can be seen looking in. A man (Péter Halász) with a long black beard appears outside. One arm of his overcoat is in flames. After watching for a time he moves on. (The overcoat, like most objects used in the play, has a history. It was worn by the actor's grandfather in the First World War.)

The woman begins to read Stavrogin's confessions from Dostoevsky's *The Devils*. (Stavrogin feels guilty because of a child's suicide by hanging.) The reading is taken over by the woman's taped voice, then by the voice of a man. As the little girl plays with the goat, the woman unwraps a package of assorted animal viscera. Some of the innards she arranges on the table, paints them red, and flours them. She then holds the goat on her lap, lays large pieces of meat on its back, slices them, and sprinkles them with flour. The man with the black beard, accompanied by a police dog, peers through the glass and moves on.

The woman stands the little girl on a chair, and puts make-up and a wig on her. From inside her own dress she takes a pair of plastic woman's breasts and ties them around the child's chest. The man with the dog appears again. The taped reading of the confessions stops. The first words of dialogue are spoken – the man protests that the document was incomplete and inaccurate. The woman pounds on the glass and the man opens his overcoat. He is naked. He leaves quickly.

The woman pulls away the giant figure leaving a man (Pétr Brežnyik) hanging by his neck, an erect penis protruding from his flies. As the body convulses, the man ejaculates. He removes his mask to reveal an identical real face beneath, then he dies. As German dance music plays, the woman clasps the man's swinging body. Then she cuts the goat's rope and carries the animal off with the child following. The man with the dog is now inside. He looks around.

In part two, 'Dinner and Nous Sommes les Mannequins', two television monitors face the audience and a third is outside where a woman and four children are eating dinner and talking. The inside area is dark, but one can make out a man slumped over a table. A woman in red sits by the glass looking out. A video camera pans the inside and outside spectators and their images are seen on the monitors. A car drives into the dinner table as the diners scatter. A man in a trenchcoat and hat gets out of the back seat. An

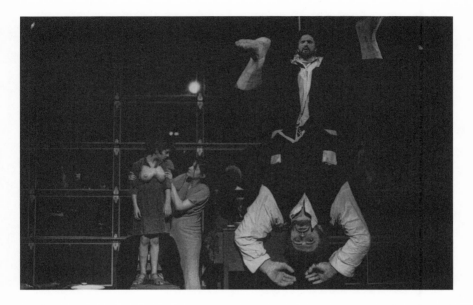

113. *Pig, Child, Fire!*

identically dressed man enters. The two draw guns, aim at each other, and stand frozen. The woman in red draws a gun and shoots the man closest to her, and the second man shoots her. The gunman comes inside to the man slumped over the table, sharpens an axe on an electric grinder, and chops off the man's hand. The slumped man sits up startled and pulls a bloody stump from his sleeve revealing his undamaged hand. He pulls a gun and tries to shoot the gunman, but it is only a toy. Submissively, he stands on the table, drops his pants, kneels down and sticks the gun in his anus. He fires the toy gun and falls forward, ass in the air. The gunman puts his trenchcoat over the bare posterior with the protruding gun.

The third part is 'Letter to André Breton by Antonin Artaud, February 1947'. Anna Koós stands outside behind a lectern. A video camera and a small spotlight are under her skirt on the ground between her feet focused on the naked crotch. The image is transmitted to the television monitors. During the eight minutes it takes to read the Artaud letter, small but visible changes can be seen in the projected image.

The fourth part, 'The Last One', was originally presented in the group's Budapest apartment in May 1972. A man stands eating a piece of bread. A second man enters with a pane of glass which he measures and cuts. Neither speaks.

The play contains no set dialogue. Except for the readings of Dostoevsky and Artaud very little is spoken. The group's ideas are developed through discussion and as they consider the possibilities of the space in which they are

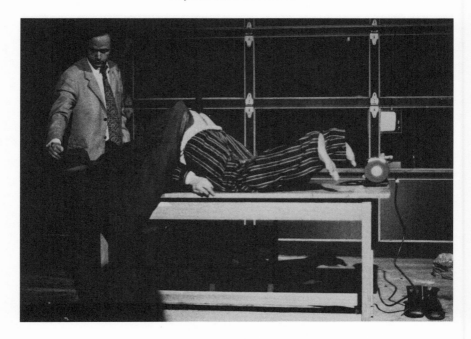

114. *Pig, Child, Fire!*

to perform. For example, when they went to Rotterdam to make the first performance of *Pig, Child, Fire!* they found an empty store with living space upstairs. They conceived of the idea of using the glass storefront to allow the audience inside to see spectators who gathered on the sidewalk outside and vice versa.

The glass division also relates to some of the group's theoretical ideas. In their view, since the ancient performances of Greek tragedy there has not been a unity between the cosmic drama presented by the performers and the private-life drama of the spectators. They believe that actors have become mere vehicles for ideas and ideologies which remain separated from the lives of both performers and spectators. In an age when there is no engulfing cosmic drama (mythology) inextricably relating people and events, Squat is committed to presenting the resultant abyss. They accept this abyss as the present day universal cosmic drama; they live in it and they present it.

When the group decided to settle permanently in New York, they needed a space that would be both their home and their performance space. And it had to have a shop window facing the street. They found a suitable building on West 23rd Street. *Andy Warhol's Last Love* (1978) was their first work to be made in the United States. In a sense it is two plays – one that is seen by the paying spectators inside the theatre and one seen free by those passing on the sidewalk outside. Seeing each other through the glass window, the two audiences become part of the performance for each other. The inter-

115. *Pig, Child, Fire!*

mingling of actual elements with fictional illusion, of living and art, is a dominant characteristic of *Andy Warhol's Last Love* as it was of *Pig, Child, Fire!*

Squat Theatre has been compared to Pirandello because of its different levels of illusion. But there is an important difference. In Pirandello's plays, although one illusion may be replaced by another, we are not permitted to focus on the actual performer in the present; we perceive only the fictional characters in a fictional time and place. Squat Theatre intermingles actuality and illusion in such a way that actual persons and events become more mysterious and fictional ones seem more real.

The first section of *Andy Warhol's Last Love*, 'Aliens on the Second Floor', immediately blurs the line between actuality and theatrical invention. The spectators enter the room where group members Eva Buchmüller and Istvan Balint live. Their personal belongings are there. Buchmüller and Balint are also there engaged in natural activities. He is lying on the bed, she is sitting at the table listening to a radio and nervously twisting her hair as she does both on and off stage. From time to time she changes the station and the audience hears whatever is actually being broadcast at the time. Gradually fictional elements are introduced. The voice of Ulrike Meinhof is heard over the radio speaking for the Intergalaxy 21 Revolutionary Committee. (A disco formerly in the building was called Galaxy 21.) She instructs the listeners to make their deaths public so they can be provided with new bodies and

116. *Andy Warhol's Last Love*

taken away to the planet where she now lives. Other bizarre events take place. The hem of the dressing gown Buchmüller is wearing is nailed to the floor and she is shot. A table cloth burns and a man rolls out from under the table in flames. And at the end of the scene a woman from space (Anna Koós) enters to resurrect the dead Buchmüller. She wears a silver cloak and has an erect penis protruding from the dress covering her belly which is very large with an actual pregnancy.

The rest of the play takes place in the main room on the ground floor which is separated from the street by the glass storefront. Members of Squat have said that they came to realize while still in their Budapest apartment that when they looked into the windows of other apartments, natural everyday actions took on a theatrical quality. Like a mirror or the frame of a picture, viewing objects and events through a transparent separation helps to set them apart from the everyday world so they become objects and events for perception and seem to lose their efficacy. The window also directs our focus, making it difficult for us to ignore what is happening on the other side. Although on the street we would feel awkward looking at a stranger for more than a fleeting moment, we stare unflinchingly at the person through the window. We perceive others and we perceive others perceiving us without embarrassment. But it is not simply the window that makes staring acceptable; in the theatre – etymologically 'a place for seeing'

184

– it is as acceptable to look at spectators who are made objects of perception by the window as it is to look at the other performers.

The window, which allows New York to present itself, is a metaphor for our relationship to our peopled world, our distanced voyeur-like relationship which permits us to observe without being touched, to experience vicariously the events around us. Andy Warhol exemplifies this relationship and other American attitudes and values. He is rich and famous, he is a television addict, he is seemingly uninvolved and uncommitted. He says in *The Philosophy of Andy Warhol* that when he got his first TV set he stopped caring about having close relationships. Until he was shot, he always thought he was watching TV rather than living life. When he got his tape recorder it ended whatever emotional life he still had 'because a problem just meant a good tape, and when a problem transforms itself into a good tape it's not a problem any more'. He experiences events vicariously through television, by interviewing others, and by encouraging friends to phone him and tell him what is happening. By avoiding and distancing what might affect him, he remains unaffected.

Warhol is the principal figure in the film which comprises the second part of *Andy Warhol's Last Love*. It begins with the video portion of an actual TV commercial message by Crazy Eddie who is giving a pitch for the television sets, tape recorders, and other electronic equipment which surround him in one of his stores. The audio portion is a hyped-up reading of Kafka's brief narrative 'An Imperial Message', which tells the story of a messenger unsuccessfully attempting to bring 'you' the whispered message of the dying emperor. Although the messenger may go on for thousands of years, through the crowd at the emperor's deathbed, down the stairs, through the courtyards, even to the outer gates of the palace, he still would have the capital city with its refuse before him and no one can force a way through that. 'But you sit at your window when evening falls and dream it to yourself.' A performer wearing a life-like mask of Andy Warhol rides a horse through the deserted streets of Manhattan's financial district. Events occur – a girl raises her skirt for him, a man is shot, a man with his face half burned passes on the street – but the artist on his horse gallops along unseeing, untouched, and unmoved. On the film we see him arrive in front of Squat Theatre, and then live he enters the theatre.

For Squat Theatre Andy Warhol is a tragic hero who in his films searched for an ideal of making living event and artistic form inseparable; but like the alternative culture of the sixties with its similar aims, he succumbed to the powerful anti-spiritual counter-revolutionary forces of the present. The last ten or fifteen years have proved, according to Squat, that the ideal was unattainable. In the hands of Warhol art became banal and reproducible, failing to express the essence of life. It is not useful for the artist to focus on the unachievable ideals: such a utopian focus keeps the artist uninvolved, an observer at an emotional distance. The focus of the artist must be on what is, not on what should be. The counter-revolutionary forces cannot be negated

by artistic idealism. But if the only value of an artist's work is his own material gain, if this is the function of art, then Crazy Eddie is one of the greatest. Furthermore, his message is as useful as that of the utopian artist or the secret deathbed message of Kafka's emperor. Squat does not believe that theatre can transmit a message, especially not one from elsewhere – not even from writer to audience. Like the message of the emperor, it is never received.

When the performer masked as Warhol enters the theatre from West 23rd Street he is accompanied by performer Kathleen Kendel. The final section of the play, 'Interview with the Dead', begins. She removes her cloak and, naked, performs an incantation calling up various spirits. The curtain over the window, on which the film was projected, is pulled aside and throughout the rest of the performance the actual people and events of West 23rd Street become part of the play. And spectators who gather outside can see in.

In the interview which follows actuality and illusion are again indistinct. As Warhol and Kendel sit at the table passing a microphone back and forth, a taped voice claiming to be Warhol asks questions of the real Kendel who answers live and extemporaneously insisting that she is an actual witch. Among the actual spectators visible outside through the storefront window is the man seen burning upstairs in the first scene and again in the film. His face is burned, but some spectators do not realize that he is a performer. As the interview progresses a video camera outside transmits to a television screen inside scenes from the street – the faces of individual spectators, cars passing, the Empire State Building (actually a model) burning. The TV screen gives everything – actual and fictional – the same distanced sense of reality. From among the spectators outside Ulrike Meinhof enters. She carries out the sentence of the Intergalaxy 21 Revolutionary Committee. Warhol is 'shot for his merits'. (It was almost exactly ten years before that the real Andy Warhol was shot.) The woman from space with her silver cloak, pregnant belly, and erect penis enters from the street to take Warhol to her planet.

At the end of the performance a mylar mirror is lowered from the ceiling in front of the inside audience. We become conscious of looking at ourselves as we have been looking at those outside. But, like Warhol, we have been observing the people and events of New York from the secure, removed position of voyeurs. However, there is another irony. While inside we may think of ourselves as voyeurs exploiting the drunks, kids, and Chelsea Hotel clients who pass by and become our entertainment, outside the spectators are talking, smoking, some drinking or eating, moving around freely, generally having a good time watching the antics of a naked woman and a man who looks like Warhol. They see rows of spectators sitting stiffly on chairs. They look rather silly, and they paid five dollars to get in. Both audiences have a vicarious experience and there seems to be no risk.

For the Squat company, however, there is considerable risk. They are a small community outside the larger society in which they live, but they are

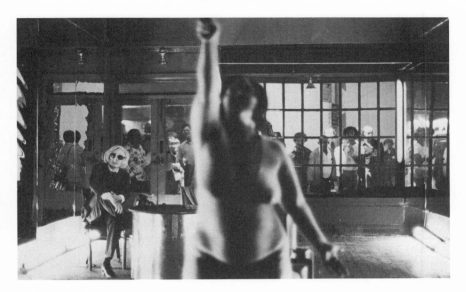

117. *Andy Warhol's Last Love*

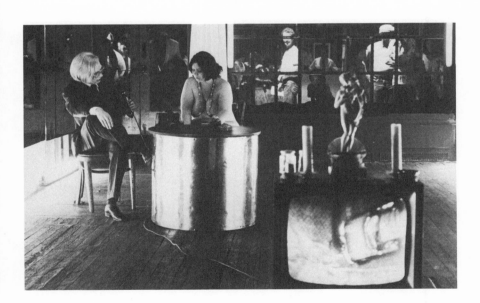

118. *Andy Warhol's Last Love*

not free from its impact. They take physical and legal risks and, like Ulrike Meinhof, they are anarchists – not political but aesthetic. They are audacious in their confrontation with oppressive aesthetic views which

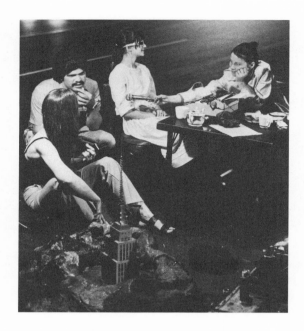

119. *Andy Warhol's Last Love*

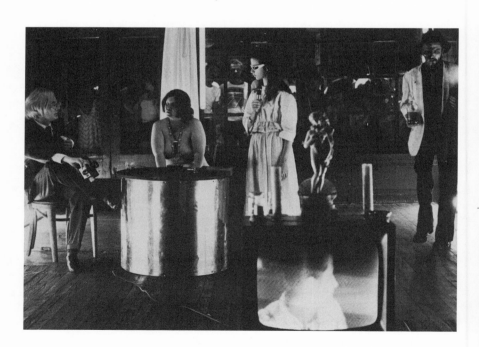

120. *Andy Warhol's Last Love*

separate art and life. For them art and life are intertwined, and consequently they risk more and more artists. They take physical risks with fire and have been threatened by those passing in the street – by both spectators and police. They risk being arrested for any number of charges from breaking fire regulations to obstructing the sidewalk, to indecent exposure and the corruption of minors. And there is the risk of being deported as undesirable aliens.

Instead of conveying a message about life that is not theirs, Squat believes theatre is a living, ongoing event in which no distinction is made between performer and character. They are not carrying a message from elsewhere. The performers do not play characters from a source outside themselves; they are themselves even if they wear bizarre costumes. To Squat this is the essence of theatre, that art and living overlap.

PART II

American Alternative Theatre since 1980

CHAPTER 7

An Introduction to Alternative Theatre since 1980

The counterculture that gave birth to the alternative theatre movement in the 1960s and that continued through the 1970s no longer exists. But the alternative theatre does continue to exist. The counterculture was a collection of disaffected, mostly young, people who rallied around a handful of political and social causes—some opposed U.S. involvement in the Vietnam War, and others championed various civil rights movements. Some simply wanted to drop out of the established culture, of which they disapproved. Free of the Establishment's pressures to conform, the artists among the disaffected could be experimental—that is, they could create new forms and techniques to express afresh their emotive knowledge of their world. In short, they based their work on experience rather than theatrical conventions, which had been devised to express experience in former times but which continued as the foundation of the established theatre even when times had changed.

This is not to say that there are no longer disaffected individuals or alternative cultures in the United States, but those that exist tend not to make theatre. Some are religious, and some are formed in reaction to specific issues such as abortion or government and use violence as their mode of expression. There are exceptions to this generalization. The LAPD (Los Angeles Poverty Department) is a theatre made up of homeless and formerly homeless people. As in earlier decades, there are theatres dedicated to the experiences of ethnic and racial minorities. But most of the alternative theatres are now a part of the cultural mainstream. Though they continue to be poor, they survive within the dominant economic structure of the country; they apply for and receive grants from foundations, including the National Endowment for the Arts; and they solicit corporations for contributions. Nonetheless, they are alternative the-

atres because, by being experimental and by exploring the unique possibilities of live theatre, they provide an aesthetic alternative to the mainstream theatres of Broadway and the principal nonprofit regional theatres.

The two driving forces of earlier alternative theatres continue to motivate these groups. Some, like Anna Deavere Smith and Guillermo Gómez-Peña, direct their energy outwardly to social issues and intend to inform their audiences while, of course, also entertaining them; others, like Richard Foreman and Elizabeth LeCompte, are inwardly focused on their own psyches and intuitive thought processes and attempt to express them directly in theatrical forms. Some groups, whether inwardly or outwardly focused, explore the use of media in ways not usually found in the established theatre. All groups intend to entertain—or they will lose their audiences. However, they are primarily concerned with theatre not as a commodity, but as a means to an artistic and social end.

These two tendencies—inward and outward—while existing simultaneously have nonetheless at different times alternated in prominence in the culture at large. History does not accommodate neat periods, but if one considers individual self-interest versus community interest in the United States during the twentieth century, there are rather clear shifts in the country's cultural ambiance approximately every thirty years. These shifts are also echoed in the alternative theatre that reflects the culture.

In the Roaring Twenties, the boom 1950s, and the self-reliant 1980s, individual self-interest dominated over social concerns. In the 1980s this tendency was clearly reflected in government, economic theory, and the arts. Governmental leaders showed little concern for social issues, the dominant economic theory was trickle-down, and artists seemed more concerned with self-expression than collective expression or addressing social problems. There were programs designed to help individuals develop their full financial potential; some banking organizations ignored caution in their attempts to maximize profit; even highly regarded statesmen in their entrepreneurial zeal sometimes behaved as if the laws did not apply to them. Everything was possible so long as one did not get caught or go bankrupt. On the other hand, in the depression-dominated 1930s and politically active 1960s, the cultural ambiance reflected a greater interest in community and social issues. Alternative theatres in the 1960s and early 1970s were often concerned with the war in Vietnam or with civil rights—especially the rights of various ethnic and racial groups, homosexuals, and women. Political activists working together as a communal force exerted pressure on the government and were instrumental in bringing about change. Civil rights activists achieved legal equality for their constituents, though social equality is still only a concept. Antiwar activists succeeded in bringing an end to the war in Vietnam. The alternative culture believed in community action; the pronoun of the time was *we*. But as time passed through the late 1970s and into the 1980s, *I* again became dominant.

In the 1980s the politically active alternative culture of the previous decades largely disbanded. Theatre artists, reflecting the culture at large,

tended to be socially and politically disengaged. Instead of directing their focus outward toward society, they were inclined to face inward. They created self-focused and self-reflexive concepts, expressing individual feelings about themselves and their art. They devised, not collective expression about society, but a great variety of individualistic, nonrealistic forms to express their emotive concepts—their attitudes, emotions, images, and mental processes. A different structure emerged in alternative theatre, reflecting the revived focus on the individual artist instead of the group. The new companies—often formed around a single dominant artist who combined the traditional functions of playwright, director, and designer—were structured as hierarchies rather than as democratic groups.

These artists were less interested in collaborative or collective work, as they wanted complete control over their art in order to express their subjective selves. A few, like George Coates, became auteur directors, as Robert Wilson and Richard Foreman had done earlier. More often, like Spalding Gray, they became solo performers creating their own work. Other factors also contributed to the plethora of solo work in the 1980s and after. Along with the emphasis on individual self-reliance the idea developed, not always articulated, that arts, like corporations, should be self-reliant, in keeping with the capitalist philosophy. If audiences liked the product, they would and should pay for it. Public money for the arts decreased. In these financially difficult times, solo works were cheaper to produce or present, and artists who had been members of groups but now were older, with greater personal financial responsibilities, found it easier to make a living on their own. As support decreased for established theatres, they became more conservative in their programming, and some artists found the work available too artistically restrictive. Solo performances also became more plentiful because many of the performers, like Karen Finley, came from backgrounds in the visual arts, in which one person usually creates the work alone and the work is often a subjective expression of the individual's psyche and unique aesthetic.

In some instances soloists' work resulted in confrontations with the political establishment. As the spirit of activism resurfaced in the 1990s, several performers ran into trouble with politicians who considered their language, subject matter, or nudity indecent. The National Endowment for the Arts was pressured into withdrawing grants to some solo artists.

While such solo performers as Karen Finley and Tim Miller are concerned with their own personal stories, others are socially focused. Guillermo Gómez-Peña, whether performing alone or in collaboration, is concerned with the relationship of Mexicans and Mexican Americans to the Anglo establishment. African American Anna Deavere Smith has created solo dramas that explore conflicts between ethnic minorities and between minorities and the police.

Some groups were considered outrageous. Ron Athey, who engaged in body alteration and mutilation, was castigated for cutting an HIV positive black man and using his blood as ink to print papers that were suspended

over the spectators. In the spirit of fun, Annie Sprinkle permitted spectators to peer into her vagina. Others presented ironically cynical work as metaphors for the culture around them. Mark Pauline founded Survival Research Laboratories in 1979 to create large outdoor performances with disused industrial equipment. These reconstructed, self-propelled, radio-controlled animalistic machines perpetrate acts of violence on each other, often leading to their complete destruction. The machines are often made more grotesque by having parts of dead animals attached to them. The Jim Rose Circus Sideshow revived one of America's forms of popular entertainment—the freak show. Members of the company perform feats that have caused the more squeamish in the audience to faint. Such performances seemed to express a culture with an insatiable curiosity for the bizarre.

In contrast with the superindividualistic culture of the 1980s, the 1990s saw a renewed interest in social issues, in some ways coming to resemble the 1960s. Instead of one distant war, the decade was bookended by distant conflicts in the Persian Gulf in 1991 and the Balkans in 1999. The protests against these wars were indications of a surge in social activism. College campuses renewed their activism, with protests against incursions into affirmative action by conservative forces, strikes in support of the unionization of student teachers, and rallies and teach-ins demanding that universities refrain from doing business with corporations operating sweatshops overseas. By 2000 two other social objectives had gained momentum. Environmentalists objected to countries, especially the United States, that contributed to the causes of global warming. Protests spread, sometimes leading to violence, against economic globalization and capitalism in general. Although they lend support to the idea of thirty-year cycles of social concerns versus individual concerns, these activities did not lead to the kind of counterculture that took shape in the 1960s.

Their relative degree of idealism is an important difference between alternative theatre companies in the 1960s and in the 1990s, when idealism came to be mixed with a large portion of realism, even cynicism. No longer were the young theatre companies structured as superdemocratic collectives that eschewed a hierarchy and encouraged all participants to contribute to every aspect of the work. Although these newer companies believed in collaboration, they also acknowledged individual specialties among the artists. Directors, designers, and performers worked within the areas of their most highly developed skills.

The changes that took place from the 1960s through the 1990s are exemplified by the San Francisco Mime Troupe, which is probably the oldest of the surviving alternative companies. Formed in 1959, it began with a strong director who made all of the important decisions. A revolution took place in 1970, and the group became a collective in which everyone participated in all aspects with no hierarchy. Soon the troupe made a conscious effort to become multiracial in its membership. In the 1980s the company evolved into

an organization that respected individual skills—performers performed, writers such as Joan Holden wrote, and Dan Chumley directed.

Collaboration is still very important to the San Francisco Mime Troupe and to other companies, and some collaborations have gone beyond the multicultural United States and become international. The Mime Troupe's *Off Shore* (1993), which deals with free trade between the United States and Asian countries, adapted techniques from Kabuki and Chinese opera and was developed with the collaboration of theatre directors from Hong Kong, Taipei, Tokyo, and the Philippines as well as Asian Americans. Similarly, Ping Chong's *Kwaidan* was created in collaboration with an American master puppeteer and Japanese designer Mitsuru Ishii. These international collaborations and others have been facilitated through e-mail and the Internet, which partly explains why they did not happen in previous decades.

The alternative theatre aesthetics have had an important impact on the mainstream commercial theatres of Broadway and the principal nonprofit regional theatres. And members of alternative theatres have left to work in the mainstream theatres and film. Willem Dafoe and Ron Vawter (d. 1994) took leaves from the Wooster Group and returned. And Ron Vawter for a time toured his one-man show. Spalding Gray of the Wooster Group left to present his personal monologues and has not returned. Lee Breuer and Ruth Maleczech, two of the founders of Mabou Mines, work both outside and inside the company. The other two founders of the company, Philip Glass and JoAnne Akalaitis, left the company for other work and have not returned. Akalaitis was producer of the New York Public Theatre from 1991 to 1993, and Glass tours his music ensemble and creates work in collaboration with directors including Robert Wilson. However, the aesthetic of all four, developed in the alternative theatre, went with them and has enriched the mainstream. Richard Foreman has directed the work of others in large mainstream houses, including the Paris Opera, but continues to present small-scale work in his tiny Ontological Theater in New York's East Village. Robert Wilson is a prime example of an alternative theatre director's moving to the mainstream and continuing his unique aesthetic. He began creating pieces in the 1960s with a commitment to working with handicapped people; later he achieved international acclaim for his imagistic productions, which tour internationally to major theatres and opera houses.

Other directors in the mainstream have made use of techniques developed in the alternative theatre, and some of them, for example Julie Taymor, began there. Like Peter Schumann's Bread and Puppet Theater, Taymor makes use of puppets of various sizes and masked actors. After years of smaller-scale work off-Broadway, she reached the height of commercial success on Broadway with *The Lion King* (1997), adapted from the Disney film and presented by the Disney Company. It received the Tony Award for best musical in 1998. The environmental and site-specific techniques used earlier by Richard Schechner's Performance Group, Snake Theater, and others have

been adapted for several productions, notably *Tony N' Tina's Wedding,* a staged wedding performed in a church with the audience as wedding guests. The price of admission included a wedding reception dinner. Originally presented off-off-Broadway in 1985 by a troupe called Artificial Intelligence, it ran through the 1990s as a commercial production in New York and spun off productions to other cities. A nonprofit theatre known for site-specific work was En Garde Arts in New York, founded in 1986 and dissolved in 1999 when the founder-producer, Anne Hamburger, was appointed artistic director of the La Jolla Playhouse, a major regional theatre in California. During its thirteen years, En Garde presented productions at a variety of New York sites including outdoors in the financial district, on a Hudson River pier, around a lake in Central Park, and in the West Side railyards.

One of the most distinctive aspects of alternative theatre is the mode of acting (performance) that began taking shape in the 1960s. Exploring the unique possibilities of live theatre, alternative companies employed means to take advantage of performers' and spectators' shared time and space. This practice has had little impact on the established theatre, which, in the main, separates the performers and the audience by lighting, by proscenium arches, and especially by creating an impenetrable illusion of a time and place different from that of the spectators and an illusion of people (characters) who live in a separate world from those in the audience. By contrast, the alternative theatre has let actuality be the performance or share focus simultaneously with whatever illusion may be presented. A linear plot creating suspense is the principal means used by the established theatre to keep the focus on the fictional illusion. For the most part, in alternative theatre the performance itself is of the greatest importance. It is this characteristic more than any other that creates an experience for spectators qualitatively different from a performance in the typical established theatre, or movies or television. The performances are uniquely live. Perhaps this is what has made the alternative theatre of enduring interest.

CHAPTER 8

Outrageous Performance

"Indecency" and the National Endowment for the Arts

In 1989 Andres Serrano was one of three winners of a fifteen-thousand-dollar visual arts fellowship offered by the Southeastern Center for Contemporary Art, which received support from the National Endowment for the Arts. Serrano's winning submission was a photograph of a crucifix suspended in the artist's urine. A few months later a clergyman, head of a fundamentalist Christian group, organized a protest asking people to contact their representatives in Congress. New York Senator Alphonse D'Amato followed with a speech that deplored the photograph and insisted that the NEA develop guidelines to keep such an outrage from occurring again. Reverend Pat Robertson reached a larger audience on his Christian Broadcasting Network when he urged his listeners to send a message to Congress insisting that their tax money not be used to support the NEA until there were absolute guarantees that such blasphemy would be avoided. Representative Richard Armey, later to become Republican majority leader of the House of Representatives, and Senator Jesse Helms also condemned the NEA. In 1990 Congress passed a law requiring the NEA to take into consideration "general standards of decency and respect for the diverse beliefs and values of the American public" when making grants to artists and arts organizations. The relationship between Congress and the NEA continued to worsen.

The Corcoran Gallery in Washington, D.C. had planned to present, later in the same year, a retrospective of Robert Mapplethorpe's photographic images, which included nudes of men, women, and children in poses more classical than erotic, though a few did include sadomasochistic objects. The

costs were partially covered by the NEA. In a political climate that was already hot because of the Serrano photograph, the Corcoran canceled the exhibition.

It was in this atmosphere of a rising conservative wind against the NEA that the next major storm arose. A peer panel of the NEA, the Solo Theatre Artists and Mime Panel, chose eighteen performing artist from ninety-five applicants to receive grants in 1990. The National Council on the Arts, which must approve all awards, voted against funding four of the artists.[1] These four—Karen Finley, John Fleck, Holly Hughes, and Tim Miller—became known as the NEA Four. The performances of all four involved sexual politics. They were sympathetic to the gay movement, they talked about AIDS, homophobia, and sex, they talked about the abuse of women in a male-dominated culture. Nudity was sometimes a part of their performances. Some members of Congress considered their work obscene. Some also considered it an outrage that tax money was awarded performers with openly "deviant" sexual orientations. Hughes is an acknowledged lesbian, and Fleck and Miller are gay. Finley, although a heterosexual feminist, was not spared, as her politics were like the others, and she was considered obscene because her language was irreverent, scatological, and sexual, and in her performances she was sometimes naked and usually smeared with food of some sort, an expression of the degradation of women in our society. In fact, she came to be known derisively as "the chocolate-smeared woman." It has been suggested that her principal crime was her refusal to be a *beautiful* nude.

The NEA director, apparently in an attempt to reassure congressional critics and thereby gain their support for the NEA, instituted a pledge that had to be signed before grant money would be paid. The recipients had to promise that they would not use the money "to promote, disseminate or produce" works that "may be considered obscene." In protest more than twenty artists and arts organizations declined their grants. Subsequently the pledge was abandoned, but the political accusations of obscenity and indecency continued to be used by the political and religious Right in an attempt to eliminate funding for the NEA. It is unknown to what extent this constant pressure has resulted in self-censorship by artists and unspoken, perhaps unconscious, censorship by NEA panels in the belief that they were helping to preserve the NEA, which was clearly under threat. While controversy had no immediate impact on the annual budget, which in 1992 reached a peak of $176 million, sustained badgering by the agency's enemies led to decreases beginning in the following year. By 1998 the budget had fallen to $98 million—a decrease of 44 percent. The budget did not increase again until 2001 when the appropriation was $104.8 million.

To put its budget into an international context, the NEA's supporters point out that all "great" nations support the arts. Canada and France spend thirty-two dollars per capita and Germany twenty-seven dollars, but the annual expenditures of the NEA have amounted to no more than thirty-eight

cents per person. These funds are augmented by matching grants from states, foundations, corporations, and individuals.[2]

Some supporters of the arts, such as Edward Rothstein, argue that the politicization of the NEA in the name of democracy was inevitable and suggest that proper arts patronage is inconsistent with a democratic philosophy. Weeding out artists whose work falls outside the community standards contradicts the very idea of art as an individual extraordinary expression. Democratizing of art is antiart.[3]

Cutting the NEA budget was not the only destructive act by Congress, which also stipulated that there be no more grants to individuals. No doubt this was primarily a result of arguments against the NEA that first gained prominence with respect to Serrano, Mapplethorpe, and the NEA Four. While theatre companies could still receive grants, the budget decrease was devastating because most of them were already living on the financial edge. A few artists who were denied grants became famous in the controversy, but that was of little help because they now found some venues closed to them. At the brave places where they were presented, audiences increased. Such theatres, however, took steps to protect their grants. For example, in 1997 when Finley's *The American Chestnut* was presented at Theatre Artaud in San Francisco, the publicity pointed out that she was "being presented without any [NEA] agency funding whatsoever."[4]

Finley and Hughes received grants for 1991, but in the same year they and the other NEA Four artists sued the NEA for the grants they had been denied the year before. The issue was whether the NEA could consider standards of decency when making grants. The artists won a decision in 1993 and received their grants, but the decision was appealed by the Bush administration. In 1996 the U.S. Circuit Court of Appeals in San Francisco ruled the decency provision unconstitutional because it "gives rise to the danger of arbitrary and discriminatory application." The justices, by a vote of two to one, ruled that "even when the Government is funding speech, it may not distinguish between speakers on the basis of the speaker's viewpoint or otherwise aim at the suppression of dangerous ideas." The Clinton administration appealed the decision to the Supreme Court, which, in the following year, ruled eight-to-one that the policy does not violate artists' free-speech rights and that the NEA can consider decency, as well as artistic merit, in deciding who gets public money. The law "neither inherently interferes with First Amendment rights nor violates constitutional vagueness principles," Justice Sandra Day O'Connor wrote for the Court. "So long as legislation does not infringe on other constitutionally protected rights, Congress has wide latitude to set spending priorities." The House of Representatives was still not happy and voted to abolish the NEA, which was saved in the conference committee with the Senate after a similar attempt to eliminate the Endowment was defeated in that body.

The NEA Four had lost their case, but the harm done reached much fur-

ther. Congress had slashed away at the NEA budget, devastating artists and putting the very existence of the NEA under threat. To make matters worse, many private grant-giving foundations shifted their giving to other areas, and arts organizations have been drained emotionally and financially by having to defend their programs and artists from audits, public attack, and harassment by city officials and police. Finley decried the impact of this conservatism on the spirit of the country at large: "We've lost sight of what made America so innovative—we were daring, original and not afraid of offending the old guard. We have lost our inventiveness for the sake of appearance."[5] The 1990s were the low point for the NEA with respect to funding artists and companies. By 2001 the attitude of Congress had become more sympathetic because the NEA was supporting more conservative art, but the agency's budget was still well below the $176 million of 1992.

The Shock of Nakedness

Performances by the Living Theatre in the 1960s were shockingly outside generally accepted artistic taste and received wide attention. Such work broke through the usual aesthetic frame, abandoned illusion as an artistic means, diminished the distance between art and life, and presented the self, one's body, one's experience—emotive, cogitative, and perceptual. In this more direct relationship with the audience, a more immediate form of communication seemed possible. Shock broke down the barriers of aesthetic distance, allowing for a direct political impact. Some performers presented themselves naked, but without the gloss of eroticism; some exposed their body mutilations, alterations, and tattoos. Some badgered the audience, some made them cringe, some attempted to charm them. Many of the resulting highly personal works were of necessity performed by the creators themselves.

Karen Finley, "The Chocolate-Smeared Woman"

Karen Finley's solo performances offer a raw critique of society in the United States, of its homophobia, degradation of women, suppressed desires, and commercialism, which sets standards of appearance and behavior for women based on the desires of men. And she does so courageously, expressing the emotions that surround these subjects and her political views in poetic images and language and by smearing food on her body as an expression of female degradation. Her aim is political, but she insists that it is not negative. "I try to fix things," she says.[6] "I think I stir people to be responsible for what's going on in their own personal lives, in their one-to-one relationships, interweaving this into the whole society's corruption. That's very disturbing."[7]

Her background is in visual arts, with an MFA degree from the San Francisco Art Institute in 1981. Although she is best known for her monologues, performed in art centers, theatres, galleries, and museums, she also writes

plays and essays and creates paintings, sculptures, and installations, all of which are concerned with the same issues.

When Finley was twenty-one, still studying at the art institute, and just beginning to perform, a devastating event occurred. While she was home for Christmas vacation, her father went into their garage and shot himself. The event, she says, "put an effect on me that reality is stronger than art. And it makes me interested in real time. When I'm performing, real time is stronger for me than theatre pretend-time. . . . That really put me in such a reality state, of realizing that nothing really ever matters. In some ways, it actually freed me."[8] She always strives to make what happens in performance actual rather than illusory.

After receiving her degree, Finley began collaborating with a variety of performers in Europe and the United States. A principal collaborator during this period was her former graduate adviser, to whom she was briefly married—one of the Kipper Kids (see chap. 6). Her first major solo work was *The Constant State of Desire,* first performed at the Kitchen, New York, in December 1986.

Her creative process is a unique combination of older methods and her own invention. In performances she speaks of certain events that she has fantasized or observed rather than experienced herself, but she does not pretend to be another person. She insists that the performance present her actual feeling self rather than an illusion. Some of her techniques—nakedness without eroticism, lack of rehearsal which increases risk, and breaking into the monologue to comment on what is happening in the theatre—result from her striving for an actual presence. She writes about things she has seen.

> A lot of it is from me. [It's] like trance writing, like lots of times I just wake up and it just comes to me. And sometimes I really believe I have other voices coming to me. So I open up to the voices. . . . [I don't] do a lot of rewrites. . . . I write little sections, and then I sort of associate to them, and it just comes. . . . A lot of the writing happens after I speak it, and then it's written. . . . I don't like the writing to sound too calculated. I don't want my piece to sound like theatre.[9]

In performance she puts herself into a kind of trance state,

> so that things come in and out of me, I'm almost a vehicle. And so when I'm talking it's just coming through me. . . . I pick up the energies from the people, I got to completely psych into them because I want them to feel that I am really feeling it . . . I'm giving everything I have to make it an experience . . . It's the live experience, and that's really important. . . . I get horrible stage fright.

The process is very exhausting and sometimes, she says, "after I perform I have to vomit, my whole body shakes."[10]

Act 1 of *The Constant State of Desire* begins with Finley talking in a stream-of-consciousness fashion, in the third person, of a woman's dreams. "She dreams of strangling baby birds. . . . She dreams of being locked in a cage and singing loudly and off key." Then she accuses the doctors (who seem to be stand-ins for males in general), "the same doctors who anesthetized her during the birth of her children. These were the same doctors that called her animal as she nursed. These were the same doctors that gave her episiotomies. No more sexual feelings. . . . But she knew it wasn't the doctors' fault. That the problem really was the way she projected her femininity." Then, in the first person, she refers to her father, "who told me he loved me after 40 years then went into the bathroom, locked the door, put up pictures of children from the Sears catalog, arranged mirrors, black stockings and garters to look at while he masturbated as he hung himself from the shower stall."[11]

In act 2 she has an Easter basket with colored unboiled eggs, and there are stuffed animals on the table. She takes off her clothes. She puts the raw eggs and the animals in a clear plastic bag and smashes them till the contents are all yellow (photo 1). Using the soaked animals as applicators, she smears the mixture on her naked body and sprinkles glitter and confetti on her sticky self. She talks of engaging in various violent activities, but the actions are ineffectual. So she fantasizes about what she will do to Mr. Yuppie, who sees her art "as just another investment, another deal. My sweat, my music, my fashion is just another money-making scheme for you. . . . So I open up those designer jeans of yours. Open up your ass and stick up there sushi, nouvelle cuisine." She fantasizes stealing his BMW and driving to the stock exchange. "I go up to all the traders and cut off their balls. They don't bleed, only dollar signs come out." After imagining that she has coated the balls in melted Hershey's Kisses, she sells them. "I love to watch all of you Park Avenue, Madison Avenue know-it-alls eating your own chocolate-covered balls for $25 a pound."

Finley believes such images and harsh critiques are very disturbing: "I destroy the games people live on, a very yuppie world where security is having a $40,000 job, or $120,000. People really don't want that questioned. What happened to the motivations of 20 years ago of having a much more socialist-humanist society?"[12]

In parts of the performance she speaks from the perspective of others whom she apparently fantasizes. She speaks as a man who "looks for hot mamas with hot titties in laundromats." And occasionally the harshness has a hard-edged wit. "Let me tell you about POWER. Being gang raped by a group of youths at the age of 15 in a subway. Until they discover my secret of being born without a vagina. They throw me onto the train tracks."[13]

Finley's performances are frequently concerned with abuse, and she believes "we're really scared of our own sexuality which is no longer a sexuality of love but a sexuality of violence."[14] Speaking in the first person in *The Constant State of Desire,* she says,

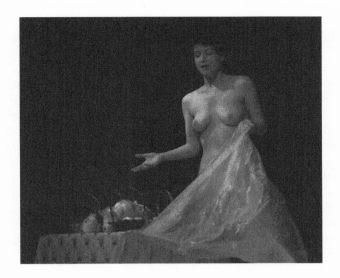

1. Karen Finley, *The Constant State of Desire* at Sushi,
San Diego, 1998. Photo: Becky Cohen

And the first memory, memory I have, I have of my father, is he putting me into the refrigerator. . . . Then he opens up the vegetable bin and takes out the carrots, the celery, the zucchini, and cucumbers. Then he starts working on my little hole. Starts working my little hole. "Showing me what it's like to be a mama," he says. "Showing me what it's like to be a woman. To be loved. That's a daddy's job," he tells me.[15]

The experience seems to be autobiographical, but perhaps it is a fantasy, as Finley has said she was not sexually abused as a child.

She speaks articulately about sex and politics in *The Constant State of Desire* and other works.

If you're not a mother and you're not a whore in this society you're considered unproductive. Woman's value is still based on her biology. If a woman becomes a bank president she still conforms to a male image of what that is. . . . The only two things that a woman does that is not compared to a man is giving birth and spreading her legs. I bring that to light, and that's very threatening. . . . The reason why the feminine way or the maternal way has been oppressed is because the male energy is so scared of it. And so the only way males can deal with it is to knock it down, to not allow it to come up. In *The Constant State of Desire* I wanted to show

vignettes of capitalism, consumer society where people go far out, stretch the boundaries—but still they never can be satisfied. So they take things into themselves, and this is what incest or abuse are about.[16]

The language of this production and others is loaded with images of biological functions (vomiting, urinating, defecating), violent sexual activities (forced fellatio, sodomy, rape), and body parts (penises, vaginas, tits). Its religious references some Christians may consider sacrilegious. She confronts our patriarchal capitalist culture, psychiatry, and the horrors committed in our society by men. Those who reject her work as merely obscene or degrading to women ignore its social and political expression: "I deal with difficult issues. But pick up a magazine or look at an ad, or TV . . . everything is degrading toward women. I just mirror what's going on. . . . If some women feel degradation when they watch me, then they're feeling the right feelings."[17] She lives in a violent world, an uncontrollable world—especially for women—a world that at any moment might devastate her and us.

It was not until her performances of *We Keep Our Victims Ready,* which premiered in 1989 at the Sushi Performance Gallery in San Diego, California, that the campaign against Finley and the National Endowment for the Arts took shape. The production expressed a favorite theme—concern for those who are oppressed by the white patriarchal system for political, economic, social, and sexual reasons. The campaign against Finley was promoted by syndicated conservative columnists Rowland Evans and Robert Novak, who in May 1990 derided her as a "nude, chocolate-smeared young woman" whose outrageous style was endangering the entire NEA. In the production Finley compared our own society with Nazi Germany. She stripped to her underwear and put gelatin in her brassiere. Then, after discarding that item of clothing, smeared her body with chocolate frosting and sprinkled herself with glitter.

The American Chestnut (1997) incorporates into her performance the other media in which Finley works—painting, video, installations—and is lighter in tone. She now has a daughter, and that change has introduced her to the needs and desires of children as well as to the commercialism aimed at them. But her performance still sharply skewers two of her favorite targets—the degradation of women and the creation by men of the images to which women are expected to aspire. Again, there is a sense of improvisatory chaos that reflects a chaotic world in which anything can happen. Finley disrupts the set performance and reacts to actual events of the moment, speaking in her normal voice and character, thus reinforcing the presence of the actual person, Karen Finley, who is speaking to us. We are made coconspirators in her attacks, rather than being the objects of her wrath.

The American chestnut, once the most abundant tree in America, early in the twentieth century was struck by a blight that keeps it from developing to maturity; but it struggles to stay alive, trying to overcome its disease. It is a metaphor for the social ills in our society and the pain Finley's performance laments.

Its message shows the pain of surviving tragedies—war, spouses to AIDS, children to war, discrimination, racism, misogyny and violence. I attempt to show the frustration and acceptance in order to survive amidst these conditions.[18]

The stage for her performance at Theatre Artaud in San Francisco is a four-foot-high platform with a projection screen as a back wall. Finley performs both on the stage and in front of it, on the same level as the audience. On the stage are objects relating to housewife-mother—a doll's house with furniture, a telephone, a vanity with mirror. At the beginning, two slide projections are on the screen—one of Finley's painting of a woman's head, the other of a dried flower arrangement. Superimposed in the middle is a live video image of a portion of the audience. As they recognize themselves, they giggle.

Finley enters in front of the stage, on the audience level, wearing a wedding dress backward with a long train that she carries over her arm. She is pushing an upright vacuum cleaner that is running. The plug accidentally pulls out and she replugs it. As in other performances she improvises before moving into the written performance. In a performance at Theatre Artaud she notices that the front row of seats is empty. "Doesn't someone want to sit in the front row?" Dozens of people scurry to get closer to the stage. Noticing the competition of two men who are racing toward the same seat, she asks one of them for twenty dollars for the seat. He gives it to her. She says, "Wow, I should sell seats onstage. I bet I could get a hundred bucks. I think I'll try that." There aren't enough seats down front to accommodate all comers, so she goes out of view and brings in more. She directs people like a benevolent house manager solving problems. When all the seats are taken and someone is left without one, she says, "You have to accept that some people get fucked up."

When she starts to perform the written material, it is in a distinctly different style of voice projection—louder, heightened, more formal and stagy, spoken directly to the audience, often in an apparently intentional irritating screech. This presentational mode of speech serves to keep the audience from accepting her as portraying a character, even when she speaks in the first person of experiences that clearly have not happened to her.

She says that since her daughter was born she has been doing things she never thought she would do, like buying a Barney stroller. "I feel it is important in child development for the child to adore something the parent hates." And today, before the performance, she went to Macy's and bought a Barbie doll that she shipped to her daughter.

She describes the objections of the sales staff on an occasion when she needed to nurse her baby while in a store. She talks of reading *Winnie the Pooh* to her daughter, and the story spins off into a sexual and scatological fantasy involving the characters in an S-M bar.

Don't you always wonder about that Pooh-poopoo shit thing going on there? "Hi, I'm Pooh. Hi, I'm a piece of shit." . . . Piglet is in some corner

being peed on by Tigger. Eeyore is having his tail nailed on his hiny saying, "Could you nail that tail in my butt a little slower, Christopher Robin?"

In a section dealing with the absurd things credited to God, Finley tells us of a woman who lost two sons in the bombing of the federal building in Oklahoma. She decided to start another family, but she had had her tubes tied. A surgeon offered to reverse the operation for free. The woman said it was "a gift from God."

God always gets into it. . . . To me God getting in the act is getting the war over with—stopping the murder, the rape, the genocide, the ethnic cleansing. God doesn't get involved there.

In another break from the set performance she hears a door closing offstage. She goes off the stage, still in view of the audience, opens an exit door and calls, "Hey, I've started now."

Inside the doll's house she arranges a tiny chair and a rose and focuses the video camera on the scene that is projected on the video screen. Then a film of wriggling worms is projected on the screen and a knife chops them up as she talks of the humiliation of little girls peeing on themselves.

In an amusing section she goes offstage and we watch a film of nude female sculptures in an art gallery. In the film Finley appears naked and walks around the gallery posing by paintings and sculptures of nude women, thus putting into focus the difference between real live women and the idealization of them by male artists. In another short witty film, made during the period when she was nursing her daughter, she squirts milk from her nipples onto black paper in the exuberant manner of Jackson Pollack's action painting. She signs it "Nursing Painting #1."

She returns to the stage wearing a black lace teddy. She lies on her back with a live video camera projecting an image of her face on the screen. She reads from a script and screams her lines. The section is a parody of a lingerie shop, Victoria's Secret, which caters to women who are trying to fulfill male expectations. She imagines that a man named Victor has to decorate his genitals with fantastical lingerie items. She imagines Sean Connery's rear cleavage and proposes a set of falsies for Vice President Al Gore. "I want that now," she screams. The audience finds it hilarious.

As a film of a pair of gnarled, ancient feet is projected, she describes the death of a man from AIDS. And in the middle of the next section she genuinely breaks down and starts crying. She explains, "My head is still in that last scene. I miss him so much. He gave me so much. I miss him." She wipes away her tears and continues with the scene.

As she sits at the vanity, two slides are projected of the birth of her baby with the head emerging from the birth canal. She speaks for an abandoned wife whose husband has run away with a college girl. In contrast with her ear-

lier crying, her sobs here are intentionally artificial. She speaks in the first person as Hilary Clinton, screeching a long list of apologies: "I'm sorry America that I never got into shopping . . . I'm sorry about the cookies . . . I'm sorry America that I'm smarter than Bill is. I'm sorry America that Bill knows I'm smarter than he is." It's another example of an American woman finding it difficult to live up to (down to) the culture's expectations of her.

Few artists are as courageous as Karen Finley. She makes herself vulnerable by revealing herself—her body without the cover of eroticism as well as her fantasies and experiences that others would keep secret, and she expresses openly her fears, angers, and desires in a language that is uncensored. She has also defied the right-wing elements in her country—religious, governmental, judicial—at the risk of financial penalty because some venues more timid than she is will no longer engage her.

Holly Hughes, Everybody's Girlfriend

Holly Hughes, who in recent performances looks like a cross between a sex kitten and the nice middle-class girl next door who would make a model wife, is a lesbian. Beginning in 1983 at the WOW Café in New York's East Village, a performance space for women that she managed for a time, Hughes has been presenting witty monologues about her life, fantasies, and experience. She says that after the NEA withdrew her grant, she was no longer seen as an artist but as a symbol for both sides of the controversy.

> Either I have been told that I'm a lesbian, and that's grounds enough for rejecting my work. Or people say I'm not lesbian enough, and the work isn't shocking enough. . . . The most damaging thing the NEA did . . . was to target us so that you wake up on the morning and have to defend your work to people who have never even seen it.[19]

To the performer's dismay, the NEA publicity brought some people to the performances who were disappointed when she was not outrageous enough.

> All of a sudden I don't know who I'm talking to anymore. Is it the group over there in that corner who've come looking for a freak show? Should I give them what they've paid for? Or should I be talking to the group over on the left who think that questions of sexuality and culture aren't legitimate political concerns? Is there a way I can perform my story so they'll understand it as a chapter in a much larger story? I don't think there's much I can say to those members of the audience who think any time a member of a traditionally silenced group pipes up they're just whining.[20]

The piece she was performing at the time of the NEA controversy, *World without End,* concerns her thoughts about her mother, who had died. As

Hughes said, "It explores my relationship to her and both the negative and positive sides of the relationship. It explores how she helped me, how she hurt me and what choices she had."

Sometimes she speaks in a storytelling mode, as when telling about going to a Denny's restaurant with her mother.

> Hunched over the menus, lost in the smell of fresh Formica, potato salad, and things, in general, frying, my mother straightens her bifocals. She folds her menu.
> "I want to ask you a question, young lady. Do you like boys or girls, or both?" . . .
> I lean forward, my nipples grazing the shrimp in a basket.
> "Both," I said. "I like both."
> "Well, no wonder you can't hold down a full-time job," my mother says.

The waitress overhears and thinks by "both" the girl means she wants both cocktail sauce and tartar sauce.

At other times Hughes speaks directly to a spectator. She approaches someone she could take a shine to, someone who might shine back, and delivers the following "at point-blank range."

> Do you realize the entire solar system is moving?
> Twelve miles a second toward the constellation Hercules?
> Is that news to you?
> I knew it the first time I kissed you.
> Back then I laughed.[21]

In certain sections of the piece, Hughes says,

> I also reexamine my relationship with men, both as a category and as individuals. I find that even though I identify myself as a lesbian, my feelings run the gamut from incredible anger to sexual attraction, and I wonder how I reconcile that with being a lesbian.[22]

These sections, in the minds of right-wing politicians like Senator Jesse Helms who believe "all the blow jobs in the world just won't erase one muff diving," justified the loss of her NEA grant. While her words are graphically sexual, she undercuts sexuality with wit. She says that "a little while after my mother died, the only thing I really wanted to do was fuck." So she picked up a guy at work and told him, "You're on the menu. We're gonna take the plunge. We're gonna go for broke. I got plans to rewrite the Bible tonight." It is the story of Adam and Eve: "This is the start of history."

> Adam is happy. Eve is happy. They're both happy there's Sheetrock surrounding this Garden of Eden. And then Mr. Adam is very happy because

he is all the way inside her, and he can feel her feel him hit—paydirt. . . . All of a sudden, Eve has got to say: "Yo, buddy! Do you know who I am? Do you have any idea at all who you are porking? I'm the preeminent lesbian performance artist from southern Michigan."[23]

At once fragile and aggressive, she frenetically skips from one topic to another, but most have to do with gender and sex and the ever-present memory of her mother. Everything seems self-revealing—the wit, the irony, the anger, the deprecating self-references. One cannot help liking her for her craziness, being intimidated by her, wanting to comfort her.

In her performance of *Clit Notes* (1994) Hughes wears a red dress and tells of the first time she was in love with a woman.

Actually, *she* was a *woman;* I was just thirteen. In fact, this little anecdote might have a happier ending if there'd been some sort of gay youth organization in my home town. Some sort of North American Woman-Girl Love Association. But, nooooo!

The men, they get everything good.

The lesbian chicken, who worries about them, huh?[24]

Above all Holly Hughes is a politically committed entertaining comedian akin to Lenny Bruce, who also got into trouble for his "indecency." She tries to combat homophobia by flaunting her homoerotic behavior. While some lesbians were charging that for women to desire women sexually was no different from male heterosexuals desiring women, Hughes made performances out of her sexual desires and practices or, perhaps, the stories are made up—but she accepted the consequences.

Tim Miller, Everybody's Boyfriend

As a high school student in Los Angeles Tim Miller was involved in most of the arts—film, music, literature, theatre, and especially dance. He continued to study dance after high school when he moved to Seattle. In 1978 he moved to New York to study with Merce Cunningham but instead began performing solo, incorporating dancing.

Tim Miller was one of the performers who helped rescue abandoned Public School 122 in the East Village. The school was closed in 1977, and soon artists began using the upper floors as studios. Shortly after, rehearsals were held there. By 1980 it was regularly used for performances curated by Miller and others and came to be known as P.S. (Performance Space) 122. Tim Miller developed some of his early pieces there. Spalding Gray was also involved in some of the laboratory sessions, and Miller says that an important influence on him was the trilogy of Wooster Group works *Three Places in Rhode Island,* which used Spalding Gray's life as its source (see chap. 6).

This autobiographical material "suddenly opened up the world to the incredible specificity of everyone's lives. What we can create from what happens to us can be done cheaply and simply, it's transportable, it's subversive, it's all kinds of things, and can take all kinds of forms."[25]

In 1989 Miller cofounded Highways Performance Space in Santa Monica, California, and continued as the artistic director for several years while writing and touring his performances. He has said that performance in the Los Angeles area attracts him because it "is in a social context, coming from cultural communities: Asian or Latino or lesbian or gay."

Miller is gay, and his monologues always deal in an important way with his homosexual experiences. Like Holly Hughes he is witty and attractive and gives the impression of being completely open about the most intimate matters. Also like Hughes, he satirizes the homophobic attitudes of those who consider him indecent. While his performances are autobiographical, they resonate in the larger political world. He is a member of ACT UP (AIDS Coalition To Unleash Power), an arts organization with a political agenda. Although the NEA gave no official reason for canceling his grant, the cause no doubt was his focus on these subjects, the fact that he is often nude for part of his performances, and that in one of his monologues he said "Jesse Helms should keep his Porky Pig face out of the NEA and my asshole."[26]

Naked Breath, presented in London and elsewhere in 1994, is typical of his recent work. The entire performance consists of Tim Miller talking to the audience. In the dark he comes down an aisle, breathing heavily. The lights come up, and he talks to the audience about breathing. "They say every time you breathe you breathe in a few molecules of air that Leonardo de Vinci breathed. Also of Attila the Hun and Richard Nixon."

He goes into the audience and asks a person to breathe on his palm, then on his heart, then on his dick (it's a joke). He is charming, outgoing, boyish, cute, open, and innocent. He acts out the story of his adult life in a combination of narrative and dialogue. He begins by talking about his boyhood interest in carpentry, which is the one thing he had in common with his dad. He uses only one prop besides the clothes he is wearing—an electric, handheld circular saw.

He tells of going to New York and working as a carpenter to support himself as a performing artist. One day he hits an oak knot while planing a piece of parquet and cuts off the tip of his right forefinger. He quickly goes to a Catholic hospital nearby, and by coincidence it is the day the pope has been shot in Vatican City. Eventually he is tended too, though the nurses consider the injury very minor. He phones John, who takes him home and bathes him. At this point in the performance, Tim lowers his pants and takes off his shirt and is completely naked. A man comes onstage with a bucket, and the man washes him.

He tells of meeting Andrew, going home with him, making love, and the next morning discovering Andrew is HIV positive. Tim is negative. They make love again, even better. Tim says he is still negative. What is really safe?

he asks. Crossing the street? Never getting close enough to touch? He does feel fear at times. You ask, he says, isn't something bad going to happen? No. He and Andrew are still lovers. After telling of the lovemaking with Andrew, he describes the ritual of all rituals: going naked to the kitchen, opening the refrigerator with its weird light, and drinking orange juice. How does this look from outer space? he asks, and describes it from a detached point of view without mentioning AIDS.

In 1997 Tim Miller selected his favorite sections from past monologues and published them in a book called *Shirts & Skin.* He toured across the United States in a show based on the book. The book and the performance talk of his adolescence, his coming out, and gay love in the age of AIDS.

Juliana Francis and *GO GO GO*

Juliana Francis worked as a performer with Reza Abdoh, the Iranian-born radical playwright-director. When he became too ill with AIDS to continue (he died in 1995), she decided to create a solo production influenced by his intense, frenzy-paced, imagistic productions. Her first performance piece, *GO GO GO* (1997), was based on stories she had written about bars in which she had worked as a go-go dancer. Many women working in the sex industry— pornography, prostitution, and the like—had experienced sexual molestation or incest when they were young, and she wanted to deal with their emotional experience as well as her own. This personal material she intertwined with the myth of Erysichthon, from Ovid's *Metamorphosis.* Erysichthon violates a sacred grove of the goddess Ceres and is punished with a hunger that can never be satisfied. To sate his hunger, he sells everything he owns, and then he sells his daughter. In order to escape her fate in the hands of her owner, she changes into undesirable objects and returns to her father, who sells her again and again. Such changing of personae echoes the multiple-personality symptom sometimes triggered by childhood abuse.[27]

In addition to the live solo performance of Juliana Francis, *GO GO GO,* as directed by Anne Bogart, makes use of three TV monitors that show fragments of video clips; recorded voices, music, and loud static; film projection; quick-changing, flexible lighting; and many props carried on and off by Brenden Doyle, another former member of Abdoh's company. Francis's voice is miked throughout most of her loud, energetic, emotional performance. As the audience comes in, she stands onstage motionless. She wears a long white dress and a blond wig with hair that spirals up to the ceiling. Her fingers have long twigs attached like claw fingernails, a reference to the story of Erysichthon. On the monitors are a series of quick-changing video images. They are described in the stage directions as an

> infantilized adult woman on a man's knees . . . The man's face is never visible . . . The infantilized woman is asleep . . . The man pulls open her eyelids . . . The man puts his hands in the woman's mouth . . . The woman

bounces on man's knees . . . Woman is finger-fucked by man . . . Extreme closeup of woman's face: Trance-like . . . A real five-year-old child, wearing a skeleton mask and costume.[28]

The amplified music is often interrupted with loud static that causes Francis to twitch violently. Finally, she falls and screams, and a body mask of breasts and innards is placed on her. When it is removed, she sits facing the audience, raises her legs in a V showing underpants "stuck with bits of matted hair, bits of plastic tubing, stained bits of stuff, blood clots, snails and dead mice." She says, "Don't you WANT me anymore?" Then, wearing a tuxedo jacket, she takes on the persona of a gratingly obnoxious telethon MC. At times an "Applause" sign lights up, and recorded applause is heard. At another point she puts on a teddy that says, "Fuck Me," climbs on top of the large TV and squats repeatedly on a dildo. She goes through the motions of a go-go dancer rubbing herself on a pole. She puts on a jacket with many dolls attached, puts jam on the crotch of one of the dolls, and licks it off (photo 2). Later, topless, she goes into the audience and puts her breasts in the faces of several men, sits on their laps, and squirms in a lap dance. This is done in such an aggressive manner that it is repulsive rather than seductive.[29]

This sharp-edged performance abstractly expresses how her world of child abuse, rape, sex, pornography, and go-go dancing feels. The performance is multilayered. She shifts quickly from one schizophrenic character to another, each relating to some aspect of sex in the United States—abuse, rape, southern belle, go-go dancer, telethon MC using sexiness to raise money against child abuse, prostitution, and so on. Many of them are performed at a high emotional pitch, sometimes genuine, sometimes hyper—as with the MC—sometimes seductive. At times Francis is genuinely sexy; at other times the sexiness turns strident and ugly. The world is fragmented; she is disassociated and alienated from herself, her body an object apart from herself—which may be the way those in the sex industry deal with what they do or are forced to do. At the end of the performance, Francis avoids a phony cathartic healing. Instead, according to Morgan Jenness, who served as dramaturg on the production,

> she wanted to capture something more true to the reality of the cessation of an actual horrific situation. First, she wanted to explore the notion that there is something that is given up: "The girl character [says Juliana Francis] has lost her wings, her magical powers; she's safer than she was, but she's less gifted." Juliana also was aware that this kind of damage never really gets totally resolved. . . . "I wanted the girl character to be slightly aware but in a somewhat disassociative state where she is watching herself escape," says Juliana. So in the final tableau her character sits quietly eating and watching a film of herself running.[30]

2. Juliana Francis, *GO GO GO* at Performance Space 122,
New York, 1996. Photo: Sasha Stollman

Annie Sprinkle, Post-Post-Porn Modernist

While most of these "outrageous" performers deal with the darker side of sex,
with its abuses and the harmful degradation caused by the sex industry,
Annie Sprinkle seems to think sex is taken too seriously. It is fun, a source of
entertainment, satisfying. She acknowledges darker aspects of sex, but they
are not the focus of her work. Instead, her performances spoof sex and those
who are obsessive about it. A serious message lies behind the fun. In an inter-
view with Linda Montano, her mentor, Sprinkle spoke of her background in
relation to sex.

I had nothing to do with sex until I was 17 when I lost my virginity. . . . I thought it was the greatest—so great that I left him so that I could try every other guy in town. So I . . . made myself available. . . . I had to know everything about sex. I had to do it with everybody, in every combination, with as many or as few people as possible. . . . And I knew in my heart that it wasn't a bad thing although sex itself is not always a positive experience. But I knew that I had to do it so I became a hooker, a porn star, and everything but a swinger.[31]

At her performance, *Post-Post-Porn Modernist,* presented as part of the Solo Mio festival in San Francisco in October 1993, colorful condoms are handed out with the programs. The program lists items she has for sale including "Tit Prints," which can be made to order by Annie and "Speculums (with instructions for use)." Sprinkle ostensibly tells the audience about her life and experiences and presents some demonstrations. She wears a low-cut dress, her breasts about to fall out. Before long she takes them out, and they are out for much of the show. With illustrative slides, she tells of having been born Ellen and then becoming Annie. She shows contrasting slides of a plain girl (Ellen) who was very shy and an attractive, sensuous girl (Annie) who was very popular with the boys. The transition in her life, she says, came when she began selling soiled panties by mail. She didn't think many people would be interested, but business was so brisk she couldn't keep up—she figured she had to wear a pair for two or three days. So she got her friends to wear some for her.

She discusses acting in porno films, in which you have to act dumb, and tells other tales from her previous careers. At one point, quite matter-of-factly, she douches at the toilet stage right and then wipes herself. Someone in the audience asks if the toilet paper is recycled. She says she doesn't know, but she leaves the used wad on the floor in case someone else wants to use it.

In a section she calls "Pornstistics" she shows a picture graph with the Empire State Building along side a giant erect penis. She calculates mathematically that if the cocks she has sucked were stacked one on top of the other, they would be as tall as the Empire State Building—not counting the antenna.

Her performances present a lighthearted, permissive attitude toward sex, but ironic and grotesque elements sometimes enter, as when she sucks six or so rubber cocks that are attached to a board. They are of different colors and sizes and she moves rapidly back and forth from one to another. The mood changes suddenly when she says that the first time she performed this section she couldn't keep from crying, and that the second time she became angry.

While *Post-Post-Porn Modernist* is a solo performance, spectators are involved. In the last section before intermission Sprinkle sits on a chair at the front of the stage with legs spread. She inserts a speculum and invites spectators to line up to have a look at her cervix. Her assistant holds a flashlight so the viewers can see better. At the performance I attended, approximately a hundred people, men and women, lined up and filed past. Some had still or video cameras to capture the cervix on film.

During intermission Sprinkle raised money for her new movie by charging interested spectators five dollars for an unusual photograph. She stood behind the spectator with a breast on each side of the spectator's face, smiling beatifically. Each participating spectator received a Polaroid memento of the occasion. Four women having a group picture taken with Sprinkle bared their breasts as well.

An element of subtle ridicule surrounds those who line up to view the cervix or have their photos taken with Sprinkle's breasts, but it is not vicious. And the performance is fun rather than titillating, neither erotic nor pornographic. It is the opposite of pornography, which mystifies sex by way of being erotic; Sprinkle's wit and irony demystify sex.

Annie Sprinkle has made a transition from the sex industry to performance art that she finds satisfying.

> The difference between the art world and the porn world is that now I can really tell the truth without prostituting myself. It's being able to express what I really feel instead of worrying about what "they" want. . . . The only place that is open enough for someone like me is the art world.

Sacred Naked Nature Girls

The Sacred Naked Nature Girls formed in Los Angeles in 1993 to explore through structured, collaborative improvisations the concept of "flesh memory . . . the symbols, language and memories held by and in the body." They christened their group early one morning on a California beach when they "spontaneously shed their clothes during an improvisation at the water's edge."[32]

For the most part, the Girls perform naked. Their work "is situated in naked space to create a primary identification with the body as a central site of performance." They shift between two perspectives, "public women" and "private concerns." Their work comes from a sense of their strength, they say, not the victimization of women. They acknowledge the erotic in their performances and explore the concept of "the gaze."

The Girls' first production, *Untitled Flesh,* was performed from 1994 to 1996, changing somewhat in each presentation. In a performance in San Diego presented by Sushi the audience sits facing a wall of mirrors, looking at themselves, waiting for the performance to begin. Four women dressed in street clothes enter and stand between the spectators and the mirrors, arm's length from the first row. They are Akilah Oliver, an African American, Denise Uyehara, an Asian American, and Danielle Brazell and Laura Meyers, both European Americans.

They undress in a perfectly natural way—no shyness, no attempt to be sexy—and stand facing the audience, looking at individuals. The spectators look at them and see themselves in the mirror watching the naked women. The mirrors are then rolled away, and for the rest of the time the women alternately interact with each other, act out their fantasies in a private world,

assume a character and speak directly to the audience, and interact with the spectators. They chase each other, fall into each other's arms in a version of the trust exercise. Two of them wrestle and end up with one lying atop the other, breathing heavily. In a spoken sequence they overlap in a choral effect, repeating phrases. "I enter the secret dreamscape of women" is repeated, as others add "With blood on my hands." They are also witty. In a section where they each take turns speaking directly to the audience as an invented character, Meyers says, "I'm not a girl, a woman, a broad . . . I am a man. So you can suck my dick." Meyers goes into the audience and gets intimately close, her breasts only a few inches from a spectator's face, and talks seductively. Two of the women fantasize being on a beach, being raped, and having a climax. Two others mime masturbation and orgasm. They put mud on their bodies in patterns and feed each other strawberries. Near the end they go into the audience and feed strawberries to the audience. Except for their initial entrance, they are naked throughout.

The Girls' work is intended to raise several questions:

What is desire? How do we see ourselves? How is the gaze conditioned by external and internal mythic and cultural influences? What is magic? How does the body's memory inform how we come into being as women? What is sexuality? What is power? How do women use and abuse power between ourselves? How are women's bodies appropriated and when is that appropriation abuse? How do we differentiate erotica and pornography?[33]

These questions are raised and spectators are made to think about them. The interest of the group in multiple perspectives is clear from the start. To begin with, they are of different ethnic backgrounds and have different sexual preferences. They are not "politically correct." A performance at the Naropa Institute in Colorado was canceled because the name *Girls* was found demeaning, and their nudity and explicit sexuality also ran counter to feminist doctrine. Oliver says, "We're concerned with the objectification of women's bodies. How do we look at ourselves? How do others look at us? What do we bring to our particular gazes? Performance art should instigate dialogue."[34] The group uses improvisation to draw upon memories and to explore such feminist issues as exploitation. Moments in their performances may be seen differently by different spectators. The women's fantasy rape on the beach—is it violation or sexuality? Are they really being raped, or are they willing participants? Of course, fantasy and actuality differ. Furthermore, no male is present, and the fantasy is part of a performance, not even a "real" fantasy. What is the difference between fantasy and sexuality? Is the performance confessional, erotic, pornographic? Through this multilayered questioning, the Girls provoke their spectators into thought about real issues.

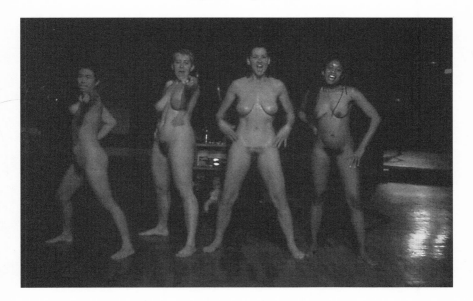

3. Sacred Naked Nature Girls, *Untitled Flesh.* Denise Uyehara,
Laura Meyers, Danielle Brazell, and Akilah Oliver.
Photo: Sacred Naked Nature Girls

Body Mutilation and Performance

In the last decade or so body piercing, tattooing, scarification, branding, cut-
ting, and other body alterations and mutilations have become more plentiful
and more visible. In some forms, they have become accepted into the fashion
mainstream. Body mutilation has long been practiced in other cultures and
our own, where ear piercing, face-lifts, and circumcision are commonplace,
as were tattoos when they were considered a badge of masculinity. But until
the late 1980s other forms of modification largely remained a part of coun-
tercultures. "One thing was clear," said a practitioner, "we had all rejected
the Western cultural biases about ownership and use of the body. We
believed that our body belongs to us. . . . Our bodies did *not* belong to some
distant god . . . or to a father, mother, or spouse."[35] By 1978 interest in tat-
tooing was sufficient to motivate the organization of the first International
Tattoo Convention, which took place in Reno, Nevada.

Fakir Musafar, who grew up in South Dakota, claims to have invented the
term "modern primitives" to describe himself and other atavists who saw
themselves as reclaiming practices of the past. His piercing went well beyond
body decoration. With the help of sympathetic friends he explored the spear
Kavadi practiced by the Tamil Hindus two thousand years ago.

I was pierced by ninety 4-foot-long steel rods in my upper chest and back. I danced for hours with this 50-pound load while I went into a state of ecstasy and drifted out of my body. It was sweet. It was bliss. . . . I repeated "taking Kavadi" many times after that one [experience] and was eventually asked by other modern primitives of several subculture groups to put them in it too. I did it and also acted as a shaman who guided them on trips to unseen spaces.[36]

By the early 1990s tattoos and body piercing were becoming fashionable in the mainstream culture. More recently body alteration and mutilation have become the basis of theatrical performance. The individuals engaging in body mutilation are usually motivated by more than decoration and entertainment, and the artists who practice it as performance are aiming at more than sensationalism. For them these practices are a form of self-expression. Some are atavists, adopting a practice of an earlier time; some find ecstatic experience. For some the pain may provide the kind of repentance that comes from flagellation; some, for whatever psychological or aesthetic or political reason, feel the need to explore their bodies in this manner.

Some of the performers described in part 1 of this book (see chap. 6) are precursors to these self-mutilators. Chris Burden's performances involved bodily risks and sometimes pain. Linda Montano inserted needles into her face for a performance about her reaction to the violent death of her estranged husband. One of the Kipper Kids punched himself in the nose until he had a nose bleed. More recently several artists have created performances embodying some of these self-mutilating practices.

A French performer who calls herself simply Orlan has demonstrated that a common surgical practice can be framed as performance. Beginning in 1990 she set out to make her series of cosmetic surgeries an ongoing performance under the title *The Reincarnation of Ste. Orlan.* Her intention was to reconstruct her facial features to resemble those of subjects in well-known works of art so that she would have, for example, the mouth of Boucher's Europa, the forehead of the Mona Lisa, the chin of Botticelli's Venus, etc. (Commentators have pointed out that altering one's appearance through surgery so as to conform to ideals of various periods is not much different from undergoing cosmetic surgery to conform to contemporary ideals.)[37] Orlan is operated on while under local anesthetic so she can direct dancers, music, and costumes. Videotapes of the process are made and sold. Her seventh operation took place in New York in 1993 and was relayed by satellite to art galleries internationally where spectators could watch and communicate with her electronically.

The Jim Rose Circus Sideshow revives the spirit of the sideshows that toured the United States from about 1840 to 1950. According to Rose they died out because gradually they substituted hoaxes and cons for authentic human feats. The feats in the Jim Rose's show are genuine and are performed in the semicomic, weird spirit of the earlier tradition. Some of the acts could

not have been shown publicly in earlier times, and their gruesomeness causes spectators to faint at nearly every performance.

Rose is the son of a circus clown who worked as a street performer in California, swallowing swords, razor blades, and lightbulbs. In 1991 in Seattle he assembled other performers and formed the Jim Rose Circus Sideshow, which has toured widely in the United States and Europe. Strung together with witty patter from Rose, the show consists of a series of fast-paced, bizarre events. Rose himself hammers a nail into his nose and lies on his face in broken glass while a spectator stands on his head. The other acts are equally grotesque. Tube, later billed as Enigma and tattooed with a jigsaw puzzle over his entire face and torso, is force-fed through his nose a concoction of beer, chocolate syrup, and ketchup. It is then pumped out of his stomach, poured into glasses, and offered to members of the audience. Slug is fed a meal of live maggots, worms, crickets, and slugs. Torture King eats lightbulbs, pierces himself with pins and needles, and pushes a barbecue skewer through both cheeks. Mr. Lifto lifts a variety of heavy objects with rings in different parts of his body. He suspends concrete blocks from rings in his nipples, a car battery from his tongue, and, for a finale, lifts a steam iron attached to a ring in his penis (photo 4).

Why is the audience interested in these feats? It is because "humans are curious," Rose says. "They're curious about the human body. That's one subject anybody anywhere in the world has input on. Why are they curious? They live in one."[38]

Ron Athey: Self-Mutilation as Religious Experience

In 1994, while Congress was considering the NEA budget for 1995, the religious Right found another kicking boy to parade before lawmakers and the public in an attempt to eliminate the Endowment. The new weapon was Ron Athey, whose performances draw upon his turbulent life. Trained in childhood as a Pentecostal minister, he became a heroin addict, is HIV positive, is a member of the "modern primitive movement," and has a fascination for pain, tattooing, scarification, body piercing, and bloodletting. The brouhaha resulted from a performance of *4 Scenes in a Harsh Life* in March 1994 under the sponsorship of the respected Walker Art Center in Minneapolis. It has been estimated that the portion of the Walker's NEA grant that was used for Athey's fee was less than $150. That was enough to cause an uproar and put the NEA in jeopardy.

4 Scenes in a Harsh Life had been previously presented in Los Angeles, and it varies depending upon the circumstances of performance. In one version five men and three women participate. All the performers are tattooed, and at some point during the performance all are pierced by needles. Athey's tattoos cover his arms, legs, back, and chest. All the men's heads are shaved bald. One of the women is bald; the other two have short-cropped hair. Sometimes

221

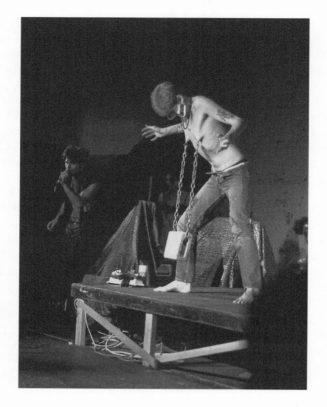

4. Mr. Lifto of the Jim Rose Circus Sideshow. Photo: Roger Nieboer

they are completely nude; sometimes they wear loincloths or jockstraps, but rarely are they completely clothed.[39]

In the opening scene Athey, dressed as a turn-of-the-century holy woman, stands at a pulpit. Beside her is a naked woman who suggests St. Sebastian, with a dozen or so "arrows" resembling barbecue skewers inserted through the flesh on her sides, arms, and legs. Athey, reading from a text, describes a childhood experience of being taken to the Mojave Desert to see a woman with stigmata and his disappointment that the blood did not come. Athey removes the "arrows" from the body of the woman.

It was the following scene, including the section called "The Human Printing Press," that caught the attention of the press, the religious Right, and the U.S. Congress. In it Athey as the factory worker called Steakhouse Motherfucker is at a strip joint, relaxing after his day's work. Divinity Fudge, an African American drag queen, is wearing a balloon dress. As she dances, Steakhouse Motherfucker pops her balloons with his cigar, then puts the cigar out on her behind. Two factory workers strip Divinity Fudge and strap

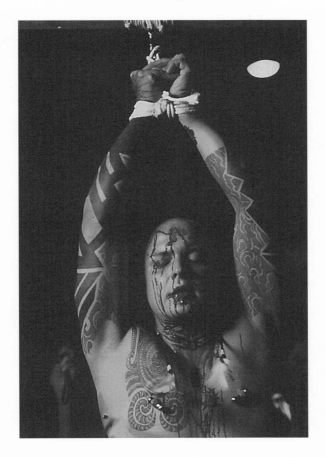

5. Ron Athey, *4 Scenes in a Harsh Life.* Photo: Jim McHugh

him down. Athey then carves an African scarification pattern into his back with a knife, blots the bloody pattern with paper towels, and attaches them to a clothesline rigged on pulleys. Then the "printed" paper towels are pulled out above the aisles over the audience.

In subsequent scenes the performers engage in other sadomasochistic activities. Athey enacts an intravenous drug-user in withdrawal convulsions. He inserts about twenty hypodermic syringes into his arm and sticks other needles into his scalp, which causes blood to trickle down his face. In the final scene Athey officiates at a wedding ceremony. The three brides are naked except for loincloths, and dozens of bells have been attached to their bodies— chests, breasts, backs, legs—by needles. Athey talks of having grown up with sounds of people speaking in tongues and having fits of religious ecstasy. He tells of having renounced his religious heritage, of his heroin addiction, and

of his salvation in a metaphorical church of self-flagellation. To the beat of drums played by the men, the women dance wildly until exhausted as the bells bounce up and down and side to side, making their bodies bleed. From time to time they and the men scream. Athey says, "There are so many ways to say Hallelujah."

The performance, according to Athey, "explores the role personal fetishism plays in our sanity. Understanding fetishism as the mantra, the obsession. Linking tattooing, scarification, and primitive ritual to leather, white weddings and evangelism. And further, acknowledging the role of self-destruction."[40] "I think there's something inherently spiritual in what I do that makes it a ritual. It's like a public sacrifice, I think. It is really parallel to doing penance."[41]

Shortly after the Minneapolis performance, complaints were made to the health department, and a reporter wrote about the incident. When the report went out over the Associated Press newswire, the event received national attention. The flame was blown up into an inferno because of the political controversy about the NEA budget. The Christian Action Network issued a "declaration of war." In the imagination, homosexual blood (most reports said "AIDS-infected blood") passing over the heads of spectators was a volatile image that Athey believes played upon not only a "disease phobia" but also a "body phobia," which Athey sees as the root of homophobia.[42] The enemies of the NEA used these fears to their benefit. Again, some members of Congress wanted to eliminate the NEA altogether. When a budget was finally passed, the NEA funds were cut nearly 5 percent.

In October Performance Space 122 presented the production in New York but took special precautions to avoid jeopardizing its NEA grant and to preclude lawsuits. Fees were paid from private sources rather than the NEA, and each spectator signed a "Release and Waiver of all Claims."

I understand that in tonight's performance of *4 SCENES IN A HARSH LIFE* by Ron Athey blood will be drawn and prints from it will be exhibited as part of the performance. By entering the performance, I agree not to hold liable Ron Athey, Performance Space 122 or its staff or Board of Directors . . . for any injuries, property damage or incidents of any kind that may occur in connection with performance.

And a registered nurse was on hand.

CHAPTER 9

Social Commitment

In 1985 Julian Beck died. He had been cofounder with Judith Malina of the Living Theater, which, since its politicization in 1964, had promoted their anarchist pacifism on an international scale (see chap. 2). Although since Beck's death the company has continued under the direction of Malina, the work is less startlingly confrontational. The 1980s also brought to an end a particularly active era of socially committed theatre. The late 1960s and the 1970s had spawned many theatres advocating social change, driven especially by the Vietnam War and the civil rights movement, but the energy of the alternative theatres in the 1980s came to be directed toward individual expression and subjective artistic visions. Some socially conscious theatres, including El Teatro Campesino, faded; others, like the San Francisco Mime Troupe, struggled, changed, and survived.

So long as there are theatre artists who perceive injustices, there will be theatres advocating change. So it was in the 1980s, even though such theatres were in the decline. In the 1990s the pendulum swung toward a greater concern for social issues, and small companies and solo performers dedicated to changing society, or at least pleading their cause, reemerged. Marginalized groups including African Americans, Latinos, Chicanos, Asian Americans, Native Americans, Jews, gays, lesbians, and the homeless increasingly use theatre to present their concerns and create communities. Some of these groups have been quick to make use of inexpensive electronic communications—e-mail, web sites, and list servers—to extend their constituencies and develop communities at geographical distances.

Some groups such as New Jersey's Crossroads Theatre Company, founded in 1978, continue to explore and celebrate African American culture and its

225

interconnection with other cultures. The company has premiered produc-
tions of plays by black Americans such as George C. Wolfe *(The Colored
Museum* and *Spunk)*, Ntozake Shange *(The Love of Space Demands)*, and
Leslie Lee *(Black Eagles)*. The company's cross-cultural goals led to a joint
production with the Oregon Shakespeare Festival of Pulitzer Prize–winning
poet Rita Dove's *Darker Face of the Earth* (1997), which sets the Oedipus
story in the antebellum American South (photo 6).

Another organization with cross-cultural aims is Cornerstone Theater
Company, formed in 1986 as a touring group that has now settled in Los
Angeles. During the first four years it created twelve projects in ten states,
staying a few months and creating a production with each community before
moving on. In Marmarth, North Dakota, population of 190, the company
produced their version of *Hamlet* (1986). In Port Gibson, Mississippi, a town
of 2,371, the group produced an adaptation of *Romeo and Juliet* (1989)
involving more than fifty local residents, who worked together with members
of the company. The obstacle between the young lovers was race: Romeo was
a black eighteen-year-old Port Gibson high school student and Juliet a white
member of Cornerstone (photo 7). In 1991 the company brought together
performers from the communities in which they had worked to produce *The
Winter's Tale: An Interstate Adventure,* which toured, presenting outdoor
performances in towns and cities across the country. In 1990, after moving to
Los Angeles, which is one of the most culturally diverse cities in the coun-
try—they created collaborative productions with a variety of ethnic commu-
nities, black, Latino, Asian, and Arabic among others.

The name of LAPD (Los Angeles Poverty Department) is a spoof on the
initials of the Los Angeles Police Department. The company formed in 1985
and comprises primarily homeless and formerly homeless people brought
together by director John Malpede to develop productions in night shelters,
theatres, and outdoor spaces in the skid rows of American cities. The com-
pany is dedicated to telling the real story of life on the streets. Malpede
believes artists should be going out into different parts of our culture and, like
firefighters and nurses, giving of themselves. "As long as artists have 'more
important' things to do than give to others, they will continue to operate
from the child's point-of-view: me, me, me. . . . Art should not be used/abused
as a defense from life. It should be a surprise result from the tumult of liv-
ing."[1]

In 1980 Lois Weaver and Peggy Shaw, who had worked with Spider
Woman Theatre and Hot Peaches, organized the first Women's One World
(WOW) Festival in New York's East Village and gave the name to the WOW
Café there, a women's center and space dedicated to women's performance.
Together with Deborah Margolin, Weaver and Shaw presented their play
Split Britches (1981) and took the title as the name for the group they formed
to create feminist performances. The group continued to be associated with
the WOW Café, which became one of the most important venues for feminist
and openly lesbian performances.[2]

6. *The Darker Face of the Earth.* Narrator (Saidah Ekulona),
Musician (Ron McBee), Diana/Dancer (Jacquelyn R. Hodges).
Photo: Crossroads Theatre Company

The typical alternative theatre in the late 1960s and the 1970s was a collective that created work collaboratively, but in the 1980s and 1990s the number of solo performers increased, stimulated in part by budgetary restraints. The African American John O'Neal, who in 1963 was a cofounder of the Free Southern Theatre, in 1980 began working solo, touring the country telling stories as the bodacious Junebug Jabbo Jones. The material for such solo pieces as *Don't Start Me Talking or I'll Tell Everything I Know* and *You Can't Judge a Book by Looking at the Cover* comes from his own experience, his imagination, folklore, and research into African American life. O'Neal's acting style is similar to that of commedia-based companies such as the San Francisco Mime Troupe and El Teatro Campesino. He does not immerse himself in the character, but remains partly outside, enjoying the scene along

7. Cornerstone Theater Company, *Romeo and Juliet.*
Juliet (Amy Brenneman), Romeo (Edret Brinston).
Photo: Cornerstone Theater Company

with the audience. "When you put on a character," he says, "it's like putting on clothes. You use whatever experiences you've had as the fabric of the fiction, but at the same time it's very important for us as performers to distinguish the artist from the artifact."[3] In the spirit of the trickster, confronting cheating plantation owners, promoters of Jim Crow laws, or macho cowboys, Junebug outwits them all.

Robbie McCauley, another African American performer, always has a "personal and political investment" in her work.[4] She complains that theatre in the United States "is not committed deeply enough to its own stories," a concern reflected in her work.[5] Born in the South, she was affected by racism there and later in New York. Her early work, *Confessions of a Working Class*

Black Woman, was a series based on the experience of her family, beginning in the nineteenth century. In the late 1980s she helped create *The Buffalo Project,* which was researched by the actors who interviewed people who had experienced the Buffalo riots of 1967. In the 1990s she created works on other historical racial conflicts: *Mississippi Freedom,* about the 1964 voting rights struggle in Mississippi, *Turf,* about forced busing in Boston in 1974, and *The Other Weapon,* about the Black Panther Party in Los Angeles in 1969. She based each on interviews with participants, much as Anna Deavere Smith was doing in the 1980s and 1990s.

In San Francisco another African American woman, actress-singer-dancer-writer Rhodessa Jones, not only makes use of events in her life, but also adapts material from prison inmates with whom she sometimes works. Jones, one of thirteen children of an itinerant farmworker, and sister of the dancer Bill T. Jones, gave birth to a daughter at sixteen. As a single mother she worked as an exotic dancer and in the glass booth of a peepshow in the sleazy Tenderloin district. It was this experience, she says, that led her to start writing. Her subject matter has always been sex, and women as sex objects. Her first composition was a one-woman show called *The Legend of Lilly Overstreet* in which she sang, danced, stripped, and delivered a sexy monologue. While performing this piece she met a jazz musician, Idris Ackamoor, with whom she teams up for some of her performances. In 1987 she began working in the San Francisco County Jail, first teaching aerobics to the women prisoners and talking about her life. Soon the prisoners were telling their stories, and Jones began developing characters based on them—Crazy Deborah, the addict, who for her own safety was kept separate from the other prisoners because she had killed her baby; Regina Brown, the foul-mouthed alcoholic prostitute; Doris, the thumb-sucking child-woman; Mama Pearl, the wise peacekeeper; and others. *Big Butt Girls, and Hard Headed Women* was a solo piece based on this experience. In 1990 Jones founded the Medea Project to help the inmates develop their own shows that, with the blessing of the county sheriff, were performed in local theatres. Her hope is that the audience will take away from her performances "personal empowerment," the "freedom to examine grief," and "permission to embrace anger."

> Hopefully, people will be encouraged to take more of a moral, social responsibility [and] get closer to their own humanity and consequently be much more susceptible and open to how different we all are.[6]

While performances such as those by Cuban American Carmelita Tropicana, alter ego of Alina Troyano, may not consciously aim at social change, they do have the purpose of celebrating their uniqueness, spoofing puritanical seriousness about gender, and breaking down stereotypes in an entertaining, satirical way. Carmelita Tropicana is a lesbian who first began performing at WOW Café. She went there, she says, "looking for girls and found something more long-lasting: theatre." At WOW she found "all kinds of

women, in all kinds of clothes and haircuts and colors—not just your battle-fatigue serious feminist! It was wonderful. And they had a sense of humor!" Ironically, some white feminists, she says, were offended because they thought Carmelita Tropicana was too much of a Latina stereotype.[7]

Three important groups concerned with social issues are examples of the variety of approaches of groups in the 1980s and 1990s. The productions of the San Francisco Mime Troupe present a clear point of view and directions for action. Anna Deavere Smith does not consider herself a social activist; she confronts issues arising from social conflicts and presents them without solutions but with an implicit call for cross-cultural understanding. Guillermo Gómez-Peña works with an ironic perspective, sometimes involving the interaction of spectators. Although his aim may resemble earlier political theatre, his means are quite different.

The San Francisco Mime Troupe

The San Francisco Mime Troupe is probably the longest-surviving political theatre in the United States and the most honored (see chap. 3). It has been awarded a special Tony for "Outstanding Contributions to the American Theatre" (1987) and has received three Obie (off-Broadway) Awards as well as numerous Drama-Logue Awards.

Founded in 1959, the troupe began performing outdoors in the parks in 1962. Many of the shows are still intended to be performed outdoors, and the style remains commedia-melodrama but they have become more nuanced, have fewer black-and-white hats, and more psychologically complex characters—"more up close and personal," according to Joan Holden, the troupe's principal playwright until her retirement in 2000. They have also experimented with other styles adapted from Asian theatre.

Over the years the San Francisco Mime Troupe has targeted the most urgent social problems and conflicts in the Bay Area, the United States, and beyond. Most recently the troupe's focus has shifted to the global economy and its effect on the distance between the world's poorest and richest. A 1996 flier asking for donations states the recent aim of the gadfly company.

When "economic recovery" leaves millions homeless and a fifth of our children in poverty; when destroying public services is called "reinventing government"; when "reaffirming America's values" means building fences along the border, the work of gadflies is vital to the national health. Since the early 1960's, the San Francisco Mime Troupe has toured the Bay Area and the nation with original satires that decode the official story: exposing the CIA/drug-trade connection, predicting the disastrous results of Reaganomics, reporting U.S. secret wars, showing who pays the price for free trade.

Joan Holden says that during the Vietnam War and for a time after, political activists like the Mime Troupe members "weren't very sophisticated."

We felt we could do anything. I went to the Peoples Constitutional Convention and actually half-allowed myself to believe we were going to write a new constitution for a government led by the Black Panther Party. To a kid today, believing that would seem absolutely ridiculous.[8]

"Our inspiration is as political as it ever was," says Holden, "but the world has changed, and our understanding of things has changed. The work we do reflects that understanding."[9]

The structure of the company, which ranges between ten and fourteen members, has continued to be a collective. The collective serves as artistic director and producer responsible for hiring, firing, and financial decisions. The company as a whole, through discussions of the pressing social issues, determines the subject for the next play. Except for a professional manager, which the company has had since about 1980, no one has a formal title. By tradition Joan Holden has been the principal playwright and Dan Chumley the principal director. However, in recent years Holden has frequently asked others to collaborate with her in the writing of the scripts, thus teaching others her craft.

The financial history of the San Francisco Mime Troupe is similar to that of some other alternative theatres—especially those with political agendas. In the 1960s they were sponsored by radical student groups. In the 1970s they were sponsored by community organizations, such as tenants unions and food co-ops, who presented the Mime Troupe, sometimes using money they had received in grants. In the 1980s and the first half of the 1990s the troupe, like many other alternative theatres, came to rely heavily on the National Endowment for the Arts. In addition to grants from other NEA panels, the Mime Troupe and several other companies received major three-years grants intended to support ongoing ensembles. They were doing well until the cuts came in the mid-1990s, when they not only lost their NEA grants, but saw the organizations that had presented the troupe lose theirs as well. The troupe lost one hundred thousand dollars in one year and has been scrambling to make it up, Holden says. "We knew it was coming, but we have lots of bridges to cross; you can't worry about the one down the road when you're trying to cross the one right in front of you."

The financial crisis made it necessary to reduce free performances in the parks by half, and the troupe went in search of funds from two other sources: individual donors and from foundations and government agencies promoting youth programs. In 1994 for the first time the Mime Troupe accepted a commission from the government. The San Francisco Health Department commissioned a play on the harmfulness of tobacco for high school audiences. An initial grant of eighty thousand dollars led to the musical comedy satire *Revenger Rat Meets the Merchant of Death.* "High schools are supposed to be the toughest audiences," says Holden, "but our style really works. It was dynamite."

In their research for *Revenger Rat* Holden and the entire company visited

8. *Revenger Rat Meets the Merchant of Death,* 1997 spring tour.
Photo: Ben Martinez

high schools to gather information about students' smoking and lifestyles. Some of the dialogue was taken from these encounters. Ultimately the production was presented thirty times to an audience of twelve thousand for a budget of $108,000.[10]

Rather than focusing on the harmfulness of smoking, the play focused on the cynical demographic manipulation by tobacco companies of vulnerable groups, especially young smokers. It was inspired by the success of the advertising character Joe Camel. A three-year study of adolescent smoking reported in the *Journal of the American Medical Association* found that Joe Camel was the most popular advertising device and estimated that 34 percent of smoking by this group "could be attributed to tobacco promotional activities. Nationally this would be over 700,000 adolescents each year."[11] In the fifty-five-minute musical the protagonist, a young comic-book artist, despairs because his antiauthoritarian superhero comics cannot find a publisher. An ad agent offers to publish and distribute the comic book, making only one condition: in every frame Revenger Rat must be smoking a "Duke" cigarette. The young artist agrees and dismisses the danger, but finds he must make a moral choice when teenagers begin smoking in record numbers, attracted by the "cool" image of Revenger Rat.

The success of this project prepared the troupe to work more directly with high school students. The next year (1995) supported by the Rockefeller

Foundation, the Mime Troupe undertook a joint project with the San Francisco State University Theatre Department to work with high school teenagers in after-school workshops. The students created plays that were presented in February 1996 at Cowell Theatre. These youth-created plays inspired the Mime Troupe to create *Gotta Getta Life* (1996), which synthesized their themes, content, and characters, and they toured the production to high schools. Gregory R. Tate, the principal writer of the script, said, "Working with all these young people—80 all told—hearing their stories and what they feel are the stresses in their lives, has been an eye-opener." And director Keiko Shimosata added, "They have life stories many adults and parents can only guess at. They want to tell them—they hunger for the tools that will show them how."[12]

The forty-five-minute musical is atypical for the Mime Troupe. While it has a social focus, it is not concerned with broader political issues. It is about high school students and for high school students. In *Gotta Getta Life* Thelma, the African American leader of the Eight Ballers girl gang, warns Anastasia, a recent Russian immigrant, that she's on gang turf. Thelma is trying to break out of the cycle of drug abuse and violence and make a life for herself. When her boyfriend, Mark, puts a move on the new Russian girl, gossip and misunderstanding result in an explosive conflict.

The process of helping high school students to develop and produce their own plays continues and has become the Annual Youth Theatre Festival. And the Mime Troupe again in 1997 used these plays—plot ideas, characters, and language—to make its own play for touring to schools.

While their work in schools and, more recently, in prisons has been important in several ways, the principal productions of the company have recently dealt with the globalized economy, and frequently they have been created with an international cast.

From the early 1970s the Mime Troupe conscientiously selected new members so as to create a multiracial company and chose themes reflecting the concerns of its membership. However, except for *The Dragon Lady's Revenge* in 1971 (see chap. 3), they had not made a play dealing with Asia. An Asian American member of the company requested one, leading in 1993 to *Offshore; or Why You Should Read the Business Page,* which was performed not only in the United States but toured to Asia. The play reflects the two developing interests of the Mime Troupe: the destructive side of a global economy and international collaboration. Another factor had been brewing for some time: the troupe wanted to find an alternative to their commedia/melodrama style that had served them well since the late 1960s. These three aims were served in *Offshore.* Dan Chumley, the principal director of the troupe, had traveled to various parts of Asia, talking to theatre people, and came back with the idea that the play should be a fusion of Kabuki and Chinese opera in acting, costumes, dance, and music.[13]

A double question triggered the story: Why are many jobs going to Asia, and why are many Asians leaving home and coming to the United States?

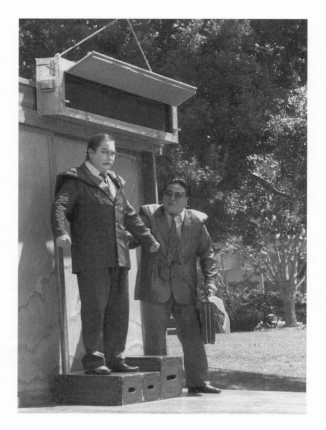

9. *Offshore; or Why You Should Read the Business Page,* 1993.
In Tokyo, Japanese tycoon (David Furumoto) stands his ground as
underling Ninkitori (Kelvin Han Yee) hears of the tycoon's plan
for him to marry his daughter. Photo: Jillen Doroan

Holden says the answer to both parts of the question is the same: cheap
wages. The characters include a Japanese tycoon who is trying to corner the
American market for a high-tech product; a California factory owner who
can't compete with him; the tycoon's daughter, who is forced to sacrifice love
and to marry for business reasons; her lover, an American bar hostess, who is
the mistress of the tycoon; and the hostess's father, a security guard at the
doomed factory.

The company for *Offshore* was augmented by Asian Americans from San
Francisco and by guest artists from Taipei, Tokyo, Hong Kong, and Manila
who contributed as playwrights, choreographers, and dramaturgs. Five writ-
ers collaborated on the script; there were four choreographers; and five musi-

cians created the score, songs, and music. A dance movement vocabulary, based on Asian models, was invented for each character. One of them moved as the Monkey King of Chinese opera; the security guard's movement came from the Kabuki clown-servant. The mom's movement was based on Chinese opera, and when the negotiator and tycoon meet in Tokyo, they confront each other as Kabuki samurai. The musicians improvised on ancient Japanese and Chinese melodies and fused them with American models. The security guard's theme, for example, was a Chinese folk song played like American country music.

When asked if the Mime Troupe in appropriating these theatrical styles was not exploiting Asian cultures and giving nothing in return, Holden offered a thoughtful but firm answer.

> With all respect to the sensitivities created by colonialism, people who raise this issue had better take off their Levis, stop making movies, and stop listening to rock and roll. . . . Unlike natural resources, cultural ones aren't depleted by use, only by neglect. Cultural cross-pollination is an old trade; it's the good side of globalism. The Mime Troupe will continue its explorations of Asian theatre.[14]

Holden believes that soon there will be no areas of the world untouched by the global market and that the result will be a widening gap between wealth and poverty. Nevertheless, she is hopeful because a grassroots internationalism is engendered by globalization, facilitated by the same communication technology that creates a worldwide market. "People won't defeat the oppressor on the battlefield, but instead will make the moral cost for the oppressor so extreme that the empire can't continue to oppress."

This idea is reflected in *13 Dias/13 Days—How the Zapatistas Shook the World* (1997) inspired by the first thirteen days of the Zapatista revolt in 1994 of Mayan peasants in the state of Chiapas, Mexico, who reacted against the North American Free Trade Agreement (NAFTA) between Mexico and the United States. They took seven towns to demand land rights and protest provisions of the treaty. Holden points out that it was the first organized revolt against the globalization of the economy. The Zapatistas used the Internet to inform the world of their ideas and actions, leading to peace talks with the Mexican government. "Why has the Mexican government not crushed the Zapatistas?" Holden asks. "Because the whole world was watching."

A collaboration between the Mime Troupe and Borderland Theater of Tucson, Arizona, *13 Dias* uses satire, video, and music based largely on the traditional Mexican corridos and ranchero music to tell of the impact of the Zapatista revolt on characters from both sides of the border. An Indian villager and a priest attempt to get a communal cornfield returned from a local cattle baron who is using it to fatten cattle for the fast-food market. The revolutionary figure from the past, Emiliano Zapata, steps in to provide historical perspective on the 1994 events.[15]

While *13 Dias* is more realistic than most previous Mime Troupe productions, it is still boisterous, funny, full of music, and sympathetic to those who suffer as a result of the capitalist global economy. Like other recent Mime Troupe works, it is bilingual, and it uses family relationships to address political economic issues. Since World War II, Holden remarks, theatre in the United States has been smothered in family issues that reduce the scope of our vision and tell us nothing of the causes of our common problems.

The San Francisco Mime Troupe continues to experiment to develop a theatrical style that is popular and international. In *13 Dias* the troupe incorporated Mexican music and singing. In *Offshore* they experimented with Japanese Kabuki. The group hopes to work with a Chinese master to develop a big production that will fuse the troupe's own style with classical Chinese opera. Holden believes there is a common international gestural language.

There is a place where popular theatrical thoughts merge—Chinese opera, Kabuki, and Indian theatre have aspects that are totally arcane and don't read, but there are common elements as well. We want a style that crosses borders, that is global. It will have elements of Eastern and Western theatre.

The troupe's international collaborations *Offshore* and *13 Dias* not only reflect its view of a global economy but its interest in developing a popular global theatrical form.

Anna Deavere Smith

Anna Deavere Smith first gained attention by performing her solo multi-character plays based on interviews with individuals concerning their personal experience with controversial events or subjects. In this series of performances, under the umbrella title *On the Road: A Search for American Character,* she was trying "to use the ambiance and techniques of theatre to inspire discussion about the events of our time."[16] Although she had been presenting these solo performances since 1982, her work first became well known through *Fires in the Mirror: Crown Heights, Brooklyn, and Other Identities,* which, in its early form, premiered at the Joseph Papp Public Theatre in New York in December 1991 and in 1993 was seen nationally on PBS television.

Anna Deavere Smith grew up in Baltimore, the daughter of middle-class African American parents. She attended a predominantly white private women's college and, after graduating in 1971, moved to San Francisco, where she received a master of fine arts degree and acted at the American Conservatory Theatre. Frustration with the limitations of traditional theatre led her to find another model. In Johnny Carson's *Tonight Show* and other television talk/interview shows she discovered some of the techniques that she used in the creation of her own productions.

236

In *Fires in the Mirror* Smith portrays more than twenty African American and Jewish people selected from the many she interviewed. The event that was the impetus for *Fires in the Mirror* took place in the Crown Heights area of Brooklyn, New York, in August 1991. A car carrying a Jewish religious leader, a Lubavitcher Hasidic rebbe, ran a red light, collided with another car, and swerved onto the sidewalk, where it struck two children. A seven-year-old black boy, Gavin Cato, was killed. The relationship between Jews and blacks in the area was already tense, and the black community exploded in violence against the Lubavitchers and the police. Three hours later a group of young black men took revenge by stabbing to death a twenty-nine-year-old Hasidic scholar named Yankel Rosenbaum, and for three days the riot continued with black people fighting police and Lubavitchers, burning police cars, and torching businesses; some Hasidim responded with violence as well.

What Smith is "ultimately interested in is the struggle . . . that the speaker has when he or she speaks to me, the struggle that he or she has to sift through language to come through." In each interview she tries to be inclusive. "My experience of the interviews I included was that there was an 'us' before I left." She studies her subjects, observes them, listens to them, tape-records them, studies the tapes, and using verbatim excerpts distills their personality traits, vocal inflections, gestures, and body language into the characters she enacts onstage. She likes to use a section of an interview without interruptions, "a section in which their psychological through-line is reflected in language." She makes no judgments about the people she interviews. She cares about them and wants to know what they think and feel. Her intention, she has said, is to "capture the personality of a place by attempting to embody its varied population and varied points of view in one person—myself."[17] The characters she portrays are presented honestly, without caricature or parody, but with understanding that has come from spending time with them. She says it is not her job to like or dislike the people she interviews, but to love the characters she makes of them.

In the ninety-minute performance Smith, as the characters, usually speaks directly to the audience, as the interviewees must have done when talking to her. They express their beliefs about the event, sometimes eloquently, sometimes haltingly. Smith makes quick changes of costume parts—a hat or jacket—to help suggest the physical appearance of each of the characters. But the characters are distinguished primarily by the actor's embodying the traits she has studied.

> I can learn to know who somebody is, not from what they tell me, but from *how* they tell me. This will make an impression on my body and eventually on my psyche. Not that I would understand it but I would feel it. My goal would be . . . to become possessed, so to speak.

The monologues are arranged in a structure that is balanced between the two sides of the issue and follows events chronologically, focusing on the back-

ground, the car crash, the riot, and the aftermath, followed by a kind of epilogue.

The first section presents the background to the conflict and information on cultural differences.[18] A human rights commissioner gives demographic data on Crown Heights. The Hasidim comprise only 10 percent of the neighborhood, while the African Americans and Caribbean Americans make up the dominant culture. A Lubavitcher Woman in her home is wearing a bandanna and holds a dustcloth. We learn in an amusing way a Lubavitch belief that sets them apart from blacks in the neighborhood. The Woman's baby accidentally switched on a blaring radio during Shabbat, and the Torah forbids turning a mechanical device on or off on this day, so she went into the street and found a little black boy and got him to turn off the radio. As Reverend Al Sharpton, the civil rights activist, Smith wears a double-breasted pin-striped suit and explains that he wears his hair the way he does as a tribute to James Brown. Smith wears a bow tie to play Minister Conrad Muhammad of the Nation of Islam, who tells us that the condition of the black man in America is due to the devilment of the Caucasian people and that while the Holocaust was "a stink in the nostrils of God," many more died on the slave ships. This speech is balanced with a monologue by a Jewish woman who tells the story of her Uncle Isaac, who in Germany had been selected by his community as a designated survivor who would be able to tell the world of the Holocaust. And as Professor Angela Davis, Smith paces back and forth as she gives a lecture on colonialism.

The section on the car crash and death of Gavin Cato is largely devoted to Rabbi Spielman (in black hat, glasses, suit jacket, and tie) and an anonymous black Young Man wearing a cap and sitting sprawled in a chair. For the PBS broadcast the speeches of the two are arranged into a kind of dramatic conflict, with Smith shifting back and forth between the two characters. Rabbi Spielman takes the side of the Hasidic driver, who, seeing he was going to hit someone, steered into a building and for the most part avoided injuries to pedestrians—but regrettably, one child was killed. The Young Man saw the car weaving and running a red light. "First we was laughin, right? They can do anything and get away with it. . . . And then, then, we regretted laughin cause 'Watch the kid, man. Oh, my god.'" The Young Man believes the driver was drunk and should have been arrested.

Spielman says two ambulances arrived—a city ambulance and a Hasidic-owned ambulance. The police, seeing that the passengers of the car were in danger from the crowd, asked the Hasidic ambulance to take them away. But the Young Man saw a different story. The ambulance ignored the dying boy and took away the Jews. Spielman relates that three hours later a young Jewish scholar, Yankel Rosenbaum, was set upon by a group of about twenty young blacks, egged on by a man of about forty, who was saying, "Kill Jews. Look what they did with the kid. Heil Hitler." And they stabbed Yankel. The story that the car had run a red light and the ambulance had ignored the boy was spread maliciously to start a riot. The Young Man believes the driver was

drunk, but "words don't mean nothin as black people in Crown Heights. You realize, man, ain't no justice, ain't never been no justice, ain't never gonna be no justice."

The section concerning the riot and the aftermath begins with Henry Rice, a black youth coordinator, who tells of going through the streets during the riot and urging kids to be peaceful, to go home, when he was hit on the head by a policeman. Michael Miller of the Jewish Community Relations Council says that at Jewish events sorrow was expressed for Gavin Cato; but at Gavin Cato's funeral not a word of condolence was offered to the family of Yankel Rosenbaum. "Frankly it was more a political rally than a funeral. But Heil Hitler! from blacks. Hitler didn't finish the job in Crown Heights. Better turn on the ovens again." Richard Green, executive of Crown Heights Youth Collective, acknowledges the rage among black kids, but they don't know who Hitler was; the only history they know is Malcolm X. At a rally in New York the brother of Yankel Rosenbaum says his brother's blood cries out from the ground for justice, but only one of the twenty who attacked Yankel has been arrested. Anonymous Young Man #2, wearing hooded rain gear, believes the sixteen-year-old who was arrested is innocent.

> That 16-year-old didn't stab that Jew. He was a athlete. A bad boy stabbed that man. . . . He's not interested in stabbin people. . . . Somebody who's groomed in badness or did badness before stabbed the man. Because I used to be a athlete and I used to be a bad boy and when I was a athlete, I was a athlete. All I thought about was athlete. . . . He's a athlete he's not a bad boy. It's a big difference.

Spielman was shocked to hear the black suspect was found not guilty. We are the victims of black anti-Semitism, and the mayor just stood idly by. He is no longer the Mayor of New York City, he is the Mayor of African Americans "because they have their rage." Reverend Al Sharpton makes a parallel complaint at a news conference. The jury made no indictment against the Hasidic driver, and the man left the country for Israel. A Jewish woman resident of Crown Heights believes the police did nothing to stop the riot. The boy's death was an accident. Jewish people don't drive into seven-year-old boys.

In a kind of epilogue Smith presents the father of Gavin Cato. He speaks quietly, in grief, sometimes sobbing as he tells of trying to get to his bleeding son as the police blocked him. "Sometimes I think there is no justice because the Jewish people they are very high up. From the judge right on down they are runnin the whole show."

It almost seems that Anna Deavere Smith feels like sobbing with the father, but her sympathy is not only for him, but for all her characters. She has not loaded the case for either side of the controversy. She has presented a problem; the solution we must find ourselves as we mourn with her the death of cross-cultural understanding; and we hope that justice is not dead.

Smith's next work responded to another racial confrontation, which took place in Los Angeles in April 1992. *Twilight Los Angeles, 1992* is about a con-

flict between Latinos, blacks, Korean Americans, and the police. The uprising was fomented in the spring of 1991 when Rodney King, an African American, was stopped by Los Angeles police after a car chase and was badly beaten by four white officers. The event was videotaped from a nearby apartment. The police were tried and, against most people's expectations, were found innocent. A riot ensued that continued for three days with stores being looted and burned and people being beaten and shot. One of the events that received widespread attention was the beating of Reginald Denny, a white truck driver who was dragged from his truck and nearly killed before being rescued by strangers.

In the spring of 1992 Gordon Davidson, the artistic director of the Mark Taper Forum in Los Angeles, commissioned Smith to create a one-woman performance about the uprising. In the course of her research, which followed the same process as *Fires in the Mirror,* Smith interviewed about two hundred people and selected about twenty-five of these for her production, which premiered in May 1993. She interviewed Latinos, blacks, Anglos, Korean Americans, a police sergeant, Rodney King's aunt, a juror from the police trial, a person who saw the beating from her apartment, the mother of a gang member, a representative of the Coalition against Police Abuse, the president of the Los Angeles Police Commission, the founder of Mothers Reclaiming Our Children (mother of a former gang member who organized a truce), the president of the Korean American Victims Association, the district attorney of Los Angeles, the captain of the fire department, gunshot victims, Congresswoman Maxine Waters, Police Chief Daryl Gates (who resigned as a result of the Rodney King beating), the Los Angeles County coroner, and others.[19]

The interviews are arranged in a structure similar to that of Smith's earlier work—background, the riot, aftermath, and reflection. As before, the performance uses only a few props and quick changes of costume pieces. She performs barefoot, as she likes to be in touch with the floor.

As Tom Bradley, the black mayor of Los Angeles, Smith tells of his preparation for the verdict on the four policemen. He had three separate statements ready—one for guilt, one for partial conviction, and one for an acquittal on all counts, which he doubted could happen. But it did, and the riot he feared erupted despite his appeal for calm.

Richard Kim, a Korean American owner of an electronics store, remembers that

> a neighbor called and said you better
> come down here because
> there are hundreds of people and your store's being looted
> at this time.

A reporter for the Los Angeles News Service describes the video of Reginald Denny's beating, taken from a helicopter, as she plays it for Smith. She tells how the riot changed her views.

These people have no heart.
These people don't deserve
to live.
Sorry for getting emotional,
but I mean this is not my United States anymore.
This is sicko.

Big Al, a former gang member, ex-convict, and activist in a national truce movement that attempts to bring peace between gangs, says the fundamental problem is not the Rodney King beating, it's the ghetto. "This Reginald Denny thing is a joke. . . . That's just a delusion to the real problem."

Reginald Denny tells how his truck window was smashed and he was hit with an oxygen canister. He learned later, after coming out of a coma, that he had been rescued by four people who risked their lives.

In the final section, called "Justice," Smith presents Twilight Bey, the former gang member for whom the production was named. He helped organize a truce following the riot and shares Smith's regret that movement across boundaries of race and ethnicity is all too infrequent.

So twilight
is
that time
between day and night.
Limbo,
I call it limbo. . . .
I am a dark individual,
and with me stuck in limbo,
I see darkness as myself.
I see the light as knowledge and the wisdom of the world and
understanding others,
and in order for me to be a true human being,
I can't forever dwell in the idea,
of just identifying with people like me and understanding me and mine.

"The price we pay," says Smith, "is that few of us can really look at the story of race in its complexity and its scope. If we were able to move more frequently beyond these boundaries, we would develop multifaceted identities and we would develop a more complex language."[20]

Smith's next production, *House Arrest,* was a much larger project. It deals with the media and the U.S. presidency and was first presented in the fall of 1997 at the Arena Stage in Washington, D.C., as "a work-in-progress" under the title *House Arrest: First Edition.* In her search for American character Smith had previously looked to the disenfranchised, but she felt it important also to search among those in power.[21] In the original version fourteen actors were involved in four narrative strands. One of these makes use of her previ-

10. Anna Deavere Smith as Big Al in *Twilight: Los Angeles, 1992,*
Mark Taper Forum, Los Angeles, 1993. Photo: Jay Thompson

ous technique of interviewing hundreds of people, then selecting and dupli-
cating their speech; this time, however, the roles were distributed among the
actors. Some of the people whose interviews were available are well known:
President Bill Clinton, Dee Dee Myers, Studs Terkel, Peggy Noonan, Alice
Waters, Jesse Jackson, Bella Abzug, Mike Wallace, Gloria Steinem, and
many others. The second strand has the performers speaking for historical
figures, including former presidents, and takes language from memoirs, let-
ters, and speeches. The third strand is a play about a theatre group making a
play about the presidency based on first-person accounts from the period.
The fourth strand is comprised of scenes from this presidency play itself.[22]

In addition to interviews, as in her previous work, Smith used another
technique in the workshops to develop what she called "historical romps"—
for example, the "Murder of Lincoln Romp," based on historical sources. In
performance some of this material was combined with contemporary inter-
views. So the scene unfolds as if two newscasters are covering the visit of the
Lincolns to the theatre on the night of the assassination.

242

11. Lee Thompson as Studs Terkel in *House Arrest: First Edition,*
Arena Stage, Washington, D.C. Photo: Diana Walker

In the "For Colored Girls" section four actors playing prominent contemporary African American women sit behind microphones at a long table facing the audience. The women portrayed are the secretary of labor, Mrs. Clinton's chief of staff, Anita Hill, and a parolee who gained media attention by being associated with Smith. The image evokes a congressional hearing, but under the table the women are seen to be barefoot. Their interlaced monologues concern their experience as the objects of media attention.

Following the Arena Stage performances *House Arrest* was scheduled for production at the Mark Taper Forum in the spring of 1998 and at other nonprofit theatres, but these performances were postponed, partly because of President Clinton's impeachment following the investigations of an indepen-

12. *House Arrest: First Edition,* Arena Stage, Washington, D.C.
Sherri Rideout (Lynette DuPre), Alexis Herman (Nicole Ari Parker),
Anita Hill (Judy Reyes), and Maggie Williams (Gail Grate).
Photo: Diana Walker

dent counsel. In a modified form *House Arrest* was finally presented in April
of that year after the impeachment trial was concluded. In that work-in-
progress version, called *House Arrest: An Introgression,* the entire play was
condensed into one act, and the second act consisted entirely of a public dis-
cussion between the audience and public figures from civil rights organiza-
tions, community centers, the newspapers, radio stations, and government. It
was Smith's hope that conjoined theatre and civic dialogue would cause par-
ticipants to think more deeply about the issues introduced by the play—race,
gender, power, the media, and private versus public morality.

One more version of *House Arrest* was presented at the Public Theatre in
New York in 2000. The theatre's artistic director, George C. Wolfe, persuaded
Smith to perform it herself, as she had done with her previous plays. The pro-
duction, with Jo Bonney as directorial consultant, was two-and-a-half hours
long and, as in the past, consisted of monologues based on interviews.

The process involved in working with the interviews is far different from a
method aiming at psychological realism in which the performer tends to be
hidden inside the character. The process is described by Smith and the vocal

coach, Eva Barnes, who worked on *House Arrest.* Using a tape player and headphones, the actors would talk along with the person speaking on the tape.

> The actors meticulously followed the interviewees' rhythm, inflection, pauses, laughs, stammering sounds—everything—to the letter. At first, the actors instinctively tried to get comfortable with the words and the person on the tape. They would relax, lean back in a chair, and try to make the words seem natural. But Smith did not want comfort. She wanted to see the actors on the edge of their chairs, listening, reaching, trying to distill a moment of truth. "If I can see your EFFORT, your EFFORT to be someone else, then I begin to see your humanity," Smith urged one actor in rehearsal. "The process is to REACH for someone specific, the humanity is the result." The actor tried to make sense of a stammering "aaahhh" sound on the tape. "Don't speculate about the missing word, don't fill the pause with speculation, that's psychological realism," she continued: "Focus on the sounds you've been given. 'Aaahhh' is the home base. The character lives in the pause. The character always lives in the broken sentence. I'm interested in the place where speech stops. That pause is where you feel the result of all those words. Don't worry about the logic of filling the pause. Free yourself of the why. We don't know why."[23]

Smith says her creative process as a performer entails standing somewhat outside the characters as if demonstrating them by way of informing us about these people, their anxieties, and their convictions. Using an example from *Twilight: Los Angeles* she says,

> I don't want to own the character and endow the character with my own experience. It's the opposite of that. . . . Psychological realism is about . . . saying: Here's Leonard Jeffries. You have to play Leonard Jeffries now. Let's look at Leonard. Let's look at his circumstances. Let's look at your circumstances. How are the two alike? How can you draw from your own experience? Contrary to that, I say this is what Leonard Jeffries said. Don't even write it down. Put on your headphones, repeat what he said. That's all. . . . The point is simply to repeat it until I begin to feel it and what I begin to feel is his song and that helps me remember more about his body. My body remembers.[24]

The power of Anna Deavere Smith's performance is that she allows us to relate to her as well as the characters. She is present simultaneously with the characters. It is somewhat as if she is demonstrating the real people whom she interviewed, holding them up for our observation. Our relationship with the performer is deepened by the fact that she presents many characters. What they have in common is Smith's humanity.

Smith presents her characters so as to humanize a social conflict by allow-

ing us to see and hear the people caught in it. She gathers evidence and edits the monologues so as to highlight the conflict from several perspectives, and she presents them in a balanced way. She does not advocate a particular view or solution, but insists we be aware of the problem and take it seriously. She commands our sympathy for the participants who are suffering and implies that the causes beneath the surface need urgent attention. Her work gives us a glimpse into how it feels to be caught in the world of Crown Heights or South Central Los Angeles.

Guillermo Gómez-Peña

The border shared by Mexico and the United States has been responsible for political circumstances that have stimulated the work of several theatre companies. The production of *13 Dias/13 Days* by the San Francisco Mime troupe is an example. Most of the earlier productions of El Teatro Campesino (see chap. 3) were in support of the farmworkers who migrated, legally and illegally, from Mexico to the United States in order to work in the fields. For the most part these workers were welcomed as cheap labor by their employers so long as the workers did not unionize. But antagonisms grew. The children of these workers and other immigrants attended state schools and universities, made use of other social services, and competed for jobs wanted by the white population. Some politicians seized upon the opportunity to play upon the anxieties of the white population, resulting in anti-immigrant measures and even the repeal of some civil rights legislation. While the older stereotype of the Mexican immigrant, as presented, for example, in El Teatro Campesino's *Los Vendidos,* was a benign, docile, lazy creature, sleeping in the sun shaded by a big sombrero, or a comic-book version of a Mexican revolutionary, by the 1990s he was perceived as responsible for the increased cost of social services and a threat to white males because of preferential treatment in hiring as a result of affirmative action programs. The work of Guillermo Gómez-Peña, the writer and creator of interactive performance installations, is in response to this more threatening view of immigrants and Mexico itself. "The anti-immigrant political rhetoric," says Gómez-Peña, "portrays Mexicans as invaders. Mexico is seen as filled with corrupt politicians, drug dealers, terrorists."[25]

From the beginning, the work of Gómez-Peña has reflected his cultural schizophrenia. He was born in Mexico, came to the United States in 1978 while in his early twenties, and has continued to travel back and forth between Mexico and the United States, as well as performing in Europe. He speaks two languages, has written essays in both Spanish and English, has received grants from various U.S. organizations including the National Endowment for the Arts, and is a recipient of a MacArthur fellowship, the so-called genius grant.

His earliest works in the United States were solo performance installations. Shortly after arriving in the United States he presented a work intended to

express, as its title put it, *The Loneliness of the Immigrant* (1979). He spent twenty-four hours in a Los Angeles elevator "wrapped in Indian fabric and tied into a bundle with rope." His anonymity and vulnerability seemed to grant people the freedom to verbally abuse and kick him.[26] In another early twenty-four-hour work he sat on a toilet in a public restroom reading aloud epic poetry from a toilet paper roll describing his journey to the United States. Whoever happened to come in experienced the work.

In 1984 he and like-minded artists in San Diego formed a binational arts collective called Border Arts Workshop/Taller de Arte Fronterizo, which organized performance events presented at the Mexican border. These included a symbolic "performance wedding" between Gómez-Peña and Emily Hicks, an Anglo who became the mother of his son. Members of BAW/TAF also created performances and installations for various art spaces. These included a "macabre ritual space with containers of pesticides and fertilizers, red flowers, and ultraviolet lights." The idea, says Gómez-Peña, "was to create a beautiful, meditative space which was also dangerous, to reveal the contradictions of a 'utopia' built [in California] with the blood and sweat of migrant workers."[27]

During the quadricentennial of Columbus's "discovery of America," Gómez-Peña and Coco Fusco, a frequent collaborating performer, toured a living installation to remind people in the United States and Europe of the earlier bicultural collision. Drawing upon the popularity of pseudoethnographic tableaux vivants and dioramas of circus sideshows, they exhibited themselves in a cage as "undiscovered Amerindians." The cultural hybrids they created—Gómez-Peña as a kind of Aztec wrestler from Las Vegas—"were hand-fed by fake museums docents, and taken to the bathroom on leashes. Taxonomic plates describing our costumes and physical characteristics were displayed next to the cage." In keeping with some such carnival sideshows, at the Whitney Biennial in New York Gómez-Peña offered an additional attraction: "for $5.00, the audience could 'see the genitals of the male specimen'—and the well-heeled Whitney patrons really went for it."[28]

The concept of cultural hybrids and ethnographic dioramas is the basis of his most expansive work, *The Mexterminator,* created in collaboration with Roberto Sifuentes. This interactive installation, incorporating video, poetry, and computer art, also plays upon the fear of the other—especially the Mexican immigrant. The title character, performed by Gómez-Peña, has invaded the North, redefined the American West, reconquered his land, and recouped the Southwest for Mexico. The fictional circumstances for the event are described in the program for the San Francisco performances in 1998.

Dear Visitor:

As you well know, the nation-state collapsed in 1998 immediately after the "Second US/Mexico war," which Mexico won. The ex-USA has frag-

mented into a myriad of micro-republics loosely controlled by a multira-
cial junta, and governed by a Chicano prime minister. Spanglish is the offi-
cial language. Anglo militias are desperately trying to recapture the Old
Order, which they paradoxically helped to overturn. The newly elected
government sponsors interactive ethnographic exhibits to teach the per-
plexed population of the United States of Aztlán how things were before
and during the "Second US/Mexico war." This exhibition is an example of
the new "official hybrid culture." Inside you will find several fine *human
specimens* and unique archeological artifacts which are both residues of
our dying Western civilization, and samples of our emerging *Nova Cultura,*
a culture in which the margins have fully occupied the center.

> The Minister of Aztlán Liberado
> Califas, 1999

The large warehouselike space has been arranged for *Mexterminator* to
resemble a natural history museum with tableaux of bizarre living ethno-
graphic specimens placed on platforms in front of diorama-like backings.
The specimens represent cultural hybrids of the period before and during the
"war." They include elements of several cultures: ancient Aztec, inner city
urban Latino, gay, U.S. Caucasian middle class, Mexican revolutionary, and
transsexual. But elements of the new technologies combine with the human,
resulting in science-fiction-like cyborgs. The specimens are identified by plac-
ards. Gómez-Peña himself appears as El Mexterminator *(homo fronterizus)*
ethno-cyborg number 187, also known as the Mad Mex, whose habitat is the
American borderlands (photo 13). He is an indestructible, illegal border
crosser, and he may abduct innocent Anglo children. Sometimes he wears a
headdress of feathers, sometimes a Stetson; he holds a scepter with a skull,
has a cross and a gun. Behind him is projected a film collage of battle scenes,
alien attacks out of science fiction, and other violent images. Another speci-
men is El Morra Diabólica, an Anglo school girl imprisoned with her school
desk behind a wire link fence that she climbs like an ape attempting to escape.
The placard says that she obsessively reenacts her loss of innocence. La Cul-
tural Transvestite *(femma gringotlanis)* sits on a nacreous toilet in front of a
large cross. He/she wears a mustache, net stockings, a sequined bra, and a
sombrero and carries a carbine (photo 14). The Paramilitary Samurai's plac-
ard informs us that his habitat is Super Nintendo games and Iraq, Bosnia,
Haiti, Chiapas, or wherever he is needed. The Cyber Vato is found in the U.S.
inner cities. His legs are partially chrome steel; one forearm is accoutered
with a gauntlet of spikes; the other arm is tattooed. He wears dark glasses and
carries an exterminator device resembling a fly sprayer. La Super Chicana,
also known as Femma Extrema, go-go dances in her leather bikini. These and
other specimens are in continuous motion, accompanied by hybrid rock-
Mexican-disco music. The premise of the work, according to Gómez-Peña, is

13. Guillermo Gómez-Peña as *The Mexterminator,* San Francisco, 1998. Photo: Eugenio Castro

14. Sara Shelton Mann as La Cultural Transvestite in *The Mexterminator,* San Francisco, 1998. Photo: Eugenio Castro

"to adopt a fictional center, and push the dominant Anglo culture to the margins, treating it as exotic and unfamiliar."

Spectators entering the space may elect to have their hands stamped with various cultural identities. A sign explains the options: Gringo, Skin[head], Undocumented [Caucasian], Reverse [Racist]. Once in the "museum" they are free to wander at their own pace from exhibit to exhibit and are encouraged to interact with the specimens. Spectators can feed them, touch them, smell them, attempt to engage them in a conversation. Occasionally they are invited to alter the identity of a specimen by changing the artists' makeup and costumes, and even to replace them briefly on their platforms and enact their own fantasies. Spectators can also have their ethnic identity modified by La Bruja Estilista and her "Cultural Make-over cart." Visitors can stay as long as they like, buy drinks and food, and have Polaroids taken with their favorite specimens. One Caucasian spectator (a visiting artist) arrived carrying a white-power sign—"White is beautiful, White is Pure, White is Right, White will endure" (photo 15). For some photographers he posed with the Mexterminator in a pugilistic stance. Gómez-Peña describes the ambiance as Tex-Mex rave and end-of-the-century freak-show extravaganza. An easy camaraderie, even intimacy, develops among the spectators as they interact with each other and perhaps participate actively in the event.

Mexterminator is part of a long-term project that Gómez-Peña says is "to make relentlessly experimental yet accessible art; to work in politically and emotionally charged sites, and for diverse audiences; and to collaborate across racial, gender, and age boundaries as a gesture of citizen-diplomacy."[29] The cross-cultural interaction brings together spectators of various ethnicities, and for this production Gómez-Peña invited several San Francisco guest artists, Anglo and Latino, to participate as specimens. As we spectators observe the freaks on display, we seem by contrast to have much more in common with each other, regardless of our ethnicity.

An important source of information on what people are thinking with respect to Mexicans and others who migrate to the United States is provided by Gómez-Peña's temporary web site, where those logging in can respond to provocative questions. They can express their views and confess their antiracial behavior. Anonymously they can say what they really feel; they can be crass, obscene, hateful. Some of the questions are these:

Where do aboriginal peoples belong? On the reserve or in the city?

Where do Mexicans belong? In Mexico or everywhere?

What do you think of the fact that Mexican immigration is increasing dramatically and irreversibly?

Do you fear that Latino immigrants are taking over your city?

Would you support an anti-immigration initiative in your own state or nation?

15. A spectator and Guillermo Gómez-Peña, *The Mexterminator,*
San Francisco, 1998. Photo: Eugenio Castro

Do you think that political correctness has gone too far?

Do you feel that in the 90's, reverse racism is more of a problem than
white racism?

The views of respondents, abstracted and shaped by the artists, are incorpo-
rated into the bizarre ethnocyborgs on display. It is through these specimens
that Gómez-Peña expresses his view of the country.

America is living with an incredible paradox. It's the most multicultural
society on earth—that is its utopian strength—but it's also riddled with
fear of otherness and change. I want to make that visible through the cre-
ation of these Ethnocyborgs. Hopefully people will see their own inner sav-
ages—which are in all of us—and deal with them. We're saying, Hey we're
not that different.[30]

CHAPTER 10

New Technologies
and Techniques

The companies discussed in this chapter and the following one have in common the use of a variety of technologies and techniques. They use film, slide and 3-D projections, TV monitors, individual tape players, MP3 players, the Internet, sound and music, dance and dancelike movement, and flexible nonrealistic expressive lighting. Their work is imagistic, abstract, importantly or predominantly visual, and nonlinear. It is also initiated and developed as the primary expression of a dominant director who, like many of the directors in previous chapters, is sometimes also the playwright and designer.

The work of each director discussed in this chapter is aesthetically distinct but has something in common that sets it apart from the work discussed in the next chapter. The principal difference is that Ping Chong, George Coates, Alan Finneran, and Chris Hardman are interested in the social and political context in which their work is presented, while those in the next chapter—Mabou Mines, Richard Foreman, and the Wooster Group—are more self-reflexive, focusing on their own subjective psyches or reflecting the process and interaction involved in the creation of their productions.

While the social-political positions of the artists discussed here are not so precisely detailed or overt as the San Francisco Mime Troupe or Guillermo Gómez-Peña, they nonetheless have a position. Most of the productions of Chinese American director Ping Chong are one way or another concerned with the immigrant, the outsider. In fact, in his series of productions under the collective title *Undesirable Elements,* he actually puts onstage immigrants from the community where the work is being performed. George Coates questions the impact on our culture of digital technology, which, ironically, he is using in his productions. Some of Alan Finneran's work has dealt with

the entertainment media's use of violence as a product, with war, and with a potential nuclear holocaust. In recent years he has dispensed with text and has taken his performance installations outdoors, where they are intended to elicit a passerby's thoughts concerning social issues. Chris Hardman created his new company, Antenna, to receive information from the public, transform it into performance, and transmit it back to the public. His social themes have concerned the capitalistic culture of selling, homelessness, and the American obsession with the automobile. In *Enola Alone* he explored the idea that physical distance increases emotional distance, which makes killing remote and easier.

Ping Chong

Since 1972, when the Chinese American director Ping Chong created his first independent work, *Lazarus,* he has conceived and produced over twenty-five major multimedia works for the theatre incorporating live actors and dancers, slide and film projections, shadow images, puppets, and music. In addition he has created installations and video works. He studied filmmaking and graphic design and began his professional work as a collaborator with Meredith Monk. His interest in film has continued to influence his stage work, especially with respect to structure, and his images reflect his interests in graphic design. The Asian origin of his family is expressed in certain techniques such as shadow images as well as an overall formality. He says that because he is Asian, he is a formalist.[1] The objective of Ping Chong and Company (originally named the Fiji Theatre Company) is the creation of "innovative works of theatre and art for modern, multi-cultural audiences in New York and throughout the world."[2] The home base of the company is New York, but productions also tour widely and have been presented at many venues in North America, Asia, and Europe.

Ping Chong grew up in New York's Chinatown, where his parents, Chinese opera performers, settled on arriving in the United States. They spoke no English, and Ping Chong's first language was Chinese. After growing up in the homogeneous culture of New York's Chinatown, he attended a city high school and felt himself an outsider. According to his introduction to *Nuit Blanches* (1988), "As a young adult I felt like I was sitting on a fence staring at two cultures. You go out into the bigger world, and start looking at it with the kind of objectivity an anthropologist has."[3] As a way of trying to feel positive about what he had lost when he left Chinatown, he began to think of the entire world as his culture.

The feeling of estrangement permeates his work. Characters often seem to be strangers in their environment, and the images he creates are made strange by seeming out of context. The audience is distanced from them in such a way that they experience the strangeness. Chong has said that his frequent use of languages other than English helps to put the exclusive English speaker in the position of the outsider. "I want the audience to understand the other side of

the fence, what it feels like not to comprehend."[4] After a brief time, of course, the audience stops trying to understand the words, which become merely sound, only one element in the total work rather than the dominant element. He has said that his work relates to Magritte,[5] but it relates to surrealism in general. Placing the alienated individual in a strange environment or estranging the character in other ways, he juxtaposes images in surprising ways, making the familiar strange.

His narratives are nonlinear and are created bit by bit from a series of images. There are ambiguities and things we don't understand, as if we were trying to make sense of the images and sounds we saw and heard in a foreign place. In *Lazarus* the first images are slide projections of a lonely street and staircases. Then some of the objects seen in the projections, including a table and coffee pot, are brought onstage, and a man enters. He is Lazarus, dressed in ordinary clothes but with his head wrapped mummylike. He sits down to eat at the table, and we hear a letter being read by a woman. Later in the production we see an image from a 1950s film of an alien creature brought to earth in an egg, from which he hatches; he is then pursued and killed. At the end of the production night has fallen, and the image of a street returns, now with an open manhole from which a light shines. Such images of strangeness, loneliness, and alienation are characteristic of Ping Chong's work, as is the bricolage of these auditory and visual images, creating an ambiguous world.

A Race (1983) seems to be set in the distant future, when humans have forgotten what it is like to be human—or perhaps it is a world populated by an alien race resembling humans. A robed Headmaster presides over a kind of graduation ceremony, the "final regional testing . . . to honor our ancestors." The Acolytes are semizombies who march in stiff-legged, wearing white shirts, ties, dark trousers, and black fingernail polish. They are to be tested, it seems, on their ability to behave like their human ancestors. "We must not forget our origins," the Headmaster says as the Acolytes stand expressionless and are manipulated by black-hooded and booted Guardians. One Acolyte is alternately thrown to the floor and cuddled; another is teased into sucking on a plastic tube, which somehow suggests drug taking. Another brings in a dog and recites a series of clichés about dogs: "let sleeping dogs lie," "a dog's life," "man's best friend," and so on. Another twitches as he speaks of breathing; another makes a speech about money. The Acolytes attempt what might be a senior prom, rigidly dancing the two-step, accompanied by the Guardians. On suspended disks are projected slides of humans from various cultures and also of animals and fish. Perhaps these are extinct beings. These Acolytes could be our descendants, attempting to reclaim something of the past, but the play remains ambiguous. The sense of dislocation is enhanced by the eclectic music alternating with animal sounds.

While *A Race* has a more cohesive story than some of Chong's other work, it is told through an imagistic fusion of film, slides, multitrack sound, and twenty-two performers who act, sing, and dance. Chong has said that his first idea for the play was to retell the story of the *Nosferatu,* the F. W. Murnau

silent film version of the Dracula legend. "My premise was to do a piece about a race of people not unlike ourselves. What if vampires were an off-shoot of Homo erectus different only in their feeding habits?" Although two years later he created a production loosely based on, and titled, *Nosferatu* (1985), for *A Race* he retained only the idea of an alien race that resembles human beings, placing them in a situation "like a high school graduation" with the audience as family and friends.[6] But a program note mentioning the insectlike behavior of the naked mole rat suggests that Chong's anthropological interests also led him to think of the parallel between human and animal social structures. In *A Race* we have a dominant central figure surrounded by Acolyte-workers and the equivalent of soldier ants.

In 1992 Chong began an ongoing series of works exploring the effects of history, culture, and ethnicity on the lives of individuals living in the communities where the works are performed. The first of these was *Undesirable Elements/New York,* which was followed by similar but unique productions in Cleveland, Minneapolis, Seattle, Long Beach, and Tokyo. Others are in process for Newark, New Jersey, and Rotterdam. In each locale eight local residents are selected to participate. They are of different ethnicities, but each is bilingual and bicultural, and no one is a performer. In *Undesirable Elements/Seattle* (1995) the eight were a Native Alaskan, a Palestinian, a Japanese American, a Latvian, an Iranian, an African American, an Icelander, and an Indonesian. Each production in this series of ongoing community-specific works, according to Chong's company brochure, explores "the effects of history, culture and ethnicity on the lives of individuals who vary in many ways but share the common experience of having been born in one culture and are now part of another." The brochure also announces that "Ping Chong is available to create new versions of *Undesirable Elements* based on the experiences of individuals in your community. Three weeks minimum residency required."

In the productions the eight participants sit in a semicircle and speak into microphones. Behind them are projected maps of their countries of origin. First the participants introduce themselves in their native language, and then, in a text made up of their own material (but edited, woven together, and arranged chronologically by Chong), they take turns singing songs and reciting poems from their culture. They tell stories and anecdotes of their ancestors, immigration to the United States, experience as outsiders, and discovering, rejecting, and embracing the culture of their ancestors. These language sections are interspersed with formal elements such as unison gestures, walking, and clapping.

The series of *Undesirable Elements* productions continues Chong's exploration of the outsider and relates directly to his own contradictory feelings of alienation and acceptance. In creating productions that are simpler in their staging than his other works, he allows focus to be entirely on the individuals and their community and has made the works capable of being created inexpensively in a comparatively short time.

255

Chronologically overlapping the *Undesirable Elements* productions was Chong's work on a series of three productions with an international perspective on culture. Beginning with *Deshima,* which premiered in Holland in 1990, he set out to explore East-West relations—past, present, and future. The production had its American premiere at La Mama in New York in 1993 and was followed by *Chinoiserie* (1994), presented in the Brooklyn Academy of Music Next Wave Festival, among other venues, and *After Sorrow* (1997), which toured internationally, including the Theatre of Nations Festival in Korea.

The Mickery Workshop in Holland commissioned Chong to make a work commemorating the centennial of van Gogh's death. *Deshima* was the result. A few years earlier, in 1987, a Japanese insurance company had bought van Gogh's *Sunflowers* for a record $39.9 million and shipped it to Japan. This treatment of the painting as a mere commodity led to Chong's view of van Gogh as an outcast controlled by foreign economic forces, and he saw a parallel with an event in 1641 when the Japanese ordered Dutch traders and missionaries to be quarantined on Deshima, an island off the coast of Nagasaki. The production is described by the company as a "meditation on the effects of politics, trade, religion, art, and racism on the formation of the modern world." It considers the history of East-West relations from several perspectives: the colonization of Asian countries by the Dutch East India Company, the Catholic conversion of the Japanese, the ill treatment of missionaries and converts, the internment of Japanese Americans by the United States during World War II, the destruction of Japanese cities by atomic bombs, the revival of Japan's economy, and the selling of van Gogh's painting.

Chong's collaborator on the script was Michael Matthews, the late Cuban American who lived in Holland. He also appeared in the production. Typically, Chong's scripts were collectively developed during the course of rehearsals; however, in this instance, with the collaboration of Matthews (who also collaborated later on *Chinoiserie*), the script was ready when rehearsals began. Although incorporating historical material and figures, the structure of *Deshima* is nonlinear and multilayered, allowing for ironic contrasts and comparisons between events from different periods. As in his other works, music and sound, dancelike movement, and projections create a unique world contrasting Western and Asian cultures. For example, as counterpoint to a waltz sequence there is a Javanese dance with the sounds of traditional Javanese music and a recording of an interview with the chairman of the Sony Corporation. Van Gogh himself is portrayed by both a black man (Matthews) and a woman of Asian descent. In one scene he is a poor street person selling postcards of his paintings as he walks through the cornfield of his painting *Crows in the Cornfield,* where he is seen with a group of Japanese schoolgirls.

Chinoiserie is the most personal of Chong's productions in that it concerns his own Chinese heritage, and it is the only one in which he has performed as himself. Chong suggests that the work might be called a "docu-concert-lec-

16. *Deshima* at the Mickery Workshop in Holland, 1990.
Photo: Ping Chong and Company

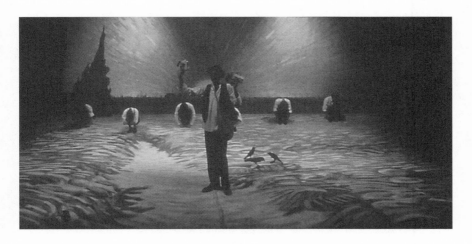

17. Michael Matthews as van Gogh in *Deshima,* Mickery Workshop,
Holland, 1990. Photo: Ping Chong and Company

ture" because it deals with real events—some personal (related by Chong from a podium) and some historical (enacted by the company)—and the physical arrangement suggests a concert with the podium downstage and music stands for the other four performers at one side. Again the work deals with strangers and the strange. The term *Chinoiserie* is a style in imitation of the Chinese that has fascinated the West for its romantic otherworldliness, though the West failed to understand the culture it was attempting to imitate. The two historical events depicted also concern a lack of understanding between cultures. In one Lord George Macartney, the late-eighteenth-century British emissary to the Chinese emperor Qianlong, is concerned about protocol in his first meeting with the emperor. How many kowtows are appropriate? The other event concerns the murder in 1983 of Vincent Chin in Detroit, when angry autoworkers mistook him for Japanese and clubbed him to death with a baseball bat. Images relating to the Opium Wars and ironic images from baseball are juxtaposed with the murder of Chin. *Chinoiserie* premiered as a work in progress at the Yellow Spring Institute in Chester, Pennsylvania, and was presented as part of the 1995 Brooklyn Academy of Music Next Wave Festival (photo 18).

The third play in Ping Chong's East/West Trilogy, *After Sorrow* (1997), premiered at La Mama in New York and was presented at the Theatre of Nations Festival in Seoul, Korea, later in the year. It presents four sorrows in the most spare of his productions. Chong wrote the text, Josef Fung composed the music, and the only performers are two women—dancer-choreographer Muna Tseng and musician Wu Man, who plays the pipa, a four-stringed Chinese lute. This production is less about alienation or estrangement than sorrows experienced in one's own country and coming to terms with that pain.

Tseng begins the first section of *After Sorrow*, "L'histoire Chinoise," with the intriguing statement: "The day my father sold me I was nine years old." In words based on the experience of a nineteenth-century woman, she tells with bitter anger the story of being sold as a bride. She wears an embroidered robe, and for much of the story she sits on a carved Chinese stool in front of a blue window, snapping and folding her pleated fan. When she dances with a red scarf, her movements are light and slow, but her tense facial grimace contrasts with her apparent serenity.

The second part, "The Whisper of the Stone," uses projected images of domestic life—family snapshots and decorative china. Tseng is a widow, and she holds the portrait of her dead husband plaintively, asking the audience, "Has anyone seen my husband?" (photo 19). In the next part, "98.6: A Convergence in 15 Minutes," Tseng (while dancing) and Chong (on tape) have a dialogue about working together and about growing up. Each has lost a brother, Tseng's to AIDS and Chong's strangely given away by his mother before Chong was born. It may be that sharing sorrow eases the pain.

The research Chong did in Vietnam in preparation for this production is especially evident in the final section, "After Sorrow," which was used as the

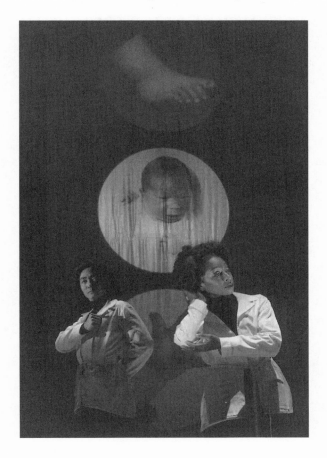

18. *Chinoiserie* at the Walker Arts Center, Minneapolis, 1995.
Shi-Zheng Chen and Aleta Hayes. Photo: Walker Arts Center

title of the production. An American woman revisits the rice paddies of Vietnam, where an old woman tells of the despoliation of her country by the French, Japanese, and Americans, and of her son, who found and brought home an American-made bomb that exploded and blew him to pieces. "How can a house of thatch withstand an American bomb?" she asks repeatedly. Tseng plays both the visitor and the old woman. The rice paddy setting is lighted in red with a doom-laden sky. At the end, under the Quaker phrase referring to that part of each person that is "of God," an old woman plants rice and the plants gradually turn green. Life goes on after sorrow (photo 20).

Increasingly Chong has worked with collaborators who have also created works independently. The writer Michael Matthews collaborated on the scripts of *Deshima* and *Chinoiserie;* Muna Tseng was the choreographer on

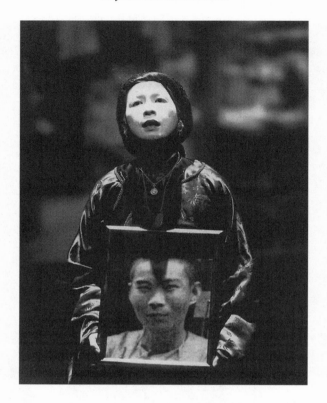

19. Muna Tseng in *After Sorrow,* La Mama, New York, 1997.
Photo: Ping Chong and Company

After Sorrow; and for *Kwaidan* (1998) Chong collaborated with the Japanese designer Mitsuro Ishii and Jon Ludwig, a master puppeteer. *Kwaidan* is based on three Japanese ghost stories by Lafcadio Hearn, which attracted Chong because they convey a sense of longing. Each of them concerns spirits that cannot find peace. The stories are enacted by one live performer and four puppeteers who manipulate both shadow and rod puppets. As usual, great use is made of projections, music, and sound. The same unit set serves for all three stories, but the images vary greatly. A wall suggesting Japanese screens can slide open to reveal three large windows, which can change in shape, and a smaller window high up in the center. These are used for rear projections, puppets, and shadows of puppets and of people. The windows allow for magical appearances and striking transformations. Another acting area is in front of the wall.

The first two stories are in the style Chong refers to as "the 'Old Japan' of fact and fantasy." The cinematic beginning of the first of these, "The Story of

20. *After Sorrow,* 1997. Photo: Beatriz Schiller

Jikininki," is described in Ping Chong's unpublished "Treatment" for *Kwaidan.*

> Across the three main windows, a microscopic image of the cells of a pine tree dissolve in sequence to the macro—an entire mountain of pine trees. . . . Muso, an itinerant priest, is seen in miniature walking along the mountainside. The small center window fades up with a closeup of Muso's face looking around, lost, and then seeing a hut, which fades up on the right window. In the landscape filling the left and center windows, the priest stops at the hut.
>
> An old priest appears in the right window, and Muso asks him for shelter. The old priest refuses, but directs him to a nearby town.

The townspeople claim there is no hut on the hill and there has been no priest for generations; only Muso has seen the old priest. In the center window a golden full moon appears, and a cloud slowly passes in front of it, turning the moon blood red. Muso has taken shelter in the home of a man who has just died. In the night a monster appears, covering the corpse. Sounds of glutinous eating and the crunching of bones are heard. Later the old priest confesses that when he died many years ago, he was turned into a Jikininki, a flesh-eating ghoul. He asks Muso to pray for him to be released from the curse. Instantly the hut and the old priest vanish.

261

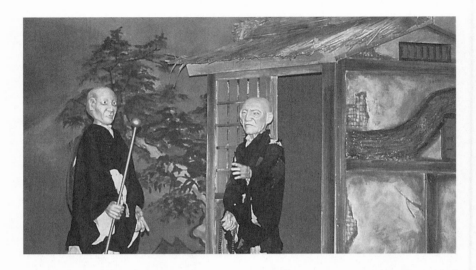

21. *Kwaidan,* "The Story of Jikininki," 1998. Photo: Peggy Cozart

In "The Story of Mimi-Nashi-Hoichi" a blind musician, Hoichi, plays music in a Buddhist temple built to appease the spirits of the Heike clan, who were slaughtered some seven hundred years ago. The temple is created by a layering of images and sound.

A temple bell tolls in a deep mournful tone in the small center window. Sliding doors of different shapes and sizes open in the back wall to reveal objects: a temple candle stand with a lit candle, a Buddha with offerings and other items suggestive of a temple.

As Hoichi, a live actor, plays his musical instrument, a door suddenly slams, a *whoosh* is heard, the candle is blown out, other doors slam shut, and a commanding voice calls his name. Instantly windows right and left open to reveal two huge eyes blinking at the blind Hoichi (photo 22). As protection against the ghosts, prayers have been written (projected) over Hoichi's body, except for his ears. In the end the restless spirits tear off his ears, and he becomes known as Hoichi the Earless, Mimi-Nashi-Hoichi, but he is assured that he is now safe from the spirits.

The final section of *Kwaidan,* "The Story of O-Tei," is set in modern times and concerns a pair of teenage lovers separated by death but reunited through reincarnation. It is a surprising contrast with the two previous stories because of the contemporary images: a revolving McDonald's sign, a high-speed train crossing on the horizon, and other evidence of urban Japanese

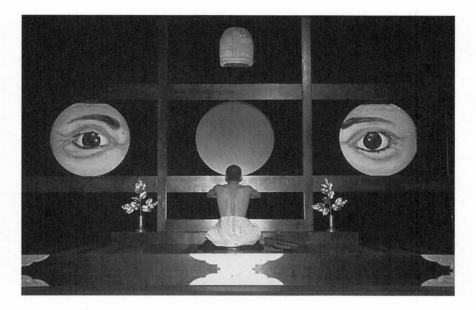

22. *Kwaidan,* "The Story of Mimi-Nashi-Hoichi," 1998.
Photo: Peggy Cozart

life. The windows for this story are circular, and the puppets are shoulder-to-head puppets seen in the windows as if they were cinematic close-ups. Through a combination of narration, images, and puppetry the story is told of O-Tei, who dies of consumption before she can marry Nagao, her betrothed. As she is dying, she sends a message to Nagao telling him not to grieve because she will be reincarnated as a girl, and when she is grown, she will marry him if he wishes. However, to please his parents Nagao marries another. Years later, after his wife has died and Nagao is again alone, he meets O-Tei, and they marry, though she does not remember her previous life or her promise.

Unlike Ping Chong's early work *Kwaidan* was the result of a collaboration of peers, even though Chong was responsible for the overall concept and direction. Another change from his earliest work is a shift from abstract allegorical images that were not structured as linear narratives, toward more cohesive narratives grounded in history or literature or in his Chinese heritage, even in the specific history of his family. Always, however, whether allegorical or historical or inspired by fiction (as in *Kwaidan*), his work tends toward a cinematic structure. His images are influenced by his Asian experience, and live performers, projections, sound and music, dance and dancelike gestures, and fluid expressive lighting help create his unique worlds.

George Coates Performance Works

George Coates, the artistic director of George Coates Performance Works, uses a variety of new technologies and techniques in the creation of live multimedia music-theatre works. His recent productions combine live performers, music, film, slides, 3-D computer-created projected images, and even the Internet. Coates is an innovator, using whatever materials and resources are at hand, through improvisation exploring their interaction, and creating scenarios from the discoveries he makes.

In his early work the means at hand were simply live performers. In 1969, when he was seventeen, he left Rhode Island and, as he says, "headed for California looking for the summer of love."[7] He stayed, and for a time toured as an actor with the traditional National Shakespeare Company. During this period he also worked for awhile with the Blake Street Hawkeyes, an experimental theatre group transplanted from Iowa that based its work on improvisation. In 1976 he began creating his own original work in collaboration with virtuoso performers ranging from belly dancers and wrestlers to mimes and opera singers, but using their skills in unique ways in a theatrical context.

His first major piece, *2019 Blake* (1977), takes its name from the Berkeley address of the Blake Street Hawkeyes. Coates's interest in improvisation as a means of developing a piece dates from his work with the Hawkeyes. His interest in transformation developed from character roles as an actor; he "enjoyed the character transformations, entirely changing my persona—physically, visually, audibly." Mime Leonard Pitt was the sole performer in *2019 Blake;* however, Pitt's skills were not used to create characters and tell a linear story. Instead the piece became an abstract transformational work. With a few props, including an overstuffed chair and a pair of antimacassars, Pitt suggested strange unnamed creatures (photo 23). With his next one-man show, *Duykers the First* (1979), Coates began working with a trained opera singer, tenor John Duykers, a relationship that continued in other productions.

The Way of How (1981) was more elaborate, involving the performers from the two previous works and another operatic tenor, Rinde Eckert. The focus was still on the performers creating abstract transformations, but a new element was music composed by Paul Dresher. Dresher had invented an electronic sound-processing system that made it possible for his solo performances to sound as if more than one musician were playing. The device, which functions somewhat like a live recording studio, consisted of a four-channel tape machine using a tape loop and three playback heads located at different points. Dresher operated this system with an array of foot pedals and switches that left his hands free to play synthesizer or guitar. Sounds from instruments as well as those created onstage by actors or singers were fed through the machine via wireless microphones. By laying down multiple tracks on the tape loop, a performer created the effect of an ensemble by playing or singing along with the tape.

Coates's next two productions, *Are/Are* (1982) and *Seehear* (1983), also

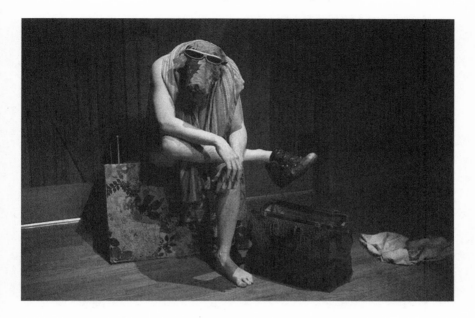

23. Leonard Pitt in *2019 Blake.* Photo: Theodore Shank

used music by Dresher. However, in these pieces projected environments became an important element, which has increased in prominence and complexity in subsequent work by Coates. The environments were photographed and filmed without the performers; then the slides and film clips were projected on screens stepped back in forced perspective so live performers appeared to be in the environment. A complex method of lighting performers was developed so as not to affect the projections. A curtain of thin venetian blinds could be opened or closed and, like a scrim, could be opaque when lighted from the front or transparent when performers were lighted behind the open blinds. From this point on Coates was deeply involved in collaboration not only with performers but with visual designers and technicians—especially Jerome Serlin, an architect-designer who had been working in photomontage. He was scenic designer for several productions. The increased visual focus and technical complexity were counter to the spontaneity and economy that Dresher had found so compelling in earlier work, and he left to form his own company. For Coates's next production, *Rare Area* (1985–86), he collaborated with a new composer, Marc Ream (photo 24).

Coates's productions are inspired by a problem that, as he says, is sufficiently interesting or challenging to dance with. He approached *Seehear* as a chamber concert, wanting to explore what music could look like. The concert form typically appeals primarily to the ear, and theatricalization of the con-

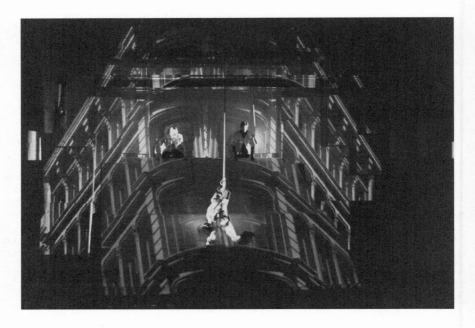

24. *Rare Area.* John Dykers, Hitomi Ikuma, and Kathryn Neale.
Photo: Marion Gray

cert would compete. So the company approached the production as "a con-
cert of phenomena composed of sound waves, light waves, and clichéd con-
ventions to be reissued in new ways." In *Actual Sho* they began with the con-
ventions of the choral concert and investigated the vocalist as a performer
and the realities evoked by these conventions—everything from gospel cho-
rus to madrigal, aria, the duet, and the oratorio form. The music was devel-
oped along with the rest of the production and was written according to the
skills of the cast.

The process for developing each work has remained much the same but has
become more complex with the increased use of technology and the con-
comitant increase in the number of collaborators. Coates's productions may
be the most elaborate being created today through improvisation. It is a labo-
rious and time-consuming method. Coates says that only one out of ten jux-
tapositions of sound, movement, and visuals is worth further exploration.
Given this process, the pieces are expensive to create. Fortunately, Coates's
entrepreneurial abilities have been equal to the task of raising the necessary
money and finding prestigious bookings for his work, which has been pre-
sented at major festivals, including the Next Wave Festival of the Brooklyn
Academy of Music, the Spoleto Festival, the London International Festival
of Theatre (LIFT), and the São Paulo International Festival in Brazil, and

the company has toured to Japan as well as major cities in Western and Eastern Europe. Personally, however, Coates says, the more successful his work becomes, the poorer and more in debt he becomes.

"My art form," Coates says "is synthesis and live art." His expertise is not in any one of the elements but in shaping the interactions and mutual influences generated by the elements he has brought together. Coates believes that you cannot make discoveries if you set out to find a particular thing. Rather than predetermining what will be discovered, Coates sets up the circumstances in which discoveries can be made. "My job is to disorganize thinking," he says. "I think one job of the artist in multi-media is to 'get lost.' If we don't know where we are going, we will find things that we didn't know we needed when we began looking."[8] He gives the same advice when asked how audiences should experience his work. They should "get lost," letting the mind wander so as to avoid filtering the experience through a predetermined idea of what it should offer. He would like his theatre to be experienced the way people experience music, willing to accept it as a subjective experience. His theatre aims to achieve a direct subconscious connection to the audience, similar to dreams.

Even when we do talk about our dreams . . . the experience goes through a language filter which is linear. I think a lot of our perception, the perceived phenomena of our reality, passes through the filter of our trained ways of seeing so that we experience reality indirectly. In some ways, my theatre is an effort to short-circuit the translation and appeal instead to direct experience.

Coates has a keen interest in new technology and its potential uses in his work. A major early influence was the San Francisco Exploratorium, where artists and scientists are brought together to create unusual devices that demonstrate scientific principles and to experiment with new art forms. A similar resource is Silicon Valley, where the electronics industry has attracted scientists and engineers with an experimental bent. Some of these inventors have become intrigued by Coates's work and the problems he encounters in creating a production.

Actual Sho (1987) made use of additional such resources. For the previous show the company had used a ramp and screens for projection. But Coates was not satisfied with the ramp because it was static. He then remembered a film they had seen with a raft going down white-water rapids. He was fascinated by way it could tip into the air, spin and dip, yaw and pitch and thought that a stage with that capacity would solve his problem. He discussed his idea with engineers at the Exploratorium and with a defector from Silicon Valley who had set up his own engineering business. The result was a bowl-like structure with a lid of perhaps twenty feet in diameter that was attached to the stage floor with a pivot so that it could move as the raft had done when performers moved from one side to the other. This device was used in combi-

nation with the venetian blind curtain and five sets of proscenium-like screens receding up stage. All of these surfaces, including the pivot stage, could be used for slide and film projections, and all could be disassembled for touring. The scenic projection designer, Charles Rose, built a model of the stage in his studio, and he and Coates experimented by projecting environments and images with the pivot stage in various positions. Coates was determined to discover what projections could best make the pivot stage disappear and transform into something else.

> When the bowl was tipped toward the audience and we projected on its top surface, we found that low bas-relief worked the best from any audience perspective in the theatre—manhole covers, hot plates, checkerboards— imagery that doesn't have too much of a three-dimensional illusion in it, because the third dimension is actually there accepting the projection. . . . When the rolling stage was tilted away from the audience and we projected on the front of it, we had a whole different set of rules. . . . If you wanted to turn it into a boat, we discovered we already had the boat; what we didn't have was the material or finish. We could project iron for a cargo ship or wood to create a virtual sailing ship. When we made this discovery, it became a search for textures and materials rather than the thing we wanted it to be. We had to find textures that would interact with the angle and shape that the stage was set at. . . . The different projected materials gave meaning to the stage configuration. For instance, a projection of rough craggy rocks on the same stage would not make a boat of rock, but would become instead a mountain cliff jutting out towards the audience.

In the beginning of *Actual Sho* a clergyman swallows a chicken wishbone, and what follows may or may not be layered fragments of his life passing as a dream on his way to death. Except for the few words of the clergyman, everything is sung nonverbally by an ensemble of four opera singers accompanied by harp, drums, trombone, and saxophone performing the music of Marc Ream. Photographic projections on the screens continually transform—strange architectural structures from a Moorish alcazar to the frame of a building under construction to an electronic operations center to a multistory building that allows live performers to lean out of the windows. And separate projections transform the pivoting bowl stage into such objects as a boat and a kitchen stove. At one point projected rays of light converge at a vanishing point. They transform into a railroad tunnel (projected on the screens), dark inside, with tracks extending toward us (projected on the top of the bowl stage). From inside the tunnel comes a light, which we think is a train until the clergyman emerges with lantern and a metal detector. The tunnel transforms into an underground sewer, and the top of the bowl stage is a giant manhole cover with ventilation holes. With the metal detector the man draws other performers up through the holes (photo 25). The manhole cover

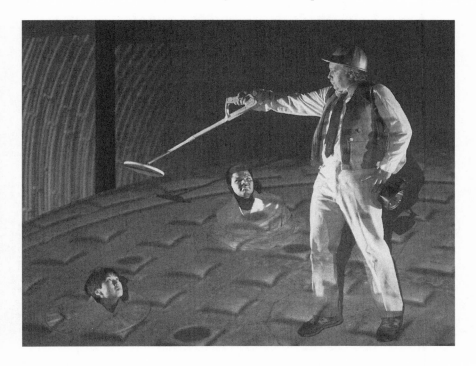

25. *Actual Sho.* Hitomi Ikuma, Larry Batiste, and Sean Kilcoyne.
Photo: Charles Rose

becomes a frying pan with three chicken drumsticks, then an electric burner on a kitchen stove. The man now reads from the "Tibetan Book of Poultry" and is surrounded by a latticelike rotating pen, on which are projected spots of red and blue, creating thousands of flickering points of light like fireflies. Near the end the man says he doesn't know what happened. At the wedding he got a wishbone stuck in his thorax. Water is projected onto the sides of the bowl stage, and a mast is raised, converting it into a sailboat. The mast transforms into a maypole. Again the stage becomes a railroad track and tunnel and a green light is seen coming from the darkness. It suggests the experience of death. The bowl stage begins to spin, turned by figures in skeleton costumes.

Coates has described *Actual Sho* as a requiem for people who are passing. Although unannounced as such, the production was a memorial to Coates's father, who, on his way to a wedding one day, said that if he had to eat chicken again, he would die. He did, and he did.

Coates describes the improvisational method used to develop this and other works:

We'll come in with what imagery has been developed in the lab that day, and Marc Ream, the composer, will come in with the music that he's been working on that may come out of an improv that we had a couple of nights earlier, and we'll be throwing projections on the screens, and we'll be propping the rolling stage up in different configurations. We might just work with one configuration for a week or two, until we find a series of architectural imagings that are accepted by the geography of the stage. Then we prop it up in another configuration and go on a new search. Some images that work in one configuration will not work in another. We have to be careful we don't throw things away simply because one arrangement of components didn't work together.

Sometimes the performers just sit on benches in front of the stage waiting for a projected environment to give them an idea on how to enter the picture. . . while a random piece of music is playing, and the responsibility of the performers is to go on stage and fit themselves into whatever they're seeing in some way of their own choosing. . . . There's one projection environment we use [in *Actual Sho*] of a house in mid-construction; you can see its I-beams and all of that (photo 26). And the singers all ran up to balance themselves carefully with arms outstretched trying to walk along the I-beams, and someone might grab a hammer and start hammering into one of the beams. You'd start those kind of interactions. . . . We'd get through all the obvious clichés first, and then new things would start to emerge. It's trying to behave according to what the other elements are informing us. . . . All the while language will be improvised.

A storyboard develops from the events, images, and juxtapositions discovered; and different sequences are then tried out. . . . In sequencing we are concerned with how the human element and the music can take hold early. After we discover what we can do with the stage and the other technologies, we try to find ways to make it all human-driven, so that it's not just a show of special effects and phenomena, but that a quality of mind is generated that uses symbols and archetypes to evoke resonant meanings and take the audience on a kind of journey. Otherwise we just end up with a *son et lumière*. . . . A special effect, no matter how spectacular, doesn't go into a performance if it is not necessary to the resonating meanings of the total piece.

The productions of GCPW continued to become more complex technologically. In 1987, the same year as *Actual Sho,* Coates was hired by Steve Jobs, one of the founders of Apple Computers, to design the unveiling ceremony for his new NeXT computer. From that point on Coates began incorporating computers into his shows, which made it possible to combine his multimedia techniques with the new digital technology. A couple of years later he set out to formalize the relationship between independent artists and technology companies, founding the Science Meets the Arts Society (SMARTS) "to break through traditional research and development structure found in most

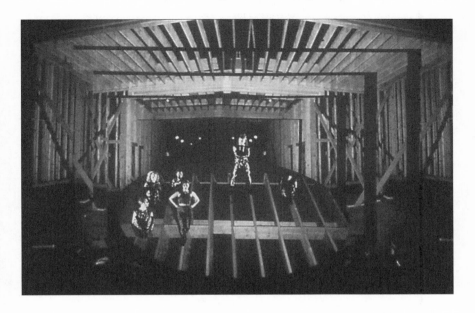

26. *Actual Sho.* Photo: George Coates Performance Works

technology companies in order to encourage new forms of live art through innovative uses of emerging technologies." In an address to the 1990 Multimedia Roundtable he pressed the computer industry "to get their media 'out of the box.'"[9] The National Endowment for the Arts awarded a $175,000 challenge grant to further the development of SMARTS.

Actual Sho was an especially popular production. In part because of this success, the American Conservatory Theatre (ACT), the best-known and best-financed theatre organization in San Francisco, invited Coates to open the 1989 season in ACT's thirteen-hundred-seat Geary Theatre. In *Right Mind* Coates used the improvisatory and projection techniques he had developed to present an abstract musical spectacle of the world of Lewis Carroll, with book and lyrics by Coates and music by Marc Ream. It was GCPW's biggest production so far, involving thirteen performers from ACT and their Young Conservatory, a Japanese *taiki* drumming group of eight, and four additional musicians on guitars, saxophone, and percussion. The production played to sold-out houses, but two weeks into the run the Loma Prieta earthquake struck San Francisco. The massive lighting grid crashed into the auditorium, the building was seriously damaged, and special equipment was destroyed. Fortunately the earthquake struck when no audience was in the theatre. Coates had hopes that *Right Mind* could be revived at the end of the season, but the Geary Theatre did not reopen for more than six years.

Despite a multitude of difficulties caused by the earthquake, on its first anniversary GCPW opened its next production, appropriately titled *The Architecture of Catastrophic Change* (1990). The title of the new work refers in part to the earthquake and to GCPW's new theatre, its first permanent base, reclaimed from an unused neo-Gothic cathedral built in 1929, which had been converted into a warren of offices. Coates renovated it as a theatre of 250 seats with a raked floor. As the audience enters the Performance Works, projections on the walls and sixty-foot-high vaulted ceiling give the appearance of ancient hewn stone or circuit boards, depending on the projection. The aisles are marked by strips of tiny lights as in airliner aisles, and the whole gives the impression of entering a neo-Gothic fantasy.

For *The Architecture of Catastrophic Change,* involving nine months of trial-and-error rehearsals, Coates brought together several musical sources: Zulu Spear, a group singing South African songs a cappella; members of an Eastern European singing group, Savina, performing their native folk songs; members of the San Francisco Chamber Singers; and a boy soprano. Marc Ream composed a new score, and Charles Rose designed scenic projections.

The ideas and iconography of the work concern catastrophe. An airplane crashes in San Francisco's Civic Center not far from the GCPW theatre, and rescue workers come to aid the homeless rather than the air-crash victims. A man in a space suit swims through barrels of toxic waste dumped into the ocean. One of the main characters is a product tester engaged by a company that is investing in the disaster-service industry to benefit from inevitable future catastrophes. The boy soprano is an aviator who has invented a way to leave the planet. While Coates's work is not political in a doctrinaire way, he nonetheless believes that theatre serves a practical purpose. "I think our job in the live-art biz," he says, "is keeping people alert and somehow creating interactions with the audience that increase their perceptual abilities."[10]

From 1990 on, all of the company's work has played at its own theatre, though commissioned works have premiered in countries such as Japan and Brazil. Nearly every year GCPW has opened a new production and, most often, introduced new technology combined with new performance elements. In *Double Vision* (1991) Coates brought together dancers, a choral group, and a sculptor. The internationally known dancers Eiko and Koma had studied the Japanese avant-garde form known as *butoh.* The musical element was Chanticleer, a San Francisco choral group. The artist-architect David Ireland was involved in the renovation of the Performance Works theatre and is known for his site-specific deconstruction sculpture projects. The three elements were fused by Coates into an aesthetic whole. It was just a year earlier at a conference that Coates commented on the progenitors of his particular art form. "My work," he said, "traces back to the events in the sixties called *happenings.* People from different mediums would come together—dancers, artists, and sculptors—and improvise." While the work does in fact have some elements of the happenings, especially in bringing together disparate elements, his use of improvisation is primarily in rehearsal rather than in per-

formance. The work of GCPW, because of the variety of technical elements, is too complex to depend on chance in performance.

While *Box Conspiracy* was in the process of development, Coates was approached by a representative of Digital Equipment Corporation and asked to present an early version of the production at SIGGRAPH, an important trade show for computer graphics professionals. It became the first GCPW show to receive substantial financial support from the computer industry. With money, equipment, software, programming, and consultations from Digital Equipment Corporation, a workstation to generate images from Silicon Graphics, and additional support from more than a dozen other companies, GCPW created *Invisible Site: A Virtual Sho* and presented it first at the trade show in Las Vegas in July 1991.

For *Invisible Site* Marc Ream again provided a nonstop score. The live performers included two actors, a martial arts expert, two tenors, an alto, and a soprano. For the first time GCPW used projected three-dimensional computer-generated environments that required the spectators to wear polarized glasses. Images were projected on a thirty-foot by sixty-foot perforated aluminum screen, and when the actors behind it were lighted, the spectators saw both the projection and the actors, who appeared to be in the 3-D environment, whether floating in a giant birdcage or walking down a rainy alley in San Francisco. Another new element, made possible by the high-speed multimedia computers, was the interaction of live actors and computer-generated imagery. Unlike conventional film or slide projections, the 3-D computer images used in *Invisible Site* could respond to the actions of performers. At one point a giant eyeball appears and stares at a character who attempts to avoid its gaze by moving frantically around the stage; but the computer-generated eye follows him, controlled by an offstage technician with a joystick. While 3-D projections had been used before in movies, this may have been the first time that interacting live actors and 3-D computer images were used in a theatre production (it preceded *Monsters of Grace* [1998], by Robert Wilson and Philip Glass, which used such projections).

Coates says the beginning idea for *Invisible Site* was his "interest in Arthur Rimbaud, and in the idea of exiles, and in the notion of forgiveness being a subversive political strategy. When you forgive someone, you are also charging them with something. That's what the Dalai Lama knew when he forgave the Chinese."[11]

In the fragmented narrative a woman "end user" seeks a virtual reality adventure on the "Singles Rendez-Vous Network," where she chooses the theme of "Prospero's Island." In this fantasy she takes on the character of Prospero from Shakespeare's *Tempest* and engages in an S-M relationship with a male end user who has adopted the character of Caliban. Their good time is spoiled by an uninvited hacker who logs on in the character of Rimbaud, seeking a full "derangement of the senses." The adventurers become outcasts and spin through various landscapes and literary fantasies with references to Medea, the fourteenth Dalai Lama, and others. The spoken text is

taken from Rimbaud, Euripides, and Shakespeare. At one point the Dalai Lama is caught in a jar into which milk is poured and the jar transforms into an ice cube that melts. Such effects could only have been achieved with the extensive financial and technical assistance of the computer companies.

Since *Actual Sho* Coates has become increasingly interested in narratives that an audience is intended to follow. No longer is he content, as in his earliest work, to present only abstract images arranged along lines more musical than dramatic. But narratives in his more recent work are still not exactly coherent; they are comprised of nonlinear fragments in various media— visual images, language, music—that carry forward the story. Sometimes these narratives derive entirely from imaginative invention, as in *Box Conspiracy* (1993) and *Twisted Pairs* (1996); at other times they are inspired by historical figures, as in the earlier *Right Mind* and in *The Desert Music* (1992), *20/20 Blake* (1996), and *Wittgenstein: On Mars* (1998).

There was a twofold inspiration for *The Desert Music: A Live Sho.* First was Steve Reich's eponymous composition, transcribed for a combination of electronic and live acoustical instrumentation by Marc Ream, with lyrics from the poems of William Carlos Williams sung live by the San Francisco Chamber Singers. Second was D. B. Cooper, the skyjacker who has taken on mythical proportions. In 1971, with two hundred thousand dollars in ransom money, he bailed out of a passenger airliner over the Cascade mountains in Washington State. A few bills from his loot were found scattered in the forest, but nothing has been heard of Cooper since.

The production, which opened on the twenty-first anniversary of Cooper's disappearance, begins with a projection of an empty airliner with clouds blowing through an open door. Cooper (live) materializes in the aisle of the plane. Then we move to a projection of the forest in the Cascades with a running creek in the foreground from which three live creatures emerge. Cooper wanders through the trees and climbs forty feet or so into the treetops, scouting a place for his parachute landing. Sparks from Cooper's campfire are projected on the creatures who dance, creating a spectacular effect. Next we are at the airport where Cooper boards the plane and presents the ransom note demanding that the plane fly a course over the forest at ten thousand feet. He bails out into a starry sky, and as he floats toward the ground, his money flutters into the air and into the audience as spectators reach for what turns out to be real money. At the end of the eighty-minute performance the audience is asked to return the "props"—"This is a non-profit Theater," the audience is reminded via a projection. Like Cooper, they are in possession of money that does not belong to them.

Box Conspiracy: An Interactive Sho was a further development of the theme of *Invisible Site* and introduced interactive technology that allowed the performers to manipulate graphics and text live. It is an admonitory look at the future of the digital converter box for interactive cable television and its effect on a family. "The dark side" of this technology, says Coates, "is that

two-way television also means that without their knowledge, home users of the box will be monitored, their use of it recorded, and their service purchase records sold to marketers and insurance companies."[12]

Another technological innovation was introduced in *The Nowhere Band* (1994), which premiered in Tokyo. It tells the story of a little girl, played by Coates's four-and-a-half-year-old daughter Gracie, who imagines herself the leader of a music group and wants to stage a musical about a magic bird that teaches people to fly. The little girl is onstage with a portable computer that enables her to go on-line and make the musical happen. In preparation for the production Coates auditioned musicians via the Internet and selected players from as far away as Australia, where he engaged a bagpipe player, to join the onstage band and vocalists performing Marc Ream's music. The company claims this to be the first use of digital "interactors," cast members seen on monitors playing real-time roles while physically elsewhere. At one point in a dark forest a remote interactor helps out a live actor onstage by lighting a match that is dropped, setting the forest ablaze.

In *Twisted Pairs* (1996) Coates explored in a satirical way another level of ambiguity on the Internet. The characters in *Twisted Pairs* were inspired by individuals (or the characters they pretend to be) whom Coates had found posting on newsgroups. The production spun off onto the GCPW web site with web pages for each character. A surfer could listen to a performance, view images, and leave messages by way of contributing to subsequent performances. The title, *Twisted Pairs,* literally refers to the pair of wires necessary for a telephone connection or to connect a computer to the Internet. But Coates also sees another meaning: "The Internet and the established broadcast media are a twisted pair of contending cultural phenomena fighting, as they say, for the hearts and minds of the people."[13] By incorporating news items from viewers of the GCPW web site, he was suggesting that the news might be different if it originated, not from the powerful elite, but from the consumers of the news.

The plot of *Twisted Pairs* is nearly as fragmented as a surf on the Internet. An Amish farm girl, Annette Diva, finds a solar-powered portable computer in a field and meets characters whom she finds on her favorite newsgroups: alt.support.relationships, alt.romance, and alt.angst among others. The characters she meets, performed by live actors, include Sister Justice, whose on-line dating service matches people with identical psychological dysfunctions. Someone is stalking Annette Diva, and she turns for help to an on-line paramedia militia that has plans to turn her into a celebrity web star. Along the way she meets feminist Flame Smith, is courted on-line by the inventor Derek 2.0, who has found a way to give TV viewers control of the evening news teleprompters, and Jack Troll from alt.beer, who directs an Alaskan TV station and is a practicing Buddhist (photo 27). These fictional characters are intermingled with a news broadcast incorporating items sent in by viewers of the GCPW web site that may or may not be true and with a true story of the

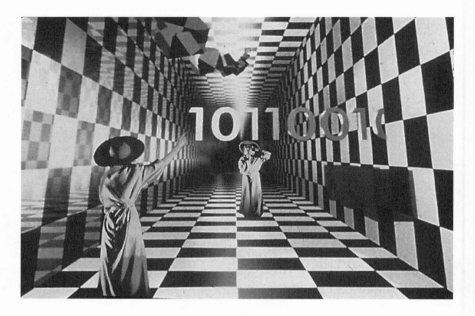

27. *Twisted Pairs.* Photo: George Coates Performance Works

six-year-old Panchen Lama, whom the Chinese government replaced with another boy. Coates believes that it is the fluid intermingling of the fictitious and the factual that makes cyberspace so compelling.

The production for Coates's twentieth season, *20/20 Blake* (1996), did not explore new technology, but a different sort of new territory. He had previously made use of the language of well-known writers of the past, but in the new work he incorporated not only the poetry but also the projected paintings and engravings of William Blake (1757–1827), which were digitally manipulated, enabling live performers to appear in the artworks (photo 28). The company was invited to premiere the production in Brazil at the São Paulo International Festival of Scenic Arts. While the presentation costs were to be covered by the festival, GCPW had to cover the costs of making the production, and cuts in the NEA budget were making it increasingly difficult to create these expensive productions. *20/20 Blake* was five months in development and was budgeted at ninety thousand dollars. As in the past, Coates succeeded in raising the money from a variety of sources. In this instance he acknowledged support from seven foundations, twenty-one electronics and computer companies, nearly a dozen individuals, and dozens of contributors to the Twentieth Anniversary Benefit.

Coates felt a special kinship with Blake, who was an experimentalist and a multimedia artist inventing techniques for merging words and visual

276

28. *20/20 Blake.* Nathan Aaron Place, Katy Stephan, and Aurelio
Viscarra. Photo: George Coates Performance Works

imagery. In Coates's production the visions of Blake become three-dimen-
sional environments for the live actors, and his poetry is rendered into song,
completing the multimedia experience. The starting point was the poetic and
visual masterwork *The Marriage of Heaven and Hell,* but the production
drew not only from the works of Blake but also from events in his life, his
visions, and his metaphysical encounters with spirits including Urizen, the
false god of fear and punishment, the ghost of a flea, the spirit of his brother
Robert, and giants, demigods, and goddesses. The lyrics were set to music by
Adlai Alexander and Todd Rundgren and sung by the San Francisco Cham-
ber Singers, who enacted all the roles except for Blake himself and a dancer-
tenor who plays both the mystical Los and Isaac Newton. The music is based
upon the strong pulse of the rock aesthetic. Some of it is recorded on Midi
tracks augmented live by electric and acoustic guitar, jazz saxophone, and
drums.

The performance begins with Blake's brother Robert lying on a bier beside an open grave. Lightning strikes the body, the fires of hell burn by way of a projection, and the white doves of Robert's soul fly away. The open grave remains throughout the performance. Blake, as was the case with the historical figure, has his own death mask made. In another historically based episode Blake is humiliated when forced for financial reasons to provide illustrations for a catalog of Wedgewood china. Blake and his wife, Catherine, print etchings and hang them to dry on a clothesline, where images are projected onto them.

Many images are striking: a starry night, rain and thunder, a flock of birds flying over a landscape. A giant 3-D hand raises the projection curtain so a performer can move downstage. During a duet by two women, a pair of giant hands removes one of the women. Later one of the giant hands points toward the audience and scans ominously from one side to the other. Pairs of glowing eyes emerge from the open grave. Above a rocky plain two birds fly as a tenor sings "The Song of Los."

When Blake dies, Catherine puts his death mask on him, and we see a large 3-D projection of it suspended in space, opening and closing its eyes. Lightning strikes the body as it did that of his brother. The giant projected hands, now clasped, come through a large gold picture frame toward the audience, and Blake's spirit rises from his body and puts on an astronaut's helmet while his body disappears in the open grave. The last image is in the large gold picture frame: "William Blake" appears as if being written, then a projected knife comes through the canvas toward the audience and cuts out the section with his name. A voice is heard: "You never know what is enough until you know what is more than enough."

20/20 Blake was a culmination of Coates's visual inventiveness, made possible through his adaptation of electronic, computer, and Internet tools for use in the theatre, where he combined them with live performers and music, which was usually vocal. He had completed a shift from his early work, when the skills of unique performers were used in unusual ways, to slide and film projections creating environments, to settings projected in three dimensions. While the productions were becoming technically more complex, in *Box Conspiracy* and *Twisted Pairs* Coates issued warnings against the very technology he was using.

While he considers his recent productions to be celebrations of the complex technical culture in which we live, he also is aware of the social and human consequences of these technologies. "I love these tools," Coates says, "and, just as passionately, I am very afraid of what they may mean. Our work at the theater derives its energy and focus from this contradiction."[14]

The development of an alternative rehearsal process (a new technique) can be more important than any single element or tool (a new technology) employed in that process. The range of creative expression available to artists working in live theater does not expand simply because new tools

emerge. . . . Most important is the ability to create a working environment where the elements at play can mix and interact freely. . . . The ability to extract and compose scenarios from unanticipated discoveries, surprising relationships, juxtapositions of "found" dynamics and other unintended complications generated from the creative process is the method I have developed to help me make theater. . . . An effective creative process will foster fresh interactions and generate original material and relationships between the performers, the stage environment and the audience.[15]

Coates's theatre is uniquely live theatre because, even though it uses elaborate technical tools, a spectator can only experience the work when in the presence of live artists and technicians. His form of theatre, as he says, is "precarious, unstable, and economically barbaric. But it survives because the experience is not translatable to any other format other than being here, in this room, as the *immersion* of the experience washes over you. Presenting the imagination unbridled is the most revolutionary act I can imagine."[16]

Alan Finneran: Soon 3

During the 1980s and 1990s Alan Finneran's "performance landscapes" (see chap. 5) continued to combine film, sculpture, and live performers as he explored the possibilities of visual narrative. But there were important developments during the period. Originally he had not used text; then he introduced recorded speech; more recently he began using live spoken text for some works and then, in the last few years, once again abandoned text. During this period his landscapes became more elaborate and on occasion involved spectator interaction. Finally productions were created for the outdoors, where their physical size could more easily be accommodated. By moving outdoors, Finneran made interaction with the performance circumstances possible not just for the performers and the intended audience, but for passersby as well.

While his productions were originally cool, hard edged, and unemotional, Finneran's recent work has become more complex in feeling, and social themes have been introduced. In 1981, for *Renaissance Radar,* Finneran developed what he called a "compositional theme," which continued to be an element in subsequent works. *Renaissance Radar* was the first in a series of three works, including *Voodoo Automatic* (1983) and *Outcalls/Riptides* (1984), that dealt with the way film and video relate to our culture, often being taken as more real than reality itself. Another innovation introduced in *Outcalls/Riptides* had performers speaking live onstage, but they did not really enact fictional characters, although the audience might project certain qualities on them.

Normally Finneran's work on a piece did not begin with content or theme. Instead, the initial idea was usually an image that came to mind with no idea of its meaning or how it would be used. However, the inceptive idea for *Magi*

(1986), which premiered at Theatre Artaud in San Francisco and toured to Europe, was overtly political—a theatrical statement about the frightening possibility of a nuclear holocaust. The work with its oblique Christmas references incorporated large-scale geometric sculptures with television-style "family films" made especially for the production (photo 29). Another new element was the involvement of the Kronos Quartet, the well-known San Francisco Bay Area music ensemble, to play the music of Bob Davis, who, beginning with *Renaissance Radar,* has composed music for most Soon 3 productions. The second production to begin with a political idea was *Ace Taboo* (1990), which Finneran describes as an antiwar "Opera Landscape." In it a team of winged magicians stages elaborate illusions of violence, interrogation, and chemical warfare, using constructions of sculpture and film installed during the course of the performance. The music in this production used an original score, in this instance sung in Sumerian.

Several works in the late 1980s had physical structures as their primary concept and aesthetic core. Until 1988 all of Finneran's productions were intended to be viewed from one direction in an adaptation of proscenium staging. *Poison Hotel* (1988), however, was performed inside a seventy-two-foot-long rectangular arena surrounded by four walls. The eighty spectators watched through portholes in the walls that separated them from the performers (photo 30). As had become Finneran's practice, all of the elements introduced previously in his accumulative method were used in this latest work. By now the inventory was extensive: film and slide projections; performers engaged in tasks involving manipulation of objects; fragments of a story that, in this instance, had to do with ships; and language spoken live by performers as well as prerecorded. A new element in *Poison Hotel* was physical interaction between a performer and the spectators. Karin Epperlein, who had been a lead performer in most Soon 3 works beginning with *Renaissance Radar,* served wine to the spectators through the portholes and passed out postcards that she wrote during the course of the performance. In *Veer* (1989) a nine-foot-high red wall separated the two halves of the audience, each unseen by the other. On each side is a man who climbs pegs in the wall but does not climb over. On top of the wall is a woman using mountain-climbing equipment performing acrobatic movements on the sides of the wall. During the performance the wall slowly moves toward one half of the audience, causing them to stand and compressing them against the brick wall of the theatre, while the space for the other half of the audience is enlarged. (Concurrent with the run of the production the Berlin Wall fell.)

With *Magi, Poison Hotel,* and *Veer* the physical/sculptural elements of the productions had become increasingly elaborate, which may have been one of the reasons for marking the twentieth anniversary of Soon 3 by moving outdoors. *Asylum (Red)* (1992) and subsequent productions were called "performance architecture" or "performance installations" and were presented exclusively outdoors in urban landscapes without text. Finneran identifies another reason for designing productions for outdoor public spaces.

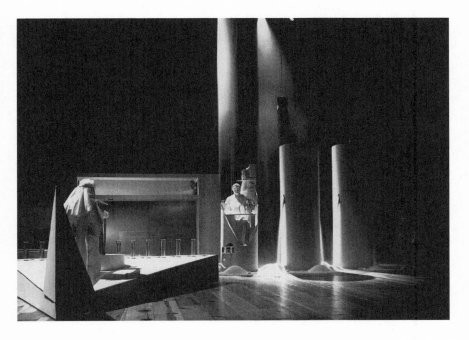

29. *Magi* at Theatre Artaud, San Francisco, 1986.
Photo: Luis Delgado

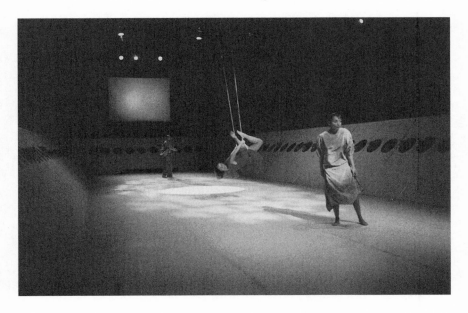

30. *Poison Hotel* at Theatre Artaud, San Francisco, 1988. Robin
Bowen, Karin Epperlein, and Henry Steele. Photo: Luis Delgado

I felt that it would be a compelling experiment to take the abstract and visually enigmatic style of the work that we produce to outside locations that are normally sites for performances by groups such as the San Francisco Mime Troupe and Shakespeare in the Park . . . For several years, SOON 3 has been trying to develop an abstract style of politically charged performances which incorporate deliberately enigmatic compositions in order to provoke individual responses and questions relating to global issues. What better way to extend this experiment than to take the work out into the streets.[17]

The principal object in the piece is a red eighteen-foot-square steel cage. Finneran says it "was built ahead of time without any preconceived notion of what would be occurring inside. Ultimately, the performance installations within the cage were generated by a series of responses to the structure itself."[18] Within the cage are three hollow geometric shapes that the performers can use as individual dwellings; suspended from above is an inverted pyramid, and on the floor are miniature cubes and cages. All of the objects are painted bright red, like the cage itself. Other objects include a Plexiglass tank containing red water that is continually pumped through a plaster human leg, a plaster human hand in a begging position, a pile of white salt with partially buried black fragments of human faces, and ten black platelike disks with conical piles of salt on each. Protruding from each pile is a test tube of blood red water. This is the evocative image a passerby sees before the performers arrive.

The three performers are completely covered in red robes and turbans. Except for the color of their garments, they resemble ancient nomadic desert dwellers. The performers, first a man, and then a woman and child, come from separate directions, walking a considerable distance through the people who are in the public place, and enter the cage. They do not speak.

Finneran describes what happens next, including the spectator interactions that occurred during some performances:

The audience comes close to the sides of the cube/cage.

The audience stares at the Inhabitants inside.

The Inhabitants stare back.

A small child tries to enter the cube/cage.

A mother pulls the child out.

The child inside the cube/cage has a large doll.

The doll is an exact copy of herself.

Slow, quiet things begin to happen inside the cube/cage.

It is different every time.

31. *Asylum (Red)* in Washington Square Park, San Francisco, 1992.
Photo: Soon 3

32. *Asylum (Red)* in Washington Square Park, San Francisco, 1992.
In turbans are Kate, Bean, and Max Finneran. Photo: Soon 3

The red man reaches up to the tip of the inverted pyramid.

He adjusts a device to release salt.

The salt pours down in a white line.

The salt begins to cover the floor.

The woman enters her dwelling.

The child plays with the fragmented faces.

The man puts his hand in the red water.

The salt continues to pour.

The child stands and stares out between the bars.

A group of children stare silently back.

Sometimes the children are silent.

It is different every time.[19]

These simple events continue to take place. People come and go, some stay a short time, others longer: riders on bicycles and horseback, conga drummers, executives on lunch break, homeless people with their shopping carts, children on school outings, noisy volleyball players, picnickers, people embracing, cursing, eating, laughing. Eventually the Inhabitants of the cage leave, walking slowly through the people, and disappear.

While the work was intended to evoke spectators' thoughts in relation to international issues, Finneran was determined that the work be abstract and enigmatic, open to individual projection rather than conveying an overtly political message. Finneran's reminders to himself make his intention clear.

Don't create "fictitious" sequences and events. Let the cube/cage, its Inhabitants, and its interior sculpture be the composition. Let its very presence in the landscape be the statement. Don't allow it to become a stage set. Allow the tensions between the interior world of the cube/cage and the world outside to be the concept, meaning, and performance of *Asylum (Red)*.[20]

In 1997 Soon 3 presented *Smackers,* its sixth outdoor work. Except for *Seeing Red or Silly Bunny and the Toxic Folly* (1995), which premiered at the Cairo International Festival for Experimental Theatre, all of these "performance installations" opened in San Francisco's Washington Square Park. *Smackers,* however, was unique in that it was presented at night and, unlike the previous works, was created in response to a found object—a white Winnebago motor home, which in performance was in the middle of the park. The performance takes place inside the motorhome, with the action being

33. *Smackers* in Washington Square Park, San Francisco, 1997.
Photo: Soon 3

viewed on video monitors outside the vehicle and through one small backlit window as a "shadow play." The exterior of the Winnebago was brightly lit to resemble a film shoot, a common sight in San Francisco.

Inside the camper are three couples—a man and woman, two men, and two women—a videographer, and a stage manager. Each couple takes turns sitting on a turntable in front of the live video camera. As they slowly begin revolving, a loud bell signals the beginning of a round, and the couple begins kissing. The performers hold lipsticks that they use to continually replenish their own or their partners' lips. The goal is to keep kissing until each face is entirely red. The couple then leaves the turntable and is replaced by the next couple, who repeat the activity. The three couples each do three rounds per performance. The action is accompanied by recorded birdsongs.

Outside, on the television monitors the kissing is seen in brightly lit, high-resolution full color. Because the images are extreme close-up head shots and the faces are quickly covered in lipstick, the spectators are unable to tell the gender of the participants (photo 34). In keeping with Finneran's insistence that the means of creating images always be apparent, another monitor shows a wide angle view of the entire interior of the camper complete with camera man, actors, and stage manager; and a backlit translucent window shows shadows of the "offstage" performers. Still another monitor shows the source of the accompanying sound—a reel-to-reel audio tape recorder with

285

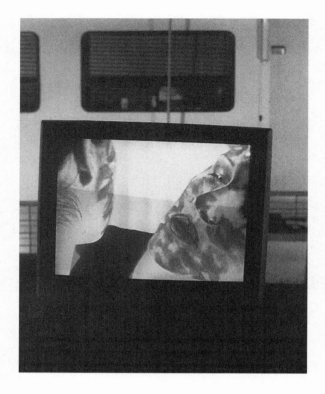

34. *Smackers,* the outdoor monitor, 1997. Photo: Soon 3

one of its slowly turning reels labeled "bird track." After the final round of kissing, the lights blink off, and the birdsongs give way to the sounds of the city at night.

These outdoor performance installations are the most recent of Finneran's works. In the first twenty-five years of Soon 3's existence, from 1972 to 1997, he created more than thirty productions. And between 1980 and 1995 the company made seven overseas tours, presenting its work in Italy, Germany, Denmark, Sweden, Spain, Yugoslavia, Austria, Russia, and Egypt—usually as part of an international festival. While the form of the work has ranged from small-scale indoor performance landscapes to elaborate outdoor performance installations, and while Finneran's motivating ideas have varied from the purely abstract to political intention, he has been true to the main aspects of his aesthetic. While a spectator may project a fictional time or place onto the events, it is not given by the work.

In the early work of Soon 3 no illusion was created; the spectator focused only on the present time and place, as one does when viewing real-world events such as a tennis match. When a task was initiated, there was a kind of

suspense until it was completed, even though no illusion was created. Later, Finneran introduced illusions similar to those of painting or sculpture. Because in his work the means used to create an illusion are important, they are not hidden. Slide and film projectors are visible and are moved by the performers as part of the performance. There are no conventional scene changes; the rearranging of props or set pieces by the performers are tasks to be perceived and comprise part of the action. Watching an illusion being created results in a different sort of suspense than that of a conventional dramatic story. It is similar to the suspense associated with watching a painter create a pictorial illusion. Over the years Finneran has explored element after element, coloring the tasks and the objects with music, language, styled movement, the suggestion of character, and a narrative that is always open and evocative.

Antenna Theater: Putting the Spectator in the Performance

When Snake Theater (see chap. 4) metamorphosed into two theatres in 1980, Chris Hardman formed Antenna Theater and developed a new concept to guide its work, a concept embodied in its name. The new aim was to involve the audience in quite new ways. Hardman set out "to explore or invent or discover the ways in which a live theatre company can relate to the public." He wanted the audience to be more than spectators, even to involve them in playmaking. Hardman's new process was indicated in his description of the function of an antenna, which is to *receive, transform,* and *transmit.* In an interview he articulated the purpose of his new theatre.

> This theater goes out to collect information, receiving attitudes and ideas from the general populace, the world at large, then transforms that into something, a work of art, which is transmitted back to the public. I was hoping to show that there is an actual live loop here, that artists do not stand alone, that they do not work alone in vacuums, but that they are receiving and transforming and transmitting back real information, real experience.[21]

During the research phase for Antenna's first production, *Vacuum* (1981), the company wanted to *receive* information from the public about their experiences with vacuums and vacuum cleaner salesmen. This they did through questionnaires, random phone calls, taped interviews in the street, listener-response radio programs, and newspaper columns. The company then *transformed* this material into a script and prepared the sound tape including portions of the interviews, original music, narration, and sound effects. Masks modeled on members of the public were created for the performers. Finally, through performance, the work was *transmitted* to the audience, which sometimes included those who had contributed to the work through questionnaires and interviews or who served as models for the masks.

Hardman chose the commonplace subject of *Vacuum* for his first Antenna

production because he was anxious to involve the public and assumed that nearly everyone would have something to say about the subject. He was also interested in the subject of vacuum cleaner salesmen because they are nearly the only remaining vestige of an old tradition of selling door-to-door and because selling is of pivotal importance to American capitalism. As one of the interviewed salesmen said, "Until something is sold, nothing happens."

In performance the audience for *Vacuum* is seated in a conventional, end-staging arrangement. The taped sound score for the sixty-minute performance includes, in addition to music and sound effects, excerpts from interviews with salesmen, housewives, bartenders, a psychiatrist, and a legislator, who comment on the subject of door-to-door salesmen and the practice of selling. Sometimes the language does not relate directly to the visual images it accompanies; at other times the activities of the characters obliquely illustrate circumstances described in an interview. The prepared tape is played though speakers as the masked performers mime the action. Three masked characters appear onstage in addition to two masked Attendants who manipulate props that suggest a setting. Walter, a vacuum cleaner salesman, wears a mask modeled after a real salesman, and the recorded voice associated with him is that of another salesman. Mary is a housewife whose mask and voice are from two different housewives in the community.

Hardman notes that a door-to-door salesman of vacuum cleaners sells emptiness. Walter, the salesman, discovers that it is not the product he is selling; he is selling himself. Mary, the housewife, has a void in her life that needs filling (photo 35). Walter goes beyond the business relationship with Mary; she becomes pregnant and has an abortion, involving another kind of vacuum. It is through buying and selling products (and themselves) that these characters fill the void in their lives or at least keep their minds off the emptiness. The process of buying and selling provides a structure that makes social interaction acceptable in a society where noninvolvement is the norm. However, it does not lead to a contented life for either the characters in the play or the real people whose voices we hear.

Hardman's subsequent explorations, aimed at putting the audience in the action, led to experiments with different physical relationships between the audience and the performance and to the employment of a variety of technologies.

The technology that has had the most profound impact on the work of Antenna Theater is what Hardman calls "Walkmanology." An individual stereo tape player (later an MP3 player) and headset is attached to each spectator or "audient," as Hardman refers to them. This technique has been used in nearly every work he has made since 1981. He realized that putting stereo headsets on his spectators would give them the experience of being in the scene and that by giving them instructions over the headsets, which resulted in their performing certain actions of a character, the spectators would becomes characters in the play. They "could become the center of whatever activity they were in."

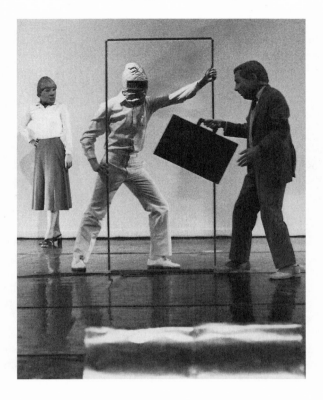

35. *Vacuum,* 1981. The Salesman (Ernesto Sanchez) meets
the Housewife (Annie Hallat) at the door held by an Attendant.
Photo: Theodore Shank

It's as if suddenly there's movie music and you're in the movie and you're standing in the center of the scene; it's almost that vivid. That's how strong stereo imaging can be. And I realized that if I connected this powerful audio experience with the physical world, a person could be in the movie. The tape could tell them to sit down and they would sit down, and it could tell them to open the drawer and they'd open the drawer. And they would realize that they are actually performing, actually acting out the character as if they were it. It's an amazingly new position for an audience to be in.

The first piece using this technology was *High School* (1981), a site-specific work presented by the Bay Area Playwrights Festival on a high school campus at night. Individually, spectators are guided through the campus by the taped voice of a recent graduate who tells of his experiences there. He leads the spectator on a route that includes a peek into the girls' bathroom, a stop at the principal's office, and graduation in the amphitheatre. Since *High*

289

School the performance concepts have become more complex and in several instances have involved the building of an elaborate mazelike structure through which the spectators, one by one, are guided. In the process each spectator-participant becomes the central character in the story and has the experiences of the character Hardman has created.

Amnesia (1984), a "Walkman walk-through play with masked actors," was originally presented by the Bay Area Playwrights Festival in a workshop production in 1983; the fully developed production opened the following year in San Francisco and then toured to the 1984 Olympic Arts Festival in Los Angeles. Each participant, wearing a tape player and headset, spends an hour as a patient being treated for amnesia. The therapy involves sorting out memories from our character's past. Guided through the constructed mazelike environment by a sound score, the participant is directed to engage in a series of tasks sometimes involving masked actors or sculptured figures of plywood with cubist features. These tasks include being sedated by a nurse with a large hypodermic, posing for a photograph, breaking up a dog fight, assisting at a childbirth, and wiping the dishes for Mom.

Another piece using the maze concept is the "interactive installation," *Etiquette of the Undercaste* (1988), which is intended to "envelop the audient in the environment of the homeless." Each member of the audience experiences the work alone as, one by one, at two-and-a-half minute intervals, they spend forty-five minutes going through the constructed environment. This environment is a maze of tiny rooms representing places that a homeless person is likely to visit. The audient's tape player plays a sound track assembled in collage fashion from interviews with the homeless, reform school graduates, former prisoners, prison guards, prostitutes, social workers, short-change artists, and so on. "So essentially," says Hardman, "it's a chorus, a cacophony of voices talking at you, giving you advice." Spending forty-five minutes alone in a world of sounds and sights of the homeless without seeing another human being is quite an immersion. The spectator begins as a corpse in a morgue, goes to heaven, and is reborn into a family where the mother is a heroin addict. We are sent to juvenile hall and hear former inmates talk about escaping; we escape through a broken window and step into a boxing ring, where a mechanical boxer attempts to beat us up. We go to jail, are released, and enter a park, where we find a bottle of wine and lie on a park bench, where we apparently we die again. The cycle is complete.

Hardman says he chose the maze concept for *Etiquette of the Undercaste* because it was a way for the spectators to experience vicariously the life of a homeless person, and the maze form became a metaphor for homelessness.

You discover that, like a rat, you are trapped in a system that is not of your making, and there's no way to undo it. I wanted to put people in that situation to dispel the Horatio Alger stories which are so deeply ingrained in society's myths of America and how it works. . . . This is the idea that everybody is just passing through one class to the next, and it begins with

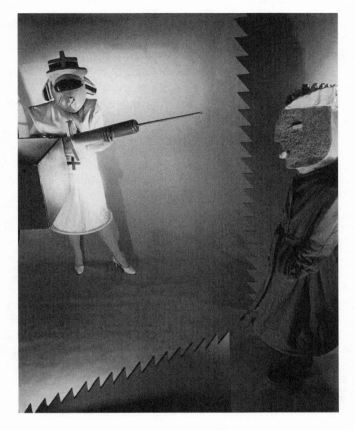

36. *Amnesia,* 1984. The Nurse and the Inspector. Photo: Eric Bergman

massive poverty, people sleeping on the street. [But] it doesn't matter, they'll make it, they'll get out, they're just sleeping there on their way to the White House.

It says something about the continuing state of the homeless in the United States that the production has become increasingly relevant and has been revived several times since its premiere, touring to other cities, including Washington, D.C., where it was presented in the Experimental Gallery of the Smithsonian.

In 1994, to commemorate the fiftieth anniversary of the dropping of atomic bombs on Hiroshima and Nagasaki, Chris Hardman presented his fifty-minute walk-through production of *Enola Alone.* Each spectator experiences the production alone, listening on a tape player to a soundscape that guides the spectator through a mazelike structure including a battlefield

trench, a stroll on a map of Europe, and the interior of a B-17 bomber (the *Enola Gay*). In the airplane the spectator looks through a window at miniature landscapes giving the perspective of flying over the earth at increasing heights and views the earth through a bombsight. The audio portion of the production was created from dozens of interviews with World War II veteran airmen, survivors of the Allied air raids over Japan, victims of the Blitz in London, and the pilot and the navigator of the *Enola Gay,* among others. These interviews are interwoven with period recordings, original music, ambient sound, and other special effects to amplify the theatrical experience. Hardman says the production "uses the metaphor of scale to make the point that military technology, particularly strategic bombing, distanced the airmen of World War II so much from their targets physically that they achieved an unprecedented emotional distance from their actions."[22] "One assumes it is much easier," says Hardman, "to destroy an entire city at 20,000 feet than to kill one individual person standing in front of you."[23]

Hardman's Walkman works have taken yet another form that involves the spectator's participation in a somewhat different way. *Adjusting the Idle* (1984), commissioned by the Mark Taper Forum and the Museum of Contemporary Art in Los Angeles, is set up like seventeen sideshows at an amusement park. Hardman calls this form of presentation the "carnival system" because spectators stroll on the midway, stop to buy refreshments if they like, and enter the sideshows in whatever order they choose. In each of these minievents of ten minutes or so the participant puts on a headset and interacts as instructed. The tapes, as in other Walkman shows, combine music and sound effects with excerpts from interviews with mechanics, pedestrians, hitchhikers, police, streetwalkers and others who have experience with automobiles. An audient can design the Detroit car of the future, pay homage to the car idol, make a used-car commercial, and service a car on the grease rack. One can also sit in the back seat of a car watching a drive-in movie and listening to a young woman describe her sexual experiences at drive-in movies.

The experience of a spectator in productions using the maze system of *Enola Alone* or *Etiquette of the Undercaste* is a rather private experience—the individual is alone participating in the created world. On the other hand, the experience in productions using the carnival system of *Adjusting the Idle* is more social. Hardman calls the carnival system "very gregarious, very open, very generous, very insane, circusy, Felliniesque." The spectator has the opportunity to interact not only with the events of the sideshows, but with other spectators.

Another interactive production of the carnival sort was *Radio Interference* (1987), which dealt with media manipulation. It was originally developed in collaboration with the Film/Video Section at the Massachusetts Institute of Technology. In its original form the work was made up of thirteen interactive events having to do with the media. In one of these the audience becomes a newscaster who is told, through a headset, what to do and say—not so different from what a television newscaster does when reading what others have

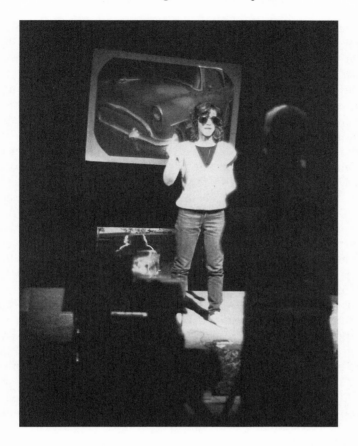

37. *Adjusting the Idle,* 1985. A spectator is being videotaped making a used-car commercial. Photo: Theodore Shank

written. One becomes aware of how little information is presented, much of it teasing the audience with what is to come later. Finally, under the strain of the media bombardment, the audient-newscaster is instructed to take a pistol and shoot him- or herself. In another event, five spectators at a time put on mackintoshes and enter what must be a television studio where *Billy Budd* is being filmed. Captain Vere commands two of the spectators to play the roles of Billy and Claggart.

Other technical innovations introduced by Antenna are 3-D slide projections and infrared sound transmitted to the headsets of a moving audience—both introduced in *Dracula in the Desert* (1986). Since then Antenna has explored the use of radio to transmit sound to the headsets of its audiences. This was the method used to guide audients at night for *On Site (In Sausalito)* in 1993. Sausalito, where Hardman has lived since moving to northern

California in the 1970s, is a culturally divided town. Located on San Francisco Bay, it is prime real estate for developers and the rich. On the other hand, the waterfront with its funky dilapidated houseboats has been a haven for artists, bohemians, and hippies. *On Site* chronicles the "wars" between these two cultures using the usual Antenna collage of sound, music, and voices as the spectators encounter scenes in the actual streets of the city, in private homes, city hall, local businesses, and public parks. Hardman used the same methods in *Pandemonium* (1997), another site-specific walk-through production, in which a radio-transmitted sound track guides audience members through the woods and meadows of the Marin headlands north of the Golden Gate Bridge, not far from where Hardman and other members of Antenna Theater's predecessor, Snake Theater, had presented *Somewhere in the Pacific* in 1978 (see chap. 4).

Antenna's development of techniques for guiding audiences through spaces has resulted in a lucrative spin-off that has subsidized productions at a time when foundation support, especially that of the National Endowment for the Arts, has ebbed way. The group founded a company called Antenna Audio Tours, which has developed an international business of making audio programs and the means of transmitting them for museums, galleries, aquariums, and other public institutions. By 1998 Antenna Audio Tours was providing approximately 85 percent of the theatre's budget, which allows the theatre group to present controversial productions without fear of offending funders. The earliest foray into the making of audio programs for others was in 1985, when a soundscape was created to guide visitors through a World War II Liberty ship, the SS *Jeremiah O'Brien,* which was anchored in San Francisco Bay as a national memorial. Visitors heard over their headsets music of the 1940s, the voices of commanders and sailors who had served on Liberty ships, and the sounds of war as they toured the ship and imagined they were on board during the war. Two years later, for the National Park Service, a soundscape was made for tours of the disused prison on Alcatraz Island. Sirens sound, cell doors are clanged, and tin cups are rattled on the bars as former inmates and guards reminisce about their time in the prison. The visitor is made to feel like a prisoner. The tape begins with a convict talking about what it was like to arrive at the Rock for the first time. The guards walked you naked down the center aisle, and that is what the tape instructs the visitors to do. They are also asked to touch the bars and feel the cold steel.

Since these early tape guides, commissions for Antenna Audio Tours have bourgeoned. Their soundscapes and equipment have been used by museum exhibitions and historic sites throughout the United States and Canada, including the American Museum of Natural History in New York, the National Gallery of Canada, the Art Institute of Chicago, and the J. Paul Getty Museum in California. In December 1998 Antenna Theater announced the sale of Antenna Audio Tours to Arts Communication Technology. The sale provided the theatre company with a $3.5 million endowment, which gives them a degree of financial freedom unique among small experimental companies.

In Hardman's view these gallery guides are an extension of his desire to involve people interactively, whether with a fictional walk-through performance or history or the artistic world of painters and sculptors. He is interested in the social interaction of his audients—sometimes with each other, sometimes with the masked actors and giant puppets of his performances, and sometimes with people who exist only on tape. Hardman says that he has always been socially attuned.

It's part of the idea I have that the artist is not out there to make vague art; there's got to be some kind of relationship with the larger world. I have never been autobiographically inclined. I believe that it's important to see ourselves in some kind of statistical or anthropological view, that we're fooling ourselves into thinking that we're really so very individual. When in fact the air of individuality is so very thin, and can fall away so quickly, that it's more important to start looking at ourselves as a species, as behavior, and start to understand those behaviors. So I guess that's where I get that social interest. I don't see each of us as being so profoundly separate.

The interaction that takes place in his performances is not possible, of course, in motion pictures or television. Hardman is especially interested in developing production concepts that are uniquely theatrical. This objective is at the center of his walk-through and interactive productions. These works give us permission to play again like children, and they guide us in this play. Unlike some audience-participation productions, the work of Hardman does not intimidate. We are not put on the spot; we are not asked to invent what we do; we are told what to do, so we simply perform the prescribed tasks. Interaction with other people is often built into these tasks and is acceptable because we are merely following directions. The fact that these works make interaction with strangers permissible may in part account for their popularity.

CHAPTER 11

Self-Reflections

The companies discussed in this chapter, while similar to those in the previous chapter in their use of a variety of media, are distinct in that their productions reflect more directly the artists themselves. Among the media that have been used by Mabou Mines are puppetry, film, video, holography, a doo-wop quintet, and a gospel choir. Richard Foreman makes extensive use of voice-overs, music loops, and recorded sounds in addition to live performers. The Wooster Group has develop highly sophisticated techniques for combining live action with live and prerecorded video. What sets the productions of these groups apart from those discussed previously is that they are actually and metaphorically related to the psyches of the directors and/or the companies creating them.

Lee Breuer, the principal director of Mabou Mines, says that his productions reflect his state of mind at the time the works are created, and that a production reflects the company and its way of rehearsing. Richard Foreman's work begins with putting down on paper his subconscious thoughts as they surface to consciousness. These are then developed into fully staged productions that are metaphors for events in his life. They are still more personal because he participates in each performance via voice-overs that often comment on the action. The first trilogy of the Wooster Group under the direction of Elizabeth LeCompte abstractly presented events in the life of cofounder Spalding Gray, who played himself in the performances. These productions launched him on his personal monologues. When Gray was no longer performing with the group, and LeCompte began using modern classics as springboards for the company's distinctive disjunctive productions, their work became a metaphor for the group itself, and, as she says, the

process of making the work is the work. Performers perform as themselves using task-based techniques by way of presenting actual events onstage—not fictional events that would cause the spectator to focus exclusively on characters and narrative, but events that take place in the present moment onstage. This sort of task performance, focusing on the performers in actual time and place, is by no means unique to the Wooster Group: it has been the fundamental acting method of alternative theatres since the 1960s.

Mabou Mines

The New York company called Mabou Mines was formed in 1970 by five artists who worked collaboratively under the artistic direction of Lee Breuer and the musical direction of Philip Glass. The performers were JoAnne Akalaitis, Ruth Maleczech, and David Warrilow. During their first summer they created *Red Horse Animation* (see chap. 6) while living near the small community of Mabou Mines in Nova Scotia. At the beginning the entire company worked together on each piece, but within fifteen years the group had enlarged to an inner circle of nine and an outer circle of several more. It had developed into a producing collaborative with artists initiating their individual projects under the umbrella of Mabou Mines. Of the original members, Breuer and Maleczech work both inside and outside the company; Warrilow left in 1978 and died in 1995; Akalaitis and Glass now work entirely outside. For two years (1991–93) Akalaitis was the producer of the Joseph Papp Public Theater in New York. Glass has presented his operas and concerts internationally and has composed musical scores for feature films. Breuer has directed major works outside of Mabou Mines including *Lulu* at the American Repertory Theatre and commercial productions of *Gospel at Colonus,* a gospel adaptation of Sophocles' *Oedipus at Colonus,* and *Peter and Wendy* from J. M. Barrie's novel. Now, with the expanded company, several members initiate individual projects in which some of the other members, and nonmembers, collaborate. And most of the members have served in more than one function: they direct, write, act, design, and are involved in technical production. The company has no fixed aesthetic but has said, in a formal artistic statement, that "Mabou Mines' focus on acting, technology and theatrical design is directed toward the realization of language as an essential ingredient of performance." Its work frequently makes use of puppets and explores theatrical uses of technology such as live and prerecorded video, holography, and film.

Over the years Mabou Mines has evolved a structure without an artistic director, though each production has a single director who gives the work a unique aesthetic. All major company decisions are made democratically by the members, who also serve on the board of directors. Because more than one artist initiates projects and takes primary responsibility for their development, Mabou Mines produces works of great aesthetic variety using a wide choice of media. A company statement in 1984 says,

The artistic purpose of Mabou Mines has been and remains the creation of new theatre pieces from original texts and the theatrical use of existing texts staged from a specific point of view. Each member is encouraged to pursue his or her artistic vision to its utmost, by initiating and collaborating on a wide range of projects of varying styles, developing them from initial concept to final performance. . . . While the director of a Mabou Mines' work is responsible for its concept and basic structure, the ultimate production reflects the concerns and the artistic input of all its collaborators.[1]

About half of its productions have been created entirely by the company from inceptive idea to performance; the other half are from plays or other writings from outside the company. Most often the inspirations have been the nondramatic writings of Samuel Beckett, adapted for the stage by members of Mabou Mines. Premiere productions of plays by members of the company have also been presented, as well as plays by Franz Xavier Kroetz and by Shakespeare—notably *King Lear,* directed by Lee Breuer with Ruth Maleczech playing the title role as a woman. However, here we are concerned only with productions created entirely by the group.

At the beginning the company played in art galleries and other nontheatre spaces and created work in line with a visual art performance aesthetic that developed out of happenings. Their audiences of visual artists, says Breuer, were interested in form not feeling and were opposed to acting and preferred task-based performance. The company considered its work to lie between visual art, postmodern dance, and theatre. Breuer, Maleczech, and Bill Raymond, who later joined the company, had worked with the San Francisco Mime Troupe in the early 1960s and were influenced by the troupe's acting style. Another early inspiration was the work of Polish director Jerzy Grotowski, especially *Apocalypse.* Akalaitis and Maleczech had studied with Grotowski, and the entire group visited Poland to see his work and came away with great respect. While acknowledging his influence, Breuer pointed out in 1972 that the work of Mabou Mines was different in several ways. "Our visual imagery is nothing like Grotowski's, and we are not interested in working with texts as he does."[2] However, the group did want to make pieces that could exist only "in a theatrical medium using stage conventions to build a work," and in that respect they shared Grotowski's idea: "it is a non-literary theatre. It either exists as a piece of theatre or it doesn't exist at all." And there were other similarities of practical importance: the performers used "scores." Each performer developed a series of mental images that were held in the mind during performance. These scores replace the Stanislavsky method of psychological motivation and action objectives that even at the beginning of the twenty-first century served as a basis for many actors in the established theatre. Mabou Mines's acting owes more to Grotowski and Brecht.

In a sense we are trying to combine the use of internal images the way Grotowski uses them with what we understand about Brecht's narrative technique and his particular objective view of epic acting where you are acting *about* what you feel instead of acting *what* you feel.

By 1976 Breuer believed that the company had found a synthesis of the two.[3]

Breuer is not interested in conventional dialogue, but rather in "narrative texts, storytelling." He calls *The Red Horse Animation* "a choral narrative without a choral leader." The words are not used as dialogue: no one speaks to anyone else; everything spoken is narrative, whether an amplified voice from an audiotape or live performers speaking separately or simultaneously. The three performers, lying on the stage, build an abstract image of a horse that is viewed from a steep angle requiring special seating. While speaking as a chorus, they join their bodies in various ways, animating the horse. Lying on the floor allows the performers greater freedom to perform certain movements such as running without actually moving from one part of the stage to another. In this respect the animation resembles a cinematic image, as if a camera were following a galloping horse that remains in the same place on a projection screen. But this work, as well as the subsequent "animations," was influenced by the ideas of the pop art movement and especially the use of cartoons.

The stage and scenery for *The Red Horse Animation* consists of a back wall made of wooden slats with cracks between them and a wooden floor with ten contact microphones underneath that, from time to time, amplify the sounds of the actors' bodies as they move and pound the floor. The performance, a metaphor for the creative process, begins with an empty stage and amplified voices: "Why pretend that I know. . . . Next to a story line other lines are incidental. . . . I didn't think it would play me for a sucker. . . . I'm changing. . . . Where am I? . . . Do I owe a debt to the cinema?" Then the performers enter carrying the props—a long red rag, an envelope containing photographs, and a roll of masking tape. (The published text differs somewhat from the performances.)

During the forty-minute performance the actors create images suggesting a horse in motion, and an amplified voice speaks as from a movie script, "In the days of Genghis Khan . . . red horses were used . . . let us go back and tell the story of one such horse." The story told is not linear but a series of images held together by an outline that implies both an organizational structure and the pictorial outline of a horse. The amplified voice says, "I think I see an outline. Roman numeral two in which I think I see my shape." Later the voice says, "I look down, I can see my story. . . . Roman numeral three: I come to where I am." The horse and its rider are seen in the most literal horse image of the piece, legs moving as if the horse were trotting. Then the performers move to one side of the stage, where they sit on the floor and sing a four-minute nonverbal song that is almost a chant. It is conducted by David Warrilow, who at times beats with his hand on the amplified floor. Philip Glass,

who composed the song and taught it to the performers over a period of three months working two hours a day, describes the song.

> The music consists of very small units which are repeated. The first one is a four-note unit, and then David signals by banging on the floor with his fist to move to the next section which is the same four-note figure plus a three-note figure, and then he hits the floor again and it becomes four plus three plus two, and then it goes back to three and then back to four. The second section goes through the same structure again, adding a percussion part that fits in with their singing. Then the third section is the percussion alone.

The song is followed by a startling effect. For about three seconds the lights come up behind the slatted rear wall, silhouetting the performers, who create dark abstract patterns against the horizontal streaks of light that come through the cracks between the slats. Following this one-time effect that could suggest a brief animated film, the piece disintegrates. "Roman numeral five." The performers freeze in tangled positions. A loud neigh is heard. Using throat microphones, the performers make strange strangling whispered sounds and distorted words. The performers' distorted sounds fade out. "I am not myself. . . . I am a representation and I am not well represented." "Roman numeral six. Showing the illness. The Red Horse tears itself apart. . . . And tries to hold itself together." The performers struggle to hold on to one another, to wrap around each other. "I can't help you, I can't find you. Item: loss of mind." The performers are panting and groping for each other. They stop moving, and the piece ends with the voice saying, "You lose it."

The Red Horse Animation was developed from its inception by the entire group. Lee Breuer describes the process.

> Usually the large form ideas come from someone who has a nonperformer perspective like Phil [Glass] or myself. Dynamically many of the ideas are Phil's; visually the ideas came from all of us, and verbally the ideas are mine. . . . We started with a couple of basic ideas that interested all of us. First, the idea of working horizontally on the floor so that the audience would look down on the image allowed us to work in two planes ninety degrees apart. This permitted a kind of cinematic structure, because when you are standing up and then lying down, it is the equivalent of a camera angle being changed. The other idea that we started with was that we wanted to deal with the image of a horse.

Breuer had remembered an incident when he was hitchhiking in Turkey and "the truck hit a red roan horse which dashed across the road—its vocal cords were cut and it couldn't make a sound; it just lay there dying."[4] Breuer says, one can free-associate on the piece forever. The director says that for him

"the horse image represents something pure, positive, going places. . . . [and] it had to do with a lot of my feelings about my father—his own silence as he kept living, beaten down by the system, and then waiting to die."[5]

For three months they worked with photographs from the book by Muybridge on the movement of horses. Breuer wrote the script as it was being rehearsed; at each rehearsal they would work on what he had written the night before. The production, he feels, reflects the way it was rehearsed. "This piece is about itself—a life, a work of art, waiting for itself to fall apart. Just as our company goes through the cycle of coming together, decaying, falling apart, coming together again."[6] As rehearsals went on, the piece became more and more abstract as tensions came in and the ideas tended to get lost.

> Another thing that we were experimenting with was taking a narrative, like the story of building a horse, and changing the medium—it would be verbal, then it would be simply movement, then it would be four minutes of music, then it would be back to text and movement, then it would be wholly text.

They wanted to stimulate an associative process in the spectator and see if a person could follow the story as it was being conveyed in different media. "We specifically did not want the mixed-media bag," says Breuer, "we wanted something cleaner and harder." He has said that it is important to him as an artist to be unsafe. This attitude has made him highly aggressive in imagining new forms, devising unique concepts for projects, and discovering new means for making them expressive. Works that he has created as writer-director encompass a great range in form and means, from the use of Bunraku-like puppets in such works as *The Shaggy Dog Animation* and *Prelude to Death in Venice,* to fully accoutered American football players in *The Saint and the Football Players,* a doo-wop quintet in *Sister Suzie Cinema,* a gospel choir in *The Gospel at Colonus,* and video combined with live acting in *Hajj* and other pieces.

The Red Horse Animation was the first part of what was to be a three-part sequence of animations in which "images of animals are used as metaphors for 'positions' or patterns of thinking." The other works in the sequence were *The B-Beaver Animation* (1973) and *The Shaggy Dog Animation* (1976); but as it turned out, a fourth production in the series followed, called *An Epidog* (1996). These animations, according to a company statement,

> are non-literary theatre works. The emphasis is on performance, not text. They are not plays. They should not be read. They are created collectively. Material is intimately bound to the lives and personalities of the performers. . . . The art of acting is their primary tool of communication. . . . The company explores both psychological and formal relationships between acting styles, movements, sound, speech and space—particularly where

these relationships have to do with oppositions such as epic and motivational acting, stylistic discontinuities between voice and face or trunk and limbs and the seeming disunity of gesture and emotion.[7]

The B-Beaver Animation, according to a program note, is an allusion to pornography and "is a satire on stoppages, blocks, retreats and defenses." It is a kind of choral monologue similar to that of the previous work, but with five performers in its original version, later increased to seven. The set is a ramshackle pile of poles, boards, plywood pieces, a sheet of tin, and fabric that is continually reconfigured during the fifty-minute piece, perhaps suggesting an abstract beaver dam. At one point, with the aid of ropes and pulleys, the fabric is lifted on poles and becomes a floating figure. A corpulent Frederick Neumann, as the beaver, sits among the rubble that is his domain, wearing a bathrobe and holding a can of beer and a cigar. He is terrified of spring when the snows will melt and wash his world away, and he is attempting to stave off material and mental chaos as he speaks a stuttering, incoherent monologue involving his "missus," tuna fish, beavers, and pain. He is soon joined by others—sometimes in chorus, sometimes overlapping—in a mélange of phrases full of puns such as "the act of damnation" without linear cohesion but with abstract meaning and a sense of industrious, frenetic, bumbling beaverness. Later Neumann uses the sheet of metal as if it were water rising, and the performers huddle together on the flotsam rolling in the flood. Finally they capsize to the sound of musical saws suggesting the sound of Kabuki waves.

Like *The Red Horse Animation,* the *B-Beaver Animation* is concerned with the creative process. Breuer says the work reflects his state of mind at the time he wrote the script.

> I found it impossible to work. I found my attitudes about not being able to work were ridiculous, but I didn't think anything I had to say was valid. The only thing I thought was funny was how ridiculous I was—self deprecation, a lot of energy there and no way to release it.[8]

The B-Beaver Animation, like previous and subsequent works, toured extensively, and in 1977 it was presented by Joseph Papp at the New York Public Theater. This association with Papp lasted until his death in 1991. The Public Theater provided rehearsal space, and works premiered there.

The B-Beaver Animation took a year and a half to develop and ran about fifty minutes. *The Shaggy Dog Animation,* written and directed by Breuer, was developed over a period of three years and was four hours in performance. The long gestation resulted from the precision necessary and because the scripts are only the starting point in the process of development, most of which took place on the stage. But it also resulted from a collective approach that was influenced by the experience of those who had worked with the San Francisco Mime Troupe. In collective work, everyone has a say in everything,

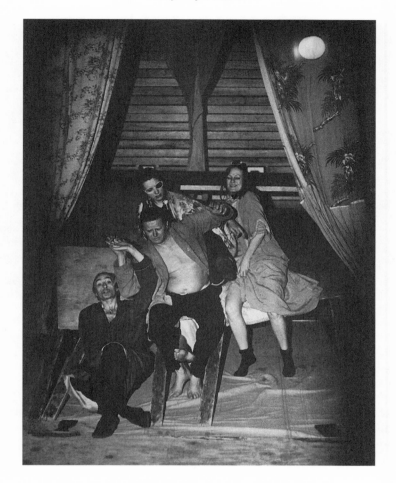

38. *The B-Beaver Animation,* 1973. David Warrilow,
JoAnne Akalaitis, Frederick Neumann, and Dawn Gray.
Photo: © Babette Mangolte

so discussions are lengthy. Because the members of Mabou Mines were anxious that the actors have creative responsibility greater than traditionally granted them, they frequently participated as directors with Breuer.

The principal character in *The Shaggy Dog Animation* is a woman, Rose, a puppet two-thirds of life-size, manipulated by the actors in her scaled-down realistic apartment. Although she appears to be a woman and actors, both women and men, speak for her, she behaves at times as if she were a dog. (By contrast, in the later *Epidog* [1996] Rose is a dog puppet but often behaves as a woman.) Rose's apartment is backed by a horizontal twenty-three-foot-long lighted radio dial that changes stations and sound. The story concerns

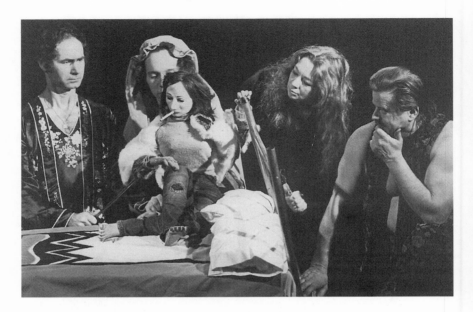

39. *The Shaggy Dog Animation,* 1976. William Raymond, Terry
O'Reilly, Rose, Ruth Maleczech, and Frederick Neumann.
Photo: Johan Elbers

the relationship between Rose and John, two filmmakers, and Rose's evolv-
ing independence and self-realization, which raises her from a doglike obses-
sive-love existence. Breuer says,

> I wanted the image of a human being who would be pet size and also the
> image of a doll's house, but it's going beyond the social issue of a sexist uni-
> verse. Rose is trying to find some perspective; otherwise she's in the animal
> world. And a John is a man who only reacts, whose ego is so insecure that
> any positive input will put him on the leash too. In this sense we're talking
> about two dogs. . . . Seeing her life as a dog's life helps Rose to escape.[9]

Breuer conceived *The Shaggy Dog Animation* as two plays taking place simul-
taneously. One story, which he calls the "image track," takes place in the
present over a two-hour period in Rose's apartment; the second story, con-
veyed by the "sound track," which includes what's going on in Rose's head,
the dialogue and narration, is in time past and is the history of an affair dur-
ing her "lifetime as a dog." The two stories are presented simultaneously with
the sound track, much of it put through a harmonizer and amplified, running
behind the image track. The Rose puppet, designed and constructed by Linda
Hartinian, was modeled after the Bunraku puppets of Japan. Sometimes the

puppet is operated by rods, sometimes by a single performer, as when she is attached to Akalaitis and bakes cream puffs, and sometimes by several performers, as when she undresses herself and gets into the bathtub.

Near the beginning we hear over the sound system in a time-past narrative a Dear John letter from Rose, a dog-slave, directed to John, her unseen master-lover, whom she loved, but then rebelled against and ran away. It is spoken by several performers, sometimes singly, sometimes together. Rose's dog/human nature is ambiguous throughout, but she gradually transcends her animal nature. It is John, left behind, who seems to become a dog-slave to the memory of the devoted animal. He is seen as a Bunraku puppet between two pay telephones wearing a leather jacket, jeans, and ski cap. Bill Raymond manipulates him with his arms through the puppet's sleeves so Raymond's hands become John's hands as the phones are dialed and dimes inserted.

This last section of *The Shaggy Dog Animation* was subsequently reworked and presented alone in 1979 as the fifty-minute piece *A Prelude to Death in Venice.* In this case Venice is Venice Beach, California. It is the story of John, again played by a puppet and Bill Raymond, who speaks for him over a lapel microphone. Caught between two pay phones, John carries on conversations with a variety of people, using different voices. On one phone, using a suave voice, he talks to his girlfriends, his mother, and their answering machines. Simultaneously, on the other phone, he talks with an organization, John's Anonymous, which wants him to give up "social fucking."

He frantically tries to hustle a movie deal and talks with his message service, which has messages from his father (who is apparently dead and may or may not be Dracula) and a message from "Tom, man," a quote from Thomas Mann's *Death in Venice.* John is an artist, a filmmaker, pathetically on the edge of schizophrenia. The sound effects (dimes dropping, the musical tones of dialing, police siren, etc.) and voices heard over the telephones are produced by Greg Mehrten. At two moments in the piece the feeling of being ineffectual and powerless is physicalized. At one point the telephones grow taller and John finds himself suspended above the ground as he holds on to the top of each phone with one hand. At another point a police siren is heard and a giant tire, taller than Raymond, pulls up to the curb. Typical of Mabou Mines productions, on one level the piece is a very personal expression of the artists involved. Breuer explains this relationship to the theme of *Prelude to Death in Venice.*

One of the themes of the piece is the experience everyone has around 40 when you begin to sense that you will never quite realize your dreams. When we created the piece, Bill and I were both around 40 and had worked together for many years. Bill, the artist who carries John, the artist-hustler, around with him, is falling apart because he realizes he's not going to be the perfect man, the perfect lover, the perfect artist, the perfect film maker. At the same time, he is still in love with the image of himself as a perfect 16-year-old.[10]

John's obsessions are those of a neurotic, overstressed, contemporary urban man attempting to deal with the forces that push him around while he attempts to control them—sex partners, parents, employers—and losing his identity in the confusion of being different people for different situations. From Bill Raymond's perspective *A Prelude to Death in Venice* is "a fable about power, about being *hooked* on power."

> This John is totally hooked on everything. He's junked up on sex, his relationship with his mother, his intellectual quests, his fantasies, the movies he's seen, manipulation, self-involvement, self-assertion and gradually self-determination.[11]

The "animations" mix bits of consumer culture in their images and sounds with references to popular as well as high art. The characters are abstract, and the language is not structured like causal dialogue. While playful and full of puns and other forms of wordplay, the work expresses in its collaged fragments the contemporary disorienting psychic condition. Breuer is sensitively in touch with his complex world and adept at inventing forms to express it abstractly.

The composer Bob Telson had collaborated with Breuer on *Prelude to Death in Venice,* for which he composed a disco version of Chopin's "Funeral March," and together they created other projects as well. The inceptive idea for *Sister Suzie Cinema* (1980) was a poem Breuer wrote on a flight from Los Angeles to New York while watching a movie. Telson set to music this "love song to a moving picture," and, with additional writing by Breuer, it became a thirty-minute doo-wop opera sung by the five-member black a cappella group called Fourteen Karat Soul. They sing of their 1950s movie idols, out of reach on the silver screen. They begin in the back row of the late show.

> I went to the late show
> And sat in the back row
> And played with my yo-yo
> And let my heart bleed
>
> Sister Suzie
> Sister Suzie Cinema
> You're my movie
> Movie star
> You're my star bright[12]
>
> Carry me back
> To the prime time
> Star studded
> You Natalie Wood, you
> Would you[13]

Later the singers are on a replica of a jet airliner wing that rises as they are carried away. It is nostalgic, camp, yet sardonic.

> You are my hope
> My trust
> And my healing
> Sister Suzie
> Cinema
>
> You are my last reel
> I can't walk out on you
> Honey
> I'm glued to my seat. . . .
> There's someone to save you
> 'Cause I'll be there
> When the popcorn's gone.[14]

The most widely seen of the Breuer-Telson collaborations was *The Gospel at Colonus,* which began as a thirty-minute performance in 1980 with only five singers and one actor and grew over the years to a cast of sixty. The idea of the writer-director and the composer-arranger was to adapt Sophocles' tragedy *Oedipus at Colonus,* which is the story of the blind Oedipus arriving in Colonus to die, as a black Pentecostal church service. They found a congruity between the storytelling of the ancient Greek choral odes and the Pentecostal service, which consists of Bible stories and gospel singing. Further, Breuer observed in the African American Pentecostal church service a living example of catharsis.

In its fully developed version the production incorporated the actor Morgan Freeman as the preacher, the Five Blind Boys of Alabama, and a gospel choir as the congregation. Oedipus is played jointly by Clarence Fountain and the Five Blind Boys. The other roles—Oedipus's daughters (Antigone and Ismene), Creon, Theseus, and others are played by members of the congregation. The preacher begins his sermon with the words, "I take my text from the Book of Oedipus," and, with others joining in, the ancient story of patricide, incest, guilt, and the need for redemption through suffering unfolds in gospel songs and blues. In keeping with gospel singing and the improvisatory nature of the Pentecostal service, the production grows on its own as singers add their own lyrics and make free with the movement. "It changed my life," says Breuer.

> I started out thinking I was going to make an art statement, and found this warm and amazingly open invitation extended to me and Bob [Telson] to enter the Afro-American Pentecostal community. We didn't change it; it changed us—after a while the show just seemed to grow as though we had nothing to do with it.[15]

The work has had an enduring history, having been performed in a variety of venues: regional theatres where local choirs were enlisted, the first Next Wave Festival of the Brooklyn Academy of Music in 1983, Houston Grand Opera, the Lunt-Fontanne Theatre on Broadway, and even as part of the 1998 Chekhov Festival in Moscow.

Breuer and Telson also collaborated on *The Warrior Ant,* produced by the Brooklyn Academy of Music for its sixth Next Wave Festival in 1988 at a cost of half a million dollars. Taking his impulse from Trinidadian carnival and the ancient Japanese tales of warriors, Breuer wrote the epic story of an ant played by a twenty-foot-tall Bunraku puppet mounted on a small car and Telson wrote Afro-Caribbean music for a cast of more than a hundred including steel-drum bands, break dancers, belly dancers, a Middle Eastern musical ensemble, black gospel singers, and a string trio.

Breuer and the other members of the company object to the manipulation of actors by directors in the traditional theatre and have increased the creative contributions of performers, who share in the conceptual development of their pieces. Actors sometimes direct themselves, and they direct other actors. According to Akalaitis, a director might say, "I don't know what I'm doing. Help me."[16] And an actor given direction might say to a director, "Well I'm not going to do that, it doesn't interest me." In the conventional theatre, that is not a valid response. But, in Mabou Mines, says Akalaitis, "that's the unspoken contract—that you'll always be working in modes that interest you artistically."[17]

Sometimes actors have initiated projects for themselves or inspired projects. An example is *Cold Harbor* (1983), an antiwar play in which a wax museum sculpture of General Ulysses S. Grant comes to life to describe his military tactics and philosophy. The play was conceived and directed by Bill Raymond with Dale Worsley and Raymond playing the leading role. Another example is *Hajj* (1983), an hour-long one-woman show written and directed by Breuer for Maleczech, his partner of many years. In this "performance poem" a woman sits at her vanity table, her back to the audience, reflected in a triptych of mirrors as she makes up her face as a child and then as a middle-aged woman (photo 40). The journey to Mecca implied by the title becomes a journey into oneself, into Maleczech's past. And it relates to a journey she took as a child with her father. The video images appearing in the mirrors are of two different sorts. There are the live images that relate to the visual focus of the actor. When she picks up an object from the table, the live camera zooms in on the object. The prerecorded images, although not literal, relate to her memories of the past, especially the childhood journey with her father. The child in the prerecorded video is played by the son of Maleczech and Breuer. The music consists of sounds made by unseen hammers tapping the bottles, jars, and bells on the tabletop. The monologue she speaks, amplified by a microphone, concerns a journey to repay a debt to a woman who is already dead; but in Maleczech's performance it becomes a debt to her father, who is also dead. Near the end the performer puts on a latex mask of an old

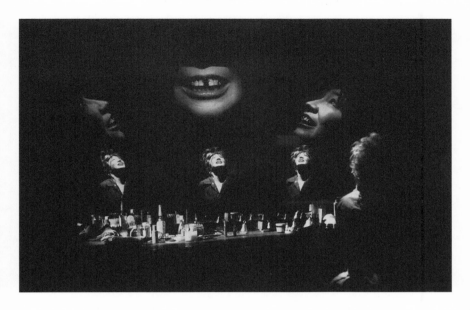

40. Ruth Maleczech in *Hajj,* 1983. Photo: Georgina Bedrosian

man that suggests her father. *Hajj* premiered at the New York Public Theater in 1983; like some other work of the company, it has been performed intermittently in various places. As late as 1998 it was presented at Moscow's Chekhov Festival.

The two major works initiated by JoAnne Akalaitis are *Dressed Like an Egg* (1977), based on the writings of Colette, which she wrote, directed, designed, and in which she performed; and *Dead End Kids: A History of Nuclear Power* (1980), which she wrote and directed. *Dressed Like an Egg* is quite different from other Mabou Mines productions. What interested Akalaitis about Colette "is that she has an uncensored female sensibility and she is extremely intelligent at the same time. So she's always talking sense, and the *kind* of sense she's talking is *romantic sense.*"[18] A feeling of fin de siècle romance permeates the production. Another difference from the work of Breuer is that the dialogue, which includes excerpts from Colette, is coherent and naturalistic. The overall structure is quite musical, consisting of recurring images drawn from Colette's life and writings and created by costumes, props, paintings, sculpture, curtains, lights, linguistic repetition, and tingling music by Philip Glass. There are also surreal elements. With the curtain raised only a couple of feet, we see women's shoes dancing, but instead of female legs extending from the shoes we see male arms. At another time a performer exits leaving her dress still stiffly in place onstage. The Seaside tableau, which Akalaitis says is her favorite, is created by the sound of the

sea, an amber stripe on the floor where a woman in period bathing costume sits, a beach umbrella, a fully clothed woman, and fully clothed men with hats and scarves frozen into wind-blown shapes. "The idea," she says, "came from a funny little drawing of a little man in a top hat on an immense isolated beach staring at the ocean." Although no one moves, "Underneath the women might be emotional, even hysterical."[19] Akalaitis says her working method was to close her eyes until a picture came and then write it down. She thinks the principal difference between her work and Breuer's is that she does not set out to make an aesthetic statement or break any new aesthetic ground, but instead thinks of her theatre as entertainment.[20] A further indication of the difference between the two is Breuer's statement that he is nearly useless when it comes to participation in the development of Akalaitis's work.

In *The Dead End Kids* Akalaitis again did something that Mabou Mines had not done in previous productions—she created a didactic piece with an overtly political point of view. The title and production imply that children will not have a future unless something changes. The production juxtaposes the history and dangers of nuclear power with the heedless devil-may-care attitude of the military, the commercial world, popular music, and the public. The production makes use of textual and film documentation, comedy, music, dance, melodrama, and satire. Act 1 traces the history of the nuclear bomb from medieval alchemy to the Cold War. Act 2 documents and satirizes the attempts to deny or minimize the dangers of the nuclear bomb. But the production is not strictly linear; temporal images echo and overlap. This is made possible by the set that designer Robert Israel has arranged like a medieval mansion stage; but instead of Hell's Mouth at one end and Heaven's Gate at the other, he has provided several locations and props that serve the telling of the nuclear story. A Franklin stove, a table with laboratory equipment, experimental mice, and a blackboard are at one end; piles of books and school desks in disarray are at the other. The production incorporates texts from ancient alchemists, Marie Curie, Goethe's *Faust,* Jorge Luis Borges, a secret report of the Pentagon to the secretary of war on the first atomic test, a lecture on how to build a hydrogen bomb, and the effects of radiation sickness.

The play, later made into a film (1986), succeeds in showing how people in the United States have been lulled into acceptance of the existence of the bomb and nuclear power by the government, the electrical power industry, the military, and nuclear scientists. The dangers of nuclear power accidents are "incidents," radiation exposure is in the range of "acceptable dosage," the chances of a hazardous "event" are "within acceptable risks."

Mabou Mines is unique in its structure as a theatre collaborative that supports its members as they individually initiate projects resulting in a variety of experimental work. The company's success is measured not only in the challenges it has taken on and the awards it has received, but in its having endured for more than three decades. It has given artists the opportunity to gain experience and credibility that has permitted some of them, such as Lee

Breuer, Philip Glass, JoAnne Akalaitis, Ruth Maleczech, Bill Raymond, and others to continue experimental work in larger venues, for larger audiences, and even in the established commercial theatre.

Richard Foreman

Since 1968, when Richard Foreman (see chap. 6) first began making theatre productions, he has written and produced more than fifty plays for the stage, including five librettos for musicals. Several of these premiered in Europe (Paris, Rome, and Stockholm), but most he produced himself in New York at his Ontological-Hysteric Theater, which in recent years has been located at St. Mark's Church in the Bowery. In addition, he has directed plays and operas by others at Lincoln Center, the New York Public Theatre, the American Repertory Theatre, the Guthrie Theater, Paris Opera, Houston Opera, the Festival d'Autumne in Paris, Yale Repertory Theatre, and elsewhere. Among the awards he has received are a MacArthur fellowship and eight Obies, including three for his plays and others for directing and sustained achievement. He is clearly one of the most honored avant-garde theatre artists of our time.

Throughout Foreman's work, whether phenomenologically static, hysterically frantic, or meditative, one thing has remained constant. Early on, shortly before starting his Ontological-Hysteric Theater in 1968, he had become an admirer of Gertrude Stein's writing and ideas. Like Stein, he became interested in creating a continuous present, a highly conscious condition in which the audience attends to the theatrical moments as they occur in front of them rather than focusing on where these moments may lead or how they reveal character or motivation. His productions keep the audience in a highly attentive state of perception, not allowing them to enter deeply into a fictional world where their attention would be seduced into a semiconscious state in which they would hang on what was about to happen in that world and would perceive less keenly the theatricality of the present moment. To achieve that state, he devised disruptions in the staging of plays.

Foreman is himself in a passive state, as he calls the semiconscious state, during the initial writing process that allows his impulses to arise. As he looks at pictures or reads or listens to music, these impulses produce notes that he takes down relatively unfiltered by a critical consciousness. "When it comes to making art," he says, "you don't have any theories, that's always after the fact. . . . I'm simply taking dictation, and I write in very small spurts, maybe a page and a half at a time. Sometimes I write to musical loops, anything just to get something on the page."[21]

In the early days of his theatre these notes were used, unedited, as the scripts for his plays. He says, "In those days I thought that if I rearranged things, rewrote things, I was interfering with the evidence of where my head was at that time, and I thought that was my task—just put down the evi-

dence." However, in the last fifteen years or so, while continuing to generate material in the same way, Foreman now is more selective, and he rewrites.

> Step by step I've reached the point where I have a big stack of pages and just look for an interesting page. So if I find an interesting page that talks about a game of field hockey [which came to be used in 1998 for *Benita Canova*], I'll look for another page that I think might go in the same play. It might be twenty-five pages away, fifty pages away. It could have been two years between the times the two pages were written. I went through a period of time when I took those collaged pages and I still didn't change very much, but for the last six or eight years I rewrite six or eight times. (Laughing.) Maybe it's only because I have a computer now. But I rewrite a lot [as I'm] thinking of my actors, thinking of the music I'm going to use; and the plays are seriously rewritten now. And, of course, in rehearsal I no longer hesitate to make all kinds of changes—to add things, to rewrite things, to write new things. So that's very different from what I was doing fifteen years ago.

In recent work, he directs his rewriting "toward a certain imaginary situation." His language still jumps around as he tries "to find a way to be creative in a situation in the same way that an artist tries to be creative by coming into a subject from a different angle, trying to see it freshly with habit removed." And he sees his characters in their situations trying to do the same, saying at every moment, "How can I respond to what has just been said to me in a way that is unexpected and might show some connection that was not heretofore imagined concerning what's just been said, what I'm going to say, and refresh the experience." The talking back and forth of characters is not really dialogue—it "tries to escape normal talking and tries to bounce around the subject in such a way that it hits the truth."

In directing actors toward a unique style of acting, he again attempts to avoid the usual. In part the acting style of his productions comes about because he hates the selling aspect of the theatre. "In most of the plays I go to see," he says, "it seems the performers are holding out their intentions and their ideas on a silver platter and trying to make it clear to everybody, 'See! See! This is what I'm feeling at this moment.'" To overcome this tendency, he tells the actors to think about their performances in a special way. They are to be arrogant and believe that what they have to say is the smartest thing in the world and that the audience is full of clods. One intelligent person might understand, but the actors don't even want the others to get it. Foreman often tells the actors that the right approach is like talking to themselves. They are not to attempt to manipulate the other characters or the audience. Foreman is so used to this style that sometimes he has difficulty distinguishing it from what actors normally do.

The first phase of Foreman's work had to do with a phenomenological

interest, objects in space without a functional relationship, the changing of a prop serving to reenergize a moment. He then became interested in structuralist thought, which influenced a shift about the time of *Hotel China* (1972) leading to the use of "a lot of objects, just junk, it didn't matter what the objects were, it was the network of their whirling around each other, being replaced and so forth." Another factor influenced the change at this time. A performer dropped out of *Hotel China,* and in looking for a replacement he found Kate Manheim, later to become his wife, who acted in most of his plays for nearly fifteen years.

> I've made no secret of the fact and celebrated the fact that when Kate started performing in my plays, she wanted the work to be more accessible. She wasn't interested in all my static, boring phenomenological stuff particularly, so that as she got more and more power over me she kept insisting that her parts get bigger and she had more vaudeville, happy, frantic stuff to do. And I was happy to be led along those lines. I think that reflects the contingency of life out of which good art is always made.

In the late seventies, when he was around forty, came another influence.

> I read Jung saying that forty years of age is a crucial point because a man either becomes a specialist, a dried-up reactionary specialist, or he makes contact at that point with more archetypal roots and with the river of feeling and myth and so forth. So I thought, "I don't want to be one of the dried up fussy old men, so I'd better try to make my work drink a little bit from that river of archetypes and so forth that he was talking about." And I did make an effort to become a little more humanist, though humanism as it is generally understood is almost a red flag for me. It's not something I identify with too much. But the work did become mellower at a certain point to the extent that I did a series of plays that were much quieter and finally with *The Mind King* [1992] got really meditative with a lot of long speeches that the actors were doing. Then I did *Samuel's Major Problems* [1993] (I think one of my best plays), a very depressing play about facing up to death and so forth that I know a lot of my audience found very tough in the sense that it was so bleak.

There may well be another cause of the depression and bleakness. Kate Manheim had become ill. When she stopped performing in his plays, Foreman felt less pressure to go in her lighter direction.

> I think that's one of the reasons for the plays getting more meditative and more cerebral again with *The Mind King. Samuel's Major Problems* wasn't quite so cerebral, but it was dark in a way. I'm sure I was responding somewhat to that situation of she not being a part of the work anymore, but it's for others to say what really happened.

313

After the dark plays, Foreman determined that for the next three years he would "return to the high-energy style." So he began "consciously trying to expand the work again," first with *My Head Was a Sledgehammer* (1994), then *I've Got the Shakes* (1995) and *The Universe* (1996). He has referred to these as a trilogy, but he has also said that all of his plays, which typically run for about sixty-five minutes without intermission, comprise one long play about the one subject that interests him—the impenetrable nature of the world. Since he stopped using their tape-recorded voices the performers have worn wireless headset microphones and are heard only over loudspeakers. Their distanced quality is like the recorded voices, but now the actors use more inflection, and the audience knows who is speaking. Another recent distancing device is large sheets of Plexiglas suspended between the stage and audience through which the performers are viewed. In certain lighting the spectators see themselves reflected in the Plexiglas, superimposed on their view of the stage.

The situation in *My Head Was a Sledgehammer* concerns a professor, dressed a bit like a motorcycle gang member, who tries to introduce the poetic method to two students—a male and a female—who vacillate between respecting and rejecting his silly and bizarre teachings. Four nonspeaking gnomes with red hair, tall black dunce caps, eyeglasses, and beards move props around as needed. The set Foreman describes as "a lecture room, but it is also a laboratory, or a studio, or a gymnasium—all at once."[22] As usual an abundance of junk litters the stage—in this instance blackboards, thin red poles with lights at the top, tall bookcases loaded with dilapidated books, garbage can lids, and other objects. Small rugs are on the floor. As usual, strings painted black and white like dotted lines are strung tautly on the set, taking the eye on a ricocheting journey around the stage and adding to the ordered chaos. At times there are flashes of light. Musical tape loops, buzzers, bells, and crashes provide the soundscape.

The Professor has a technique of making rhymes that don't rhyme. He declares that "truth revealed, believe it or not, takes the unfortunate shape of everything that isn't true." The Male Student reads from a book, "I want to be in a place through which . . . truth passes." The Professor orders him to turn the page, but the Student wants to linger over this page. The Professor grabs the book and reads, "What does it say on this page?" The Student replies, "Eat me?" The Professor sees no such message, so the Student grabs the book, tears out the page, and eats it. Such ironic juxtapositions occur frequently in Foreman's writing.[23]

In *I've Got the Shakes,* a "comic extravaganza," someone is again trying to teach. It is Madeline X, who knows she has something to teach, but doesn't know what it is. She wears a diamond tiara, a skimpy print dress, and patent leather thigh-high boots. Her face is smeared with lipstick (photo 41). The other three speaking characters are Lola Mae Duprae, who is decorated with rings and bracelets, wears pin-striped trousers, has a large white ribbon in her hair, and speaks with a southern accent; Sonya Vovonovich, a Russian-

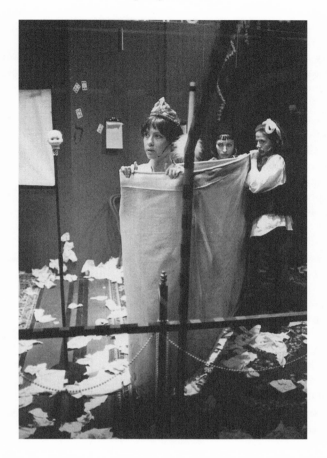

41. *I've Got the Shakes,* 1995. Madeline X (Jan Leslie Harding), Sonya Vovonovich (Rebecca Moore), Lola Mae Duprae (Mary McBride).
Photo: Paula Court

accented woman in a black and yellow sailor suit; and Rabbi Schlomo Leviticus, who speaks in a Yiddish accent and wears a black skull cap and a dirty butcher's apron. The headset microphones allow them to speak quietly as if to themselves. In this play the prop-moving attendants are Clowns, all dressed uniquely and eccentrically—one with a crown of eggs, another in blackface, two completely chalk white, and a Ringmaster in a red tailcoat and hat. The atmosphere is that of a party, "a private midnight circus." At the rear is an imposing red wall festooned with balloons and streamers, and playing cards stuck at random. There are three paintings of chairs that characters attempt to occupy. Skulls, three globes with bowler hats, and numerous pads of yellow lined paper are attached to the walls. The floor is littered with crum-

pled pieces of yellow paper. As in other Foreman productions of this period, mystical letters decorate the set.

The play is full of philosophical wit frequently enjoying the ambiguity of reality. Madeline X doesn't know what it is she is teaching; nevertheless she makes a kind of sense. Holding a globe of the earth she declares:

> MADELINE X: Know this please! Outside of me a certain mastery exists. It's called the world. *(She lets her globe fall to the floor, frightening the others.)* Everything the world does is masterful. *(She is handed a larger globe, which has a little derby perched on top of it. . . .)*
> SONYA VOVONOVICH: So what? The world is one hundred percent outside a person.
> MADELINE X: Well, not one hundred percent.
> SONYA VOVONOVICH: You mean outside is inside?
> MADELINE X: Somewhat.
> SONYA VOVONOVICH: So the mastery of the world is inside you somewhat.
> MADELINE X: I rest my case. *(She kisses the globe.)*[24]

Often the action is farcical yet witty. In order to partake of "cosmic truths" Madeline X hits herself in the head with a golden hammer, and a cymbal crash is heard. Schlomo raises the skirt of Madeline X and gives her an injection with a hypodermic needle. It has no effect on Madeline X, but Schlomo becomes dizzy and passes out. She speculates that maybe the injection gave her an hallucination making her believe she is okay and that Schlomo is the one affected. Later Schlomo gives himself an injection, and when it has no effect, he surmises that he must have developed an immunity.

In *The Universe (i.e.: How It Works)* Foreman continued the relatively light energetic tone, though the principal character, James, whom one tends to identify with Foreman, is desperate. The names of the three speaking characters are the first names of the actors. As usual, additional costumed performers, called Servants in the published version, deliver props. Again, the question of reality arises. Are appearances real? Is there only subjective reality? At the beginning James holds a glass of milk but doesn't have the urge to drink it. Tony, who may be from a parallel universe, wonders why James avoids tasting it.

> JAMES: This can't be answered.
> TONY: You don't know?
> JAMES: I can't answer.
> TONY: This is weird.
> JAMES: This is your perception of something weird.
> TONY: I agree.
> JAMES: To me it doesn't seem weird at all.
> TONY: That could be your particular perspective.[25]

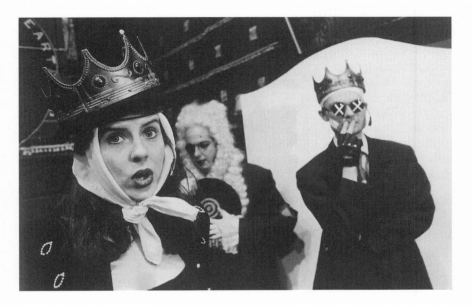

42. *The Universe,* 1996. Mary (Mary McBride), Tony (Tony Torn),
James (James Urbaniak). Photo: Paula Court

The narrative of *The Universe* is perhaps the easiest to follow of all Fore-
man's plays. James, a curious intellectual, attempts to decipher coded mes-
sages he believes are being transmitted to him by the universe. According to
the program, he "is visited by an exotic 'other' (Tony) who comes from
another part of the Universe. (Though all parts are 'right there' inside what-
ever brain registers them.)" Tony introduces him to Mary, who is so beauti-
ful she makes his eyes hurt. He alternately tells her to "Go away" and "Come
back."

> Though he tries to defend himself against her power over him (his own fall
> into the human condition) he cannot escape her ravishing eyes. He blinds
> himself in order to be "free" of bewitchment. . . . Still tempted with
> sweets—("Rejoin the human race, replace your useless books with some
> delicious pie, be re-seduced!")—the Universe (empty space) suddenly and
> upsettingly interrupts—hinting at an alternative to normal human life.

Foreman's voice booms over the loudspeakers: "Empty space calling. Empty
space calling James. Be in contact, please." James, however, turns away from
the frightening possibility of transcendence and settles for a milder pleasure,
a glass of warm milk.

All of Foreman's works are highly personal, as they deal with his ideas and

his state of mind. However, in his next play, *Permanent Brain Damage* (1996–97), the personal quality is even more pronounced, in part because his recorded voice is heard throughout and the onstage performers speak only a few phrases. In other plays he frequently made pronouncements over a microphone in a deep authoritative voice, commenting wryly on the action of his plays or the ideas, and in *Lava* (1989) he did all of the speaking. In his early work he spoke from his station in clear view of the audience, but more recently he has been nearly hidden in a partitioned-off cubbyhole at one end of the last row of seats. Perhaps *Permanent Brain Damage* seems especially personal because Foreman's self-confessed perpetual unhappiness is more directly reflected in this play, which he says is " about being tired of life."

> When I'm moved to write texts that are more philosophically me, with my sixty-year-old problems, it often comes out in a more monologic form and I find it easier to deal with if it's on tape. . . . It's really problematic for me finding an actor who will really do with the text what I want done and is able to sustain that over a long run. And of course it affords all kinds of other possibilities in terms of mixing the sound.

The central character in *Permanent Brain Damage*—a bald, bearded, cigar-chewing Man in a White Suit who seems to be Foreman's surrogate—is out-wardly stoic as he is put upon by a tormenting conspiracy of the other five characters (photo 43). Foreman's voice-over begins: "There is nothing to be afraid of really. Is there anything to be afraid of?" Eggs, echoing the bald fragile skull of the Man, are broken into a frying pan above his head, accompanied by a ping. Eggs are a recurring image. They are held over the Man's head; two are held at his groin suggesting testicles; they are pushed up the "small asshole" of a stuffed cloth duck. The torments continue. Performers behind the man say "Boo" and he falls over. He is zipped into a sleeping bag, hit in the head with a hammer; dough is plastered onto his bald head; trash is dumped on his head. One of his knees is tapped with a hammer, producing a ping; the other produces a pong.

Foreman's voice: "Here is a man whose brain has been damaged by life." A discordant version of "Sunny Side of the Street" is heard over the speakers, and the performers join in. Foreman's voice: "Here is a man whose thinking imprisons him." A two-by-four piece of lumber is held against his chest. Foreman's voice: "Here is a man who was doing some excellent thinking, but he has turned against his thinking. Why did he turn against his thinking? Because his thinking had imprisoned him." A small padlocked safe is placed over the Man's head. Four metronomes tick. Foreman's voice: "Try naming the part of this man's body that is most vulnerable, most alone, . . . most in pain. . . . What gives this man an emotional kick if there is anything which can give him an emotional kick?" The performers comically paddle each other, the paddles echoing the several small windmills among the detritus on the set.

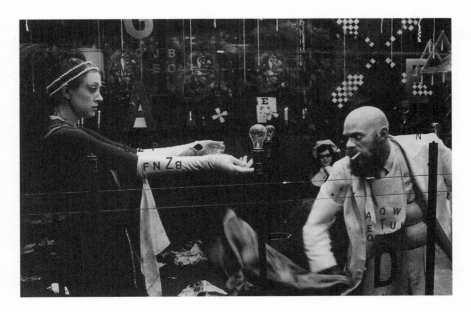

43. *Permanent Brain Damage,* 1997. Jennifer Krasinski and
D. J. Mendel. Photo: Paula Court

The windmills turn at moments of psychic tension. Foreman's voice: "And what is he left with when the magic is taken away? He is left with the world."

As the end nears, Foreman's voice gives a glimmer of hope: "When all seems lost, only then the weather changes." The Man has lost hope; he goes headfirst into a trash can. However, he is pulled out again for further torment. In the end the Man carries a six-foot stele bearing the letters "SOON?" and Sunny Side of the Street" is again heard over the speakers, but it stops abruptly. It is the end.

Foreman believed that *Permanent Brain Damage* was again too cerebral and that he would do something more aggressive.

> I thought, "I haven't done a sexy play for fifteen, twenty, years." I thought, "Can I still do it? Could I return to that and find anything what would function for me? Could I pull it off? Could I do something that was really provocative in that way and still have it be art?"

The result was *Benita Canova (Gnostic Eroticism)* (1998). In the play a Jewish schoolgirl named Benita Canova is in a strange house where she is at the center of a group of girls engaging in teenage antics of an erotic flavor. In

apparent command of the girls is Madame, who is in thrall of the vixenish Benita.

As with other Foreman productions at his Ontological-Hysteric Theater in St. Mark's Church, the audience sits in five steeply raked rows. Panes of Plexiglas separate the stage from the audience so the spectators can see themselves reflected, as well as see the performers. The set is Foreman's usual deconstructed thrift-shop baroque, in this instance made to look elegant. The usual cords, striped black and white, send the eye ricocheting around the stage, serving Foreman's aim of having the spectator see everything at once. Plastic salad bowls suggesting light fixtures are above. On the stage floor are Persian or Chinese rugs. On the walls are more rugs, striped maroon-and-black wallpaper, masks, and drapery. There are gold cherubs, plastic baby dolls, plaster garden gnomes, and magazine pages. A maroon Doric column stands upstage. Several letters, "C-C-T-D" and so forth, hang above the stage. As the audience enters, one of Foreman's tape loops is playing a phrase from a German cabaret song over and over.

Foreman says he was inspired by the French painter Balthus, who painted adolescent girls in erotically suggestive poses. The speaking characters are Madame (played in drag by David Greenspan) and three girls in modified schoolgirl uniforms. They include Benita Canova, who has a yellow star on her all-black uniform and whom Madame refers to as a "little Israelite." The other two are Benita's "chief rival," Cristina, an over-six-feet-tall blonde, and Betty, "the sly one." Three female "observers/interns" are dressed as schoolgirls. The six precocious adolescents, with their exaggerated eye-shadow, are bursting with erotic energy as they tease each other, swear, pull hair, wrestle, moon, and play a sadomasochistic game of field hockey. At times one or more of them looks directly at a spectator, making the entire audience aware of ogling the girls. From time to time an electronic flash is accompanied by a pop, and the girls scream giddily.

At the beginning Foreman's voice, slowed and lowered in pitch, says with profound emphasis, "Benita Canova," and several times during the performance his voice intrudes with "Excuse me, please." All performers have headset mikes that allow them to speak intimately and sexily. Cristina speaks in an affected Valley girl accent. Madame speaks in an invented accent as she compares the conceptualizing of humans and animals.

> MADAME: And a sleeping gorilla imagines waking up perhaps, once upon a time, to do very bad things to little ladies such that even little ladies may find it impossible to imagine.[26]

Cristina cries, "Oh—look at this, little Benita Canova's brain doing bad things to her facial expression." Benita thinks it "must have been her brain talking behind her back." The girls meow cattily, and Madame throws them a fish. Benita is wrapped in a pink comforter, arms and all.

MADAME: Do you believe you suffer from invisibility, my dear?
BENITA: (*speaking of herself in the third person*) Nothing surprises her. But she doesn't know if it's herself turning invisible, or somebody else.

Later Cristina sings,

> The girl who tried to kiss herself
> discovered when alone
> her lips had turned to razor blades
> her kisses turned to stone
> She sliced her body carefully
> and nailed the stones inside
> She threw herself against a wall
> to prove she hadn't died.

Cristina tells Benita to look in a mirror. Benita replies, as she moons the others, exposing her black underpants, "My mirror's got a big crack right down the middle."
The girls play field hockey, at times rather frenetically and with occasional screeching. Madame, grotesquely, tries to kiss Benita, who is repelled.

MADAME: Please, don't let your wonderful illusions vanish, Benita Canova! Because without our illusions, you will be forced to see things both as they are and as they are not—totally without separation. And this may be too much for such as yourself to assimilate. Because the truth, after all, hides in very strange places. Do you agree?
BENITA: Well, let's just say—the world tries to be beautiful, but it fails.

Madame puts her hand on Benita's crotch and says, "Know that I have the means to make you happy." Benita replies, referring to herself in the third person, "What means do you have—to make her happy?" Foreman's voice intrudes, "Excuse me, please." The girls, in a row, mime masturbating. A gorilla wearing a crown slowly crosses the stage as Madame says, "We are losing touch with reality. That is our one contact with reality. . . . Were we in TOUCH with something so tremendous,—Well—possibly we would die from such contact. And would we not be, then—dead indeed?" When the gorilla appears again, it screws Benita, who spreads her legs and, speaking of herself in the third person says, "Not her problem of course because she offers no resistance, she just stuffs herself with experience after experience after experience after experience."
Reality becomes rather slippery with respect to who is Benita Canova:

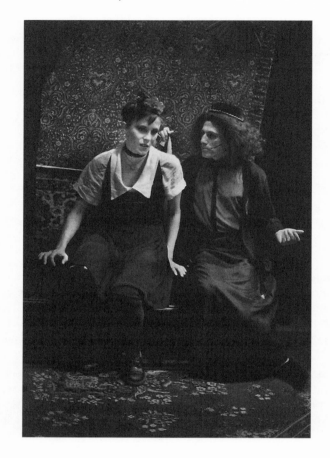

44. *Benita Canova,* 1998. Benita Canova (Joanna P. Adler) and
Madame (David Greenspan). Photo: Paula Court

MADAME: My real name is, "Benita Canova," and I—I have lost it
 completely.
BENITA: Lost what completely?
MADAME: Forgive me, of course. I do remember having a name of my
 own. Though now I do remember—only having lost the name—
 "Benita Canova."
BENITA: I am Benita Canova.
MADAME: I am Benita Canova, and I have lost it completely.

The other girls repeat "Benita Canova," and Benita concludes: "Then we are
all, in fact—named, Benita Canova. And we have all, in fact—lost it com-
pletely."

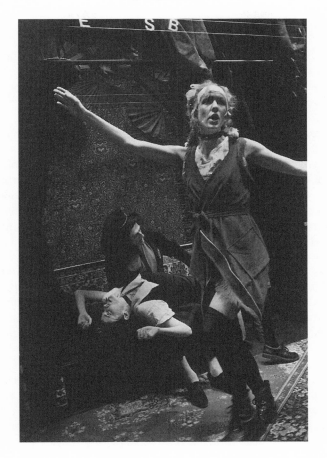

45. *Benita Canova,* 1998. Benita Canova (Joanna P. Adler), Madame
(David Greenspan), Cristina (Christina Campanella).
Photo: Paula Court

Madame claims that innocence is a disguise that never lasts forever. Benita,
however, proves that she knows one thing that lasts forever. She smothers,
stabs, and kills the gorilla.

The girls whip each other and scream. Madame chases Benita, briefly loses
her wig, and speaks in the voice of the male performer. Then, sitting,
Madame bends Benita backward over her lap and thrusts a hand under her
dress between her thighs (an image from *The Music Lesson* by Balthus), and
Benita describes the groping (photo 45). Madame faints briefly and reveals
an erect penis. Having discovered Madame is a man, Benita is attracted and
speaks of herself in the third person.

BENITA: Then she's glad we've met finally.
MADAME: *(Flabbergasted)* Glad? Why of all things glad?
BENITA: Because compared to you—she's the opposite, and opposites always attract. *(Gives Madame a kiss)*
MADAME: [As the gay male performer] *(Wipes her mouth)* Not really. Not this time at least.

Benita smears lipstick on and around her lips, kisses the Plexiglas separating her from the audience, and signs her creation. Wrapped gifts have been brought onstage, but Foreman's voice warns the girls in a double meaning: "Oh Benita Canova, never, never, never, never open such dangerous gifts."

The tone of the play is largely comic, sometimes resulting in open general laughter. The ironies and double meanings are not always readily apparent, so the spectators often do not get them at the same time, resulting in chuckles and guffaws. While the language is complex and at times intentionally obscure, the action and narrative are clear. And the philosophical questions of identity and reality, embodied as they are in naive eroticism and performances of high energy, make for a highly entertaining and sexy production.

Foreman's comments on the development of the play provide an insight into his creative process: "The play started because I'm frustrated—I'm always frustrated, perpetually frustrated and unhappy." He wanted to do a production that was energetic and provocative.

I found a page that I had written or I wrote a page, I don't know how it happened, but I remember this page where she says, "I'm not your friend, but this could still be a source of energy." I looked for other pages that could relate to that, and I wrote a couple of scenes that could relate to that, and I was a little influenced by seeing Copi's play *The Four Twins* a couple of years ago at my theatre. It's a play about these four girls knocking each other around, taking a lot of drugs, and being sexy. I thought maybe I'd do something like that. I want to get people into my theatre. So, I had those lines of dialogue, and I thought maybe it would be a play with all women. That's something I'd never done. It soon became apparent when I thought of the women I could get that maybe it would be more interesting to have David [Greenspan] do the part [of Madame] because . . . people told me he was really great when playing a woman. Then, as usual, trying to figure out how do I do this material, at first I thought—I listen to loops and I had a Spanish loop—and I thought, "Maybe they could all be Spanish spitfires and it could be in some border town." There's a David Bowie video where he's with some Mexicans in a rundown café—it seems to be Tijuana or someplace—that could be the mood and [the women could be] models out on a shoot just being decadent. I had also thought of Balthus because I had used Balthus imagery in certain other plays to stimulate my imagination. Anyway . . . Balthus sort of came

back. I was looking at pictures, listening to music, rewriting a lot. We went into rehearsal finally, with Balthus being the idea.

After rehearsing for a time, he became worried that it was turning out "like Broadway" and that he was "selling out." He had become so accustomed to his own work that the production was beginning to seem ordinary and he had difficulty telling the difference between it and conventional productions. So, working with the actors, he kept changing the concept of what was going on in the play so as to "make it less obvious." They asked several questions: What is this place? What is Benita's relationship to it? Who is the Madame? When these questions were answered one way and they had rehearsed for a time, the result again came to seem ordinary to Foreman, and so they tried different answers.

At one point we thought, "Benita Canova is coming to this house of plea- sure or pain or whatever it is," but then that seemed too obvious and we decided that actually it was Benita Canova who wanted all of this to hap- pen so it's at her house. She's this little Jewish girl and her family's away for the weekend and she's invited her classmates and the math teacher or someone to come to her house and she's really running this thing that will victimize her. So we developed that and developed the interactions and then it too became too clear, it lacked any other dimension, it just existed in the real dimension. Then we had to go back and change it to make sure it wasn't quite so committed to anything so obvious because that prevents other possibilities for your mind to explore as you're watching the piece.

At one point in rehearsal, to keep the work interesting for himself, Foreman had all of the actors look at the audience as they spoke. This is what Kate Manheim used to do from time to time, which had the effect of making the spectator aware of looking. However, that was soon abandoned as "too arti- ficial and arty," and in the end the device was used sparingly. As another means of distancing the fictional world and avoiding banality, the performers at times spoke of themselves in the third person. Instead of saying, "I'm going to get some chocolate cake," the performer says, "She's going to get some chocolate cake."

The set too underwent a metamorphosis by way of keeping Foreman inter- ested. This is a practice that has become usual in his productions. He never thinks about the theatre or the set or the staging as he is writing; he thinks only of getting something down. The physical aspects come later as he is assembling pages and writing additional scenes. However, he might look over what he had written in the last month and say to himself, "'It's all so philo- sophical. I'd better do something concrete because that's always the center of a play.' So I try to be more physical because I know that I need that to keep the plays from being boring." He might, for example, imagine going into a

glove store and devise an exchange of speeches about buying gloves. Although Foreman does not think of location while writing, the set is designed and built in advance of the rehearsals, changing along the way. The set for *Benita Canova* started out much larger than it ended up.

Usually these days my sets turn out to be half or a third the size I start out with, in terms of depth. There was a light pale sickly green wall with stripes; I thought it looked like a lonely French room; that all changed. I had to end up putting up all my junk, the color changed, the set got compressed. A lot of that baroque stuff you see was put in in the last three days. I would keep thinking, "Now this is really cluttered, I have enough," but then I got used to it and I needed more and more. And the last three days I really went crazy. It grows like it usually grows. I have an idea for a set, and I think it's going to be much more different from the rest of my work, but I end up discovering that it doesn't satisfy me, it's not compressed enough, there're not enough facets in the set so that ideas, phrases, sounds, have lots of things to bounce around off of, sort of circulating in a diamondlike structure. That glitter of ideas and sounds and set and gesture all interlacing and bouncing off of each other is what I'm really after. And I always think, "Well, this year I'm really going to do an austere play as I did in the beginning." But it doesn't work for me. It doesn't work for my texts. I don't really have the taste for it anymore.

Not only did the set become more cluttered and somewhat claustrophobic, but as Foreman became used to seeing the actors in it, he again became dissatisfied. It looked too dispersed; nothing reverberated sufficiently. So he put a line of tape on the floor and gave the actors only four feet left stage in which to perform. The impulse was to "squeeze them all together so you could see all the bodies interfering with each other, overlapping each other, and also for psychic tension." Although Foreman later allowed them to go beyond the line, in the production much of the action was still left stage.

Throughout the thirty years of Foreman's professional life he has managed to write, design, direct, and produce an average of about one-and-a-half productions per year while remaining true to his unique visions. In addition he has directed operas, plays by others, made films, written essays, and published a novel. Almost as inevitable as the seasons, in the last several years he has begun performances of a new play in December and run it for a couple of months into the new year. How long will this continue?

Now, I don't know any more. I do them. I've reached the point now where I'm seriously thinking, "My God, I don't know how many more plays I have left in me." I've been thinking that for a number of years, then I make a few scratches on a page and all of a sudden I say, "Well, I can make a play out of these two pages somehow." So that will probably go on like that, but I always have the feeling that I'm always on the edge of having nothing

more to say, and then I get very frustrated and mess all my pages up and mess my head up with reading and just in the nick of time something else sort of pours out.

The Wooster Group

The Wooster Group (see chap. 6) has developed into one of the most highly regarded American avant-garde companies and one of the best-known avant-garde theatrical exports to Europe. Several members have received Obie Awards; in 1991 the company received an Obie in recognition of fifteen years of sustained excellence, and in 1995 director Elizabeth LeCompte received a MacArthur fellowship in acknowledgment of her distinguished work. Since their beginning in 1975 their productions have become increasingly complex and layered, but their creative process has remained much the same. Their pieces are created collaboratively under the direction of LeCompte and, according to a concise company statement, "are constructed as assemblages of juxtaposed elements."

They combine radical restaging of classic texts, found materials, films and videos, dance and movement works, multi-track scoring, and an architectonic approach to design. Through a process of overlaying, colliding, and sometimes synchronizing systems, the structure of a piece gradually emerges during an extended rehearsal period and the various elements fuse into a cohesive theatrical form. The group has played a pivotal role in bringing technologically sophisticated and evocative uses of sound, film, and video into the realm of contemporary theater.

Juxtaposing seemingly unrelated elements without interpretation and creating forms presented in tasked-based performances by highly skilled actors are the hallmarks of the group.

The works are a long time in development. They are first presented as works in progress at the Performing Garage on Wooster Street in New York's Soho, and they remain in the repertoire for several years—some as long as a decade. During this time they continue to evolve, becoming increasingly layered and complex. LeCompte compares the experience of seeing Wooster Group productions to visiting a painting more than once, with additional discoveries made on each viewing.

Although the core membership of the collective has been more loyal than most, there have been changes. In the mid-1980s the seven members were the cofounders Elizabeth LeCompte (director) and Spalding Gray (actor) plus Jim Clayburgh (designer), and performers Willem Dafoe, Peyton Smith, Kate Valk, and Ron Vawter. The changes in personnel have resulted in part from the incubator nature of the group. Principal among these changes is that Spalding Gray began working less and less on group productions as he devoted his energies to personal monologues (see chap. 6), which he has pre-

sented internationally, and to acting in films. His experience in one of these films, *The Killing Fields,* he used as the focus of his monologue *Swimming to Cambodia,* which was subsequently made into a film. Willem Dafoe also began spending much of his time as an actor in films, including *Platoon* and the controversial *The Last Temptation of Christ,* while continuing to perform in some of the Wooster Group's productions. Ron Vawter, until he died of AIDS in 1994, continued to be active in the group while simultaneously working in films and performing his one-man show, *Roy Cohn/Jack Smith,* drawn from the lives of these two very different men who also died of AIDS. And, although he was not a member of the company, Michael Kirby, the founder and director of the Structuralist Workshop (see chap. 5), who performed and wrote for the Wooster Group, died of leukemia in 1997.

Since the first publication of this book, much has been written about the Wooster Group, including the comprehensive book by David Savran titled *The Wooster Group, 1975–1985.* Consequently, the discussion here will focus primarily on their second trilogy, *The Road to Immortality,* and subsequent productions that extended the process developed for their first trilogy, *Three Places in Rhode Island.* While the three productions comprising *Three Places in Rhode Island* drew upon events in the life of Spalding Gray, the last of the three plays, *Nayatt School,* also referred importantly to T. S. Eliot's *Cocktail Party,* in which Gray had acted as a college student. The epilogue to the trilogy, *Point Judith,* was in part a response to O'Neill's *Long Day's Journey into Night.* The three parts of *The Road to Immortality* continued this practice of using well-known plays and literary works as source materials.

Route 1 & 9 (1981), the production that came to be part 1 of the second trilogy, drew specifically upon Thornton Wilder's *Our Town* and a comic routine by the black vaudevillian Pigmeat Markham. In the live action the white actors play caricatures of African Americans, as was common in the theatre of the nineteenth and early twentieth centuries. They wear blackface makeup with huge lips and speak in exaggerated comic black dialect (photo 46). Playing these crude caricatures, they act out with tremendous energy Markham's *The Party,* while sentimental scenes from Thornton Wilder's *Our Town* are seen on four television monitors suspended above the stage. In the beginning of *Route 1 & 9* Ron Vawter, on the monitors, gives an impersonal deadpan satirical reconstruction of an *Encyclopedia Britannica* lecture on how to interpret *Our Town.* This is followed with *Our Town* segments including Emily's nostalgic speech in act 3, when she returns from her grave for one last look at what will be gone forever. The speech, played with total sincerity, ends with this:

Goodbye! Goodbye, world! . . . Goodbye to clocks ticking—and my butternut tree! . . . and food and coffee—and new-ironed dresses and hot baths—and sleeping and waking up!— Oh earth, you're too wonderful for anyone to realize you! Do any human beings ever realize life while they live it—every, every minute?

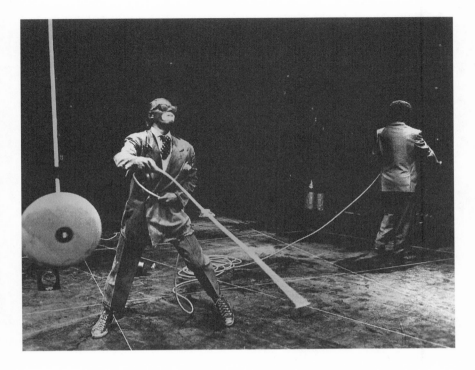

46. Willem Dafoe in *Route 1 & 9*. Photo: Bob van Dantzig

In the simultaneous live action Markham's routine is juxtaposed. At Willie's raucous birthday party someone has put castor oil in the punch. As the wild party dancing continues, one by one the guests suddenly stop dancing and run off to "send a telegram." Only Pigmeat and Willie are left.

> PIG: Oh, me.
> WILLIE: Pigmeat.
> PIG: Oh, ho, ho, oh ho.
> WILLIE: Whatsa matter Pigmeat?
> PIG: Whadya mean?
> WILLIE: Don't tell me you gotta go send a telegram too?
> PIG: No, no, I done sent mine.

Other elements in *Route 1 & 9* include a porno film with Willem Dafoe, the actor who played George in the *Our Town* film, playing a randy truck driver who picks up two young women hitchhikers apparently on New Jersey's Route 1 or 9. And while the characters at Willie's party are carrying on, moments of actuality are superimposed on the fictional as the actors, in char-

acter, consult a telephone book and phone take-out places to order food delivered to the theatre.

When LeCompte started working on *Route 1 & 9* she had no idea that the routines from Pigmeat Markham would have anything to do with *Our Town,* no idea that "they would go together." She had been working with the Pigmeat Markham material because she was interested in the form. And she was interested in Wilder's writing also for formal reasons—"a sort of poetic text" to juxtapose with the Markham material. They were intended to be two elements existing separately in the same time and space, much as John Cage and Merce Cunningham put their music and dance together without intending them to correspond thematically, or like Marcel Duchamp's assemblage of a kitchen stool and a bicycle wheel.

LeCompte has related Wooster Group productions to works of the dada movement and the nonintentionality of John Cage. They are structured as theatrical collages or assemblages with different worlds colliding in the same space. In the view of LeCompte it is not for the artists to make meaning that can be abstracted from the work itself. But it may be inevitable. LeCompte says, "Of course eventually—because I and the company are the catalysts for the two things coming together—I will see things."[27]

> The defecation joke is funny and disgusting. There's a wonderful ambivalence because it's a horrific social no-no and at the same time an elemental thing that's part of us. It's not just obscene. The joke is a way of laughing at death.[28]

The Wooster Group has always lived on the edge aesthetically, and with the first two productions of what was to become *The Road to Immortality* they found themselves on the edge politically and legally as well. Objections to *Route 1 & 9* were immediate and loud because they performed in blackface. Some detractors accused the Wooster Group of being racist. Even some supporters of the company who knew they were not racists believed a disservice had been done to African Americans because the production perpetuated a stereotype. Other supporters saw the production not as a comment on black people but on stereotypes—both black stereotypes and white middle-class stereotypes as seen in *Our Town.* The New York State Council on the Arts, from whom the company had received financial support, rescinded funding for the production. The council's statement explains that they "found it inappropriate to support the production with funds . . . that are raised by taxes from the community at large [because it] contained in its blackface sequences harsh and caricatured portrayals of a racial minority."[29] The artistic community was divided, and meetings were held to discuss the issue and the aesthetic implied by the production. At one such meeting in January 1982 it was reported that most of the white participants considered the withdrawal of funds to be a form of censorship; four of the six African Americans present

considered the council justified in not supporting racism with public funds. Elizabeth LeCompte, the report said, defended her way of working.[30]

LeCompte has said that the impetus for the next production, *LSD (. . . Just the High Points)* (1984), was the calumny she suffered as a result of *Route 1 & 9,* which in her view amounted to a witch hunt. It reminded her of the witch hunts conducted in the 1950s by both houses of the U.S. Congress. Led by Senator McCarthy and the Un-American Activities Committee of the House of Representatives, Congress sought to ferret out Communists and sympathizers. In reaction to these congressional hearings Arthur Miller wrote *The Crucible* (1953), using for its setting a parallel event in the country's history— the Salem witch hunts of the seventeenth century. Originally the Wooster Group's production incorporated a portion of the play. The director also said that her production has to do with visions, seeing things that others don't see, stepping outside the usual way of producing imagery. Her interest in visions and the vision-producing drug LSD may have led LeCompte to listen to the recording called *LSD* (1965) by the psychedelic guru Timothy Leary and to read the works of 1950s beatnik writers.

The setting for the production reverses the relationship of the audience and the long narrow table of *Nayatt School.* The table for *LSD* stretches across the front of the very high stage, requiring the audience to look up. Again, as in *Route 1 & 9,* video monitors face the audience. At the beginning the men in the company enter and sit behind the table, each with his own microphone. The image evokes several layers of meaning. First is the actuality of the Wooster Group men sitting at a table; next it suggests the arrangement for a congressional hearing, and later, more specifically, the hearings conducted by Senator McCarthy as he attempted to hunt down Communists. When *The Crucible* section is performed, it also reminds us of the Salem witch hunt inquisitions.

In the beginning, the men sitting behind the microphones take turns reading brief passages of a minute or less from the beatnik writers and from 1960s counterculture figures. As he is called upon by Ron Vawter as the MC (evoking a congressional committee chairman), each reads a passage from such writers as Jack Kerouac, William Burroughs, Alan Watts, and Allen Ginsberg. When a buzzer sounds, each stops reading and the next man is called upon. The subject shifts to the guru of LSD, Timothy Leary, who claimed that while at Harvard he had given psychedelic drugs to three hundred professors, graduate students, writers, and philosophers. A woman performer, Nancy Reilly, listens on an earphone to a tape of Leary's baby-sitter and repeats what she says. Reilly takes as a task the repetition not only of the words, but the inflections, nuances, pauses, and so on. It is one technique for being present, creating actuality rather than the fiction of character.

In act 2 the men, in contemporary street dress, are joined by women in American colonial costumes. Still using the table, and performing under the table as well, the company presents a frenzied twenty-minute deconstructed

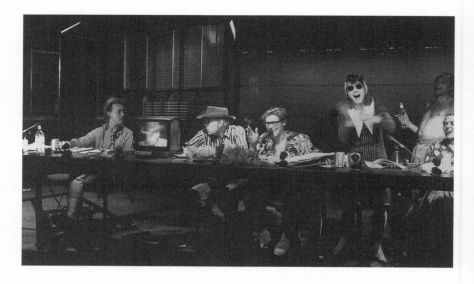

47. *L. S. D. (. . . Just the High Points).* Jeff Webster, Michael Kirby
(on the monitor), Michael Kirby (live), Willem Dafoe, Nancy Reilly,
Ron Vawter, and Kate Valk. Photo: Bob van Dantzig

recitation of a section of Miller's *The Crucible* spoken so fast that it often
sounds like gibberish. Tituba, a black character, is played by Kate Valk in
blackface in spite of the difficulties of *Route 1 & 9.*

Act 3 is a task-created performance of a videotape the company made of a
rehearsal of act 2 after taking LSD. As with the baby-sitter's text, an attempt
was made to duplicate exactly what was seen and heard on tape—every ges-
ture, every giggle, every shriek. The result looks and sounds like a wild 1960s
drug party and is a mishmash of lines from *The Crucible* and extraneous
interactions.

Act 4 is a reconstruction of the debate that took place in Miami between
two unlikely adversaries—Timothy Leary and G. Gordon Liddy, one of the
so-called Plumbers who attempted to burglarize the Democratic headquar-
ters in the Watergate Hotel, which ultimately led to the resignation of Presi-
dent Richard Nixon. This debate is juxtaposed against a sleazy Spanish
cabaret act with Kate Valk and three of the men impersonating Donna Sierra
and the Del Fuegos.

LeCompte has said that one thing that is always present in her work is "the
opposition between high art and low art, high entertainment versus low
entertainment." In *Route 1 & 9* she had juxtaposed Thornton Wilder and Pig-
meat Markham. In *LSD* the cabaret act is in opposition to Arthur Miller. But
she also had in mind a reading intended for tourists she had heard in Salem.

In the reading two high school girls reenacted with great amateur commitment excerpts from the Salem trial testimony.[31]

Beginning in late 1982 the Wooster Group attempted unsuccessfully to obtain performance rights to *The Crucible*. The company contacted Miller directly in October of the following year and persuaded him to see a rehearsal. A week later he instructed his agent to inform the group that he would not grant permission. LeCompte made further attempts by letter to persuade Miller to change his mind. In the fall of 1984 the production opened to New York critics, and the group received a cease-and-desist order from Miller's attorneys. The group's first response was to perform *The Crucible* sections in gibberish, but soon they stopped performing *LSD* altogether until Michael Kirby wrote *The Hearing* to take the place of the Miller excerpts. When a line from Miller was "accidentally" spoken or a reference made to a character from his play, the performer was silenced by a buzzer.

The final production in *The Road to Immortality* trilogy managed to avoid legal and political problems, though it was still very much in the Wooster confrontational aesthetic of literary deconstruction. The principal literary text was by Gustave Flaubert, dead for more than a hundred years. *Frank Dell's The Temptations of Saint Antony* (1987) also used as "source texts" the letters of Flaubert, an unauthorized biography of the controversial, often obscene, comedian Lenny Bruce, Ingmar Bergman's film *The Magician,* the Dead Sea Scrolls, and several other works. Frank Dell of the title was a pseudonym Lenny Bruce used in his early club appearances. In an indirect way Lenny Bruce was also responsible for the name of the trilogy. During his last days he was obsessed, it is said, with a book of that title concerning life after death written by the British psychic Geraldine Cummins. The program note for *Saint Antony* recaps Frank Dell's history in Wooster Group productions:

Frank Dell first appeared in *Route 1 & 9* as the driver of a van who stops to pick up two hitchhikers. In *LSD* he reemerges in Miami, where he and his partners fraudulently pass themselves off as the South American dance troupe Donna Sierra and the Del Fuegos. In *Saint Antony,* Frank is discovered in a hotel room on the outskirts of Washington, D.C.

LeCompte has said of the production that "the process of making the work is the work."[32] The vague plot of *Saint Antony* has Frank Dell (Ron Vawter) and his theatre troupe hiding out in a seedy hotel room. As in Bergman's film, they are on tour with a tacky magic show; but they are also rehearsing *The Temptations of Saint Antony*. The identification of the troupe is ambiguous; they are Frank Dell's troupe, but they are also the Wooster Group. They must perform to prove they are not charlatans. (In Bergman's film the troupe's tricks are revealed to be fraudulent.) The performers appear live and in a video that was made in imitation of a late-night cable television show. This video, seen on monitors, plays through most of the live performance.

The physical arrangement is similar to that for *LSD*. The actors perform

on a high platform that is not very deep, with a narrow bed instead of a table. Beneath the platform is the sound technician. Later, part of the platform floor tilts up to a ninety-degree angle and becomes a wall with two doors.

The production has several levels that echo and resonate among themselves. The most important level is the live presence of the performers themselves, who take physical and ego risks analogous to a sport event.

The first section suggests a Lenny Bruce club routine. Ron Vawter as himself, but referred to as Frank Dell, is in front of the platform rather than on it. In a video seen on the monitors the Wooster Group performers sit around nude, sometimes dancing, while a nude Vawter with a microphone interviews them. The dialogue, which is not heard by the audience, was apparently improvised from source texts. It is like a late-night cable television broadcast in which nude people sit around talking inanities as a telephone number flashes on the screen for horny people to call. The live Vawter wears a bathrobe as if he has just stepped out of the video scene, and he speaks for those on the screen, including himself, lip-synching over a handheld microphone. The dialogue that Vawter reproduces is disconnected and inane. Reproducing a speech of his own from the video, he says,

> The sphinx and the Chimera! And, uh, what have you come to tell me? *(He laughs.)* I didn't mean to be blunt or direct about it, but you know, if you feel like you have to go on, go on. But just let me know what uh, what it is that you think you came here to tell me.

Because several performers are involved in the conversation, the skill required to precisely reproduce it is even greater than in the section in *LSD* in which Nancy Reilly imitates the speech of Leary's baby-sitter.

In a performance I saw there was an electronic pop during this first section, and the sound system apparently went out. Vawter/Frank said, "Just a minute. This is not part of the show." It was not clear whether it was planned or not; but his saying that it was not part of the show, made it a part of the show. Later, Vawter told me LeCompte had told him to give that explanation anytime something went wrong. Such ambivalence occurs throughout. At another point Vawter/Frank says he has lost his place in the video and instructs the sound man, "Take the tape back, Dieter. Back to where I hand the mike to Anna." (Dieter is the character name for the actual sound person.) The tape is backed up or, perhaps more likely, the backing-up process has been prerecorded. Later an upside-down image comes on the screen, and Vawter/Frank asks the technician to speed through it, as it's not the right section. On the video Kate Valk (Onna) and Vawter/Frank on the video, both naked, dance. Similar to the images in the *Route 1 & 9* porno film, the camera zooms in on their genitals and freezes on Vawter's.

Performing naked is one kind of risk, but physical risk is another. In a later episode the floor is tilted up to become the back wall, and performers are strapped to the two doors that are repeatedly opened and violently slammed

shut. One of the performers seems to be bringing an ice bucket to Lenny Bruce in the hotel room. The force of the door slamming causes the ice cubes to be thrown from the bucket and scattered over the stage. The video continues, and Vawter asks the sound man to back it up. When he does, both the video and the live action go into reverse. By the end of the segment the performer strapped to one of the doors is bare-chested and bloody.

Oblique references to Bergman's *Magician* are evident. Kate Valk and Peyton Smith, on opposite sides of the stage, perform an unusual mind-reading act. Smith holds a book to her forehead, and Valk holds her hand over her eyes. Near the end of the performance Vawter says he would like to work the section where the bed collapses, and a video loop of the collapsing bed is played as Vawter lip-synchs to the video performers. On the real bed center stage, Vawter makes magical gestures as Dr. Del Fuego and, with the aid of ropes, levitates the dummy that has been placed there. And Kate Valk magically makes a floor lamp go off and on by gesturing toward it.

Finally, like an MC or stand-up comic, Ron Vawter as Lenny Bruce/Frank Dell goes up the aisle into the audience, speaking over a microphone. On a video monitor a figure keeps trying to get his attention, but Vawter ignores him and leaves the theatre.

Much of the pleasure in *Saint Antony* and in other Wooster Group works comes from making connections between the sources drawn upon by the production and referenced in the performance. When these connections are made by the audience, laugher often results because of the exhilaration of having made a discovery. To assist the audience, the program for the 1990 Los Angeles Festival performances listed the principal sources and briefly described them. Another pleasure is the ambivalence between actual and fictional, between unplanned and planned, and our attempts to sort out which is which. (Actually, everything is planned with precision, even though material is frequently added and mishaps occur.) Both of these pleasurable experiences are possible because the techniques employed by the group do not permit the spectators to become passively absorbed in a fictional world. The techniques create the desired state of mind in the spectators by demanding that they focus actively on the present moment and on the Wooster Group performers while being aware of the source materials and their relationship to the performance. Active mental participation allows memories of the sources to be triggered so they collide and resonate with what one sees onstage.

In *Brace Up!* (1991) LeCompte drew upon Chekhov's *Three Sisters* and both classical and popular forms of Japanese entertainment. She emphasizes that the production is not an interpretation or an adaptation of Chekhov. Rather, she thinks of it "as a double portrait of Chekhov and the Wooster Group."[33]

I'm not just doing Chekhov. I'm trying to—I'm trying to make it present for me. Which means literally reinventing . . . it from the ground up. From the way that the language resonates in the body on the stage—every way—

to the way the psychology has to be . . . crashed up against and fragmented and then reformed . . . it's akin to writing. I just have my characters, my words, my colleagues, all materialized on the stage. Writers can do it in their head. I can't.[34]

A dual impetus led to *Brace Up!* The previous productions tended to put the men of the company in central positions, and because of their developing careers outside the company—Spalding Gray in his monologues and Willem Dafoe and Ron Vawter in the movies—they had achieved more prominence than the women. The choice of *Three Sisters* helped shift this focus by putting the women in the foreground. Second, LeCompte's interest in form had led the company to Japanese presentational acting, which they studied through films and videotapes.

As in previous works the selected play was only a beginning point, with the company spinning off into a self-referential production in which, as in *Saint Antony,* they vaguely resemble a traveling theatre group. According to the translator, Paul Schmidt (d. 1999), who played Chebutykin in the production, the company had become interested in a documentary film about a provincial Japanese theatre troupe, and the "concept" was how the production would look if that troupe were to stage Chekhov's play. As the Wooster Group developed the concept, Schmidt says, the main focus was to create a sound structure that articulated the music of Chekhov's play. They used Schmidt's translation of Chekhov's text except for three scenes at the beginning of act 2 and most of act 4.

In *Brace Up!* the three sisters of Chekhov's play and Kate Valk as Narrator are onstage throughout, while the men are relegated to tables at the back and come forward only for certain scenes; most often they are seen on video monitors (photo 48). The video images of these performers also serve the practical purpose of filling in for those who may be absent during the making of a movie. In fact, according to the dramaturg–assistant director (Marianne Weems) the production was structured "so that anybody in it could go away, except for Kate [Valk], and we would still be able to continue. . . . Because we work with modular pieces, we simply close up the gaps, and have Kate narrate what's missing. We had to do that a lot on tour." However, despite this flexibility, LeCompte is obsessive about detail and creates a movement or gesture for every word in the text.[35]

Valk as Narrator, using a stand microphone at the front of the stage platform, introduces actors, sets up props, signals lights, sound, and video, and makes "corrections." Peyton Smith as Olga is often seen on a TV monitor because LeCompte thinks "she has a wonderful, soap-opera-performance quality" and because the practice works well with the conversational translation.[36] Irina, the youngest sister, is played in a wheelchair by Beatrice Roth, who is in her seventies. Anfisa, the old nurse, is seen only in black-and-white video. Valk explains to the audience that Anfisa is played by a ninety-five-year-old performer who can't be there.

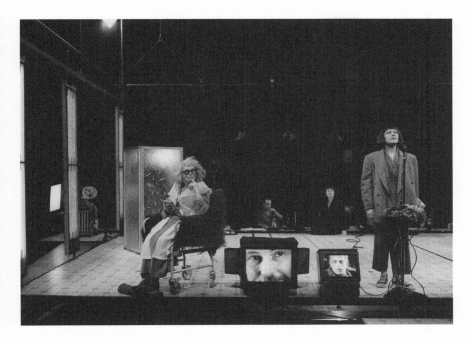

48. *Brace Up!* Irina (Beatrice Roth), Vershinin (Paul Lazar),
Tusenbach (Jeff Webster on monitor), Olga (Peyton Smith),
Chebutykin (Paul Schmidt on monitor), Narrator (Kate Valk).
Photo: João Tuna

As in other productions, sound dislocation and disruption are two of the techniques working against a cohesive narrative. Performers on video monitors carry on dialogues with live performers, and performers offstage speak over microphones for characters on video. "Mistakes" or "adjustments" occur during the performance. At one point Valk tells us that this is the wrong place for the entrance of Fedotik; at another Ron Vawter as Vershinin sings in Russian and translator Paul Schmidt, who plays Doctor Chebutykin, corrects Vawter's grammar, telling him, "It's the genitive case." And sometimes Vawter speaks as himself, as when he tells the sound operator to leave the sound off because he has something important to say. Willem Dafoe as Andrei sobs at great length until Valk taps him on the shoulder; he suddenly stops, drops character, and calmly leaves the stage.

LeCompte is interested in presenting actual events onstage rather than the fictional ones that could result in a compelling narrative and psychological acting. One of the techniques for accomplishing this and keeping the audience focused on the actual present is task performance. In rehearsal, she says, "I try to deal mostly with tasks."

I say to the actors, "you have information to present to the audience, and you are responsible for a clear imparting of this information." That's giving them a mental task, so they can get through the persona thing without coloring it emotionally.[37]

Most of the tasks used in rehearsal are more specific. Some involve games invented so as to avoid "acting" and make the performer exist in the time and space of the stage moment or to find abstract movements that do not derive from character psychology. For a time each *Brace Up!* rehearsal began with the performers blindfolded. Because they didn't know where they were walking, they had to be very careful. A bell was sounded if anyone was about to walk off the edge of the stage. Another task was to find a hidden object or get through a speech in a given amount of time. A game incorporated into the production was requiring the men to take a shot of vodka each time they heard a certain word, such as *Moscow,* the word changing every night.

Some more elaborate tasks in other productions are Vawter's imitation of the performers' voices on the video in *Saint Antony,* and, of course, the performer strapped to the slamming door is performing a task that has efficacy. Other examples are the section in *LSD* that resulted from attempts to duplicate exactly a video of a rehearsal while under the effects of the hallucinogenic drug. LeCompte says that if actors reproduce something as a task, they never have to think about the interior because they do it technically. "I'm not interested in creating the actor's vague psychological reality. The only truth is in reproducing what somebody actually did."[38]

These tasks, which are perceived as actual by the spectator, LeCompte has referred to as "real naturalism."[39] She has said that "the constant battle for me as a director is to find ways that an actor can be always present, always alive, always thinking this is the first and the last moment that she's there— doing this thing—within a structure that is so strong and so sure."[40]

For similar reasons LeCompte tries to avoid narrative. It is too closed, she says. The audience just goes along, involved in the suspense of a story, instead of being mentally active attending to the present moment. When she uses narrative material such as that from Chekhov or Wilder or Miller or Flaubert, she disrupts it in a variety of ways so it cannot flow. In this respect the work is similar to that of Richard Foreman. Also like Foreman, she avoids taking overt political positions in her work, as this too is closed, tending to tell the audience what to think rather than making them think. LeCompte has said that she has no thematic ideas. "I don't have anything except the literal objects—some flowers, some images, some television sets, a chair, some costumes that I like."[41]

The Wooster Group productions following *Brace Up!* have continued to use well-known plays as inceptive ideas. *The Emperor Jones* (1993) took off from Eugene O'Neill's play, with Kate Valk playing the title character in blackface. A short work called *Fish Story* (1994) made use of the fourth act of *Three Sisters,* which had been omitted from *Brace Up!* In 1995 the group pro-

duced on Broadway a comparatively straight version of *The Hairy Ape* by Eugene O'Neill with Willem Dafoe as Yank and Kate Valk as Mildred. Although the narrative was more cohesive, it still had the task-based acting style of previous works, and the scenic concept used the actual machinery of the theatre to stand in for the machinery of a fictional steamship.

For some time LeCompte, like several other avant-garde directors, has been interested in the writings of Gertrude Stein. Richard Foreman had directed a production of Stein's 1938 opera libretto *Doctor Faustus Lights the Lights* in 1981, and Robert Wilson directed a production of it in 1992. In 1998 the Wooster Group presented *House/Lights,* inspired both by the Stein work and by Joseph Mawra's 1964 sexploitation film called *Olga's House of Shame.* The interest in Mawra's film came about when the group was making a film for which they needed a torture scene and someone suggested *Olga's House of Shame.* Initially the connection between the works, as Kate Valk remembers, is that the narrator in the film says, "To incur Olga's wrath is to invite the Devil from Hell."[42] The two stories are intertwined, overlapped, and folded one into the other. In the film Olga and Nick run a jewel-smuggling organization. Elaine, one of their couriers, has double-crossed them. She is held captive but escapes and is recaptured and tortured by Olga. In Stein's work Mephistopheles has come to claim the soul of Faustus, which he had sold for the ability to invent electric light. Olga and Mephistopheles are played by Suzzy Roche (Peyton Smith in the work-in-progress performances) as a seasoned seductress with horns and a tongue she uses like a snake. She tempts Valk, who, as both Faustus and Elaine, is made up as a 1930s-ish marcelled vamp with bright red lips. Her voice is electronically transformed into a high squeak.

As in some previous productions, the live actors are also seen on video. Kate Valk, at a microphone downstage center, speaks the lines and stage directions from the Stein text and is also seen live on a video monitor that has a camera mounted on top (photo 49). Recorded scenes from the Mawra film are sometimes seen on this monitor and on three upstage monitors. When Valk speaks, focus is clearly on her. At other times focus quickly jumps here and there. This is especially true during the frequent loud moments of ordered chaos that punctuate the performance. At times performers run wildly around the stage, frenetically enacting scenes from the film that simultaneously are shown on the monitors. For example, when Elaine in the film is seen on the monitor attempting to escape, the actors onstage duplicate the action. At times, recorded video is seen on the monitors. Philip Bussmann, credited with the video, has created a number of special effects. At one point Valk, a live talking head on the monitor, is in black and white; she touches her lips and suddenly they turn red on the monitor. Sometimes Valk's head on the monitor freezes as the live Valk continues to talk. At other times, the opposite occurs. Brief moments from other films are also seen—Mel Brooks's *Young Frankenstein* and others. All of the video is mixed live during the performance, and the viewer often cannot distinguish recorded from live camera images. The moments ricochet and resonate between the two stories and from

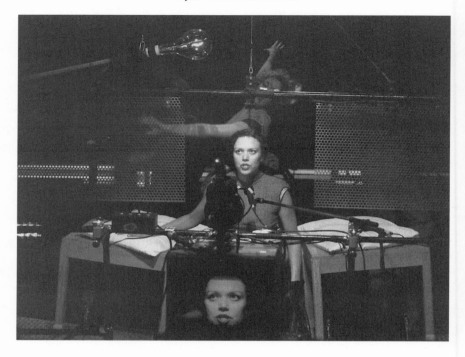

49. *House/Lights.* Helen Eve Pickett and Kate Valk (live and
on monitor). Photo: Mary Gearhart

live action, film, live video, and recorded video. This carefully planned
chaotic effect becomes one meaning of the work, reflecting a view of the
world. It keeps everything in the present moment, which may have solved a
problem Stein had with plays. She is quoted in the program as saying the
troubling thing about plays is that "your emotional time as an audience is not
the same as the emotional time of the play."

Valk says that the original idea in creating *House/Lights* was "to bury Stein
in melodrama, knowing that somewhere it had already gotten its 'highbrow'
treatment, and we wanted to find the 'lowbrow' humor." A variety of tech-
niques were tried in rehearsal: the performers mimicked the characters in
Olga's House of Shame, and they looked at films of the Marx Brothers, the
Yiddish Art Theatre, and Cantonese opera. This latter led to the electroni-
cally processed high cartoon voice Valk used in the production. They also
experimented with running the Stein text and the film simultaneously "to see
how they overlapped and what came forward and what receded." At one
point they abandoned the Stein text and worked purely physically from the
film. For a time the actors tried doing only the Stein text as a talking-head
monologue.[43] In the end all of these techniques and artistic cultures influ-
enced the resulting multilayered, complex, abstract work.

What chiefly interests LeCompte is form. She believes that more than one element can exist in a work without losing its uniqueness and being absorbed. The components "are separate, and they can stay separate and at the same time inform each other—within the same work. At best, when the form is strong enough, that's what happens. If the form isn't strong enough, it's just chaos. That's the danger."[44] The meaning is in the form and presence of the performance. Meaning cannot exist outside the work, and LeCompte refuses to attempt a discursive paraphrase of a production. "My meaning is in the piece itself. . . . It only happens for me in the space. In the moment of the theatrical act."[45]

The Wooster Group creates theatrical forms to embody and express the multilayered emotive chaos of contemporary urban life. This cannot be expressed through a linear structure. LeCompte's aesthetic involves the deconstruction of narrative. Instead of one event following another in an evolving story, many events happen at once, and the work is built up in layers. LeCompte believes this pattern reflects the way modern Americans, who are attuned to television and multimedia events, experience their world. They have developed an appetite for simultaneous happenings. This preference may partially explain the popularity of the Wooster Group—especially with spectators who are part of the psychically complex milieu of contemporary urban life. It is the way LeCompte perceives the world that feeds into her work.

> I turn on the television and turn down the sound, I put the radio on and do my writing, all at the same time. Most kids have been doing their homework while watching TV all their lives, so there's this weird mishmash for them already. . . . We cannot continue to have playwrights write these imitations of real life and put them on a stage, trying to recreate what the TV did 20 years ago and learnt to do better.[46]

The productions of the Wooster Group present no overt point of view; nonetheless they embody a direct expression of our culture, which is made up of contradictory ideas, events, and images that exist side by side, layer upon layer. That fact is often overlooked by artists who use conventional structures that were created to express how it felt to live in a simpler, bygone world. Perhaps their approach is soothing and acceptable to an audience seeking the traditional. However, the Wooster Group and other experimental artists express contemporary emotive experience, and doing so requires the creation of forms that fall outside the conventional. As avant-garde theatre artists, the Wooster Group feels on the edge, determined not to conform. Such a position is risky because financial support frequently comes from foundations whose boards and administrators have traditional artistic tastes and wish to avoid controversy. Nonetheless, as in the past, the Wooster Group and other experimental companies are stimulated and energized by their precarious positions.

NOTES

Chapter 2: Primary Explorations

All descriptions of performances not otherwise credited are from the author's performance notes.

1. Kenneth H. Brown, *The Brig: With an Essay on the Living Theatre by Julian Beck and Director's Notes by Judith Malina* (New York: Hill and Wang, 1965), 24.

2. Brown, *The Brig,* 83.

3. Brown, *The Brig,* 24.

4. Julian Beck, "How to Close a Theatre," *Tulane Drama Review* T23 (spring 1964): 181.

5. Pierre Biner, *The Living Theatre,* trans. Robert Meister (New York: Avon, 1972), 234–48.

6. Julian Beck, "Three Stages in the Genesis of *Frankenstein,* a Dramatic Spectacle Created by the Living Theatre Company," *City Lights Journal* 3 (1966): 70.

7. Biner, *The Living Theatre,* 159.

8. Lyon Phelps, "Brecht's *Antigone* at the Living Theatre," *Drama Review* T37 (fall 1967): 128.

9. All quotations from *Paradise Now* are from Judith Malina and Julian Beck, *Paradise Now: Collective Creation of the Living Theatre* (New York: Vintage, 1971).

10. Aldo Rostagno with Julian Beck and Judith Malina, *We, The Living Theatre: A Pictorial Documentation by Gianfranco Mantegna . . . of "Mysteries and Smaller Pieces," "Antigone," "Frankenstein," "Paradise Now"* (New York: Ballantine, 1970), 37, 25.

11. Biner, *The Living Theatre,* 225–27.

12. Unless otherwise noted, all information about the work of the Living Theatre in Brazil is from my discussions with them in November 1971. See Theodore Shank, "The Living Theatre in Brazil," *Praxis,* spring 1975, 66–72.

13. Julian Beck and Judith Malina, "From *The Legacy of Cain:* Favela Project No. 1—*Christmas Cake for the Hot Hole and the Cold Hole.* A Collective Creation of the Living Theatre," *Scripts,* November 1971, 5–16.

14. Judith Malina, letter to Theodore Shank, January 3, 1975.

15. Julian Beck, Charles Derevere, Judith Malina, and William Shari, "The Living Theatre and the Wobblies," interview by Erika Munk, *Performance,* May–June 1973, 90.

16. Ross Wetzsteon, "The Living Theatre at the Pittsburgh Station," *Village Voice,* April 21, 1975.

17. Information about the company's work in Italy is from an interview with Judith Malina and Julian Beck by the author in London, July 23, 1979.

18. Renfrau Neff, *The Living Theatre: USA* (Indianapolis: Bobbs-Merrill, 1970), 74.

19. Neff, *The Living Theatre,* 233–34.

20. Neff, *The Living Theatre,* 234–35.
21. Robert Pasoli, *A Book on the Open Theatre* (Indianapolis: Bobbs-Merrill, 1970), 83.
22. Unless otherwise noted, information on performances of *Terminal* is from my interviews with Joseph Chaikin, Raymond Barry, Shami Chaikin, Ellen Maddow, Jo Ann Schmidman, Tina Shepard, and Paul Zimet in London, June 1973, and from London performances of *Terminal, Mutation Show,* and *Nightwalk,* June 1973.
23. Susan Yankowitz, *Terminal,* in *Scripts,* November 1971, 17–45; and Roberta Sklar, "*Terminal:* An Interview," by Paul Ryder Ryan, *Drama Review* T51 (summer 1971): 149–57.

Chapter 3: Theatre of Social Change

1. "Interview: Charles Ludlam," by Gautam Dasgupta, *Performing Arts Journal* 7 (spring–summer 1978): 78–79.
2. Joan Holden, "Comedy and Revolution," *Arts in Society,* winter 1969.
3. Unless otherwise noted, all information from Joan Holden is from my conversations with her (1970–80).
4. "El Teatro Campesino: Interview with Luis Valdez," by Beth Bagby, *Drama Review* T36 (summer 1967): 74–75.
5. Unless otherwise noted, all quotations are from my conversations with Luis Valdez (1965–80).
6. Luis Valdez, *Actos* (San Juan Bautista, Calif.: El Centro Campesino Cultural, 1971), 1–2.
7. Luis Valdez, "Zoot-Suiting to Hollywood: Teatro Campesino's Luis Valdez," interview by Charles Pelton, *Artbeat* (San Francisco), December 1980, 28.

Chapter 4: Environmental Theatre

1. Some of the information in this section is from my correspondence and conversations with Richard Schechner beginning in 1967.
2. Richard Schechner, "Six Axioms for Environmental Theatre," *Drama Review* T39 (spring 1968): 41–64.
3. "An Interview with Grotowski," by Richard Schechner, *Drama Review* T41 (fall 1968): 34.
4. Richard Schechner, ed., *Dionyus in 69: The Performance Group* (New York: Farrar, Straus and Giroux, 1970).
5. "External Order, Internal Intimacy: An Interview with Jerzy Grotowski," by Marc Fumaroli, *Drama Review* T45 (fall 1969): 173; and Margaret Croyden, "Notes from the Temple: A Grotowski Seminar," *Drama Review* T45 (fall 1969): 181.
6. Richard Schechner, *Essays on Performance Theory, 1970–1976* (New York: Drama Book Specialists, 1977), 29–30; also a letter to Theodore Shank from Richard Schechner, New York, April 17, 1971. See also Schechner's adaptation, *Makbeth: After Shakespeare* (Schulenburg, Tex.: I. E. Clark, 1978).
7. Schechner, letter to Shank.
8. John Lahr, "On-Stage," *Village Voice,* December 31, 1970, 50.
9. Francoise Kourilsky, "Dada and Circus," *Drama Review* T61 (March 1974): 104–9.

10. Unless otherwise noted, information attributed to Peter Schumann is from letters or conversations with him beginning in 1969.

11. Peter Schumann, "With the Bread and Puppet Theatre: An Interview," by Helen Brown and Jane Seitz, *Drama Review* T38 (winter 1968): 63, 66.

12. Peter Schumann, quoted in Florence Falk, "Bread and Puppet: *Domestic Resurrection Circus*," *Performing Arts Journal* 4 (spring 1977): 22.

13. Information about Snake Theater is from my conversations with Laura Farabough and Christopher Hardman beginning in 1974, and from Hardman's presentation for the Experimental Panel I organized for the American Theatre Critics Association, May 24, 1980, San Francisco.

Chapter 5: New Formalism

1. Allan Kaprow, *Assemblage, Environments, and Happenings* (New York: Harry N. Abrams, 1966), 201.

2. This concept is discussed in Bill Simmer's "Robert Wilson and Therapy," *Drama Review* T69 (March 1976): 99–110.

3. The text of *I Was Sitting on My Patio/This Guy Appeared I Thought/I Was Hallucinating* has been published in *Performing Arts Journal* 10–11 (1979): 200–218.

4. Robert Wilson, "I Thought I Was Hallucinating," *Drama Review* T76 (December 1977): 76.

5. Michael Kirby, "Manifesto of Structuralism," *Drama Review* T68 (December 1975): 82–83; and "Structural Analysis/Structural Theory," *Drama Review* T72 (December 1976): 51–68.

6. Michael Kirby, "Structuralism Redefined," *Soho Weekly News,* July 22, 1976, 13.

Chapter 6: Self as Content

1. Information about Richard Foreman is from my conversations and recorded interviews with him, and letters from him, beginning in 1970; and from his "How I Write My (Self: Plays)," *Drama Review* T76 (December 1977): 5–24.

2. Information and quotations concerning Spalding Gray and Elizabeth LeCompte are from my conversations and recorded interviews with them and from the following: Spalding Gray, "About *Three Places in Rhode Island*," *Drama Review* T81 (March 1979): 31–42; Elizabeth LeCompte and Spalding Gray, "The Making of a Trilogy," *Performing Arts Journal* 8 (fall 1978): 81–91; and Elizabeth LeCompte, "Acting/Non-Acting," interview by Scott Burton, *Performance Art Magazine* 2 (New York) 14–16.

3. Historical information about Squat Theatre is from the company.

Chapter 8: Outrageous Performance

1. National Endowment for the Arts, *1996 Annual Report* (Washington, D.C.: National Endowment for the Arts, 1997); Peggy Phelan, "Serrano, Mapplethorpe, the NEA, and You: 'Money Talks,'" *Drama Review* T125 (spring 1990): 4–15, and "Offensive Plays: 'Money Talks Again,'" *Drama Review* T131 (fall 1991): 131–41.

2. National Endowment for the Arts, "Six Myths about the National Endowment for the Arts," and "Ten Facts about the National Endowment for the Arts," http://www.arts.endow.gov., accessed 1997.

3. Edward Rothstein, "Where a Democracy and Its Money Have No Place," *New York Times,* October 26, 1997.

4. Theatre Artaud, publicity, December 1997.

5. Karen Finley, "The Art of Offending," *New York Times,* November 14, 1996.

6. Karen Finley, "The Other Life of Karen Finley," interview by Mel Gussow, *New York Times,* September 22, 1997.

7. Karen Finley, "A Constant State of Becoming," interview by Richard Schechner, September 1987, *Drama Review* T117 (spring 1988): 152–58.

8. Finley, "Constant State of Becoming," 157–58.

9. Finley, "Constant State of Becoming," 155–57.

10. Finley, "Constant State of Becoming," 154–55.

11. Karen Finley, *The Constant State of Desire, Drama Review* T117 (spring 1988): 139–51; and a performance of the work seen by the author at Intersection for the Arts, San Francisco, November 7, 1987.

12. Finley, "Constant State of Becoming," 153.

13. Finley, *Constant State of Desire,* 145.

14. Finley, "Constant State of Becoming," 153.

15. Finley, *Constant State of Desire,* 148.

16. Finley, "Constant State of Becoming," 154.

17. Quoted in Maria T. Pramaggiore, "Resisting/Performing/Femininity: Words, Flesh, and Feminism in Karen Finley's *The Constant State of Desire,*" *Theatre Journal,* October 1992, 270.

18. Karen Finley, "The American Chestnut," unpublished statement about the performance.

19. Holly Hughes, "One of the 'NEA Four' Artists Brings Monologue to Sushi," interview by Nancy Churnin, *Los Angeles Times,* December 15, 1990.

20. Holly Hughes, *Clit Notes: A Sapphic Sampler,* including *The Well of Horniness, The Lady Dick, Dress Suits to Hire, World without End, Clit Notes* (New York: Grove Press, 1996), 22.

21. Hughes, *Clit Notes,* 158–59.

22. Hughes, "NEA Four."

23. Hughes, *Clit Notes,* 178–79.

24. Hughes, *Clit Notes,* 185.

25. Tim Miller, "Tim Miller," interview by Thomas Leabhart, in *California Performance,* vol. 2: *Performance in Los Angeles* (Claremont, Calif.: Mime Journal, 1991), 126.

26. Tim Miller, "An Anarchic, Subversive, Erotic Soul," interview by Steven Durland, *Drama Review* T131 (fall 1991): 177.

27. Morgan Jenness, "The Making of *GO GO GO,*" *TheatreForum* TF12 (winter–spring 1998): 26.

28. Juliana Francis, *GO GO GO, TheatreForum* TF12 (winter–spring 1998): 31.

29. *GO GO GO,* Performance at the Institute of Contemporary Arts, London, June 21, 1997; and Francis, *GO GO GO.*

30. Jenness, "Making," 30.

31. Annie Sprinkle, "Summer Saint Camp 1997: With Annie Sprinkle and Veronica Vera," interview by Linda Montano, *Drama Review* T121 (spring 1989): 101–2.

32. Sacred Naked Nature Girls, "Company History," unpublished, 1996.
33. Sacred Naked Nature Girls, "Artistic Statement," unpublished, 1997.
34. Akilah Oliver, "Too Controversial for Naropa?" interview by Teresa Younger, *Boulder Weekly,* April 14, 1994, 17.
35. Fakir Musafar, "Body Play: State of Grace or Sickness?" epilogue to *Bodies under Siege: Self-Mutilation and Body Modification in Culture and Psychiatry,* by Armando R. Favazza, 2d ed. (Baltimore: Johns Hopkins University Press, 1996), 326.
36. Musafar, "Body Play," 327–28.
37. Philip Auslander, "Orlan's Theatre of Operation," *TheatreForum* TF7 (summer–fall 1995): 26.
38. Roger Nieboer, "The Jim Rose Circus Side-Show: One Man's Crusade," *TheatreForum* TF3 (spring 1993): 81; and James Sullivan, "Freakishness in Bloom," *San Francisco Chronicle,* December 8, 1997.
39. Author's performance notes for Ron Athey, *4 Scenes in a Harsh Life,* performance, July 15, 1994, at the Institute of Contemporary Arts, London; and "*4 Scenes in a Harsh Life:* Synopsis of Scenes," *TheatreForum* TF6 (winter–spring 1995): 62–63.
40. Ron Athey, program note for *4 Scenes in a Harsh Life,* Institute of Contemporary Arts, London, July 1994.
41. Ron Athey, "An Interview with Ron Athey," by Julie Myers, *TheatreForum* TF6 (winter–spring 1995): 61.
42. "Spanner in the Works," panel discussion at the Institute of Contemporary Arts, London, *TheatreForum* TF6 (winter–spring 1995): 66.

Chapter 9: Social Commitment

1. John Malpede, "Statement," *High Performance* 41–42 (spring–summer 1988): 53.
2. Sue-Ellen Case, ed., *Split Britches* (London: Routledge, 1996), 1–8.
3. John O'Neal, "Junebug Jabbo Jones Spins a New Yarn," interview by Chiori Santiago, *San Francisco Chronicle Datebook,* April 9, 1989, 36.
4. Robbie McCauley, "Thoughts on My Career, the Other Weapon, and Other Projects," in *Performance and Cultural Politics,* ed. Elin Diamond (London: Routledge, 1996), 269.
5. Robbie McCauley, "Working around Power," *Theater* 27, nos. 2–3 (1997): 38.
6. Rhodessa Jones, "Rhodessa Jones' Cultural Odyssey," interview by Manu Mukasa, *TheatreForum* TF3 (spring 1993): 79.
7. Carmelita Tropicana, "Carmelita Tropicana Unplugged," interview by David Román, *Drama Review* T147 (fall 1995): 84, 91.
8. Joan Holden, "Left Field," interview by J. H. Tompkins, *San Francisco Bay Guardian,* March 19, 1997.
9. Joan Holden, interview by the author, San Francisco, March 16, 1997. Unless otherwise noted, all quotes from Joan Holden are from this interview.
10. Al Morch, "Mime Troupe Rats on Cigarette Industry," *San Francisco Examiner,* April 14, 1994; and San Francisco Mime Troupe archive publicity.
11. John P. Pierce et al., "Tobacco Industry Promotion of Cigarettes and Adolescent Smoking," *Journal of the American Medical Association* 279 (1998): 511–15.
12. San Francisco Mime Troupe archive publicity.
13. Joan Holden, "Collaborating *Offshore,*" *TheatreForum* TF4 (winter–spring 1994): 82–87.

14. Holden, "Collaborating *Offshore*," 87.

15. *13 Dias/13 Days,* rehearsal, San Francisco, March 17, 1997.

16. Janny Scott, "A Wedding of Theater and Social Concerns," *New York Times,* November 11, 1997.

17. Anna Deavere Smith, "The Word Becomes You," interview by Carol Martin, *Drama Review* T140 (winter 1993): 46, 48, 52, 57.

18. Anna Deavere Smith, *Fires in the Mirror,* PBS television presentation, April 28, 1993; description and quotes are from this performance.

19. Anna Deavere Smith, *Twilight: Los Angeles, 1992* (New York: Doubleday, 1994), xvii. All quotations from *Twilight* are from this edition.

20. Smith, *Twilight,* xxv.

21. Eva Wielgat Barnes, "Anna Deavere Smith's *House Arrest: First Edition,*" *TheatreForum* TF13 (summer–fall 1998): 86.

22. David Richards, "Anna Deavere Smith Goes to Washington," *Washington Post,* November 16, 1997; and Lloyd Rose, "'House Arrest': Too-Early Release," *Washington Post,* November 21, 1997.

23. Barnes, "Smith's *House Arrest,*" 87–88.

24. Smith, "The Word Becomes You," 51–57.

25. Guillermo Gómez-Peña, interview by Evantheia Schibsted, *Wired,* January 1996.

26. Guillermo Gómez-Peña, *The New World Border: Prophecies, Poems, and Loqueras for the End of the Century* (San Francisco: City Lights, 1996), 82.

27. Gómez-Peña, *The New World Border,* 89.

28. Gómez-Peña, *The New World Border,* 97.

29. Guillermo Gómez-Peña, press materials for performances in San Francisco, February 19–March 7, 1998.

30. Gómez-Peña, press materials.

Chapter 10: New Technologies and Techniques

1. Ping Chong, *Art into Theatre: Performance Interviews and Documents,* interview by Nick Kaye (London: Harwood, 1996), 148.

2. Ping Chong and Company, "History," unpublished, ca. 1997.

3. Ping Chong, introduction to *Nuit Blanche* in *Between Worlds: Contemporary Asian-American Plays,* edited by Misha Berson (New York: Theatre Communications Group, 1990), 2.

4. Pink Chong in Craig Kolkebeck, "Ping Chong's Mythic Theatre: Descent of Man," *Elenco* (University of Texas at El Paso), fall 1986.

5. Chong, *Art into Theatre,* 147.

6. Ping Chong, "Science and Art Meet at La Mama," interview by Mel Gussow, *New York Times,* February 24, 1984.

7. Unless otherwise noted, all quotes and paraphrases of George Coates are from the interview by Theodore Shank, "George Coates: Music-Theatre Spectacles," *California Performance,* vol. 1: *San Francisco Bay Area* (Claremont, Calif.: Mime Journal, 1989), 30–70.

8. George Coates, "George Coates Performance Works *Nowhere Now Here,*" interview by Takemura Mitsuhiro, *Annual InterCommunication '95,* 111–14.

9. George Coates Performance Works, press releases, January 21, 1992.

10. George Coates, "George Coates' Latest Born in Rubble of the Quake," interview by Calvin Ahlgren, *San Francisco Chronicle,* October 21, 1990.

11. Lee Gomes, "Data in, Drama Out," *San Jose Mercury News,* January 31, 1992.

12. George Coates Performance Works, press releases, August 31, 1993.

13. George Coates, "George Coates Interviewed by His (Virtual) Audience," *TheatreForum* TF9 (summer–fall 1996): 31.

14. George Coates Performance Works, "Company Profile."

15. George Coates, e-mail to Theodore Shank, January 28, 1997.

16. George Coates, "Science Meets Art," interview by Barbara Tannenbaum, *San Francisco Focus,* December 1991.

17. Alan Finneran, "SOON 3's *Asylum (Red),*" *TheatreForum* TF2 (fall 1992): 18.

18. Alan Finneran, letter to Theodore Shank, April 9, 1998.

19. Finneran, "SOON 3's *Asylum (Red),*" 19–20.

20. Finneran, "SOON 3's *Asylum (Red),*" 21.

21. Unless otherwise noted, all quotes and paraphrases of Chris Hardman are from the interview by Theodore Shank, "Chris Hardman: Putting the Audience in the Performance," *California Performance,* 1:157–83.

22. Chris Hardman, *Enola Alone,* in *TheatreForum* TF7 (summer–fall 1995): 12.

23. Antenna press release, San Francisco, October 4, 1994.

Chapter 11: Self-Reflections

1. Mabou Mines, "Artistic Statement and History of Mabou Mines," unpublished, 1984.

2. Unless otherwise noted, all quotes and paraphrases of Lee Breuer and Philip Glass are from the unpublished interview by the author, University of California, Davis, January 24, 1972.

3. Lee Breuer, my transcription of an unpublished lecture, University of California, Davis, April 27, 1976.

4. Lee Breuer, "Mabou Mines: Animating Art," interview by Robb Baker, *Soho Weekly News,* December 12, 1974.

5. Breuer, "Mabou Mines."

6. Breuer, "Mabou Mines."

7. Mabou Mines archive.

8. Breuer, "Mabou Mines."

9. Mabou Mines, "Mabou Mines Collaborative Creation," interview by Tish Dace, *Soho Weekly News,* May 18, 1978.

10. Lee Breuer, "Complex, Probing Portraits in Mabou Mines Revivals," interview by Stephen Holden, *New York Times,* May 16, 1986.

11. Bill Raymond, "Bill Raymond: He Knows the Trip, the Bit, and Even the Number," interview by Michael Earley, *Soho Weekly News,* July 19, 1979.

12. Lee Breuer, *Sister Suzie Cinema: The Collected Poems and Performances, 1976–1986* (New York: Theatre Communications Group, 1987), 56–57.

13. Breuer, *Sister Suzie Cinema,* 60.

14. Breuer, *Sister Suzie Cinema,* 64–65.

15. Lee Breuer, "Sophocles with a Chorus of Gospel," interview by Wendy Smith, *New York Times,* March 20, 1988.

16. Mabou Mines, "Mabou Mines Collaborative Creation."

17. Mabou Mines, "The Many Voices of Mabou Mines," interview by Don Shewey, *American Theatre,* June 1984, 4–11, 42.

18. JoAnne Akalaitis, "The Quiet Explosions of JoAnne Akalaitis," interview by Terry Curtis Fox, *Village Voice,* May 23, 1977.

19. JoAnne Akalaitis, "Scenes from *Dressed Like an Egg:* a Mabou Mines Presentation Based on the Writings of Colette," *Theater,* spring 1978, 110–18.

20. Akalaitis, "Quiet Explosions."

21. Unless otherwise noted, all quotes and paraphrases of Foreman and his productions are from the unpublished interview by the author, Soho, New York, April 2, 1998, or the author's performance notes.

22. Richard Foreman, *My Head Was a Sledgehammer: Six Plays* (Woodstock, N.Y.: Overlook Press, 1995), 193 (includes *My Head Was a Sledgehammer* and *I've Got the Shakes*).

23. Foreman, *My Head Was a Sledgehammer,* 200–201.

24. Foreman, *I've Got the Shakes,* 279–80.

25. Richard Foreman, *The Universe, in TheatreForum* TF 10 (winter–spring 1997): 26.

26. Richard Foreman, *Benita Canova,* revised January 3, 1998, typescript of the play.

27. Elizabeth LeCompte, *Art into Theatre: Performance Interviews and Documents,* interview by Nick Kaye (London: Harwood, 1996), 254.

28. Elizabeth LeCompte, quoted in David Savran, "Terrorists of the Text," *American Theatre,* December 1986, 23.

29. *The Villager,* January 21, 1982.

30. *The Villager.*

31. Savran, "Terrorists of the Text," 191.

32. LeCompte, quoted in Elinor Fuchs, *The Death of Character: Perspectives on Theater after Modernism* (Bloomington: Indiana University Press, 1996), 183.

33. Elizabeth LeCompte, "Chekhov's *Three Sisters* and the Wooster Group's *Brace Up!*" interviewed by Susie Mee, *Drama Review* T136 (winter 1992): 147.

34. LeCompte, *Art into Theatre,* 259.

35. Marianne Weems, quoted in "Chekhov's *Three Sisters,*" 151–53.

36. LeCompte, "Chekhov's *Three Sisters,*" 146–47.

37. LeCompte, "Chekhov's *Three Sisters,*" 147.

38. Elizabeth LeCompte, "Wooster Sauce," interview by Kenneth Rea, *Guardian* (London), August 21, 1986.

39. Savran, "Terrorists of the Text," 196.

40. LeCompte, *Art into Theatre,* 258.

41. LeCompte, *Art into Theatre,* 260.

42. Kate Valk, "New York's Legendary Wooster Group Navigates Gertrude Stein's 'Dr. Faustus' and Trips the Light Fantastic," interview by Bevya Rosten, *American Theatre,* February 1998, 18.

43. Valk in Rosten, 19.

44. LeCompte, *Art into Theatre,* 257.

45. LeCompte, *Art into Theatre,* 256.

46. LeCompte, *Art into Theatre.*

INDEX

Abdoh, Reza, 213

Abzug, Bella, 242. See also *House Arrest*

Ace Taboo, 280. *See also* Finneran, Alan; Soon 3

Ackamoor, Idris, 229. *See also* Jones, Rhodessa

Actual Sho, 266, 267–71, 274. *See also* Coates, George

ACT UP (AIDS Coalition to Unleash Power), 212

Adjusting the Idle, 292. *See also* Antenna Theater; Hardman, Christopher

After Sorrow, 256, 258–59, 260. *See also* Chong, Ping

AIDS, 200, 208, 213, 224, 258, 328

Akalaitis, JoAnne, 197, 297, 305, 308–11. *See also* Mabou Mines

Alexander, Adlai, 277. *See also* Coates, George; *20/20 Blake*

Alger, Horatio, 290

American Chestnut, The, 201, 206–8. *See also* Finley, Karen

American Conservatory Theatre (ACT), 236, 271

American Museum of Natural History, 294. *See also* Antenna Audio Tours

American Repertory Theatre (ART), 297, 311

Amnesia, 290. *See also* Antenna Theater; Hardman, Christopher

Andy Warhol's Last Love, 182–89

Annual Youth Theatre Festival, 233

Antenna Audio Tours, 294; Alcatraz Island tour, 294; SS *Jeremiah O'Brien* tour, 294. *See also* Antenna Theater; Hardman, Christopher

Antenna Theater, 253, 287–95. *See also* Hardman, Christopher

Antigone, 18–19, 20, 25, 94

Apocalypse, 298. *See also* Grotowski, Jerzy; Mabou Mines

Apple Computers, 270

Architecture of Catastrophic Change, The, 272. *See also* Coates, George

Are/Are, 264. *See also* Coates, George

Arena Stage, 241, 243. See also *House Arrest*

Armey, Richard, 199

Artaud, Antonin, 10, 13, 14, 30, 37, 49, 181

Artificial Intelligence, 198

Art Institute of Chicago, 294. *See also* Antenna Audio Tours

Arts Communication Technology, 294.
 See also Antenna Audio Tours
Asian-American Theatre Workshop,
 57
Asylum (Red), 280–84. *See also*
 Finneran, Alan; Soon 3
Athey, Ron, 195, 221–24
Auto, 117–20
Ave Maris Stella, 110

Bacchae, The, 94
Baile de los Gigantes, El, 80–83
Balcony, The, 101
Balthus, 320, 323, 324–25. *See also*
 Foreman, Richard
Barnes, Eva, 245. See also *House Arrest*
Barrie, J. M., 297. See also *Peter Pan*
Bay Area Playwrights Festival, 289, 290
B-Beaver Animation, The, 301, 302. *See
 also* Mabou Mines
Beck, Julian, 6, 8, 9–37, 225
Beckett, Samuel, 298
Benita Canova (Gnostic Eroticism), 312,
 319, 320–26. *See also* Foreman,
 Richard
Bergman, Ingmar, 333, 335
Bernabe, 80
Big Butt Girls and Hard Headed Women,
 229. *See also* Jones, Rhodessa
Billy Budd, 293. See also *Radio Interfer-
 ence*
Black Eagles, 226. *See also* Lee, Leslie
Black Panther Party, 229, 231
Black Terror, The, 51
Black Water Echo, 141–42
Blake, William, 276–78. *See also* Coates,
 George; *20/20 Blake*
Blake Street Hawkeyes, 264. *See also*
 Coates, George
Bluebeard, 53
Bogart, Anne, 213
Bonney, Jo, 244. See also *House Arrest*
Booze, Cars, and College Girls, 177
Border Arts Workshop/Taller de Arte
 Fronterizo (BAW/TAF), 247. *See also*
 Gómez-Peña, Guillermo
Borderland Theater, 235
Borges, Jorge Luis, 310
Bowie, David, 324

Box Conspiracy: An Interactive Sho, 273,
 274–75, 278. *See also* Coates, George
Brace Up!, 335–38. *See also* Wooster
 Group
Brazell, Danielle, 217. *See also* Sacred
 Naked Nature Girls
Bread and Puppet Theater, 37, 103–13,
 197
Brecht, Bertold, 11, 18, 37, 49, 50, 58,
 61, 70, 101, 170, 298–99
Breuer, Lee, 157–58, 197, 296, 297, 298,
 299, 300–311. *See also* Mabou Mines
Brig, The, 11–13, 35
Brook, Peter, 49, 89
Brooklyn Academy of Music Next
 Wave Festival, 256, 258, 266, 308
Brooks, Mel, 339
Brown, Kenneth, 11–13
Bruce, Lenny, 211, 333, 334, 335
Buffalo Project, The, 229. *See also*
 McCauley, Robbie
Bullins, Ed, 52
Burden, Chris, 156, 220
Burroughs, William, 331
Bussmann, Philip, 339. *See also* Wooster
 Group

Cafe Cino, 2
Cage, John, 11, 123, 330
Cairo International Festival for Experi-
 mental Theatre, 284. *See also* Soon 3
Camille, 53
Carpa de los Rasquachis, La, 83–86
Carroll, Lewis, 271
Cato, Gavin, 237, 238, 239. See also
 *Fires in the Mirror: Crown Heights,
 Brooklyn and Other Identities;* Smith,
 Anna Deavere
Ceremonies in Dark Old Men, 51
Chaikin, Joseph, 4, 6, 8, 11, 20, 37–49
Chanticleer, 272
Chaplin, Charlie, 59
Chekhov, Anton, 335, 336, 338
Chekhov Festival, 308, 309
Childs, Lucinda, 123, 125, 127, 132, 134
Chin, Vincent, 258. *See also* Chong,
 Ping
Chinoiserie, 256–58, 259. *See also*
 Chong, Ping

Chong, Ping, 197, 252, 253–63
Chopin, 306
Christian Action Network, 224
Christian Broadcasting Network, 199
Chumley, Dan, 197, 231, 233. *See also* San Francisco Mime Troupe
Clayburgh, Jim, 327. *See also* Wooster Group
Clinton, Bill, 242, 243. See also *House Arrest*
Clit Notes, 211. *See also* Hughes, Holly
Coalition against Police Abuse, 240. See also *Twilight Los Angeles, 1992*
Coates, George, 195, 252, 265–79
Cockettes, The, 54
Cocktail Party, The, 174, 328
Cold Harbor, 308. *See also* Mabou Mines
Colette, 309
Colored Museum, The, 226. *See also* Wolfe, George C.
Commune, 93, 98–101
Confessions of a Working Class Black Woman, 228–29. *See also* McCauley, Robbie
Congress (U.S.), 199–200, 201, 202, 221, 222, 331; House of Representatives, 201; Senate, 201
Congress of the White Washers, The, 61
Connection, The, 10, 36
Constant State of Desire, The, 203–5. *See also* Finley, Karen
Cooper, David, 40
Cooper, D. B., 274. *See also* Coates, George; *Desert Music: A Live Sho, The*
Copi, 324
Cops, 101, 103
Corcoran Gallery, 199–200
Cornerstone Theater Company, 226
Coss, Clare, 56
Crossroads Theatre Company, 225–26
Crows in the Cornfield, 256. *See also* Chong, Ping; van Gogh, Vincent
Crucible, The, 331, 332, 333. *See also* Miller, Arthur
Cry of the People for Meat, The, 105
Cummings, Geraldine, 333

Cunningham, Merce, 211, 330
Curie, Marie, 310

Dafoe, Willem, 197, 327, 328, 329, 336, 337, 339. *See also* Wooster Group
Dalai Lama, 273, 274
D'Amato, Alphonse, 199
Darker Face of the Earth, 226. *See also* Dove, Rita
Daughter's Cycle Trilogy, The, 56
Davis, Bob, 280. *See also* Finneran, Alan; Soon 3
Davis, R. G., 37, 59, 60, 61, 62
Davison, Gordon, 240. *See also* Mark Taper Forum; *Twilight Los Angeles, 1992*
Dead End Kids: A History of Nuclear Power, 309, 310. *See also* Mabou Mines
Deadman, 156
Dead Sea Scrolls, 333
Deafman Glance, 126–27
Death in the Family, 40
Death in Venice, 305
de Groat, Andrew, 123, 127, 132
Denny, Reginald, 240, 241. *See also* Smith, Anna Deavere; *Twilight Los Angeles, 1992*
Desert Music: A Live Sho, The, 274. *See also* Coates, George
Deshima, 256, 258. *See also* Chong, Ping
Desire Circus, The, 140
Digital Equipment Corporation, 273
Dionysus in 69, 35, 93, 94, 97, 155
Disney Company, 197
Doctor Faustus Lights the Lights, 339. *See also* Stein, Gertrude
Domestic Resurrection Circus, The, 106, 112
Don't Start Me Talking or I'll Tell Everything I Know, 227. *See also* O'Neal, John
Dos Caras Del Patroncito, Las, 75
Dostoevsky, 180–81
Double Gothic, 151–53
Double Vision, 272. *See also* Coates, George
Dove, Rita, 226
Doyle, Brenden, 213

Dracula in the Desert, 293. *See also*
Antenna Theater; Hardman, Christo-
pher
Dragon Lady's Revenge, The, 63–65,
233
Dresher, Paul, 264–65. *See also* Coates,
George
Dressed Like an Egg, 309. *See also*
Mabou Mines
Duchamp, Marcel, 123, 330
Dutch East India Company, 256
Duykers, John, 264. *See also* Coates,
George; *Duykers the First*
Duykers the First, 264. *See also* Coates,
George

Eckert, Rinde, 264. *See also* Coates,
George
Eight People, 150
Eiko, 272. *See also* Coates, George
Einstein on the Beach, 127–33
Elder, Lonne, 51
Electro-Bucks, 72
Eliot, T. S., 328
Emperor Jones, The, 338. *See also*
Wooster Group
En Garde Arts, 198
Enigma. *See* Tube
Enola Alone, 253, 291–92. *See also*
Antenna Theater; Hardman, Christo-
pher
Enola Gay, 292. See also *Enola Alone*
Epidog, An, 301, 303. *See also* Mabou
Mines
Epperlein, Karen, 280. *See also*
Finneran, Alan; Soon 3
Etiquette of the Undercaste, 290, 292.
See also Antenna Theater; Hardman,
Christopher
Euripides, 94–95, 274
Evans, Rowland, 206
Experimental Gallery of the Smithson-
ian, 291

False Promises, Nos Engañoron, 67–72
Family, The, 56
Farabough, Laura, 113–22
Faust, 310
Faustina, 9–10

Festival d'Autumne, 311
Fiji Theatre Company, 253. *See also*
Chong, Ping
Finley, Karen, 195, 200, 201, 202–9
Finneran, Alan, 4, 6, 123, 140–49,
252–53, 279–87
*Fires in the Mirror: Crown Heights,
Brooklyn and Other Identities,* 236,
237–39, 240. *See also* Smith, Anna
Deavere
Fish Story, 338. *See also* Wooster Group
Five Blind Boys of Alabama, 307. *See
also* Mabou Mines
Flaubert, Gustave, 333, 338
Fleck, John, 200
Foreman, Richard, 4, 7, 159–70, 194–95,
197, 252, 296, 311–27, 338, 339
Fountain, Clarence, 307. *See also*
Mabou Mines
4 Scenes in a Harsh Life, 221–24. *See
also* Athey, Ron
Fourteen Karat Soul, 306. *See also*
Mabou Mines
Four Twins, The, 324. *See also* Copi
Francis, Juliana, 213–14
*Frank Dell's The Temptations of Saint
Anthony,* 333–35, 336, 338. *See also*
Wooster Group
Frankenstein, 15–18, 20, 25, 29, 35, 36
Freeman, Morgan, 307. *See also* Mabou
Mines
Free Southern Theatre, 51, 227. *See also*
O'Neal, John
Frijoles, 67
Frozen Wages, 66
Fudge, Divinity, 222. *See also* Athey,
Ron
Fuller, Charles, 52
Fung, Josef, 258. See also *After Sorrow;*
Chong, Ping
Fusco, Coco, 247. *See also* Gómez-Peña,
Guillermo

Gaard, David, 101
Gates, Daryl (Police Chief of Los Ange-
les), 240. *See also Twilight Los Ange-
les, 1992*
Gay Theatre Collective, 55, 155
Gelber, Jack, 10

George Coates Performance Works (GCPW), 264, 270–73, 275, 276. *See also* Coates, George
Ginsberg, Allen, 331
Glass, Philip, 123, 127–32, 197, 273, 297, 299–300, 309, 311. *See also* Mabou Mines
Goethe, 310
GO GO GO, 213–14; and Erysichthon (from Ovid's *Metamorphosis*) 213. *See also* Francis, Juliana
Goldoni, 60
Gómez-Peña, Guillermo, 194–95, 230, 246–51, 252
Good Food, 56
Goodman, Paul, 9–10
Gospel at Colonus, 297, 301, 307–8. *See also* Mabou Mines
Gotta Getta Life, 233. *See also* San Francisco Mime Troupe
Graber, Lary, 113–14
Gray, Spalding, 7, 102, 158, 170–79, 195, 197, 211, 296, 327–28, 336. *See also* Wooster Group
Great Air Robbery, The, 67
Greenspan, David, 320, 324. *See also* Foreman, Richard
Grotowski, Jerzy, 5, 20, 37, 40, 49, 94, 96–97, 102, 298–99
Guthrie Theatre, 2, 311

Hairy Ape, The, 339
Hajj, 301, 308, 309. *See also* Mabou Mines
Hamburger, Anne, 198
Hamlet, 226. *See also* Cornerstone Theater Company
Hardman, Christopher, 113–22, 252, 253, 287–95
Hearing, The, 333. *See also* Kirby, Michael; Wooster Group
Hearn, Lafcadio, 260. *See also* Chong, Ping; *Kwaidan*
Hellmuth, Suzanne, 123, 134–40, 141
Helms, Jesse, 199, 210, 212
Hicks, Emily, 247. *See also* Gómez-Peña, Guillermo
High Rises, 72
High School, 289–90. *See also* Antenna

Theater; Hardman, Christopher
Highways Performance Space, 212
Hill, Anita, 243. See also *House Arrest*
Hippolytus, 94
Hoffman, Abby, 6
Holden, Joan, 57, 62, 65, 71, 72, 73, 197, 230–31, 234, 235, 236. *See also* San Francisco Mime Troupe
Holy Cow, 55
Hooks, Robert, 51
Hospital, 135–38, 140
Hotel China, 313. *See also* Foreman, Richard
Hotel Universe, 72
Hot Peaches, 226
House Arrest, 241–45. *See also* Smith, Anna Deavere
House/Lights, 339–40. *See also* Wooster Group
Houston Grand Opera, 308, 311
Huerta, Jorge, 52
Hughes, Holly, 200, 201, 209–11, 212

Inching Through the Everglades, 51
Independent Female, The, 62, 64–65
India and After (America), 177–78
Indira Gandhi's Daring Device, 53
International Tattoo Convention, 219
In the Deepest Part of Sleep, 52
Invisible Site: A Virtual Sho, 273, 274. *See also* Coates, George
Ireland, David, 272. *See also* Coates, George
Ishii, Mitsuru, 197, 260. *See also* Chong, Ping
Israel, Robert, 310. *See also* Mabou Mines
It's Alright to be Woman Theatre, 55
I've Got the Shakes, 314–16. *See also* Foreman, Richard
I Was Sitting on my Patio, 132–34

J. Paul Getty Museum, 294. *See also* Antenna Audio Tours
Jackson, Jesse, 242. See also *House Arrest*
Jenness, Morgan, 214
Jim Rose Circus Sideshow, 196, 220–21
Jobs, Steve, 270

Jones, Bill T., 229
Jones, Rhodessa, 229
Joseph Papp Public Theatre, 197, 236, 244, 297, 302, 309, 311
Jung, 313

Kaprow, Allan, 124, 156
Keaton, Buster, 59
Kerouac, Jack, 331
Killing Fields, The, 328. *See also* Gray, Spalding
King, Martin Luther, 25
King, Rodney, 240, 241. *See also* Smith, Anna Deavere; *Twilight Los Angeles, 1992*
King Lear, 298. *See also* Mabou Mines
King of Spain, The, 125
King's Story, The, 104–5
Kipper Kids, 156–57, 203, 220
Kirby, Michael, 6, 94, 123, 149–54, 328
Koma, 272. *See also* Coates, George
Korean American Victims Association, 240. *See also Twilight Los Angeles, 1992*
Kroetz, Franz Xavier, 298
Krone, Gerald S., 51
Kronos Quartet, 280. *See also* Finneran, Alan
Kwaidan, 197, 260–63; "The Story of Jikininki," 260–61; "The Story of Mimi-Nashi-Hoichi," 262; "The Story of O-Tei," 262–63. *See also* Chong, Ping

Laboratory Theatre, 6, 20, 37, 40, 49
Lacy, Suzanne, 56
La Jolla Playhouse, 198
La Mama Experimental Theatre Club, 2, 38, 256, 258
L'Amant Militaire, 60–61
Last Temptation of Christ, The, 328. *See also* Dafoe, Willem
Lava, 318. *See also* Foreman, Richard
Lazarus, 253, 254. *See also* Chong, Ping
Leary, Timothy, 331, 332, 334
LeCompte, Elizabeth, 7, 102, 158, 170–79, 194, 296, 327, 330, 331, 332–41. *See also* Wooster Group
Lee, Leslie, 226

Legacy of Cain, The, 26, 28, 29
Legend of Lilly Overstreet, The, 229. *See also* Jones, Rhodessa
Lewis, Evelyn, 113–14
Liddy, G. Gordon, 332
Lilith—A Women's Theatre, 56, 57, 155
Lincoln Center, 311
Lion King, The, 197
Living Theatre, 6, 8, 9–37, 49, 50, 94–96, 102, 155, 202, 225
Livre des Splendeurs, Le, 164–69
London International Festival of Theatre (LIFT), 266
Loneliness of the Immigrant, The, 247. *See also* Gómez-Peña, Guillermo
Long Day's Journey into Night, 176, 328. *See also* O'Neill, Eugene; Wooster Group
Los Angeles Police Commission, 240. See also *Twilight Los Angeles, 1992*
Los Angeles Poverty Department (LAPD), 193, 226
Love of Space Demands, The, 226. *See also* Shange, Ntozake
LSD (audio recording), 331
LSD (. . . Just the High Points), 331–33, 334, 338. *See also* Wooster Group
Ludlam, Charles, 53, 58
Ludwig, Jon, 260. *See also* Chong, Ping
Lulu, 297
Lunt-Fontanne Theatre, 308

Mabou Mines, 157, 197, 252, 296, 297–311
MacArthur Fellowship, 246, 311, 327. *See also* Foreman, Richard; Gómez-Peña, Guillermo; LeCompte, Elizabeth
Macartney, Lord George, 258
Macbeth, Robert, 52
MacLow, Jackson, 11
Magi, 279–80. *See also* Finneran, Alan
Magician, The, 333, 335. *See also* Bergman, Ingmar
Magritte, 254
Makbeth, 93, 97–98
Maleczech, Ruth, 197, 297, 298, 308–9, 311. *See also* Mabou Mines

Malina, Judith, 6, 8, 9–37, 225
Malpede, John, 226
Man, Wu, 258. See also *After Sorrow;* Chong, Ping
Manheim, Kate, 313, 325. *See also* Foreman, Richard
Man in the Nile, The, 146–47
Mann, Thomas, 305
Man Says Goodbye to his Mother, A, 104
Many Loves, 10
Mapplethorpe, Robert, 199, 201
Marceau, Marcel, 59
Margolin, Deborah, 226
Marilyn Project, The, 101
Markham, Pigmeat, 328, 330, 332. *See also* Wooster Group
Mark Taper Forum, 240, 243, 292
Marriage of Heaven and Hell, The, 277. *See also* Blake, William
Marrying Maiden, The, 11, 36
Martinez, Manuel, 52
Marx Brothers, 340
Massachusetts Institute of Technology, 292
Matthews, Michael, 256, 258. *See also* Chong, Ping; *Deshima*
Mawra, Joseph, 339
Mayakovsky, 29, 32
McCarthy, Senator, 331
McCauley, Robbie, 228–29
Medea, 273
Medea Project, 229. *See also* Jones, Rhodessa
Mehrten, Greg, 305. *See also* Mabou Mines
Mexterminator, The, 247–50. *See also* Gómez-Peña, Guillermo
Meyerhold, 37
Meyers, Dee Dee, 242. See also *House Arrest*
Meyers, Laura, 217, 218. *See also* Sacred Naked Nature Girls
Mickery Workshop, 256. *See also* Chong, Ping
Militants, The, 78
Miller, Arthur, 331, 332, 333, 338
Miller, Tim, 195, 200, 211–13
Mind King, The, 313. *See also* Foreman, Richard

Mississippi Freedom, 229. *See also* McCauley, Robbie
Mitchell's Death, 157
Modern Times, 16
Money Tower, The, 29
Monk, Meredith, 253. *See also* Chong, Ping
Monsters of Grace, 273. *See also* Glass, Philip; Wilson, Robert
Montano, Linda, 156–57, 215, 220
Monument for Ishi, A, 107–12
Moonlighting, 56
Moscow is Burning, 29, 32
Moses, Gilbert, 51
Mother Courage, 101, 102, 170
Mother, The, 70–71
Mothers Reclaiming Our Children, 240. See also *Twilight Los Angeles, 1992*
Mr. Lifto, 221. *See also* Jim Rose Circus Sideshow
Mundo, 86–89
Musafar, Fakir, 219–20; and spear Kavadi, 219–20
Museum of Contemporary Art, Los Angeles, 292
Music Lesson, The, 323. *See also* Balthus
Mutation Show, The, 44–49
Muybridge, 301
My Head Was a Sledgehammer, 314. *See also* Foreman, Richard
Mysteries and Smaller Pieces, 13–15, 16, 18, 20, 25, 26, 29, 35, 36

Naked Breath, 212–13. *See also* Miller, Tim
Naropa Institute, 218
National Council on the Arts, 200
National Endowment for the Arts (NEA), 193, 195, 199, 200, 201, 202, 206, 209, 210, 212, 221, 224, 231, 246, 271, 276, 294; Solo Theatre Artists and Mime Panel, 200
National Gallery of Canada, 294. *See also* Antenna Audio Tours
National Shakespeare Company, 264
National Theatre for the Deaf, 56
Navigation, 137–40
Nayatt School, 174–77, 178, 328, 331

NEA Four, 200, 201; and the Bush administration, 201; and the Clinton administration, 201; and the Supreme Court, 201; and the U.S. Circuit Court of Appeals, 201
Negro Ensemble Company, 51
Neumann, Frederick, 302. *See also* Mabou Mines
New Lafayette Theatre, 52
New York State Council on the Arts, 330
NeXT computer, 270
Nightwalk, 48
1984 Olympic Arts Festival, 290
Noonan, Peggy, 242. See also *House Arrest*
North American Free Trade Agreement (NAFTA), 235
Nosferatu, 254–55. *See also* Chong, Ping
Novak, Robert, 206
Nowhere Band, The, 275. *See also* Coates, George
Nuit Blanches, 253. *See also* Chong, Ping

O'Connor, Justice Sandra Day, 201
Oedipus, 101, 226
Oedipus at Colonus, 297, 307
Offshore; or Why You Should Read the Business Page, 197, 233–35, 236. *See also* San Francisco Mime Troupe
Olga's House of Shame, 339, 340
Oliver, Akilah, 217, 218. *See also* Sacred Naked Nature Girls
O'Neal, John, 51, 227–28
O'Neill, Eugene, 328, 338, 339
On Site (In Sausalito), 293–94. *See also* Antenna Theater; Hardman, Christopher
On the Road: A Search for American Character, 236. *See also* Smith, Anna Deavere
Ontological-Hysteric Theatre, 159–70, 197, 311, 320. *See also* Foreman, Richard
Open Theatre, 4, 6, 8, 20, 37–49
Oregon Shakespeare Festival, 226
Orlan, 220
Other Weapon, The, 229. *See also* McCauley, Robbie

Our Town, 328, 329, 330
Outcalls/Riptides, 279. *See also* Finneran, Alan

Pandemonium, 294. *See also* Antenna Theater; Hardman, Christopher
Pandering to the Masses: A Misrepresentation, 161–64. *See also* Foreman, Richard
Papp, Joseph, 302
Paradise Now, 6, 20–25, 26, 28, 30, 35, 36, 93, 96, 155
Paris Opera, 197, 311
Party, The, 328. *See also* Markham, Pigmeat
Pauline, Mark, 196
PBS Television, 236, 238
Penguin Touquet, 168–69
Performance Group, The, 35, 37, 93–103, 155, 170, 197
Performance Space 122 (P.S. 122), 211, 224
Permanent Brain Damage, 318–19. *See also* Foreman, Richard
Persian Gulf War, 196
Personal History of the American Theatre, A, 178
Peter and Wendy, 297
Peter Pan, 297
Photoanalysis, 150–51
Pickle Family Circus, 57
Pig, Child, Fire!, 179–84
Pirandello, Luigi, 10, 183
Piscator, 37
Pitt, Leonard, 264. *See also* Blake Street Hawkeyes; Coates, George; *2019 Blake*
Pizza, 56
Platoon, 328. *See also* Dafoe, Willem
Point Judith, 176, 328. *See also* Wooster Group
Points of Interest (America), 178
Poison Hotel, 280. *See also* Finneran, Alan
Polish Laboratory Theatre, 6, 20, 37, 40, 49
Pollack, Jackson, 208
Post-Post Porn Modernist, 216. *See also* Sprinkle, Annie

Prelude to Death in Venice, A, 301, 305–6. *See also* Mabou Mines
Prometheus, 31–34, 93
Provisional Theatre, The, 50–51, 58

Qianlong (Chinese emperor), 258
Quinta Temporada, 80

Race, A, 254–55. *See also* Chong, Ping
Radio Interference, 292–93. *See also* Antenna Theater; Hardman, Christopher
Rare Area, 265. *See also* Coates, George
Raymond, Bill, 298, 305, 306, 308, 311. *See also* Mabou Mines
Razzmatazz, 54–55
Ream, Marc, 265, 268, 270–75. *See also* Coates, George
Red Horse Animation, The, 157–59, 297, 299–301, 302. *See also* Mabou Mines
Reich, Steve, 274. *See also* Coates, George
Reilly, Nancy, 331, 334. *See also* Wooster Group
Reincarnation of Ste. Orlan, The, 220. *See also* Orlan
Renaissance Radar, 146–48, 279, 280. *See also* Finneran, Alan
Revenger Rat Meets the Merchant of Death, 231–32. *See also* San Francisco Mime Troupe
Revolutionary Dance, 150
Reynolds, Jock, 123, 134–40, 141
Ride Hard/Die Fast, 121–22
Ridiculous Theatrical Company, 53, 58
Right Mind, 271, 274. *See also* Coates, George
Rimbaud, Arthur, 273, 274
Road to Immortality, The, 328, 330, 333. *See also* Wooster Group
Robertson, Reverend Pat, 199
Roche, Suzzy, 339. *See also* Wooster Group
Rockefeller Foundation, 232–33
Romeo and Juliet, 226. *See also* Cornerstone Theater Company
Room 706, 149–50
Rose, Charles, 268, 272. *See also* Coates, George

Rose, Jim, 220–21
Rosenbaum, Yankel, 237, 238, 239. *See also Fires in the Mirror: Crown Heights, Brooklyn and Other Identities;* Smith, Anna Deavere
Roth, Beatrice, 336. *See also* Wooster Group
Rothstein, Edward, 201
Route 1 & 9, 328–31, 332, 333, 334. *See also* Wooster Group
Roy Cohn/Jack Smith, 328. *See also* Vawter, Ron
Rumstick Road, 171–75, 177, 178
Rundgren, Todd, 277. *See also* Coates, George; *20/20 Blake*

Sacred Naked Nature Girls, 217–18
Saint and the Football Players, The, 301. *See also* Mabou Mines
Sakonnet Point, 171–72, 178
Samuel's Major Problems, 313. *See also* Foreman, Richard
San Francisco Art Institute, 202
San Francisco Chamber Singers, 272, 274, 277. *See also* Coates, George
San Francisco Exploratorium, 267
San Francisco Mime Troupe, 4, 6, 26, 50, 57, 58, 59–74, 196, 197, 225, 227, 230–36, 246, 252, 282, 298, 302
San Francisco State University Theatre Department, 233
San Fran Scandals of '73, 72
São Paulo International Festival, 266, 276
Savina, 272. *See also* Coates, George
Savran, David, 328
Schechner, Richard, 6, 37, 93–103, 197
Schmidt, Paul, 336, 337. *See also* Wooster Group
Schönberg, Arnold, 123
Schumann, Peter, 37, 103–13, 179–89, 197
Science Meets the Arts Society (SMARTS), 270–71. *See also* Coates, George
Seehear, 264, 265. *See also* Coates, George

Seeing Red or Silly Bunny and the Toxic Folly, 284. *See also* Finneran, Alan; Soon 3
Segal, Sondra, 56
Serlin, Jerome, 265. *See also* Coates, George
Serpent, The, 40–41, 49
Serrano, Andres, 199, 200, 201
Seven Meditations, 28
Seventh Spectacle, 156
Sex & Death to the Age of 14, 177
Shaggy Dog Animation, The, 301–5. *See also* Mabou Mines
Shakespeare, 273, 274, 298
Shange, Ntozake, 226
Shaw, Peggy, 226. *See also* Split Britches
Shepard, Sam, 101
Sherman, Stuart, 156
Shimosata, Keiko, 233. See also *Gotta Getta Life;* San Francisco Mime Troupe
Shirts & Skin, 213. *See also* Miller, Tim
Shoot, 156
Sifuentes, Roberto, 247. *See also* Gómez-Peña, Guillermo; *Mexterminator, The*
SIGGRAPH, 273
Silicon Graphics, 273
Sister Suzie Cinema, 301, 306–7. *See also* Mabou Mines
Six Public Acts, 29, 30, 36
Sklar, Roberta, 40, 56
Slug, 221. *See also* Jim Rose Circus Sideshow
Smackers, 284–86. *See also* Finneran, Alan; Soon 3
Smith, Anna Deavere, 194–95, 229, 230, 236–46
Smith, Peyton, 327, 334, 336, 339. *See also* Wooster Group
Snake Theater, 6, 91–93, 113–22, 197, 287, 294
Solo Mio festival, 216
Somewhere in the Pacific, 114–16, 294
Soon 3, 123, 140–49, 279, 280, 282, 284, 286. *See also* Finneran, Alan
Sophocles, 297, 307
Spider Woman Theatre, 226

Spiderwoman Theatre Workshop, 56, 155
Split Britches, 226. *See also* Shaw, Peggy; Weaver, Lois
Split Britches, 226. *See also* Shaw, Peggy; Weaver, Lois
Spoleto Festival, 266
Spolin, Viola, 49
Sprinkle, Annie, 196, 215–17
Spunk, 226. *See also* Wolfe, George C.
Squat Theatre, 7, 158
Stanislavsky (method), 298
Stein, Gertrude, 311, 339, 340
Steinem, Gloria, 242. See also *House Arrest*
Structuralist Workshop, 6, 94, 123, 149–54, 328
Sunflowers, 256. *See also* Chong, Ping; van Gogh, Vincent
Survival Research Laboratories, 196
Sushi Performance Gallery, 206, 217
Swimming to Cambodia, 328. *See also* Gray, Spalding

Tale Spinners, 56
Tate, Gregory R., 233. See also *Gotta Getta Life;* San Francisco Mime Troupe
Tavel, Ronald, 53
Taymor, Julie, 197
Teatro Campesino, El, 52, 57, 58, 74–90, 225, 227, 246
Teatro de la Esperanza, El, 52
Teatro de la Gente, El, 52
Telson, Bob, 306, 307, 308. *See also* Mabou Mines
Tempest, The, 273
Tenth Spectacle: Portraits of Places, 156
Terkel, Studs, 242. See also *House Arrest*
Terminal, 40–44, 49
Terry, Megan, 38
Theatre and its Double, The, 10
Theatre Artaud, 201, 207, 280
Theatre of Nations Festival, 256, 258
13 Dias/13 Days—How the Zapatistas Shook the World, 235–36, 246. *See also* San Francisco Mime Troupe
Three Grapes, 80

Three Places in Rhode Island, 158, 170, 176, 211, 328. *See also* Wooster Group
Three Sisters, 335, 336, 338. *See also* Chekhov, Anton
Tonight We Improvise, 10
Tony N' Tina's Wedding, 198
Tooth of Crime, The, 101
Torture King, 221. *See also* Jim Rose Circus Sideshow
Total Recall, 160
Tropical Proxy, 145–47
Tropicana, Carmelita, 229–30. *See also* Troyano, Alina
Troyano, Alina, 229. *See also* Tropicana, Carmelita
Tseng, Muna, 258–59. See also *After Sorrow;* Chong, Ping
Tube, 221. *See also* Jim Rose Circus Sideshow
Turf, 229. *See also* McCauley, Robbie
24th Hour Cafe, 117–18
2019 Blake, 264. *See also* Coates, George
20/20 Blake, 274, 276–78. *See also* Coates, George
Twilight Los Angeles, 1992, 239–41, 245. *See also* Smith, Anna Deavere
Twisted Pairs, 274, 275–76, 278. *See also* Coates, George

Undesirable Elements, 252, 255–56; *Undesirable Elements/New York,* 255; *Undesirable Elements/Seattle,* 255. *See also* Chong, Ping
Universe (i.e.: How It Works) The, 314, 316–17. *See also* Foreman, Richard
Untitled Flesh, 217–18. *See also* Sacred Naked Nature Girls
Uyehara, Denise, 217. *See also* Sacred Naked Nature Girls

Vaccaro, John, 53
Vacuum, 287–88. *See also* Antenna Theater; Hardman, Christopher
Valdez, Luis, 57, 74–90
Valk, Kate, 327, 332, 334–40. *See also* Wooster Group
van Gogh, Vincent, 256

van Itallie, Jean-Claude, 38
Vargas, Adrian, 52
Vawter, Ron, 197, 327, 328, 331, 333–38. *See also* Wooster Group
Veer, 280. *See also* Finneran, Alan
Vendidos, Los, 76–77, 246
Vietnam Campesino, 78, 80
Vietnam War, 193, 194, 225, 230
Viet Rock, 38–39
Voodoo Automatic, 279. *See also* Finneran, Alan

Walker Art Center, 221
Wallace, Mike, 242. See also *House Arrest*
Wall in Venice/3 Women/Wet Shadows, A, 141–45
Ward, Douglas Turner, 51
Warrilow, David, 297, 299. *See also* Mabou Mines
Warrior Ant, The, 308. *See also* Mabou Mines
Waters, Alice, 242. See also *House Arrest*
Waters, Maxine, 240. See also *Twilight Los Angeles, 1992*
Watts, Alan, 331
Way of the How, The, 264. *See also* Coates, George
Weaver, Lois, 226
Weems, Marianne, 336. *See also* Wooster Group
We Keep Our Victims Ready, 206. *See also* Finley, Karen
Whitney Biennial, 247
Wilder, Thornton, 328, 330, 332, 338
Williams, William Carlos, 10, 274
Wilson, Robert, 6, 123, 125–34, 141, 195, 197, 273, 339
Winter's Tale: An Interstate Adventure, The, 226. *See also* Cornerstone Theater Company
Wittgenstein: On Mars, 274. *See also* Coates, George
Wolfe, George C., 226, 244
Women in Violence, 56
Women's Experimental Theatre, 56
Women's One World (WOW) Café, 209, 226, 229

Women's One World (WOW) Festival, 226
Wooster Group, 7, 170–79, 197, 211, 252, 296, 297, 327–41
Wooster Group, 1975–1985, The, 328
World without End, 209–11. *See also* Hughes, Holly
Worsley, Dale, 308. *See also* Mabou Mines

Xa: A Vietnam Primer, 50–51, 58

Yale Repertory Theatre, 311

Yankowitz, Susan, 40
Yellow Spring Institute, 258
Yiddish Art Theatre, 340
You Can't Judge a Book by Looking at the Cover, 227. *See also* O'Neal, John
Young Frankenstein, 339

Zapata, Emiliano, 235
Zapatista Revolt, 235
Zoot Suit, 88–89
Zulu Spear, 272. *See also* Coates, George